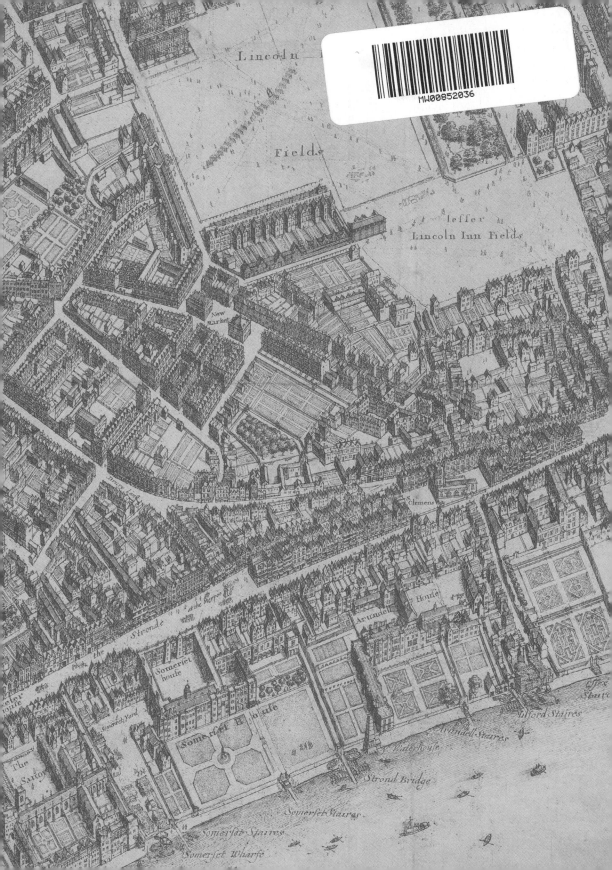

Lincoln

Fields

leffer
Lincoln Inn Fields

New
Market

S. Clemens

Arundell House

Stronde

Somerfet
house

Somerfet House

Arundell

Drury Lane

the Sheppo

Somerfet Yard

The
Savoy

Somerfet House

Strond Bridge

Somerfet Staires

Somerfat Staires

Somerfet Wharfe

Water house

Arundell Staires

Milford Staires

Effex
Stayres

Chancry

Lost Gardens

of

London

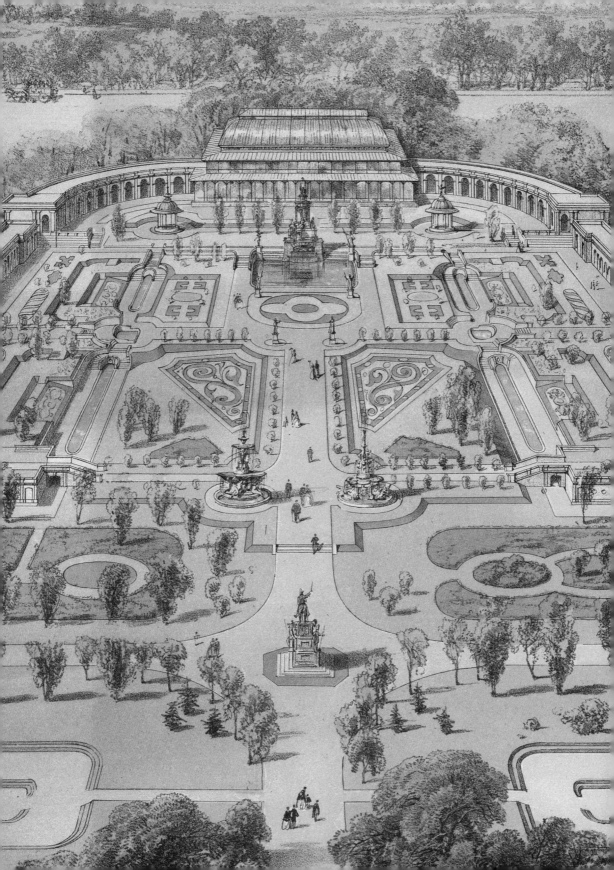

Lost Gardens of London

Todd Longstaffe-Gowan

MODERN ART PRESS

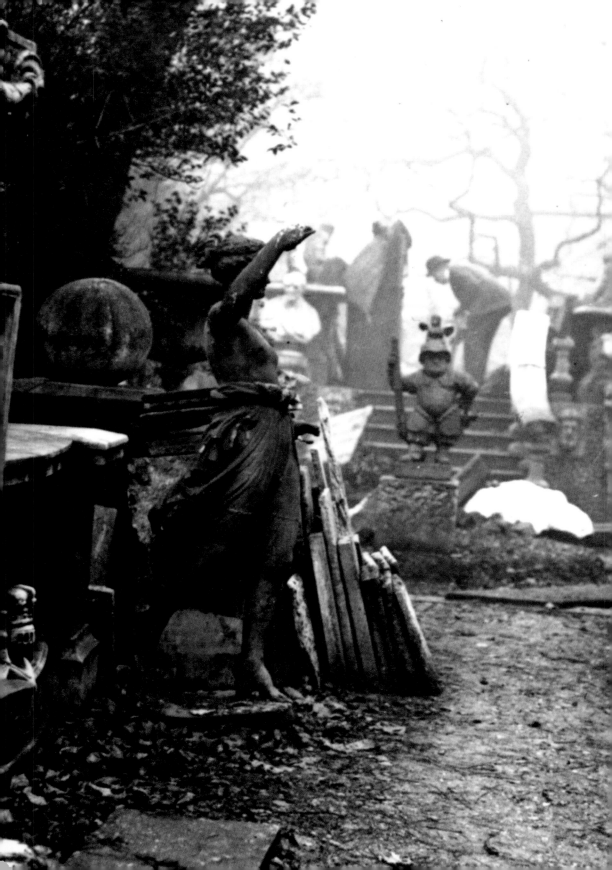

To Clare and James Kirkman, and Debby Brice
– great friends and garden lovers

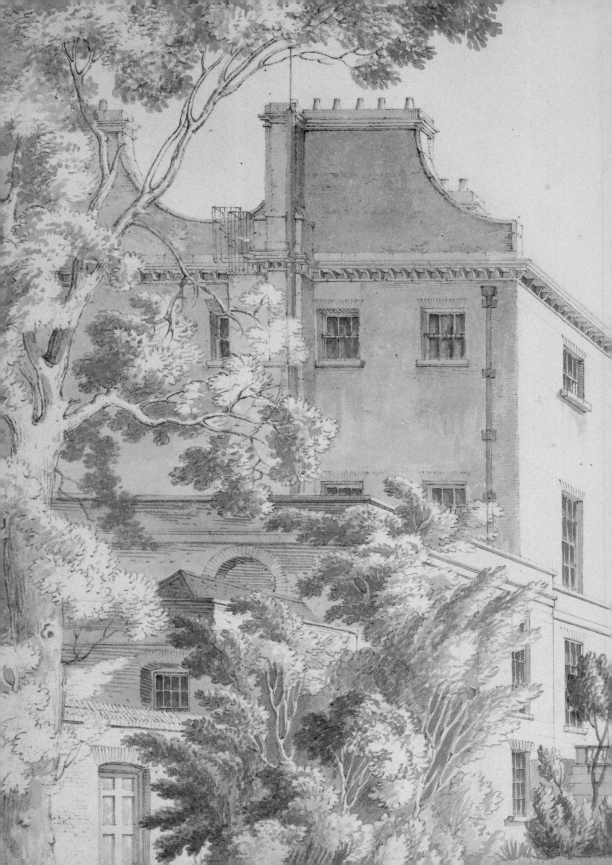

Contents

Preface 9

Introduction 11

1 Riverside Gardens 17

2 The Animated Garden 51

3 Artificial Mounts and other Swellings 71

4 Squares 91

5 Aristocratic Gardens 107

6 Gardens for Entertainment 133

7 Gardens of Artists, Literary Figures
 and Scholars 155

8 Gardens on the Margins 173

9 Gardens of Display 189

10 Ephemeral Gardens 211

11 Reflection and Recreation 231

 Notes 245

 Photograph Credits 262

 Index 263

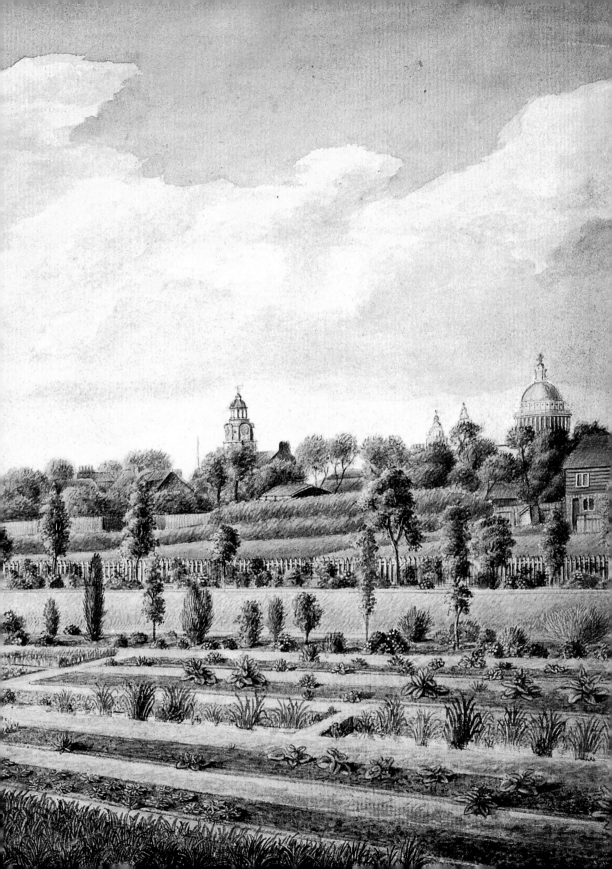

Preface

The publication of *Lost Gardens of London* coincides with an eponymous exhibition at the Garden Museum in London. In July 2023, I was approached by Christopher Woodward, the Director of the museum, to curate an exhibition on 'Lost Gardens of London', to take place in the autumn of 2024. I was especially pleased to accept this challenge because the last exhibition to focus on the history of London gardens was *London's Pride: the Glorious History of the Capital's Gardens*, held at the Museum of London in 1990.[1] Since then, the study of the history of London gardens and landscapes has been the subject of countless popular and scholarly films, publications, blogs, conferences and workshops; it has likewise become an increasingly fashionable pastime and a serious professional and academic pursuit. The focus of these efforts and activities has largely been to examine the management, conservation or reconstruction of gardens. None of these, however, has centred on or celebrated the transitory nature of London's vast and varied garden legacy – ranging from the capital's humble allotments, defunct squares and amateur botanical gardens to its princely pleasure grounds and private menageries, which have either vanished or are still extant, in whole or in part, but which have changed so much as to render them unrecognisable. This book seeks to redress this shortcoming: to remind us of what a precious asset gardened greenspace is and how it has contributed over the centuries to the quality of life and well-being of generations of inhabitants of the metropolis.

Several gardens discussed within this book have been previously researched and recorded by contributors to the *London Gardener* (est. 1995, of which I am founder and editor), the annual journal of the London Gardens Trust.[2] It has been described by the

1. (facing) Detail of fig. 151

landscape historian David Lambert as 'a pioneer of the new garden history, pushing out the envelope and redefining the subject's boundaries... [and] its contents rarely represent less than first-class academic research. With explorations of little-known sites, obscure individuals and unimagined connections, or offering new perspectives on more familiar people and places, the *London Gardener* has consistently shone a highly individual sidelight on the myriad-faceted nature of the parks and gardens of the metropolis.'[3] The aim of the publication is to encourage those interested in the capital's gardens to explore extraordinary places or material that have been overlooked and to allow contributors to pursue their own inclinations, unrestrained. The *London Gardener* is available (for free) online, with a view to making its contents widely available to anyone and everyone who has an interest in the role of gardens and landscape in the history and development of this great city.

I am grateful to Nicola Allen, Charles Beddington, Debby Brice, the Duke of Bedford, Roger Bowdler, Hugo Chapman, Dominic Cole, Stephen Daniels, David Dawson, Annabel Downs, Elena Fateeva, Nick Freed, Manolo Guerci, the late John Harris, Karen Hearn, Charles Hind, Matthew Hirst, Robert Holden, Jill Holmen, Simon Swynfen Jervis, Clare and James Kirkman, Virginia Liberatore, Cathy Lomax, Christina McMahon, Tony Matthews, Jon May, Myles Mears, Alexa Model, Jon Newman, Pilar Ordovas, David Packer, Will Palin, John Martin Robinson, Georgina Rumbellow, Charles Saumarez Smith, Grant Smith, John F. H. Smith, Sally Williams and Samantha Wyndham. His Majesty King Charles III has graciously permitted me to reproduce a delightful image from The Royal Collection.

Paula Henderson has helpfully scrutinised my observations on early London gardens. At Modern Art Press, Susannah Stone went above and beyond to obtain the images, Jacquie Meredith was invaluable as a proofreader, Christine Shuttleworth produced an excellent index and Paul Sloman created a handsome and effective design. Ella Finney has been a genial collaborator in preparing the exhibition that accompanied the publication of this book, and Jamie Fobert and his team designed an exceptionally handsome exhibition in the Garden Museum's gallery.

Gillian Malpass suggested I write this book, got the project off the ground and has been a thoughtful and generous editor; and while Chloe Chard does not regard herself as unduly lachrymose, she has told me that she shed bitter salt tears on reading some of the tales of loss and destruction recounted here.

Once again, Tim Knox indulged my antisocial tendencies when I became entirely absorbed by this project.

Todd Longstaffe-Gowan
August 2024

Introduction

In Charles Dickens's *Great Expectations* (1866), the clerk Mr Wemmick invites the protagonist, Pip, to visit him at home in Walworth, South London. Wemmick explains to his prospective guest that he has '"not much to show . . . but such two or three curiosities as I have got . . . and I am fond of a bit of garden and a summer-house'".[1]

On arriving in Walworth, Pip describes the environs as appearing to be 'a collection of back lanes, ditches, and little gardens, and to present the aspect of a rather dull retirement' and Wemmick's house as 'a little wooden cottage in the midst of plots of garden, and the top of it was cut out and painted like a battery mounted with guns' (fig. 2).[2] The mock castle had a 'real flagstaff', a 'real flag' and a drawbridge – a plank crossing a 'chasm about four feet wide and two deep' – as well as a cannon, mounted on a latticework carriage, that was fired daily at an appointed hour.[3] Behind the 'little place', Wemmick kept a pig, fowls and rabbits, and a 'little frame' to grow cucumbers, so if the castle were '"besieged, it would hold out a devil of a time in point of provisions'"; beyond this ground was an ingenious twisting bower that led to an ornamental 'piece of water' of circular form with an island and a fountain at its centre. The proprietor proudly declared, '"I am my own engineer, and my own carpenter, and my own plumber, and my own gardener, and my own Jack of all Trades'".[4] When Pip is later introduced to Wemmick's father, this 'Aged Parent' touchingly pronounces, '"This is a fine place of my son's, sir . . . This is a pretty pleasure-ground, sir. This spot and these beautiful works upon it ought to be kept together by the Nation, after my son's time, for the people's enjoyment."'[5]

While Dickens is poking fun at the cliché that 'an Englishman's home is his castle' and the eagerness of the middle classes to emulate their social betters, he also identifies in the 'Aged One' the unrealistic expectation that so 'pretty' a pleasure

2.
Edward Ardizzone, 'Mr Wemmick's
Castle', engraving, from Charles
Dickens, *Great Expectations*
(1952 edn). Private collection

ground should be saved for posterity. Alas, thinks the reader, some hope: the nature of gardens is that they are at the best of times precarious and vulnerable, fleeting and ever-changing, and they are especially so in a metropolitan context.

It is, in fact, the transitory quality of gardens that makes them so alluring and poignant. Early in the nineteenth century, the landscape improver Humphry Repton affirmed that 'the pleasure derived from a garden has some relative association with its evanescent nature… we view with more delight a wreath of short-lived roses, than a crown of amaranth, or everlasting flowers',[6] and E. C. Steadman declared in 1891 that 'the ecstatic charm of Nature lies in her evanishments'.[7]

I am intrigued by lost gardens – gardens that no longer exist, but of which tantalising fragments remain that supply some indication of what has been lost; gardens that are known solely through the eyes of topographers, artists or writers, or through the echoes of surviving elements that attest to their former presence. My interest in recovering the past of these impermanent works of art is borne neither of nostalgia nor of longing: I find fragmentary or absent objects seductive and share the sentiments of Beate Fricke and Aden Kumler, and the various contributors to their book, *Destroyed – Disappeared – Lost – Never Were* (2022), that loss – whether total, partial, temporal or imagined – can be 'intellectually productive, [and] even liberating'.[8] These authors remind us that the destruction of works of art has a history as long as their production, and to understand the history of art one must look beyond

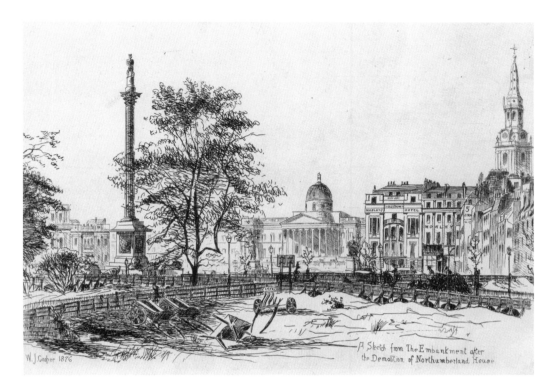

3.
W. J. Cooper, *A Sketch from The Embankment after
the Demolition of Northumberland House*, 1876,
etching. London Metropolitan Archives

*The sketch shows also Nelson's Column and the National
Gallery in Trafalgar Square, Westminster.*

those works of art that have endured to those that have been lost. Fricke and Kulmer assert that 'the study and interpretation of works that survive as fragments of some putative lost bigger picture, of works that do not survive or cannot be examined, and works that may, in fact, have never been realized as material presences ... requires intellectual creativity and energy'.[9] 'Pursued critically and with curiosity', losses awaken in us an 'historical consciousness that apprehends the past's positive forms and negative spaces in a dynamic, dialectic relation'.[10] Loss, in other words, need not give rise to melancholy; it can be 'illuminating' and can be met with optimism and with imagination.

The types of gardens I explore within this book include riverside palaces, 'animated gardens' (menageries and aviaries), squares, pleasure grounds and spas, nurseries, botanic gardens, allotments, ephemeral, zoological and ecological gardens,

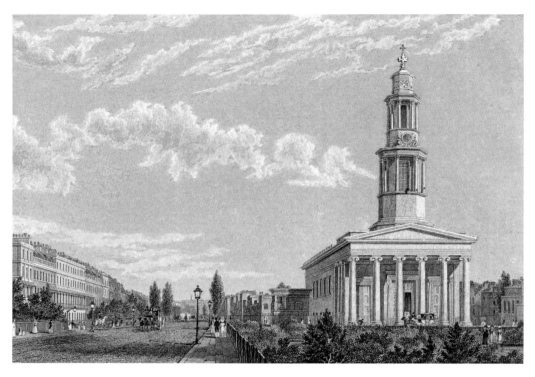

4.

After Frederick Mackenzie, *St Pancras New Church*,
1825, engraving. London Metropolitan Archives

*View looking east to St Pancras Church and the gardens
of Euston Square (left) and Endsleigh Gardens (right).*

cemeteries and suburban retreats. One chapter, 'Artificial Mounts and other Swellings', addresses the sustained interest in the creation of artificial earthworks – from decorative hillocks to a 'mountain of filth and cinders' at Battle Bridge – within a broad range of metropolitan gardens over the past half millennium.

My survey is, above all, a very personal selection of places that I find appealing, curious, unusual or representative of ever-changing trends and fashions in gardening. I have attempted to include a broad cross section of gardens from across the metropolis and over a timescale of the past five hundred years. Inevitably, owing to the nature of the historic development of London, there is a greater concentration of vanished gardens in the central boroughs, where development pressures have been greatest. There have been, nevertheless, significant losses throughout the capital: in every borough, parks, gardens and green open spaces have for centuries succumbed to the ruinous depredations of new roads (Cat Hill, Northumberland

House (fig. 3), Bedford House), street-widenings (Old Palace Yard, Westminster), railways (St James's Gardens, Euston Square (fig. 4), Endsleigh Gardens and Ampthill Square), new buildings (Mornington Crescent, Kennington Manor House, Peerless Pool, Devonshire House, and Loddiges' Paradise Field Nursery), or they have simply been 'swallowed up by suburbia' (Balmes House, Sion Hill). Not all have fared badly: some have been preserved as green open spaces – including Richmond Palace and a handful of squares – though they bear little resemblance to their original incarnations; others, such as Victoria Park Cemetery, have been considerably enhanced through the introduction of thoughtful improvements.

All the gardens included within my survey, with few exceptions – most notably the extraordinary early Victorian 'village' aviaries of the Purlands (father and son) – have been recorded by artists or topographers, and many of these views are supplemented by contemporary accounts. Every garden, moreover, lies within the ring of the orbital M25 motorway, or what is now considered Greater London (the administrative area of London, comprising thirty-two London boroughs).

A striking feature of London gardens is that they seldom adhere to any fixed aesthetic programme, and often display only the faintest of concerns with the vagaries of horticultural fashion. At least two garden-makers considered here emphasise that associations of a highly personal nature are important in their gardens: William Stukeley, with his druidical preoccupations, cultivated over the course of his life, and Hester Piozzi, with her sadness that her first husband had swept away 'the old Seats my Mother used to sit in' and a mount that a son who had died in childhood had crawled up.[11] Even in some larger and grander gardens, such as Arundel House, Sayes Court and Wimbledon House, a concern with the principles that govern landscape design outside the metropolis is often less evident than are exuberant experimentalism, random curiosity, eccentricity, a simple desire to create green spaces in which to breathe and the odd wild surmise about how plants might possibly play a role in constricted urban space. It is, therefore, not altogether surprising that some of these gardens have been swept aside out of sheer indifference to their recondite charms. In other instances – in the area around Euston Station, for example – the destruction of urban oases seems overwhelmingly sad and shocking.

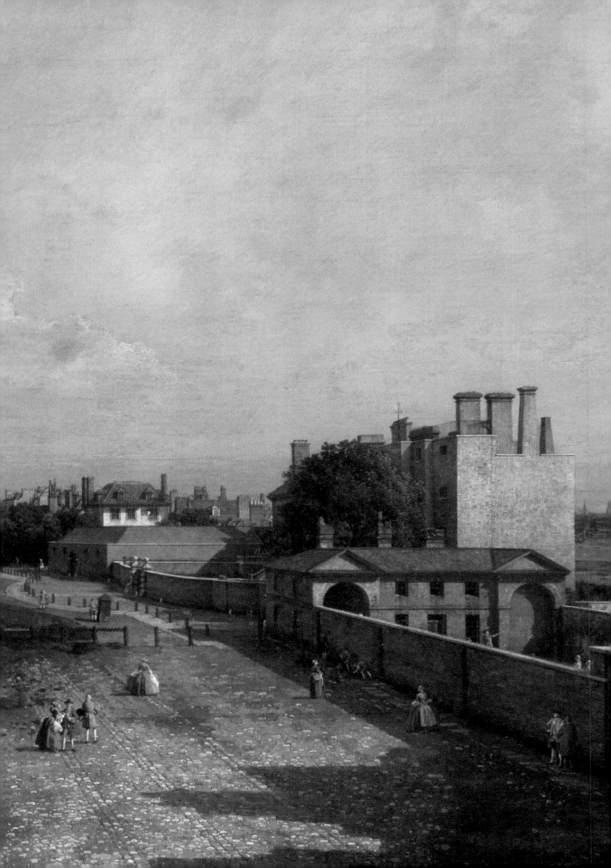

1.

Riverside Gardens

...in calm Ev'nings on the Silver *Thames*
We smile, deluded with the painted Streams,
While from the Banks, fair, sloping Gardens rise,
Here the Green shadow'd Myrtle cheats our Eyes.
There glossey Plumbs a speedy Reach demand;
The fruitful Liquid almost tempts the Hand,
Where ripen'd Grapes in bending Branches vie,
And the Stream blushes with a Purple Dye.
Blue Hyacinths false Fragrancies bestow,
And absent Roses in the Waters blow.

Laurence Eusden,
'A Letter to Mr Addison,
On the King's Accession to the Throne' (1714)

The salubrious Strand

It was announced in the *Shields Daily Gazette* on 18 July 1874 that

> to-day is the last day on which the public will be admitted to view Northumberland
> House before the demolition of that noble mansion is actively commenced. During
> all this week, and especially yesterday, large crowds of visitors have flocked to see
> it... the rooms, corridors, hall and staircases, always... heavy and oppressive in
> their magnificence, are all dismantled, and now look more dull than ever in their
> desolation... The gardens, never very tastefully cultivated of late years, are over-
> run with long, rank grass, and yesterday were not only a picture of desolation
> because of the groups of family parties, men, women, and children who seated

5. (facing) Detail of fig. 24

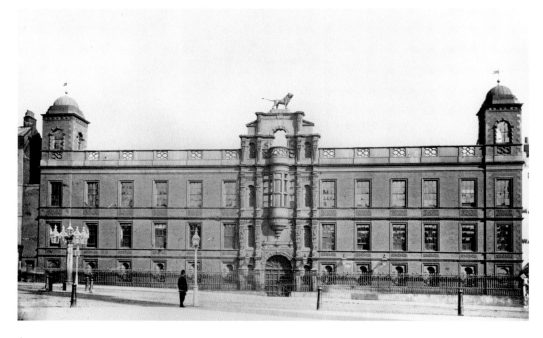

6.
Northumberland House, Strand, *c.*1870.
London Metropolitan Archives

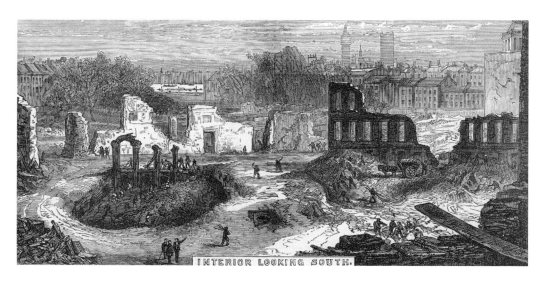

INTERIOR LOOKING SOUTH.

7.
Artist unknown, 'Interior looking South', wood
engraving, from the *London Illustrated News*, 1875.
London Metropolitan Archives

*The illustration shows the demolition of Northumberland House
in progress. After the house came down, the Thames was visible
from Strand for the first time in many centuries.*

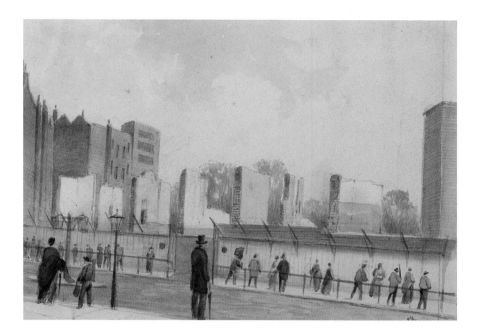

8.
Artist unknown (signed SH),
Northumberland House, Strand, during
demolition, 1875, pencil and watercolour.
London Metropolitan Archives

When Northumberland House was pulled down in July 1874,
it was remarked in the Alnwick Mercury *that now that the*
'light of publicity has been thrown' upon the gardens, the 'little
wilderness in close proximity to the busiest thoroughfare in
London' looked 'somewhat sad and ghastly, the old hawthorns
and hazels looking like Dryads of old suddenly exposed to the
gaze of an irreverent troop of Satyrs'.

themselves 'from morn to dewy eve,' under the shade of the trees which, along with the great house of the Percies [sic], must speedily pass away.[1]

The loss of this 'little wilderness in close proximity to the busiest thoroughfare in London' was much lamented, since 'with [its] departure . . . will disappear one more green spot from the heart of London (figs 6, 7 and 8).[2]

The stately Jacobean town mansion on the north bank of the Thames was demolished by the Metropolitan Board of Works and carted away as builders' rubbish. Its garden was destroyed to make way for Joseph Bazalgette's Victoria Embankment – but not before its most precious spoil was carefully removed and repurposed or sold and the garden's shrubs dug up and transferred to the Embankment's new public gardens.[3]

The mansion house was among the last of Strand's great aristocratic palaces to be built and the last to vanish. Its demolition marked the end of three-and-a-half

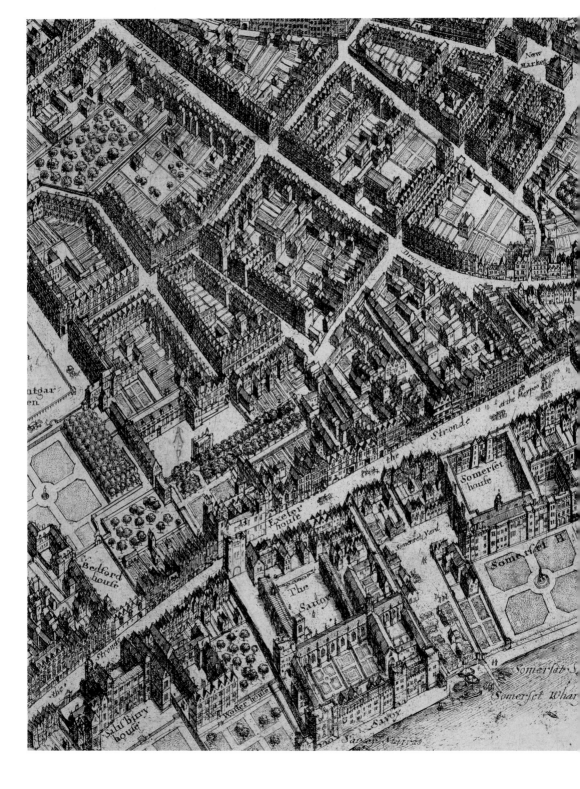

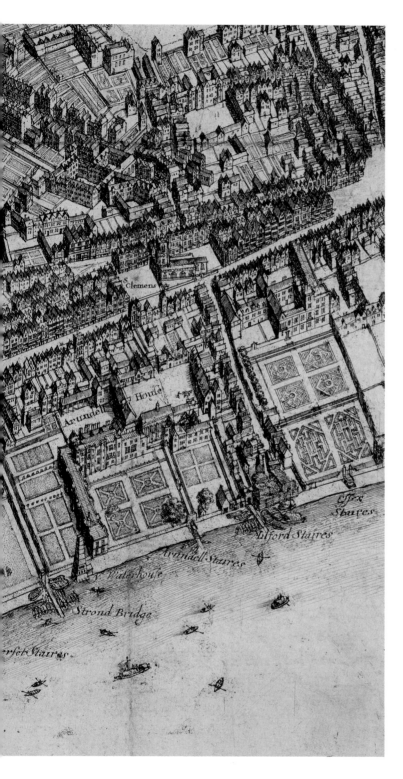

9.
Wenceslaus Hollar, bird's-eye
view of the 'West Central District',
detail, before 1666, etching.
Folger Shakespeare Library,
Washington D.C.

*Few contemporary documents convey
so clearly the princely magnificence of
the gardens of the 'Great houses' that
formerly lined the waterside of Strand.*

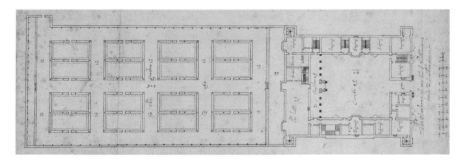

10.
Robert Smythson, survey of the ground floor and
gardens of Northumberland House [then Northampton
House], c.1609, pen and ink. RIBA Collections, London

centuries of what Manolo Guerci, writing in *London's Golden Mile: The Great Houses
of The Strand, 1550–1650* (2021), has dubbed the 'Strand palace phenomenon' – that is,
the princely occupation of a great artery that links Temple Bar in the east to Charing
Cross in the west (fig. 9). Strand, however, had been equally grand well before the
middle of the sixteenth century: from the Middle Ages it was lined with imposing
episcopal mansions, many of which possessed airy courts and magnificent gardens,
and most of which were subsequently remodelled to form the highway's later
secular palaces.[4] There was perhaps nowhere in the kingdom that could boast such
a distinguished and longstanding concentration of horticultural richness than this
verdant and fruitful stretch of the Thames.

Thomas Fairchild remarked in 1722 that 'the Part of London next the River Thames,
and in particular the riverside terrain extending westwards from the Temple to the
Palace of Westminster, including the Strand' was the most salubrious area of town in
which to garden. Here one could achieve a degree of 'Success in Gardening' that was
at the time unimaginable in the 'more Inland Parts of the Town' – 'where every Part
is encompass'd with Smoke, and the Air is suffocated, for wants its true Freedom'.[5]
Fairchild supplied specific examples where a 'good Number of Exotick Plants' could
be grown and would thrive. Among them he cited Somerset House, where it 'has also
been observ'd to produce several Varieties of Things, which more Inland Parts of
Town have not generally been garnish'd with'.[6] He surmised that those places that lie
'all to the Water, and to the Sun, so they are open on one Side to the Air; and perhaps
the constant rising Vapour from the River, helps Plants against the Poisonous Quality
in the City Smoke'.[7]

More than a century before the London nurseryman had penned his observations,
Henry Howard, 1st Earl of Northampton, had begun to create a stately house and

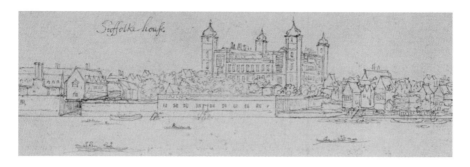

11.
Wenceslaus Hollar, *Suffolke House*, early 1640s,
pen and ink. Pepys Library, Magdalene College,
Cambridge

View of the river front of what would later
become Northumberland House.

garden at the westernmost end of Strand. Northumberland House, as it later became known, was built between 1605 and 1615 and was transformed by Algernon Percy, 10th Earl of Northumberland, in the 1640s and 1650s. The house, which overlooked the river's edge, occupied a long, narrow plot and appears to have been divided into two parts: the 'upper Garden' – a flat parcel of land at the north adjoining Strand which contained the house – and the 'The [lower] garden', which sloped down from the house towards the Thames. The layout is recorded in a survey drawing prepared by the architect Robert Smythson in about 1609 (fig. 10). The house was built around a great 'Courte' bounded on its south side by a 'Cloyster'. Access to the garden was gained by a pair of stairs that led to a broad terrace overlooking the river. A single set of steps then led to 'The garden', the gently sloping terrain of which was adorned by eight large squares, each one encompassed by hedges interspersed with trees. The paths were broad, and the garden's eastern and western boundary walls were lined with trees. The slope terminated in a tree-lined terrace and a water gate. Wenceslaus Hollar's drawing of 1646 portrays the garden as a great mass of billowing trees enclosed by high walls; the wall facing the river is pierced with windows, a central gate and surmounted by a belvedere (fig. 11).

Further east, opposite the Church of St Clement Danes, Essex House, a house of greater antiquity and episcopal origins, enjoyed a similarly elevated position overlooking the river. We know little about its south-facing gardens until the middle of the sixteenth century, when they are portrayed on the *Copperplate Map* (*c.*1555) and where the property is described as 'Paget Place'. It was then in the ownership of Queen Elizabeth's favourite, Robert Dudley, 1st Earl of Leicester, and the gardens are depicted as being divided into four quadrants, possessing a large tree, an outbuilding and two water gates. The view of 1593 by the cartographer and antiquary John Norden

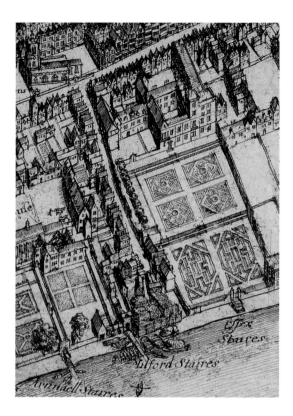

12.
Wenceslaus Hollar, bird's-eye view
of the 'West Central District', before
1666, etching, detail showing Essex
House. Folger Shakespeare Library,
Washington, D.C.

shows them (part of what was then known as 'Leycester howse') in greater detail: the central two-storey range of what the poet Edmund Spenser described in 1596 as the 'stately place' is castellated, and in the south-east corner of the garden, by 'rivers open viewing', stands a crenellated banqueting house.[8] The gardens are later described in 1600 as possessing a 'Banqueting-house near the water-side' and 1639 as having 'walkes, garden plots, and orchards'.[9] The most informative view of the gardens dates from around 1658 and suggests that they were among the most extravagant in Strand. The gardens were entirely enclosed with high walls and laid out over three levels linked by double flights of steps, with a central path terminating in a banqueting house at the water's edge. The uppermost level comprised a broad terrace walk: the middle terrace was elaborated with open knots, and possibly basins and fountains, and the lower terrace was inscribed with fret-patterned beds. The design of the whole appears to be based on Italian sixteenth-century *giardini* (as they were described by Sebastiano Serlio). The garden historian Sally Jeffrey has suggested that the 'Virtuoso' of gardening, John Rose, may have designed and made the gardens adapting earlier patterns (fig. 12).[10]

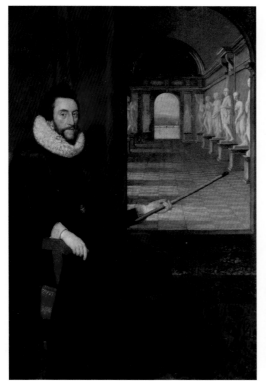

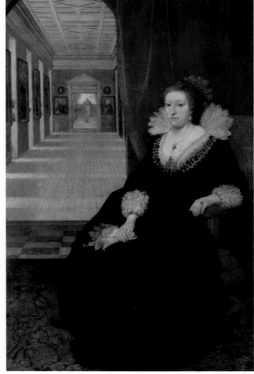

13.
Daniel Mytens, *Thomas Howard, 14th Earl of Arundel*,
c.1616, oil on canvas. National Portrait Gallery,
London

14.
Daniel Mytens, *Aletheia Talbot, Countess of Arundel*,
c.1616, oil on canvas. National Portrait Gallery,
London

The gardens were again remodelled after the Great Fire in 1666, shortly before they were 'absolutely destroyed' in 1674 by the speculative builder Nicholas Barbon. By the late 1670s, the ground had been converted into 'houses and tenements for tavern, alehouses, cookshops and woodmongers'.[11]

The history of neighbouring Arundel House can be traced back to the early thirteenth century, when Eustace of Fauconberg, Bishop of London, was granted the land in the parish of St Clement Danes. Like many Strand palaces, the mansion, with the exception of the gatehouse, had no presence in the street; it was concealed behind rows of houses and their gardens.[12] There is little detailed information about the house's garden until late in the sixteenth century, when it was in the possession of Philip Howard, 13th Earl of Arundel. A survey of 1590 describes the property as 'a messuage or mansion house called Arundel House, with courtyard, two gardens, an orchard, different passages, one [called] the bowling alley, as well as a variety of

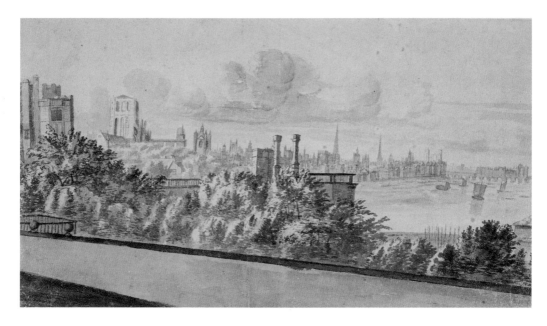

15.
Artist unknown, *London and Old St Paul's from near Arundel House*, c.1650, pen and ink with watercolour wash. British Museum, London

beautiful buildings, with a barn, stables and all related appurtenances'.[13] The garden layout is delineated in Norden's *Speculum Britanniae* (1593), which also confirms the presence of the gallery raised by the 12th earl in the mid-1560s; this would become one of the most defining features of the garden during the tenure of Thomas Howard, the 14th earl. From 1616, this earl and his wife, Aletheia (*née* Talbot), made various important interventions in the house and garden, some with the guidance of Inigo Jones. These contributions transformed the gallery wing and the garden by adding Italianate elements that framed views in and out of the garden and to the Thames; these included a 'new Italian gate', a 'newe Italian window' in the gallery and an 'Italian grate [balcony] over the watter'. Anastassia Novikova has suggested that the views from the open galleries in the backgrounds in Daniel Mytens's full-length portraits of about 1616 of the earl and countess are possibly symbolic: that they can 'be seen as male and female landscapes, the open and the enclosed, the boundless and the free-flowing river, and the circumscribed and secure garden'. The earl's gallery looks 'out', to the outside world, and the countess's looks 'in', towards a garden (figs 13 and 14).[14] Guerci has observed that these portraits give us a 'flavour of the sort of classical interiors Arundel and Jones sought' and reflect the earl's familiarity with

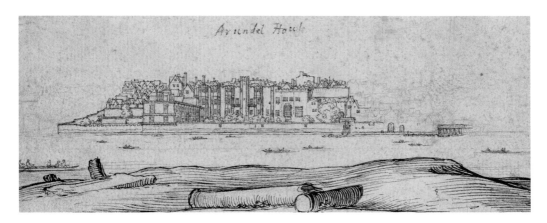

16.
Wenceslaus Hollar, Arundel House seen from the
south side of the Thames, c.1637, pen and ink.
Royal Collection Trust

'great Italian models such as the celebrated Sala Grande in the Palazzo Farnese in
Rome or Julius II's Cortile del Belvedere at the Vatican'. This 'powerful link' to Italian
precedents is further corroborated by a full-length portrait of the 14th earl of around
1627, attributed to Paul van Somer, which shows an abundance of classical statues
distributed in the garden, as well as Jones's classicised eastern gate. Guerci remarks
that the earl's display of statues, inscriptions and architectural carvings within his
garden created a 'museum *al fresco*', which was emulated by other residents of Strand,
including the Duke of Buckingham at York House, the Earl of Northumberland at
Northumberland House and Queen Henrietta Maria at Somerset House.[15]

Two seventeenth-century views document the different aspects of the house and
its setting. The first, by an unknown artist, was taken from a rooftop looking east
overlooking the gardens towards Old St Paul's and the City and captures the verdant
luxuriance of the garden (fig. 15). In the second, Hollar supplies an eye-level view
looking north from land owned by Arundel on the Southwark foreshore (fig. 16).
The presence of two columns in the foreground – one broken and the other partially
buried – suggests that the earl may have placed them here so that, when he surveyed
the south bank from his balcony, he could imagine himself in Rome; or they may
possibly be graphic devices employed by the artist, intended to allude to the 14th earl
and his London palace's exceptional collection of antiquities.

The house and garden were destroyed in two stages: the northern half next to
Strand was torn down in 1677 to make way for a new house, designed by William
Winde, on the garden, facing the river.[16] This scheme was abandoned in view of the

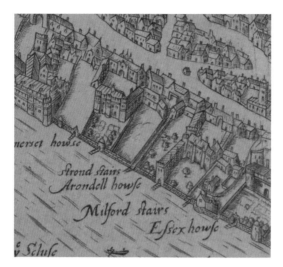

17.
John Norden, *Civitas Londini*,
1600, detail showing Old Somerset
House. National Library of Sweden,
Stockholm, Magnus Gabriel De la
Gardie Collection

deteriorating political and religious background. The remains of the gardens were finally obliterated in the 1680s. The 'Severall [surviving] Statues' in the 'Yard or Garden' were dispersed and the ground redeveloped.[17]

Somerset House, a 'large and goodly House' and its extensive riverside gardens were conceived in the middle of the sixteenth century by Edward Seymour, Lord Protector and 1st Duke of Somerset, as 'an aristocratic palace of monarchical intent'. Its presence on Strand galvanised the country's most ambitious courtiers to follow suit with similarly grandiose schemes of their own.[18] John Norden's bird's-eye view of the City of London of 1600 supplies an early view of the lineaments of the palace's garden: the ground is divided into three walled courts, one of which appears to possess a quadripartite plan and a smattering of trees; two water gates give access to the river (fig. 17).

When, in 1603, Somerset House became the official residence of Anne of Denmark, the wife of James I, immense sums of money were spent on its refurbishment, metamorphosing it into 'the most splendid house in London after the royal palace'.[19] The garden was one of the first areas to be considered: in 1609, the ground to the east of the house and its new Privy Gallery was raised and levelled to form a new Privy Garden. Robert Smythson's survey of around 1609–11 documents this and other landscape features, including a grand parterre south of the 'queenes house' (fig. 18). Two sets of steps lead from the garden to the Thames, one of which is new and designated as the 'Quenes staires'. The most striking and unusual feature was the Parnassus fountain, which was erected in the new east garden. This hydraulic *tour de force* of the French Huguenot engineer Salomon de Caus was described in 1613 as a

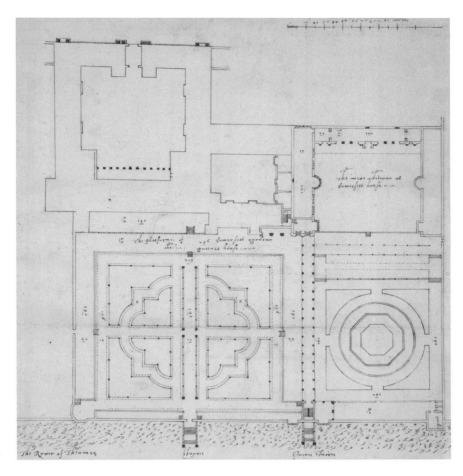

18.
Robert Smythson, plan of the house and
gardens of Somerset House, 1609–11,
pen and ink. RIBA Collections, London

'mountain or rock… made of sea-stones, all sorts of mussels, snails and other curious
plants put together: all kinds of herbs and flowers grow out of the rock which are a
great pleasure to behold … It is thus a beautiful work and far surpasses the Mount
Parnassus in the Pratolino near Florence' (fig. 19).[20]

No further significant changes took place in the garden until Charles I's wife,
Henrietta Maria, came to occupy it. During her occupation, a new water gate and
landing stage were built to the designs of Inigo Jones, forming a grander terminus to
the Privy Gallery; a new tennis court was also laid out, as was a new fountain to the
designs of Hubert le Sueur and Inigo Jones.[21] The gardens were also embellished with

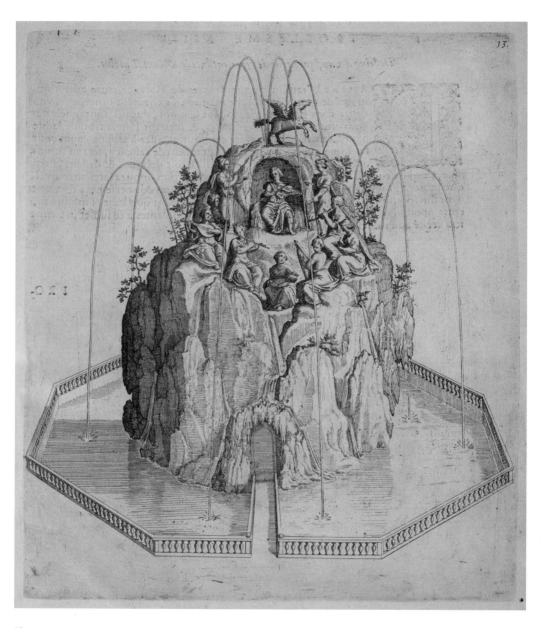

19.
Salomon de Caus, 'The Parnassus at Somerset
House', copperplate engraving, from *Les Raisons
des forces mouvantes* (1615). Linda Hall Library,
Kansas City, Mo

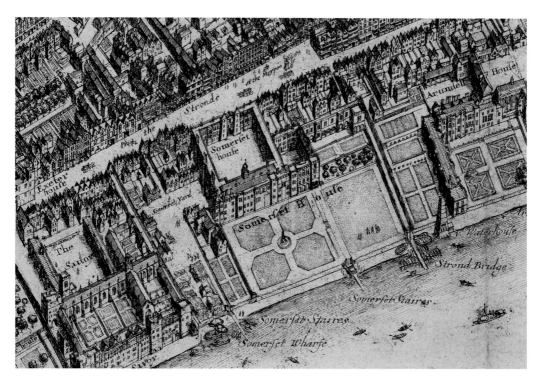

20.
Wenceslaus Hollar, bird's-eye view of the 'West
Central District', before 1666, etching, detail
showing Somerset House. Folger Shakespeare
Library, Washington, D.C.

statuary purchased by Charles I from the Duke of Mantua between 1628 and 1632
(fig. 20). The formation of a round basin within the former parterre in the early 1680s
and the planting of a '*cloyster* of the… *French* elm in the little garden near the chappel'
were among the last major changes to the take place in the garden.[22]

The gardens at Somerset House were, from the early eighteenth century, among
the only riverside gardens in Strand to be opened on a regular basis to the public. The
'handsome garden and its gravel walks' were commended as being 'extremely pleas-
ant'[23] and were much frequented by 'the genteel sort of people'.[24] Most appealing of all
was its 'charming… Situation, just in the Middle of [the] Bow, which the River forms
between the *Bridge* and *Westminster*', which was praised by Robert Seymour in 1735
for 'commanding the Prospect both Ways, and looking direct in the Hills of Surrey'.[25]
The river frontage had an 'Air of Grandeur suitable to a Royal Palace, and is the finest

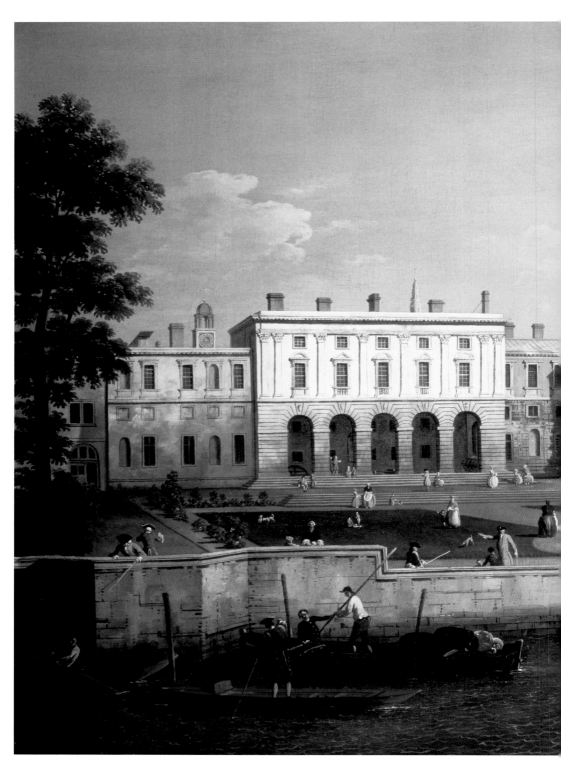

21.
Giovanni Antonio Canal, called 'Canaletto', *Old Somerset House
from the River*, *c*.1745–50, oil on panel. Private collection

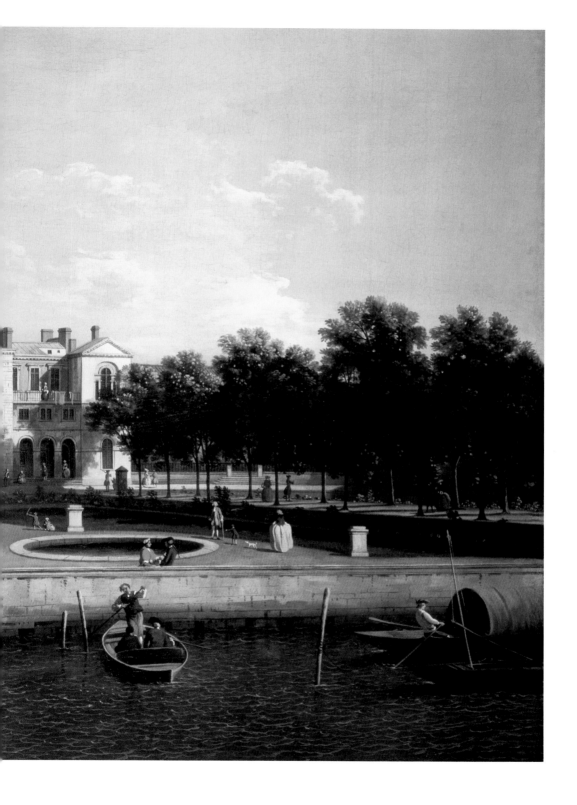

building in View of the River, to which the shady Walks, Statues and Fountain in the Garden, that extends down to its Banks, are no small Ornaments' (fig. 21).[26]

By the middle of the eighteenth century, however, Somerset House was dilapidated, and it was reported in *London and its Environs Described* (1761) that its Strand façade was 'much defaced by time and the smoke of the city'.[27] The building was pulled down and its garden was destroyed in 1775 to make way for William Chambers's 'magnificent [new] edifice'.[28]

Guerci affirms that the majority of the houses that lined the south side of Strand differed from their continental counterparts in 'a fundamental way: they lacked an urban appearance, for they hid from the street and instead opened towards the Thames, recreating *a rus in urbe* at a time of increasing development' – a quality that, he suggests, they share with the Italian *villa suburbana*.[29] His analysis unleashes a meditation on the symbolics of such gardens – hidden on one side yet resplendently visible on the other – at the centre of a large city. The evidence suggests that to the patrician inhabitants of Strand, their houses and gardens were to them simply indivisible.

Westminster

Travelling westwards along the Thames, we arrive at the labyrinthine assemblage of the Palace of Whitehall. It has been suggested that we should think of Whitehall less in terms of its physical substance of the buildings, and more as a 'complex idea (much like the royal court itself), defined as part architecture, part ritual and social function, and part urban matrix'. To this list should be added gardens, because it was gardens that mediated between the palace's many structures and provided a unifying framework and the setting for the 'largest secular building complex in England'.[30]

The former episcopal residence had been acquired in 1514 by Thomas Wolsey, then Archbishop of York, who remodelled the property and also purchased land to the north and south, which enabled him to create new and extensive gardens between the house and King Street (now Whitehall). When, in 1529, Henry VIII acquired the property from Wolsey, he embarked upon an ambitious building project that would rival his work at Hampton Court Palace.

It was Henry VIII, to whom 'pleasure was fundamental to politics', who transformed Whitehall into what has been likened to a 'royal recreation center with tennis courts, bowling alleys, tiltyards, buildings for cockfights, and galleries for courtiers to watch their king at play'.[31] Gardens were, however, an equally important constituent,

22.
Artist unknown, *The Family of Henry VIII*, detail,
*c.*1545, oil on canvas. Royal Collection Trust

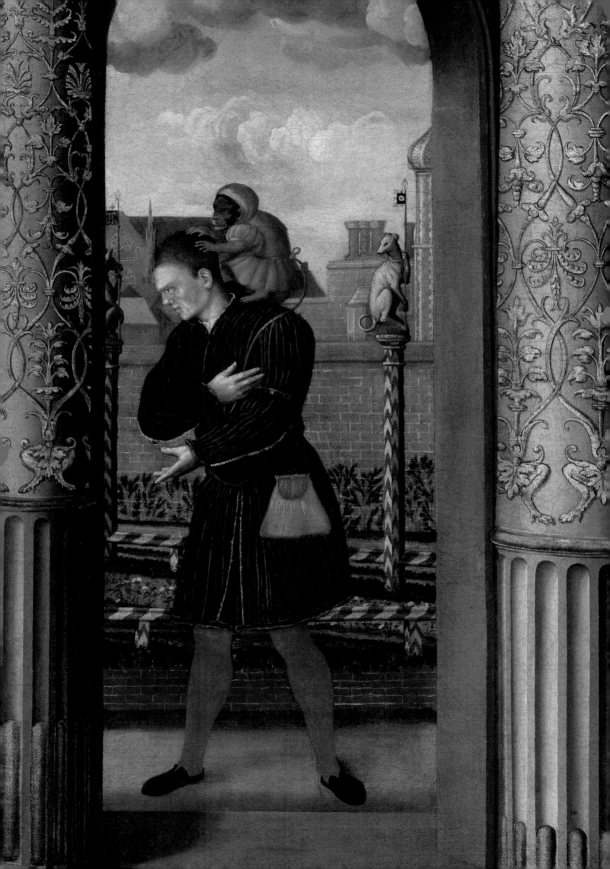

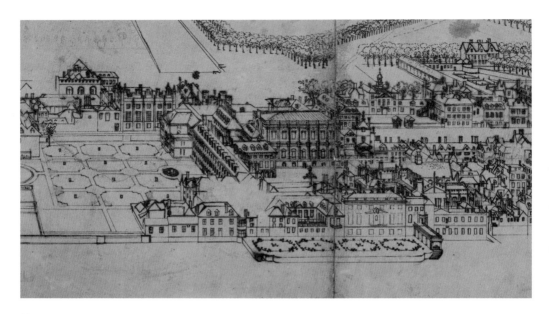

23.
Leonard Knyff, bird's-eye view of Whitehall Palace,
detail, c.1695, pen and ink and watercolour wash.
British Museum, London

and several of these were capacious and prominent, including the Great Garden, the
King's Privy Garden, and the New Orchard (later a bowling green). Two views of the
Privy Garden are discernible in the portrait of the family of Henry VIII (c.1545): of
particular note are the 'Kynges beestes', or heraldic beasts, that surmount green-and-
white stanchions that decorated the pleasance (fig. 22).

Although the palace grew incrementally and in a haphazard manner – indeed, so
much so that Samuel de Sorbière described it in about 1664 as 'ill built and nothing
but a heap of Houses, erected at divers times, and of different Models, which they
made Contiguous in the best Manner they could for the Residence of the Court'[32] –
the extent of the Great Garden remained reasonably intact. The most notable change
to this area since Henry VIII's reign had been the replacement of its latticework of
Tudor railed beds, abounding with Kynges Beestes, by simple grass plats adorned
with central statues. In 1669, a 'Pyramidical [sun] Dyal' was erected upon a pillar in
the garden by 'that most ingenious Mathematician Father *Francis Hall*, alias *Line*, of
the Society of Jesus'. It was one of 'very many sorts of dyalls' in the palace gardens.[33]

Leonard Knyff's aerial view of around 1695 shows the palace precincts not long
before a great fire consumed the greatest part of it in January 1698 (fig. 23). The topo-
grapher portrays them as Edward Chamberlayne described them in 1700: 'seated

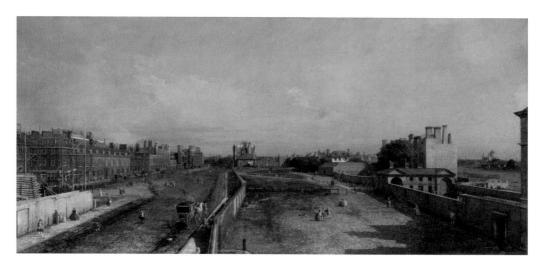

24.
Antonio Canaletto, *View of Whitehall, looking North, with the Corner of Richmond House and its Stables . . .* , 1751, oil on canvas. Bowhill House, Selkirk, Buccleuch Collection

between the Thames, and a most delectable and spacious [St James's] Park, full of great Varieties'.[34] By this time, the Great Garden (then known as the Privy Garden), which had survived the blaze, had become an informal extension of the neighbouring park and would remain an open space throughout much of the first half of the eighteenth century (fig. 24).

A short distance to the south lay the Palace of Westminster, with its collection of gardens not now often associated with horticulture. Leonard Knyff – 'the Undertaker for the Drawing and Printing [of] the Noblemen and Gentlemen's Seats in this Kingdom' – depicted Old Palace Yard around 1707, when he occupied a house in the Yard, 'adjoining to the Stairs going up to the House of Lords' (fig. 25).[35] The large, walled rectangular court was situated between Westminster Hall in the east and Westminster Abbey to the west. The southernmost wall is shown as covered with fan-trained wall fruit, and many of the buildings enclosing the Yard are decked with vines and climbers. The garden itself is laid out on a geometrical plan and embellished with clipped sentinels; at the centre is a round basin with a statue mounted on a pedestal. Although it is difficult to determine the subject of the sculpture precisely, its pose resembles that of the *Borghese Gladiator*, which might explain why a public house within the Yard was called the 'Naked Boy'.[36]

The garden boasted at least one horticultural distinction – not illustrated in Knyff's drawing: the gardener-writer Richard Bradley remarked in his *New Improvements on*

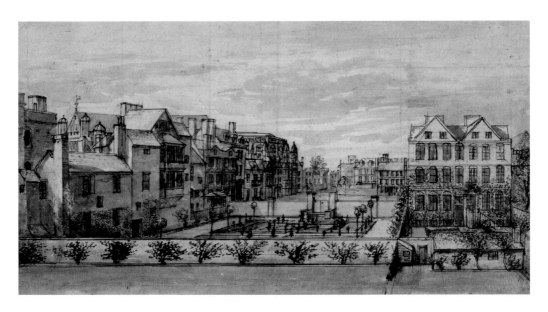

25.
Leonard Knyff, *Westminster, Old Palace Yard, looking North*, c.1706/7, pen and brown ink with grey wash over graphite. British Museum, London

Planting and Gardening (1718) that he observed Virginian '*Acacia*' – then a great rarity – thriving within it, which he suggested was 'plain Proof we might easily naturalize the *Virginian* Plants to our Climate'.[37] Thomas Fairchild also described the tree in *The City Gardener* (1722) as making a 'good Figure, and a large Tree'.[38] The Yard was, however, possibly better known as a site of execution: here, in 1606, the conspirators behind the Gunpowder Plot (1605), Thomas Winter, Robert Keyes, Ambrose Rookwood and Guy Fawkes, were despatched, and, in 1618, Sir Walter Raleigh 'mounted the Scaffold with a chearful Countenance' to meet the 'Headsman's' axe.[39]

The decline of the garden presumably began in 1724, when a new gateway was formed 'in order to make more free Passage between the old and new Palace Yards'.[40] By the 1740s, the little pleasance had been obliterated by the creation of Abingdon Street and St Margaret Street (fig. 26).

Only a short distance away, and within the palace precincts, another modest garden was formed roughly a century later, on the banks of the Thames. Although we know reasonably little about this riverside garden, designed by Humphry Repton for the Hon. Charles Abbot, Speaker of the House of Commons, it was, before it was erased by the Great Fire at Westminster in October 1834, a distinguished pleasure ground that commanded impressive panoramic views up and down the Thames.[41]

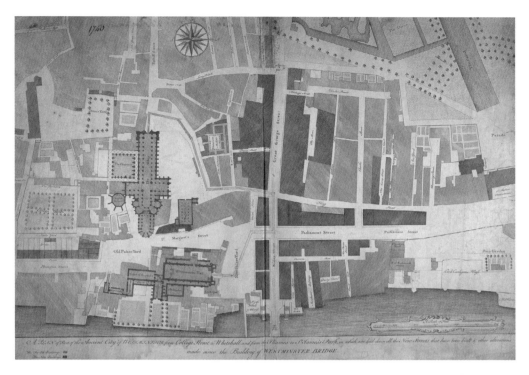

26.
Artist unknown, *A Plan of Part of the Ancient City of Westminster, from College Street to Whitehall, and from the Thames to St. James's Park*, 1740, engraving with pen and black ink, blue wash, and graphite, Palace of Westminster, London

Repton's plans for the garden were part of an ambitious package of improvements that Sir John Soane described as expected to 'produce a burst of Architectural Scenery ... unparalleled in any part of Europe'.[42] James Wyatt, then the King's Architect and Surveyor General of the Office of Works, proposed reconstructing the palace as a castellated gothic ensemble. This entailed remodelling the Speaker's House and Garden and reshaping the river front of the palace, including St Stephen's Chapel, which, at the time, accommodated the House of Commons. The scheme proposed the creation of a 'composed river frontage' and the 'finest possible picturesque architectural effect'.[43] The proposals were published in a *Report and Memorial of the Commissioners for making Improvements in Westminster, near Westminster-hall, and the Houses of Parliament* (1808) and included making good 'the line of ground next the River by an embankment', which was to be 'planted with trees' and to be 'sufficiently broad, and to be carried the whole length of the Parliament buildings, between the Speaker's Garden and the River.'[44]

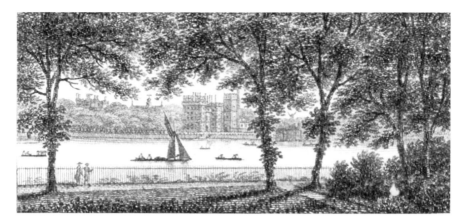

27.
John Peltro, after Humphry Repton, 'Lambeth Palace
from the Garden of the Rt. Hon.ble the Speaker of the
House of Commons', headpiece engraving for the month
of August, from *Peacock's Polite Repository* for 1808

Abbot was a 'friendly patron' of Repton and had earlier commissioned the land-
scape improver to assist him at Kidbroooke Park in Sussex. Stephen Daniels suggests
that the work at Speaker's House appears to have been undertaken informally, as part
of his longstanding relationship with his client. Repton had, however, been working
at the time on a variety of projects in London with 'wider implications for space and
urban planning.'[45]

The most illuminating view of the Speaker's new garden is a miniature scenic
view drawn by Repton and engraved by John Peltro for the annual pocket diary
Peacock's Polite Repository, or Pocket Companion for the year 1808 (fig. 27). It portrays,
like many of Repton's views, a work in progress. The engraving is inscribed 'Lambeth
Palace from the Garden of the Rt. Hon.ble the Speaker of the House of Commons'
and depicts a view looking south across an open lawn, the right side of which is
embowered by shrubs. The edge of the garden where it joins the Thames is enclosed
by a metal railing. The river is animated by passing trade and leisure vessels, and
lofty trees in the middle-ground frame views across the river to the tower of St Mary's
Lambeth on the south bank.

It is ironic that no sooner had the Speaker's riverside oasis been tastefully refur-
bished than it was transformed into a miniature garrison: during the 'tumults' pre-
cipitated by the unpopularity of the signing of the Convention of Cintra at the end
of August 1808, during the Peninslar War, the River Fencibles were moored near the
Speaker's Garden on the bank of the Thames 'to prevent any attack on the sea-side of
Palace-yard'.[46]

Semi-rural Retreats

Richmond Palace, anciently Sheen Palace, lay on the south bank of the Thames, sixteen miles upriver of London Bridge. A royal palace from the time of Henry I, it was rebuilt by Henry VII with great splendour after the original structure was destroyed by fire in 1499 and was completed in 1501. Unlike the large houses in Strand, the great Gothic-style palace-castle, laid out around a central courtyard and bristling with heraldic banners and beasts, stood close to the water's edge, with its extensive gardens encompassing it on three sides (fig. 28). Roy Strong has suggested that the palace's 'elaborate galleried gardens' were 'in imitation of those at the courts of Burgundy and France'.[47]

The earliest surviving description of the 'goodly gardeyns' dates from 1501, when they were fitted up for the arrival of Katherine of Aragon on the eve of her marriage to Prince Arthur, Henry VII's eldest son. The 'most fair and pleasant gardens' were adorned with

> … royal knots alleyed and herbed: many marvellous beasts, as lions, dragons, and such other of divers kind, properly fashioned and carved in the ground, right well sanded and compassed in with lead; with many vines, seeds and strange fruit, right goodly beset, kept and nourished with much labour and diligence. In the longer end of this garden both pleasant galleries and houses of pleasure to disport in, at chess, tables, dice, cards, bills, bowling alleys, butts for archers and goodly tennis plays… [48]

The layout does not appear to have changed significantly by 1561–2, when Anthonis van den Wyngaerde prepared a series of sketches of the palace, each one from a different angle and vantage point (fig. 29).

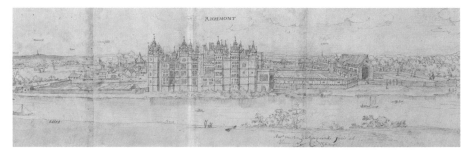

28.
Anthonis van den Wyngaerde, *Richemont*, 1562,
pen and ink with watercolour wash, detail showing
Richmond Palace from the south-west, across the
Thames. Ashmolean Museum, Oxford

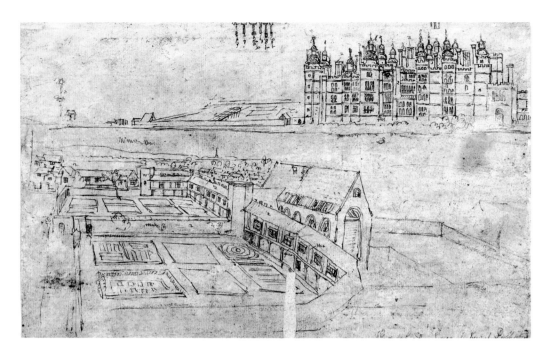

29.
Anthonis van den Wyngaerde, the river front
of Richmond Palace, c.1560, pen and ink with
watercolour wash. Ashmolean Museum, Oxford
The view includes the Privy Orchard and Privy
Garden (bottom left).

Henry, Prince of Wales, the eldest son of James I and Anne of Denmark, was the last royal incumbent to make and propose major landscape improvements, and 'faire *Richmond* standing by the *Thames*' was, during his short, two-year tenure, before his death at the age of eighteen, the centre of 'a dynamic, if short-lived, artistic community'.[49] As James Maxwell recounts in his panegyric to the late prince in 1612 – he had 'a great thirst in building, planting and repairing':

> To plant and build he had a great delight,
> Old ruines his sole presence did repair;
> Orchards and Gardens forthwith at his sight
> Began to sprout and spring, to flo[u]rish faire... [50]

Between 1611 and 1612, the prince commissioned Salomon de Caus, Mountain Jennings and Inigo Jones to produce designs for hydraulic systems, and waterworks in the grounds. Jennings prepared drawings for 'sundrye plates of the orchard, howse,

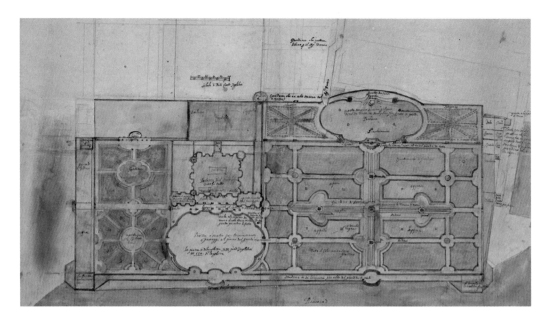

30.
Costantino de' Servi, proposal for the gardens
at Richmond Palace, 1611, pen and ink and
watercolour wash. Archivio di Stato di Firenze

Friers and the three Islandes', and payments were made for 'the making of staires or bridges to passe into ye Islands'. The historian Paula Henderson suggests that the islands were possibly 'to be part of a grand water feature with various "devices of the frenchman"'.[51]

In 1611, the Florentine architect Costantino de' Servi prepared plans for re-modelling the gardens. Robert Smuts observes that, had they implemented the proposals put forward in his 'resolutione della pianta é spartimenti de' giardini fontane e grotte', the gardens 'would not have looked out of place on the Arno or the Tiber' (fig. 30).[52] They were to be embellished with a striking variety of fanciful conceits, including a chicken house (*pollaio*), a version of Trajan's Column (*Colonna che sara come la Troiana di Roma*), a pyramid (*piramide*), a garden of medicinal herbs (*Giardino di Semplici*), a piazza and theatre for tournaments and strolling (*Piaza é teatro per torniamenti é passeggi al piano del giartino*), a loggia and new courtyard (*loggia avanti el Cortile di nuovo*), a grotto (*grotta*), bowers (*gabinetti*), an oval fishpond (*peschiera*), two wildernesses (*salvatici*) and a Mount Parnassus (*monte parnaso*).[53] Sculptures of water birds (*uccelli daqua*) were to float in the proposed basins, and sea monsters (*mostri marini*) were to flank the paths to the *peschiera*.

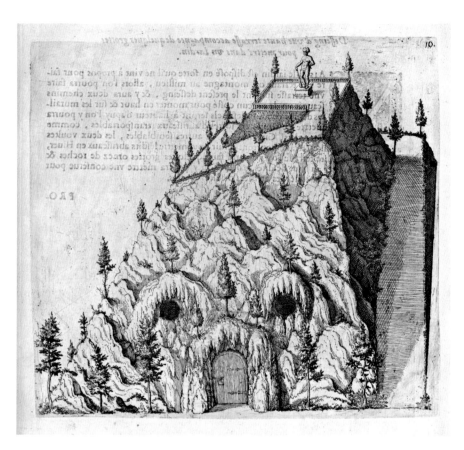

31.
Salomon de Caus, 'Desseing d'une montagne au millieu
d'un Jardin avec quelques grotes dedans', copperplate
engraving, from *Les Raisons des forces mouvantes* (1615).
Linda Hall Library, Kansas City, Mo
*The mount depicted was probably intended for the grounds
of Richmond Palace.*

Most remarkable of all was the proposed erection in the garden of a 'great figure... three times as large as the one at Pratolino, with rooms inside, a dovecot in the head and grottoes in the base'. Strong has suggested that this figure – a variation on Giambologna's eleven-metre high *Colosso dell'Appennino* – would have been 'gargantuan in size. Nothing like it can ever have been seen in England'.[54] Strong has also proposed that de Caus's published design for an 'artificial mountain with an aviary within it and a pathway leading up to a recreation of the speaking statue of Memnon' was probably destined for the prince's garden, as his royal patron took

delight 'in all Kinds of rare Inventions and Arts' (fig. 31).[55] We shall never know for certain, since the gardens and the palace were dismantled during the Commonwealth.

Some fifteen miles to the east is Sayes Court in Deptford, for which John Evelyn acquired the lease from the Crown in 1653. He explained in his diary that it was 'very much suffering, for want of some friend, to rescue it out of the power of the Usurpers; so as to preserve our Interest'.[56] The large Elizabethan house – or what he later referred to as 'my *Villa*' – had earlier belonged to his wife's family and had been 'ruin[e]d' after it had been seized during the Commonwealth.[57] Immediately Evelyn took possession, he began his transformation of a one-hundred-acre (40.5-hectare) field into a garden. His inspiration was the distinguished and ingenious nurseryman and collector of curiosities Pierre Morin and his garden in Paris which Evelyn had visited and recorded on two occasions.[58] He began by setting out his '*Ovall Garden*' in January 1653 in what had formerly been a 'rude *Orchard*' – a bold feature he later referred to as 'my Morine Garden' and which he hoped, if it prospered, 'will as farr exceed that both for designe & other accommodations'.[59] This garden was succeeded by a rash of improvements carried out at great speed – indeed, so much so that, by the autumn of the same year, Evelyn declared, 'wee are at present pretty well entered in our Gardning' and that 'the plott' was finished.[60]

Evelyn's garden improvements are recorded on a richly detailed and remarkable plan of 1653 (fig. 32): the 'Carpe pond' was 'new dug, and rail'd'; the 'evergreen thicket' supplied 'private walkes, shades and Cabinetts' for birds; the 'Mount, Center, and Dial' were 'sett about with Cypresse as likewise in everie Corner of the Parterres and Grasse plots'; the 'Long Pourmenade from the Banquetting house to the Island' was 526 feet long and 21 feet broad; the 'moate about the Island' was 'stored with Carpe, Swannes, Duckes &c and a boate'; the 'Great Orchard [was] planted with 300 fruit trees of the best sorts mingled'; and the Grove was formed of '14 Cabinetts of Aliternies, and a great french walnut at every one, whereof I have planted 24 in all, and above 500 standard trees of oake, ash, elme, Cervise, beech, chesnutt, besides the thickets with Birch, hazel, Thorne, wild fruites, greens, &c: the close walkes, and Spiders Clawes Leading to the Cabinetts'. The plan also noted such relict features as 'the old watring Pond', 'the great hollow Elme', a 'Row of tall Elmes' and 'the way Leading to the Stayres on the Thames'.

Following the Restoration of Charles II in 1660, Evelyn ceased to be able to dedicate as much time to improving his gardens as he had during what had been for him the 'politically unproductive years of the interregnum', but he continued to make 'the Garden his businesse and delight' until he quit Sayes Court in May 1694 to remove to his brother's house at Wotton. The property was then let – on the condition that the garden should be kept up – to Admiral Benbow, who in turn leased it to Peter the Great, 'Tzar of Muscovy', whom Evelyn later accused of leaving

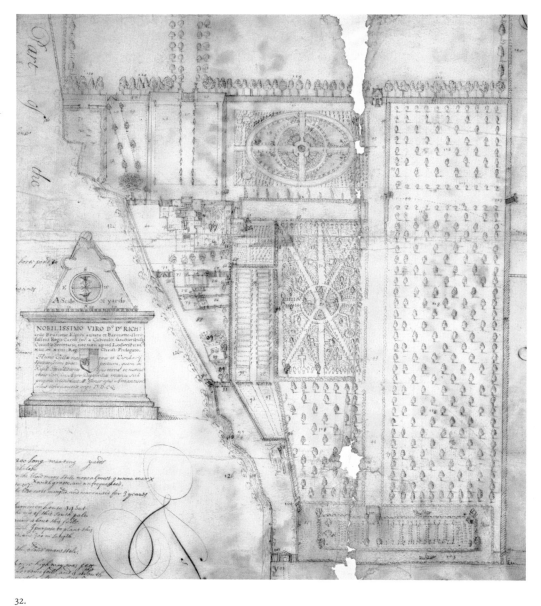

32.
John Evelyn, Sayes Court, Deptford,
c.1653–4, pen and ink. British Library,
London, Evelyn Papers, vol. 461

his house 'miserably'. The Tsar also did 'Great dammages' to the garden's 'trees and plants, which cannot be repaired', and is alleged to have caused great holes to be carved in Evelyn's much prized holly hedges so that he could be trundled through the gardens in a wheelbarrow.[61] This was the beginning of the 'decadence' of Evelyn's 'sylvan retreat': the house became first a workhouse and latterly almshouses, and by 1886 part of the old grounds were given over by a descendant of Evelyn to form a public park; the residue was developed and now lies within the brownfield site of Convoys Wharf.[62]

Evelyn's garden was more than a mere pleasure ground: here a leading light of Restoration gardening 'exercised his experimental interests in arboriculture and horticulture' and, like his contemporary John Rose, 'he had his nursery gardens, an "elaboratorie" where he practised chemistry, a transparent beehive and a walled private garden of choice flowers and simples'.[63]

Stews in Southwark

Also on the south bank of the Thames, but closer to the City of London, was a garden that might seem unexpected in the context of an area known for rackety living rather than pastoral delight.

Thomas Nashe grumbled in *Christs Teares over Jerusalem* (1593), '*London*, what are thy Suburbes but licenced Stewes? Can it be so many brothel-houses, of salary sensuality, and six-penny whoredom, (the next doore to the Magistrates) should be sette vp and maintained, if bribes did not bestirre them?'[64] The 'bawds', or whore houses of Southwark had been notorious since the twelfth century. Although the authorities had on various occasions attempted to shut them down, their efforts had been unsuccessful. Thomas Fuller remarked in 1642 that 'some conceive that when King Henry the eighth destroyed the publick Stews in this Land (which till his time stood on banks side on Southwark next the Bear-garden, beasts and beastly women being very fit neighbors) he rather scattered then quenched the fire of lust in this kingdome… But they are deceived.'[65]

We seldom associate brothels with gardens, but at least one such establishment that flourished on London's south bank boasted a modest, moated pleasure ground and was rather extraordinarily commemorated in a woodcut for posterity.

Paris, or 'parish Gardyn', was a 'privileged place' which comprised a large swathe of Southwark and a landing stage used by visitors to the south bank in pursuit of pleasure. The manor covered roughly one hundred acres (40.5 hectares) of 'marshy riverside land' and first appears in records early in the fifteenth century. Surviving surveys document that the land also possessed gardens, orchards, meadows, pastures and other open areas. Henderson has suggested that William Baseley, Bailiff of

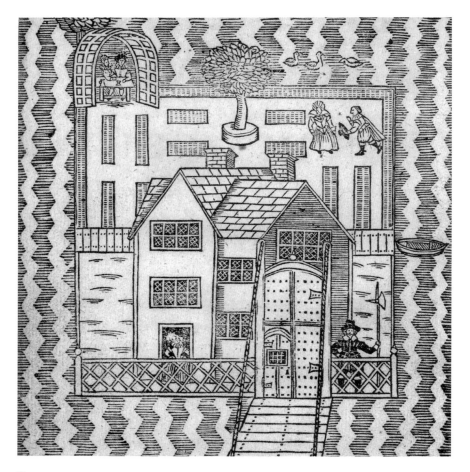

33.

Artist unknown, 'Night and day, the gate of gloomy Hell lies open', woodcut, from *Holland's Leaguer* (1632). British Library, London

This bird's-eye view of the celebrated brothel and its moated garden near the Globe Theatre on Bankside is a rare view of an early seventeenth-century brothel garden.

Southwark, was the first person to open a 'public gaming place with bowling alleys and place to play "cardes, dyze and tables"'.[66] By the middle of the sixteenth century, Paris Gardens had become a notorious meeting place for foreign ambassadors, and guards in the gardens frequently confronted them as 'night-walkers, contrarie ot the lawe'. The gardens were described at the time as 'so dark with trees that one man cannot see another, except they have lynceos oculos or els cattes eys ... it is the very bower of conspiracy'.[67]

Few resorts in the manor were as notorious as Elizabeth Holland's 'Leaguer'.[68] In January 1631/2, the attempted suppression of the brothel, which had been established

in the 1620s, became a *cause célèbre* and inspired no fewer than three publications, one of which was entitled *Holland's Leaguer: or an Historical Discourse of the Life and Actions of Dona Britanica Hollandia the Arch-Mistris of the wicked women of Eutopia. Wherein is detected the notorious Sinen of Panderisme, and the Execrable Life of the luxurious Impudent*. This scurrilous pamphlet was illustrated by a woodcut bearing the Virgilian epigraph *Noctes at que dies patet atri Ianua Ditis*, or 'Night and day, the gate of gloomy Hell lies open' (fig. 33). The view is a caricature of the real establishment, which is known to have been a fortified, moated mansion house set on one acre (0.4 hectare) of land with gardens.[69] Here, the Leaguer is portrayed as a three-storey, gabled mansion set within a small, square, moated garden. Access to the island is gained by a drawbridge protected by a pike-wielding guard. The garden behind the house is cast in beds and has a single tree and an arbour under which a louche assignation is taking place. Elsewhere in the garden, a similar transaction is poised to take place, and a woman, possibly the *Arch-Mistris* herself, stands in an open doorway of the house, surveying the *terra firma*. A boat is moored on the right side of the island, possibly used occasionally by visitors who found it convenient to make a hasty getaway.

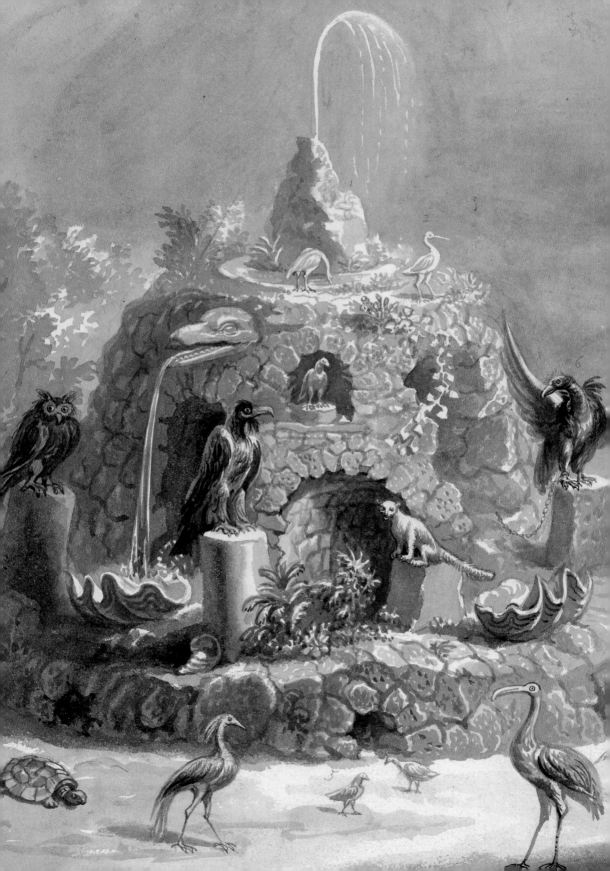

2.

The Animated Garden

Animals in Scenes of Nature

Aviaries and menageries have a long and rich history in London: from the early thirteenth century, for example, exotic beasts were kept in the royal menagerie at the Tower of London. Their development over the centuries is documented in considerable detail elsewhere.[1] While early collectors displayed their rare creatures as curiosities and consigned them to unnatural settings, from the mid- to late eighteenth century there was an increasing desire on the part of some metropolitan collectors to display their specimens of 'real animated nature' in their 'natural condition'[2] – or what they believed to be more naturalistic settings – or in gardens designed to free their captives from confinement in 'miserable dens'.[3] The Duke of Devonshire was among those who subscribed to this new type of display, keeping a 'delightful exhibition of several quadrupeds and birds' at his garden at Chiswick House, where they were able to exercise 'their natural habits almost without restraint'; and an anonymous 'private gentleman' in Limehouse kept three monkeys in a 'remarkable state of freedom' in his orchard, where they gambolled in a nearby canopy of 'high and spreading elms'.[4] James Rennie, the naturalist and author of *The Menageries* (1829), approved of these modern types of establishments, as they had the potential to 'excite a rational curiosity, and to fill the mind with that pure and delightful knowledge which is to be acquired in every department of the study of nature' – even the 'commonest animals offer to the attentive observer objects of the deepest interest'.[5]

London's rich and the well-to-do middle classes began to collect living animals and birds to adorn their parks and gardens from the late seventeenth century; the pace of this collecting mania accelerated considerably when, from about the same time, rare

34. (facing) Detail of fig. 42

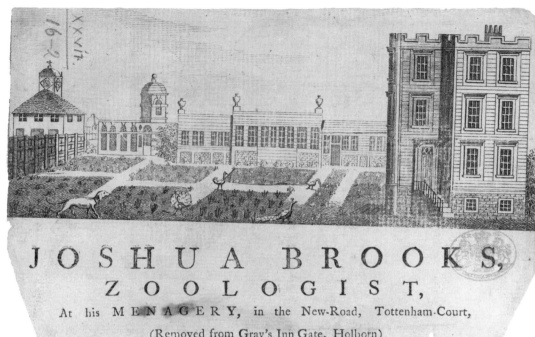

XXVII.
16-2

JOSHUA BROOKS,
ZOOLOGIST,
At his MENAGERY, in the New-Road, Tottenham-Court,
(Removed from Gray's Inn Gate, Holborn)

35.
Trade card of Joshua Brookes, 'Zoologist',
c.1775, etching

and exotic animals and birds were shown, sold and traded at a number of London tea-gardens, taverns and inns, including the Adam and Eve at Tottenham Court Road, the Bell and Bird Cage in Wood Street, the Bell at Haymarket, the Belle Sauvage Inn at Ludgate Hill, the Bird House Inn in Stamford Hill, the Black Bull at Tower Dock, the Eagle and Child in St Martins-le-Grand, the George Tavern at Charing Cross, the Horse and Groom at Lambeth, the Leopard and Tyger at Tower Dock and the Unicorn at Oxford Road.[6] At these premises, a variety of animal merchants plied their trade, and, at some of them, especially those in the suburbs, the fauna on offer was sometimes displayed in a horticultural setting.

Few of the families in the animal and bird trade were as prominent and successful as the Brookeses. The progenitor of this avian dynasty was Joshua Brookes senior, who was himself the son of 'Mr [James] Brooks, of Holborn, a great dealer in foreign birds and curious poultry...'.[7] Not only did Brookes's 'Original Menagerie' purvey an astonishing range of animals and fowl, but, from the early 1760s, their Holborn emporium, and later their more rural Tottenham Court premises began to sell

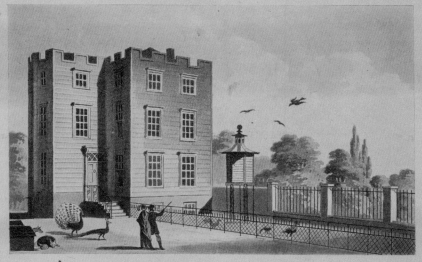

36.
Artist unknown, *Original Menagerie, New Road, near
Fitzroy Square, London. Revived by the Late Mr. Brooks's Son,
Paul, c.*1808, engraving. British Museum, London
The draft trade card of Paul Brookes.

valuable and scarce 'Plants lately arrived from America', and a wide range of exotic
flora for 'the Curious in Botany', including orchids, ferns, spurges, uncommon fruit
trees and a 'Great Variety of the Narcissus, Belladona, &c. and some very fine Orange
and Lemon Trees in Fruit'.[8] Many of these plants were supplied directly from America
by the Pennsylvania botanist William Young.[9] Presumably, Brookes's most valuable
specimens were kept in specially designed garden buildings.

An image reproduced on the header of a trade card shows Brookes's Tottenham
Court menagerie in about 1776 (fig. 35). Joshua Brookes senior, the self-styled
'Zoologist', erected a large castellated house for his family and formed a large garden
court, which he surrounded with decorative outbuildings, including pens and

aviaries. The general layout of the ensemble, which lay within a stone's throw from St James's Chapel, can be clearly discerned on Richard Horwood's *Plan of the City of London…* of 1799. A later view of the same premises, on a draft trade card of around 1808, shows the Original Menagerie after it had been revivified by Joshua's son Paul Brookes (fig. 36). An inscription accompanying the image affirms that the new owner had 'travell'd for several Years to various parts of the Globe for the Purpose of collecting and establishing a correspondence by which he will be enabled to obtain a regular supply of the most Rare and interesting Animals'. Having recently returned from South America, he had stocked his menagerie with a 'choice collection of curious Quadrupeds, and Birds', as well as countless specimens from earlier foreign voyages including 'Pheasants of every variety, Poultry, Pidgeons, &c.'[10]

Accessories to animation

The *Morning Post* reported on 29 June 1807 that 'Her Majesty, Princesses Elizabeth, Augusta Sophia, and Amelia, the Prince of Wales, Dukes of York and Cambridge' and their retinue visited Mr James Pilton's Menagerie and Wire Manufactory, in the King's Private Road, Chelsea, 'where they spent a considerable time in viewing the collection of foreign birds, and inspecting the different works in the manufactory, and particularly improvements made by Mr Pilton in the iron fences for inclosing pleasure grounds, with which Her Majesty was much pleased'. The royal party 'seemed highly entertained and gratified in viewing the different subjects of natural history, and were graciously pleased to express their highest encomiums on the judicious arrangement of the whole of this establishment'.[11]

Pilton, like several leading nurserymen at the time, had a showroom in town (at 204 Piccadilly) and more expansive premises in the suburbs – in this instance, at the Manor House in the King's Road. The 'interior' of the Chelsea menagerie is illustrated in an advertisement of 1808 (fig. 37). It depicts an extensive and neatly enclosed garden attached to a suburban villa, its lawns traversed by a sprinkling of exotic fowl, its rectangular pool adorned by swans and its capacious aviaries bearing the silhouettes of their feathered inhabitants. The garden is littered with the 'leading articles' of the manufactory, including a rustic pavilion, 'pleasure ground fences on an improved principle', gates, 'all kinds of horticultural buildings', verandahs, aviaries and pheasantries.[12] The garden was doubtless arranged for visitors on a plan similar to that of the courtyard garden at Philip Castang's miniature menagerie behind the Adam and Eve tea-gardens at Tottenham Court Road, a favourite resort for Londoners, where tables for drinking tea were laid out under large trees, 'when it could boast of a monkey, a heron, some wild fowl, some parrots, with a small pond for gold-fish'.[13]

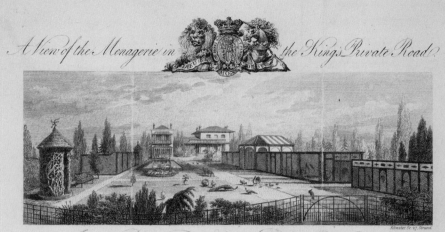

37.
'Silvester', *A View of the Menagerie in the King's Private Road*, 1808, engraving. British Museum, London

Trade sheet/advertisement for Pilton's Menagerie.

Humphry Repton would have approved of the presence of so many fences and distinctive enclosures in an 'animated garden, or menagerie'. Writing in 1840, he lamented that there was, at the time, little distinction made between the artifice of the garden and the natural scenery of the wider landscape, objecting in particular to the fashion for erecting 'invisible fences': 'an invisible fence marks the separation between the *cheerful* lawn fed by cattle, and the *melancholy* lawn kept by the roller and the scythe. Although these lawns are actually divided by a barrier as impassable as the ancient garden wall, yet they are apparently united in the same landscape, and – "wrapt all o'er in everlasting green, / Make one dull, vapid, smooth and tranquil scene."'[14] He affirmed that birds and animals should be constituents of garden scenery because the garden was an 'artificial object, and has no other pretence to be natural, than what it derives from the growth of plants that adorn it: their selection, their disposition, their culture, must all be the work of art'. Fauna animated garden scenery, endowed it with exotic vitality, and furnished it with 'greatness in variety and character, without making its dimensions the standard of greatness'.[15]

Modern Metropolitan Menageries

The surgeon Dr John Hunter was among the pioneers of animated garden scenery. In 1764, he acquired a large plot of land in Earl's Court Lane – opposite what is now the east entrance to the eponymous Underground station – where he built himself a 'highly organised … most complex or heterogenous structure; a farm, a menagerie, and institute of anatomy and physiology, and a villa decorated in the fashion of the period'.[16] Here, at Earl's Court House, he prosecuted 'curious and useful discoveries in natural history' (fig. 38).[17]

So unusual was the establishment that, according to Stephen Paget, writing much later, in 1897, 'nobody of common curiosity could have passed this original cottage without being obliged to enquire to whom it belonged'.[18] Only a few weeks before the anatomist's death in the late summer of 1793, it was observed in the *St James's Chronicle* that 'in the garden of Mr. John Hunter, surgeon… are seen buffaloes, rams, and sheep from Turkey, and a shawl goat from the East-Indies, all feeding together in the greatest harmony; besides a prodigious variety of other beasts and birds, supposed to be naturally hostile to each other, but among which, in this new paradise, the greatest friendship prevails'.[19]

The back garden of this 'ingenious proprietor' was stocked with 'fowls and animals of the strangest selection in nature', and in the front garden there were four lead figures of lions, as well as a crocodile, with its mouth 'gaping tremendously wide', positioned over the front door (fig. 39). Here he pastured his buffaloes that 'so late as in 1792 [he] put into harness and trotted through the streets of London'.[20] At the east

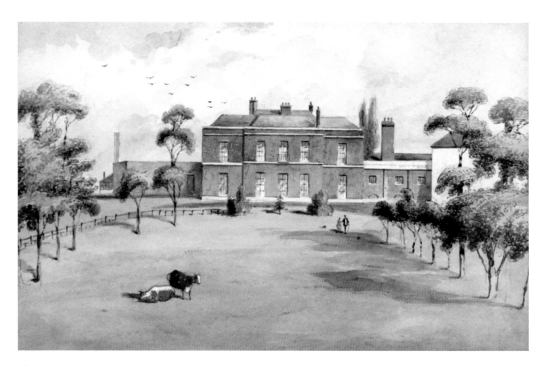

38.
Frederick Shepherd, *Earl's Court House*, 1793,
watercolour. Kensington Central Library, London,
Kensington and Chelsea Local Studies Collection

end of his grounds, he raised an artificial mount – the 'Lions' Den', where he confined his most fierce animals – a miniature tumulus, atop which was a 'little rampart made of bricks and tiles, after the fashion of a castellated tower... a sort of private fortress' (fig. 40). Here he kept a gun that he would fire to deter curious intruders. Hunter also formed a pond in the field facing his sitting room, where 'he kept for experiments his fishes, frogs, leeches, eels, and river-mussels'; it was said that this basin was 'ornamented with the skulls of animals'. He appears to have kept his retinue of 'fowls, ducks, geese, pigeons, rabbits, pigs' and 'opossums, hedgehogs... a jackal, a zebra, an ostrich, buffaloes' and 'dormice, bats, snakes and birds of prey' as much as possible in their natural condition, keeping the largest of his beasts, as Rennie recommended, in 'large open sheds, with spacious paddocks, to range in; water in plenty; and spreading trees to shade them from the noon-day sun'. (The doctor's leopards, however, were 'kept chained in an outhouse'.[21])

After Hunter's death the house was acquired first by John Bayne – who intended to keep up the menagerie and improve upon the premises – and latterly by the Duke

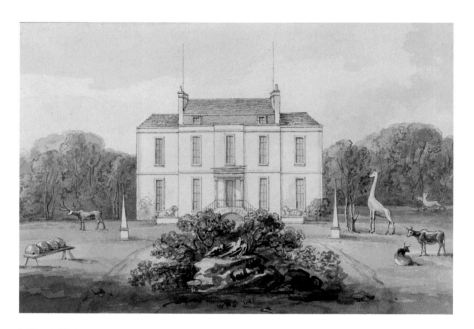

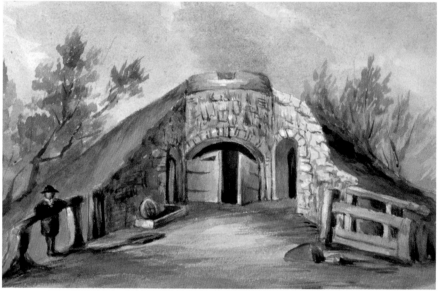

39.
Jesse Foot, the garden of Dr Hunter's House
in Earl's Court, c.1822, watercolour. Wellcome
Collection, London

*Dr Hunter's garden was described in 1829 as being
'laid out as a zoological garden for such of his
strange animals as he kept alive'.*

40.
Artist unknown, *The Dens in which John Hunter
Kept his Wild Animals, 1783, Earl's Court House,
1783*, watercolour. Royal College of Surgeons of
England, London, Hunterian Family Album

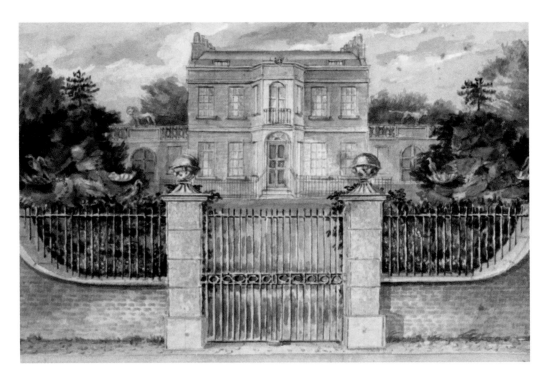

41.
Artist unknown, *Dr Hunter's House in Earl's Court*, c.1827–30, watercolour. Kensington Central Library, London, Kensington and Chelsea Local Studies Collection

The house is shown as it appeared in 1785. Large, artificial rockworks flanked the entrance to the forecourt of the villa. These were surmounted with small conifers, enriched with giant clam shells and had eagles chained to them. John O'Keeffe remarked in 1827 that the 'latter eagles might consider themselves very well off to escape dissection; for their owner dissected every thing that came in his way'.

of Richmond. The dwelling was for some years occupied by the Earl of Albemarle, during which time the 'Lions' Den' was used by 'little Princess Charlotte . . . as an excellent resort for hide and seek'. The den later became a cow-stall, and the house was converted into a private asylum. It was pulled down in February 1886, and the surgeon's 'paradise' was redeveloped to receive Barkston Gardens.[22]

Few central London gardens were as richly animated as that of Hunter's great friend Dr Joshua Brookes, the son of Joshua Brookes senior, and the brother of Paul. He was 'somewhat an eccentric character':[23] an anatomist by trade, his greatest accomplishment was his *Museum Brookesianum* – an encyclopaedic collection of comparative anatomical material 'so crammed with skeletons and other zoological specimens that it was hardly possible to move without knocking down something with one's coat-tail'.[24] His garden was situated by Blenheim Steps, off Oxford Street,

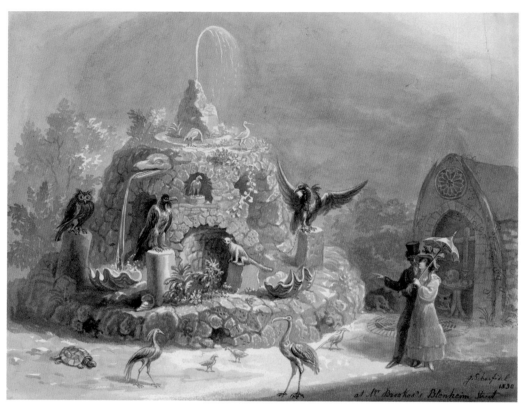

42.

George Scharf, *A View of the Vivarium, Constructed
principally with large Masses of the Rock of Gibraltar, in
the Garden of Joshua Brookes Esq., Blenheim Street, Great
Marlborough Street*, 1830, pencil and watercolour wash.
British Museum, London

*The presence of alpine and indigenous plants growing
on Brookes's vivarium is particularly fascinating,
as is the way in which they are mixed with the rock's
artificial curiosities and exotic fauna.*

and boasted a 'very large and picturesque piece of Rockwork, formed chiefly of
considerable masses of the Rock of Gibraltar, adapted to the purpose of a Vivarium, at
present inhabited by an Eagle and several smaller rapacious Birds' (fig. 42). Described
in 1829 as 'a curious assemblage of life and death', the rockwork may have been started
as early as the 1770s, though it was presumably enriched over the years to form what
Brookes himself described in 1830 as covering an area of 'about thirty feet… upwards
of ten feet in heighth, somewhat in [the] shape of a truncated cone, on the surface of
which there is a spacious reservoir for Fish, aquatic Plants, and oceanic Birds, with a Jet
d'Eau in the centre, ascending through an interesting specimen of Rock, considerably
elevated above the level of the water, which is prevented from overflowing by a

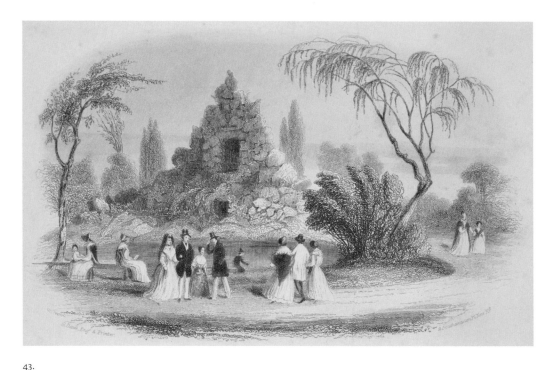

43.

G. Dawe, *Rockwork at the Surrey Zoological Gardens,*
*c.*1840, engraving. London Metropolitan Archives

This rockwork may have been the Eagle Rock made
with 'rocks from Gibraltar' donated by Joshua Brooks
on the demolition of his vivarium.

syphon which conveys it through the mouth of an antique head of a large animal
nearly resembling that of an Ichthyosaurus'. The interstices of the rock were 'occupied
by Alpine and appropriate indigenous Plants; these, descending over the stones,
embellish and augment the pleasing appearance of the fabric', and the rock's 'four
chief Caverns were for many years the residence of a Vulture, a white-headed Eagle,
an Ossifrage, and a magnificent auriculated Owl'. The garden, which was opened on a
regular basis to Brookes's students and distinguished or foreign visitors, also possessed
a gothic 'Pilgrim's Cell... constructed principally of the jaws of a Whale.'[25]

The design of Brookes's Gibraltarian rockwork may owe something to an earlier
'Rocke'. De Caus's Parnassus fountain designed for Anne of Denmark at Somerset
House was described in 1613 as a 'mountain or rock... made of sea-stones, all sorts
of mussels, snails and other curious plants put together: all kinds of herbs and
flowers grow out of the rock which are a great pleasure to behold' (see fig. 19).[26] The
anatomist's assemblage was, however, remarkably similar in character to a pair of
towering artificial rockworks erected by John Hunter in the forecourt of Earl's Court

House, upon which 'eagles perched before his door' (fig. 41).[27] It almost certainly influenced Hunter's 'Lions' Den' as well.

When, in 1830, Brookes decided to close his anatomy school and to move house, he offered his vivarium to Sir John Soane and John Loudon, suggesting that it could be adapted to form 'a beautiful object in an Arboretum, or at the termination of a Vista' and affirming that it was 'perhaps the only means of constructing a noble rural ornament with several tons of the Rock of Gibraltar'.[28] In the event, the anatomist presented his 'parts of the Rock of Gibraltar, pieces of Basaltic Columns of Staffa and the Giants' Causeway, &c' to the Surrey Zoological Gardens in South London where it was reconfigured to create another 'piece of fancy rockwork', which became known as Eagle Rock (fig. 43).[29]

A 'complete work of art'

The vivarium was one of numerous curious gifts to be presented to these gardens, which were newly formed at the time. The Royal Surrey Zoological Gardens in Walworth, Southwark, were a modern zoological collection 'with novelties introduced', conceived in 1831 by its projectors, Edward Cross and Henry Phillips, as a 'place of healthful amusement', for the 'promotion of zoology' and 'the most attractive lounge in or near the metropolis' (fig. 44).[30] Cross had made his reputation as the keeper of the Menagerie at Exeter-Change (the capital's largest exotic animal emporium), and Phillips was a celebrated author, landscape gardener and botanist. The new gardens were adorned with statues and 'little gothic and other ornamental edifices', diversified with parterres and lawns, threaded with gravel paths and profusely stocked with 'specimens of trees from almost every part of the globe, labelled with their English and scientific appellations'. The whole was also laid out around an expansive sheet of water covered with waterfowl of every variety and encompassing two wooded islands.[31]

The Eagle Rock was not the only rockwork to be raised in the gardens: several craggy promontories were scattered across them, harbouring fountains and providing habitations for reptiles, birds and quadrupeds. Among the more unusual was the Tortoise's Grotto (fig. 46).

The Surrey Gardens, as they became known, were an instant and popular success: C. F. Partington declared in *National History and Views of London and its Environs* (1834) that 'the great taste displayed in the arrangement of these gardens, and the careful selection of animals, render it worthy in every respect the extensive patronage it has hitherto received',[32] and a contributor to *Paxton's Magazine of Botany, and Register of Flowering Plants* (1834) affirmed that, though some of his readers might level the criticism that Cross's giant menagerie, with its multitudinous birds, beasts,

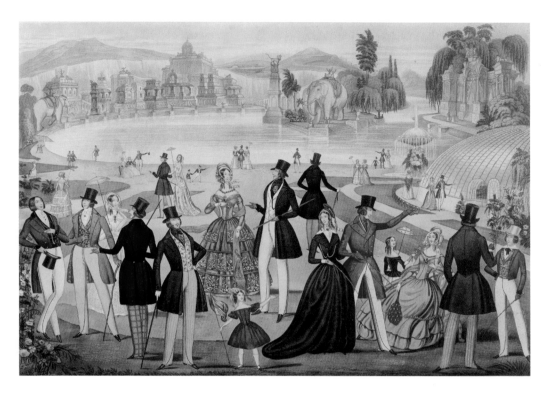

44.

Artist unknown, *Summer Fashions for 1844*, 1844, aquatint. London Metropolitan Archives

The Surrey Zoological Gardens were laid out in the extensive grounds attached to Manor House in Walworth, Southwark. In the background is the lake of the Surrey Zoological Gardens and behind the lake is Danson's new 'Stupendous Panoramic Model', the principal attraction of the gardens in 1843. Also visible is the large dome of the conservatory, which contained wild animals.

cages and compartments, was 'not much connected with the culture of plants', the 'distance is not so great as at first sight may appear'. The skill of laying out such a piece of ground, 'whether that ground is to be occupied by either plants or animals', was, he believed, to give equal consideration to both with a view to creating a complete work of art.[33]

Besides the attractions of the menagerie, the gardens – unlike those of the London Zoological Society in Regent's Park – had frequent flower shows, balloon ascents, and a succession of 'Splendid New Spectacles!'[34] Here, the phenomenon of the modelled, three-dimensional panorama, lashed up with great quantities of paper, canvas, plaster and timber, cleverly painted, reached its zenith (fig. 45). Some of the 'Colossal Pictorial Typorama' staged between 1837 and 1856 included 'Views of Naples, [the]

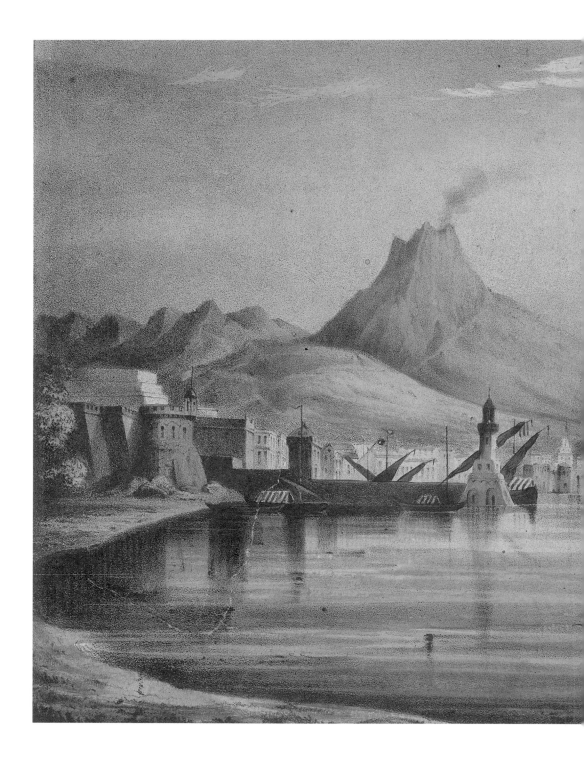

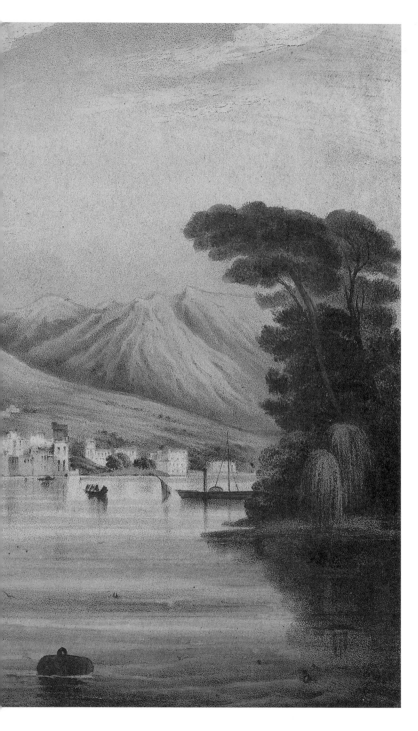

45.

Mount Vesuvius, as represented at the Surrey Zoological Gardens, 1837, lithograph. London Metropolitan Archives

The exhibition consisted of 'an immense framework of wood, securely built and put together, over which many hundreds of yards of canvass are stretched, and the whole painted in very durable oil colours, to represent the city of Naples, the adjoining country, and Mount Vesuvius' (Bell's Life in London and Sporting Chronicle, 18 June 1837, p. 2).

46.
E. J. Capell, *Tortoise's Grotto, Surrey Zoological Gardens*,
1831, watercolour. London Metropolitan Archives

Eruption of Vesuvius, and Destruction of Herculaneum and Pompeii, in the year 79',
'The Great Fire of London', a 'View of the Town and Bay of Gibraltar' (fig. 47), 'The
Passage of the Alps by Napoleon and his Army' and a 'Great Picture of the Temple
of Janus in Imperial Rome'.[35] George Danson was the genius behind the gardens'
giant 'Allegorical Pictorial Tableau[x]', and his 'new Stupendous Panoramic Model
al-fresco, of Wondrous Caverns, Subterranean Palaces, and far-famed excavated
temples of elora, the greatest Marvel of India' was declared by a contributor to
the *Sun* as 'decidedly the most novel and extraordinary Pyro-Scenic Display ever
imagined!! The advance of the Fire God on his floating Throne of Flaming Dragons,
and brilliant Apotheosis of Vishnu nightly received with rapturous bursts of delight
and astonishment!!!'[36] (fig. 48). It was remarked in the *Atlas* that the painting of the
'rock-hewn' structures was so 'skillfully executed as to convey a very excellent idea
of the extraordinary mountain excavations, which excite wonder and admiration of
every traveller in India'. Mr Southby's pyrotechnical displays were also commended
for their ingenuity and novelty.[37]

The spectacles at 'this very intellectual place of amusement' invariably took place
by the lake and generally at dusk, so that it was 'impossible to distinguish the real
features of the View from the artificial'. The 'sumptuous tank' formed a natural and

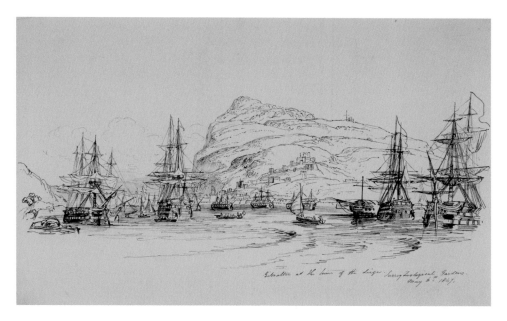

47.

George Frederick Sargent, *Gibraltar at the time of the Siege, Surrey Zoological Gardens May 6th 1847*, pen and ink. London Metropolitan Archives

This spectacle was staged at the Surrey Zoological Gardens in May 1847. A contributor to the Illustrated London News *remarked in July 1847 that, such was the 'general burning of the ships, and uproar of infernal noises, that anybody of ordinary nerves may well be excused for feeling uncomfortable at his proximity to the scene of destruction'.*

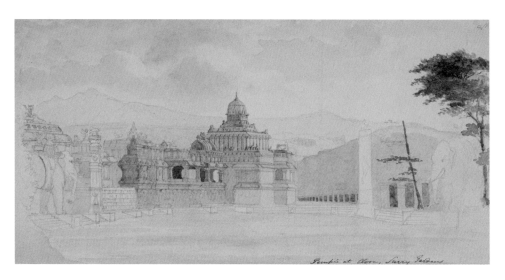

48.

George Frederick Sargent, *Temple at Elora, Surr[e]y Gardens*, 1847, watercolour. London Metropolitan Archives

George Danson's 'Colossal Pictorial Typorama' of 'The Wonders of elora, with the Mystical Transformations in the Great Hall of "Keylas"' (1843).

reflective amphitheatre and was reported at the time to have given the performances 'a motion and vitality not to be suggested by any other means'.[38]

A 'mimic picture of real life'

While Cross and Danson were masters of the extensive extravagant gesture, the Purlands, father and son, were their rivals on a domestic scale. Sometime early in the nineteenth century, 'Mr. Purland, senior', a dentist-surgeon based in Wilson Street, Finsbury Square, formed what was described in the *Morning Post* in May 1827 as 'the most extraordinary aviary ever heard of or seen'. His 'production' formed a 'complete country village with its peculiar objects', and contained:

> real cottages, barns, stabling, public-house, church, toll-bar, barber's and black-smith's shop, together with trees, shrubs, flowers, hedges, &c. actually in a state of flourishing vegetation; also a water-mill and wind-mill, the former turning its wheel from a reservoir of water, supplied by a fountain, which plays in a grotto, and falls into a river! the latter performing its motions actuated apparently only by the wind. There is a fine piece of ruins on the right hand of a monastery, partly hid by thick foliage; and on the left, an ancient castle; these are sublime and beautiful.

The 'Monastic Village Aviary'[39] contained a great number of singing birds, 'together with some of the larger kind':

> these flying about and perching on trees, give life and animation to the whole, which is greatly enriched by their melody. This seemingly large and distant extent of country is contained in a space of sixteen feet by eight, entirely open and exposed to the weather. The Nobility and Public can see it daily, from eleven in the morning, till eight in the evening, by consulting Mr Purland Professionally, or by purchasing a Box of his Tooth Powder…We have given but a feeble description of its real beauties; those who are curious and fond of contemplating nature in her varieties, will be highly gratified by viewing it.[40]

Sometime in the late 1830s, Purland's son, Theodosius – also a dentist-surgeon – 'accelerated by praiseworthy industry, and considerable cost', erected his own aviary in Mortimer Street, Marylebone. This 'Antiquarian Village Aviary' reflected the interests of its 'designer and founder', who was an antiquary, 'something of an Egyptologist', 'a powerful and enthusiastic mesmerist', a numismatist, and a balloonist.[41] Hailed in the *Mirror* (1840) as a composition of 'manifest ingenuity, and superior masterly execution', the animated tableau required 'a few moments' consideration whether the vivifying music of the birds, the windmill in the distance … the rush of water dashing down the declivities, the noise created by the working of the over-shot water-

mill, the apparent floating reality of the swans, the flitting by of the birds... do or do not constitute a species of enchantment, a sensation lulling out better reason into a delirium of quietude and inconceivable extacy'.[42]

It was conceived as 'a village hamlet in the olden day, richly studded with edifices distinguished by local associations'. The aviary, which was open by appointment to the public, was viewed from a veranda at the back of his Museum of Antiquities. This 'mimic picture of real life' was 'grouped in one grand scene, bedecked with rural beauty'; the walls were painted with landscapes, and it possessed an astonishing array of miniature models of historic monuments, including Shakespeare's House at Stratford-upon-Avon, the gateways to Rougemont and Carisbrook Castles, 'Fotheringay Castle, in its ruined state', ruined portions of 'St Benet's and Kirkstall Abbeys, and Great Chatfield Manor House'. The presence of bridges, water courses, windmills, a butcher's and a barber's shop and miniature sheep materially further enhanced its 'pictorial effect';[43] and the miniature garden's 'locomotive automata' conveyed 'a perfect impression of real life to the beholder'.[44]

The avian denizens, however, added the greatest animation to the scene: blackbirds, thrushes, linnets, red-pole, larks, nightingales, robins and 'other varieties of singing birds, indigenous to our climate', who were 'mellifluous in note', poured forth 'in unceasing rivalry the richness of their several tones'.[45]

Mr Purland senior, put his 'country village in miniature' up for sale in June 1842.[46] There is no record of what happened to his son's rival 'hamlet', although it had vanished by 1855 when the aviary and its builder were singled out for praise by John Timbs in *Curiosities of London: Exhibiting the Most Rare and Remarkable Objects of Interest in the Metropolis*. Mr Purland was, he observed, one of 'few ingenious individuals in the metropolis and its suburbs [who] constructed Aviaries in or adjoining their houses, long before "Zoological Gardens" were thought of'.[47]

It is vexing that there does not appear to be a visual record of this masterpiece of avian architecture.

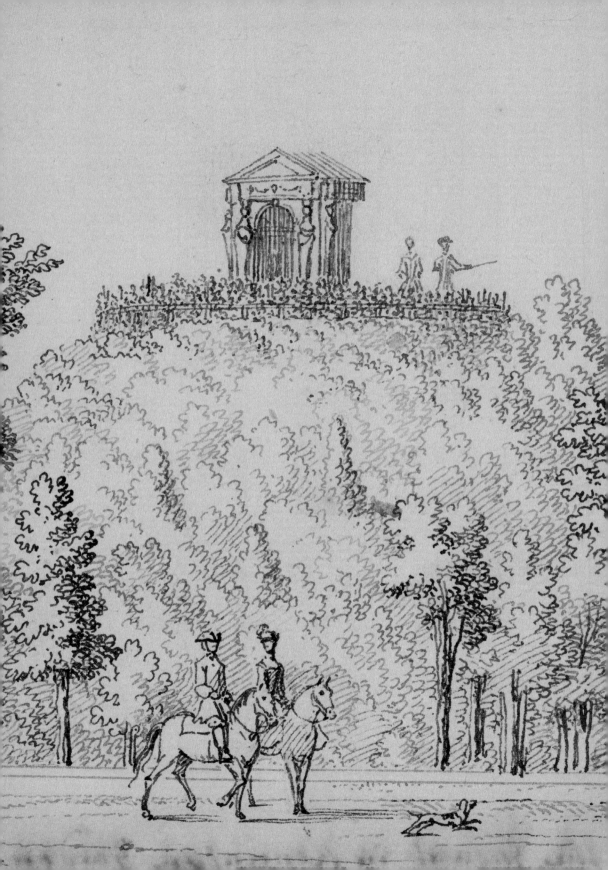

3.

Artificial Mounts and other Swellings

I hail thee, Mound! O mightiest of peaks, That
towereth o'er adoring Oxford Street Like high
Olympus, thronged by ancient Greeks, Or Pan's
Parnassus, paced by pilgrim feet! As mighty Rome
is crowned by Palatine, Whence her Imperial
power proudly flowed Through arch of Titus and
of Constantine, Thou, Mound, surveyeth glorious
Edgware Road! I watch — as Moses, by God's edict
banned, Once wistfully beheld from Nebo's heights
The milk and honey of that Promised Land — The
streets of London, where I spend my nights; My
cardboard home, its corrugated lid, The conscience
cup of Costa whence I sup Beneath a Mound that
cost six million quid — O Mound! Art thou what's
meant by Levelling Up?[1]

David Silverman, 2021

Mounts, or large artificial hills, appear to be persistently alluring to London gardeners. In January 2021 a twenty-five-metre-high temporary artificial mount was erected at Marble Arch at the western end of Oxford Street (fig. 50). It was commissioned by Westminster City Council as part of a £150-million package of initiatives to revive Oxford Street and entice shoppers back to the West End at the time of the global pandemic. The immense, faceted, gimcrack swelling was constructed using scaffolding blanketed with sedum turf and a sprinkling of trees; it also boasted

49. (facing) Detail of fig. 55

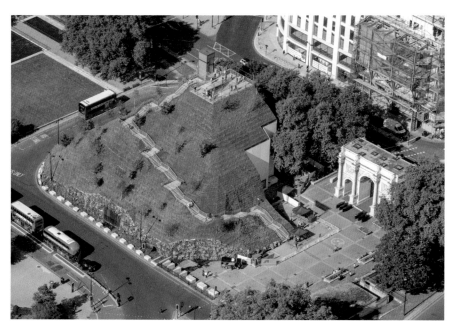

50.
Marble Arch Mound, 2021

The twenty-five-metre-high artificial mount opened to the public on 26 July 2021 and was widely mocked on Twitter for its resemblance to a 'slag heap'.

a 130-step external path, an internal retail 'events space' and a viewing platform at its summit. The project architects described the Marble Arch Mound (MAM) as a 'mound that is not really a mound in the middle of London . . . [and] a folly in the best British tradition'.[2] The scheme was a rehash of the 'huge artificial mountain' they had proposed in 2004 to envelop the Serpentine Gallery which proved too expensive to build. Although the visualisations were compelling, the results were disappointing. Jem Bartholomew wrote in the *Guardian* on 7 January 2022 that 'the widely mocked Mound promised lush vegetation, mature trees and thick greenery from an elevated platform on the corner of Hyde Park and Oxford Street in London, but when it opened on 26 July, visitors reported spindly trees, unhappy plants and a general sense of dereliction'. Sadly, the 'Teletubby Hill' failed to fulfil its primary function – to supply panoramic views over the metropolis and neighbouring Hyde Park: the view was obstructed by mature trees and compromised by a rigging of metal safety wires. Many visitors, having paid for the privilege of ascending, found the vantage point 'bland' and demanded refunds. Following what the council called 'teething problems', the attraction was closed and dismantled within six months of

its opening. The materials – including the dead and dying plants – were purportedly redeployed at a local housing estate.

This infamous 'hillock of fake and threadbare barrenness, Sad foster-child of fairground and waste time' did, nonetheless, in the tradition of Queen Caroline's eighteenth-century mount in Kensington Gardens, inspire some imaginative poetical responses.[3]

Artificial mounts are curious garden accoutrements: they are mediaeval in origin and have never entirely dropped out of the garden lexicon. They have reappeared in London gardens with startling regularity over the centuries, yet, from at least the late eighteenth century onwards, they (unsurprisingly) have invited suspicion as well as praise. One of the preconditions for a successful mount has presumably been the prospect of a view over reasonably flat terrain – a view beyond one's garden boundaries, a vista to a notable landmark or a great sweep of the gaze over boundless countryside. There are, however, other preconditions: that they should, where possible, command a view of water and that they should be occasionally enclosed by high walls.[4] As London gardens are by their nature enclosed, the possibility of surveying what lies beyond their boundaries from a raised vantage point has long been an aspiration of garden builders and garden owners. Indeed, few would cavil at Stephen Switzer's injunction published in *Ichnographia Rustica* (1718) that 'Elevation is so necessary' that 'all Gardens must be esteem'd very deficient' without it'.[5] For centuries, the most common means of rising above a London garden's walls or gaining a distant view was to ascend a terrace or an artificial mount. There seems, however, a productive contradiction in attitudes towards them: whilst they erupt with some frequency, there are discernible traces of unease about what these structures are actually doing in town.

In William Mudford's *Nubilia in Search of a Husband* (1809), the eponymous narrator, a young woman travelling in the Lake District, suggests that mounts in a metropolitan context are open to charges of absurdity. While Nubilia, the heroine, and her uncle – 'a man of the world' – are in Keswick, they happen to meet with an 'intimate London acquaintance, who has resorted thither for the *fashionable purpose of seeing the lakes*'.[6] Mr Wilson – 'a man of independent fortune, and eminent among the gay and the dissipated' – talks volubly and with facility on every topic, so much so that 'he might be considered a rival to the *admirable Crichton*'.[7] Nubilia informs her readers that, 'while we were at dinner, it was a natural topic of conversation to expatiate upon the beautiful scenery with which we were surrounded. I was curious to observe what effect it could possibly have upon a mind like that of our guest.'[8]

When Nubilia's uncle praises the 'placid beauty of Derwent Water' and the 'sullen grandeur' of 'the lofty Skiddaw', Mr Wilson supplies flippant answers that disgust the gentleman. Nubilia ventures to suggest to Mr Wilson that, 'having always lived in

London, he probably had no relish for rural beauty'.[9] 'Oh miss,' says he, 'I am vastly fond of the country. I think it quite charming to walk in the fields; and, when I am in town, I never omit to ride in the Park on Sunday. Two or three of us make it a point to exhibit ourselves in *Rotten Row*'.[10] The uncle, clearly baffled, replies, 'You have a strange notion of rural beauty… if you go to seek it in Hyde Park'.[11] Mr. Wilson rejoins, 'trees are trees everywhere; and then, in Hyde Park you have a beautiful piece of water, and, besides that, you have company, which, in my opinion, is necessary to make any thing delightful. I should feel no pleasure in driving between two hedges, with no body to look at me.'[12] 'Well,' adds the uncle, 'though, as you observe, trees are trees everywhere, yet you'll allow that trees may derive their beauty from position. Pictures are pictures everywhere, but pictures may receive accidental embellishment from local circumstances. Besides, in Hyde Park, which seems to be your *rus in urbe*, you have neither hills nor valleys, which are an essential adjunct to a landscape.' 'There's a *Mount* in Kensington Gardens', replies Mr. Wilson, with seeming satisfaction. The narrator professes that she is ignorant of 'the claims of this *Mount* to the name of a mountain'. Next time she is in London and visits Kensington Gardens and beholds 'this rival of Skiddaw, of Plinlimmon', she is, however, reminded of the 'metropolitan exultation of Mr. Wilson'.[13]

Clearly Nubilia and her uncle regard such an improbable object as a mount in a London garden incapable of producing a dramatic effect, and the audacity of their guest's comparison of the Lake District's most breathtaking peaks to the queen's artificial swelling in the royal gardens, risible.

Early Metropolitan 'monticelli'

In *Il Moro* (1556), Ellis Heywood supplies an early account of Sir Thomas More's riverside gardens at his Chelsea manor. Although the idyllic setting is revealed in an imaginary meeting between More – Heywood's great uncle – and six anonymous friends, the description is thought to be a reasonably accurate account of what Heywood affirmed was 'among the many delightful estates that grace the River Thames'. The gentlemen had come to the manor to dine:

> After the meal they went to walk in the garden that was about two stone's throw from the house. On a small meadow (in the middle of the garden and at the crest of a little hill) [*in un pratello posto in mezzo il giardino sopra un uerdo Monticello*], they stopped to look around. The spot pleased them greatly, both for its comfort and for its beauty. On one side stood the noble City of London; on the other, the beautiful Thames with green gardens and wooded hills all around. The meadow, beautiful in itself, was almost completely covered with green and flowers in

bloom, and tender branches of fruit trees were interwoven in such beautiful order that they seemed, to the guests, to resemble an animated tapestry made by nature herself. And yet this garden was more noble than any tapestry, which leaves more desirous than content the soul of him who holds the images painted on the cloth.[14]

It is not known whether this account describes More's privy garden or his 'Orchard or garden Yarde'. The presence, however, of a *'Monticello'* suggests that the surroundings were flat and that the prospects were noteworthy.

Heywood's description the humanist's 'little hill' encapsulates the attributes of a typical artificial mount: it was a dramatic scenographic conceit raised to supply panoramic views over its surroundings, often crowned with a small edifice, invariably placed at a short distance from the house and frequently positioned immediately adjacent to and giving views over a body of water. Like its antecedent the mediaeval 'motte', it was both elevated and intended to be difficult to access, it was carefully constructed to resist erosion and its top was flattened to receive a structure or form a belvedere. It was, however, not merely a practical conceit: John Evelyn averred in 1657 that 'grott[o]s, mounts, and irregular ornaments of gardens do contribute contemplatiue and philosophicall enthusiasme'.[15]

A point of reference for Thomas More's mount was supplied by a striking earlier example of such a garden feature: Henry VIII's very substantial swelling-*cum*-banqueting house in the 'Kyngs New Garden' at Hampton Court (dismantled in the late seventeenth century by William III). Work on this artificial mount commenced in 1532–3 within a small triangular plot surrounded by high brick walls that lay between the palace and the banks of the Thames. One round and three quatrefoil-shaped towers were raised at the corners of the enclosure, giving it the appearance of a fortified garden. The mount soared roughly thirteen metres (42 feet) above the walled garden and was crowned by the Great Round Arbour; its hollow core concealed a subterraneous kitchen and cellars. Anthonis van den Wyngaerde's panoramic view of the palace gardens of around 1558 depicts the arbour's cupola rising from behind the Water Gate (fig. 51). When the mount was built, the views to the east, south and west were largely unencumbered, so those who wound their way to the lofty summit gained panoramic views up and down the Thames and to the Surrey Hills. The journey up the mount was, however, as important as its apex: the spiral path was a processional route lined with heraldic beasts mounted on poles interspersed with fancifully shaved, evergreen topiaries. The Duke of Nájera described the latter in 1544 as 'monsters', and the Swiss visitor Thomas Platter affirmed in 1599 that the mount garden was like the Privy Garden, filled with 'all manner of shapes, men and women, half men and half horses, sirens, serving maids with baskets, French lilies and delicate crenellations all round made from

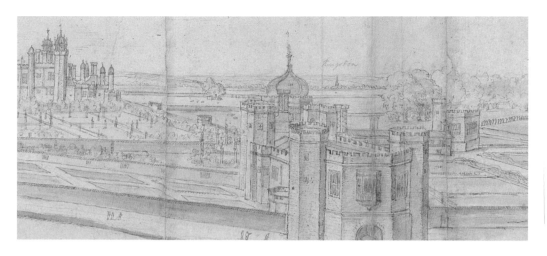

51.
Anthonis van den Wyngaerde, view of
Hampton Court from the south, detail, 1558,
pen, brown ink, watercolour and black chalk.
Ashmolean Museum, Oxford

The onion dome roof of the Banqueting House atop the
Mount is visible behind the Water Gallery, and the steps
leading up the swelling are demarcated by posts bearing
heraldic beasts emerging from foliage.

dry twigs bound together and the aforesaid evergreen quickset shrubs, or entirely of rosemary, all true to life, and so cleverly and amusingly interwoven, mingled and grown together, trimmed and arranged picture-wise that their equal would be difficult to find'.[16]

A smaller mount of a similar character was also raised in East London in about 1540. It lay within the grounds of a large, red-brick mansion 'anciently denominated Balmes, Baumes, Bams, or Baumes', off the Kingsland Road, in what is now de Beauvoir Town in Hackney.[17] Built by two brothers who were Spanish merchants, the house was approached by a drawbridge, and its extensive gardens were enclosed by high walls and a moat. A bird's-eye view of the estate, published in James Beeverell's *Les Delices de la Grand Bretagne et de l'Irlande* (1707) and based on an early drawing, depicts the geometrical gardens in considerable detail (fig. 52). A large, dome-shaped mount emerges from within a rectangular plantation criss-crossed with diagonal hedges; like its royal precursor at Hampton Court, it sits between the dwelling and a body of water – though here a broad moat instead of the Thames. Its slopes were too steep to possess 'windings' (paths) to ascend, so visitors must have entered a passage – possibly a grotto – at the base of the mount that led to an internal staircase. This supposition is corroborated by what appears on the engraving to be a gate in the mount garden's perimeter hedge that leads to an opening in the mount. This was no ordinary mount: it brings to mind the description of an imaginary garden mapped

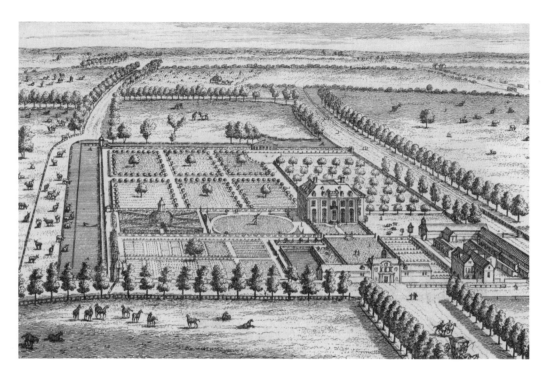

52.
Johannes Kip, *Balmes in the County of Middlesex,*
*c.*1707, engraving. Victoria and Albert Museum,
London

Bird's-eye view of Balmes House in Hackney.
The pavilion atop the mount supplied panoramic
views over the entire estate and beyond.

out by Aaron Hill and published in the *Prompter* in 1735, which is described as a large, square garden with a circle at its centre – this 'Inner Division is quite *private*, being separated from the Rest by a *Wall*... on the Top of an artificial *Hill*, within this Circle, high enough to be visible in all Parts of the Garden, stands the Temple of Happiness.' The Temple commands 'a *View* to the prouder Parts of the Garden'.[18]

Sadly, we have no idea what motivated Thomas More, the king or the Balmes brothers to raise their mounts. John Milton, however, writing in *Paradise Lost* (1667) about 'delicious Paradise' supplies us with a possible clue. He recounts how Satan, gains a view of the various swellings within Paradise, and an awareness of the prospect enjoyed by Adam ('our general sire'); the description begins with the envious fallen angel poised at the borders of this landscape:

> Of Eden, where delicious Paradise,
> Now nearer, crowns her inclosure green,
> As with a rural mound, the champaign head

Of a steep wilderness, whose hairy sides
With thicket overgrown, grotesque and wild,
Access deny'd; and over head up grew
Insuperable highth of loftiest shade,
Cedar, and pine, and fir, and branching palm,
A sylvan scene, and as ranks ascend
Shade above shade, a woody theatre
Of stateliest view. Yet higher than their tops
The verd'rous wall of Paradise up sprung:
Which to our general sire gave prospect large
Into his nether empire neighb'ring round.
And higher than that wall a circling row
Of goodliest trees loaden with fairest fruit,
Blossoms and fruits at once of golden hue,
Appear'd, with gay enamel'd colors mix'd:
On which the sun more glad impress'd his beams
Than in fair evening cloud, or humid bow,
When God hath show'rd the earth: so lovely seem'd
That landskip... [19]

The Mount of Paradise is both enclosed and elevated; it is arduous to ascend, and its summit is encompassed by a hedge, but this hedge did not grow 'so high as to hinder Adam's Prospect into the neighbouring Country below, which is called his *Empire*, as the whole Earth was his *Dominion*.'[20]

Elevated Landscapes and Elevated Attention

Perhaps these walled mounts were perceived as more than mere paradises? Perhaps they should be accorded the status of artificial 'wonders' – wonders being invested with great drama and imaginative fascination, objects that excite our admiration and amazement, objects that are framed and sharply differentiated from the everyday and the ordinary.

Alexander Pope, for example, emphasised the attention that the mount in his own garden at Twickenham demanded by ironically suggesting, in a letter to the Bishop of Rochester in March 1721, that this swelling in the landscape prompts in him a corresponding swelling with pride. He expresses his eager desire to acquaint the cleric with this garden, 'where I will carry you up a Mount, to shew you in a point of view the glory of my little kingdom. If you approve it, I shall be in danger to boast like Nebuchadnezzar of the things I have made, and be turn'd to converse, not with

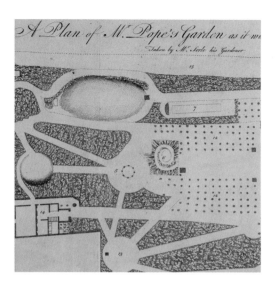

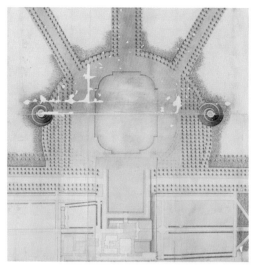

53.
John Serle, *A Plan of Mr. Pope's Garden as it was left at his Death*, 1745, engraving, detail showing the 'mount'. Beinecke Rare Book and Manuscript Library, New Haven, Conn.

Pope's garden boasted three mounts, the largest of which was probably designed by William Kent.

54.
Charles Bridgeman, plan of the mounts and the Round Pond, Kensington Palace, detail, *c.*1730, pen and ink with watercolour wash.
Bodleian Library, Oxford, MS Gough Drawings (a3* fo. 15)

the beasts of the field, but with the birds of the grove, which I shall take to be no great punishment.'[21]

Pope spent the winter of 1719–20 helping his gardeners to build this mount (now lost). It is presumed that the feature, since it was positioned adjacent to the entrance to the subterraneous passage that he made under the public highway to connect his villa to his riverside garden, was constructed using soil from the excavation. It was created as part of a processional route that traversed the garden: visitors were led up the swelling to gain a view of the garden before descending through quincunxes of trees to reach the bowling green (fig. 53).

Another mount in eighteenth-century London excited especially widespread attention and admiration by virtue of its very public situation. The initial scheme for a swelling at Kensington Palace was not, in fact, executed: about a decade after Pope and his gardeners built their earthwork, and more than forty years after William III had flattened Henry VIII's mount at Hampton Court, Charles Bridgeman, when working for Queen Caroline at Kensington Palace, proposed forming a pair of hillocks overlooking a new basin in the gardens (fig. 54). They were to be positioned

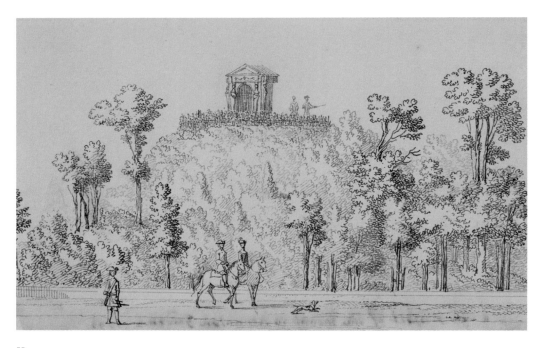

55.
Bernard Lens III, *A View of the West Prospect of the
Mount in Kensington Gardens*, 1732, pen and ink.
Victoria and Albert Museum, London

symmetrically on the central, north-south axis of what are known as the Feathers, or the large plantations that flank what is now known as the Round Pond. The mounts are depicted in a design drawing of about 1730 as possessing winding paths ascending to circular tholos pavilions at their summits.

A rather different scheme was chosen instead of this: by 1732, a single conical mount had been raised in the south-east corner of the gardens near the western end of Rotten Row. This enormous artificial hill, which is depicted on Bridgeman's plan of the gardens of about 1733, emerged from a trapezoidal plantation and was constructed either from spoil excavated during the creation of the Serpentine or the digging of the ha-ha that stretched across Hyde Park and the royal gardens. A winding path led to William Kent's 'little but very picturesque temple known as The Tower of the Winds'. Like Stephen Switzer's proposal of 1718 for '*Windsor Seat*' atop a mount, it was 'contriv'd to turn round any Way, either for the advantage of Prospect, or to avoid the Inconveniencies of Wind, the Sun, &c.'.[22] The mount is depicted in a drawing of 1732 (fig. 55) and was the subject of a 'prospect poem' by an anonymous poet published in March 1733, soon after the completion of the royal earthwork.

The poet imagines Queen Caroline, like Adam in the Garden of Eden, looking over her domain:

> Here, free from the Fatigues of State, and Care,
> Our Guardian Queen oft breath[e]s the Morning Air:
> From hence surveys the Glories of her Isle,
> While Peace and Plenty all around her smile... [23]

The poem identifies a recurrent feature of mounts: a vista over water – a reference, presumably, to the Serpentine Lake (also known as the Serpentine River), which was likewise formed as part of Queen Caroline's 'improvements' and was fed in the eighteenth century by the Tyburn Brook and Westbourne River:

> A River there waves thro' the happy Land,
> And ebbs and flows, at *Caroline*'s Command. [24]

The unusual advantages of the rising are implicitly emphasised in an account of it as an excellent place from which to observe celestial phenomena. Lord Beauchamp, writing in *Philosophical Transactions*, reported that 'being on the Mount in Kensington Gardens at the Quarter past 10. [on 11 December 1741] the Sun shining bright, in a serene Sky, I saw towards the South a Ball of Fire, of about 8 Inches in Diameter, and somewhat oval, which grew to the size of about 1 Yard Diameter... it seemed to descend from above... and seemed to drop over Westminster'. [25]

Anne-Marie du Bocage, writing to her sister in 1750, judged the mount on aesthetic grounds and was critical of it, but, nonetheless, in selecting the letter as one of a series that form a travel book, classified it as one of the sights of London. She commented, 'An artificial mount, surrounded with pine-trees, seems very proper for opening a view to the plain; but the turret which crowns it turns uselessly upon a pivot; the trees overshadow it, and the dry soil which nourishes them, offers nothing pleasing to the eye.' [26]

Queen Caroline oversaw the construction of a further mount: in 1733, she 'order'd a Mount to be rais'd in Richmond Gardens, for a Prospect of the Thames and adjacent Country' (figs 56 and 57). [27] William Kent was again called in to supply a design for a pavilion for the summit of this 'new made Hill'. This time, he proposed a domed Tuscan temple with a circular altar at its centre. Nor was this the last intervention to take place on the earthwork: latterly, a grotto called Merlin's Cave was inserted into its sloping bank. [28]

The royal appetite for mounts continued well into the early nineteenth century. *Baldwin's London Weekly Journal* announced in 1826 that 'an artificial Mount, but of superb dimensions' had been thrown up in the grounds of Buckingham Palace (then known as the King's Palace in St James's Park), 'to mask the stables belonging

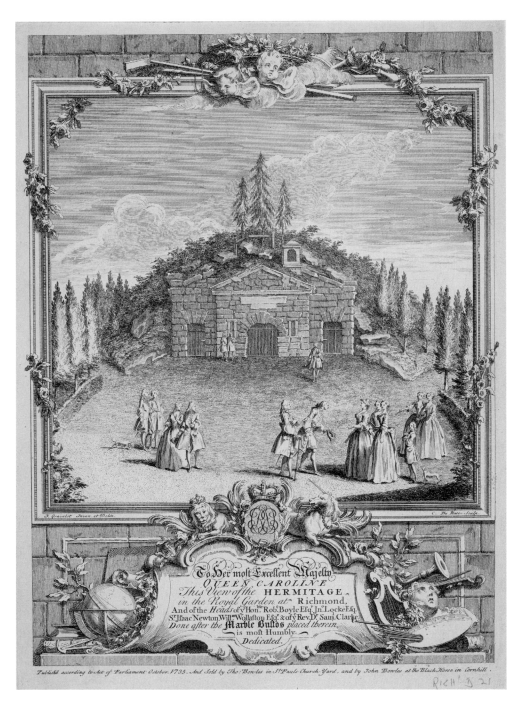

56.
Claude Du Bosc after Hubert-François Gravelot,
View of the Hermitage in the Royal Garden at Richmond,
*c.*1733, etching. Royal Collection Trust

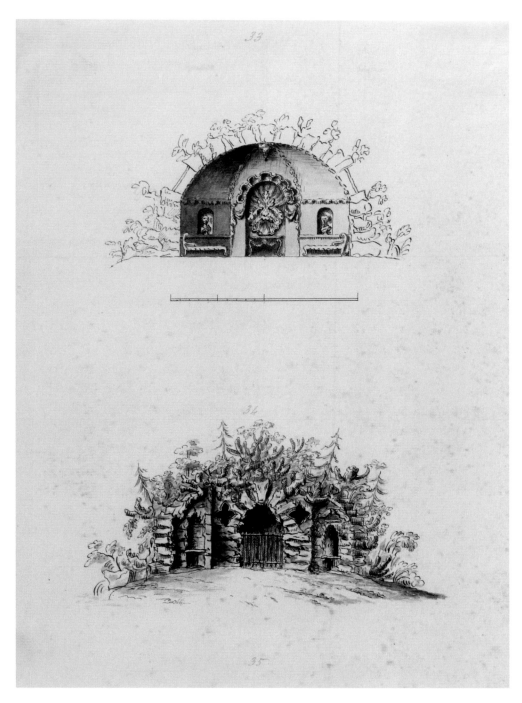

57.
William Kent, studies or preliminary design for
Queen Caroline's Hermitage at Richmond Gardens,
c.1733, pen and grey and brown washes.
Sir John Soane's Museum, London

to his Majesty at Pimlico'. Although a modest swelling, it had grand pretensions: it was 'covered with young trees and the larger species of shrubs, so disposed as to present from the Palace windows an appearance very similar to one of the lake scenery of Westmoreland and Cumberland, where its features are not upon the greatest scale'.[29]

Mounts and Garden Design

It is usually taken for granted in accounts of risings in gardens that they are clearly artificial features – the product of human ingenuity. They fulfil the role suggested by Henry Home, Lord Kames in his *Elements of Criticism* (1762), when he writes of the need to affirm that a small garden is a 'fairyland', in which features should be introduced to 'avoid imitating nature, by taking on an extraordinary appearance of regularity and art, to show the busy hand of man'.[30] Sir John Dalrymple remarked in *An Essay on Different Situations in Gardens* (1772) that, to gain the 'advantage of natural prospects [in a flat garden], the artificial mounts of the Dutch flat garden … should be introduced: and even, to create the appearance of such mounts, where there are none, the trees should be planted in clumps of avenues; the lower species of trees in the first rows, and the higher kind rising towering behind them, so as to make the stranger think he is walking around a real hill, or betwixt two rising banks'.[31] This formula had been adopted some decades earlier at Kensington Gardens, where, in about 1710–12, an artificial mount – a precursor to both those planned and the rising in fact constructed in the 1730s – was made and 'planted round promiscuously with Greens, Trees, &c.'.[32] Joseph Addison was warm in his praise for the royal gardeners George London and Henry Wise – 'our heroick poets' – who converted an erstwhile plain, scarred with gravel pits, into a 'Master piece of art in the new regular manner of greens and gravel-gardening' (fig. 58). He remarked in the *Spectator* in 1712,

> It must have been a fine genius for gardening, that could have thought of forming such an unsightly hollow into so beautiful an area and to have hit the eye with so uncommon and agreeable a scene as that which it is now wrought into. To give this particular spot of ground the greater effect they have made a very pleasing contrast; for as on one side of the walk you see this hollow basin with its several little plantations lying so conveniently under the Eye of the beholder; on the other side is of it there appears a seeming mount made up of trees rising one higher than another in proportion as they approach the center. A spectator who has not heard of this account of it would think this circular mount was not only a real one but that it had been actually scooped out of that hollow space which I have before mentioned.[33]

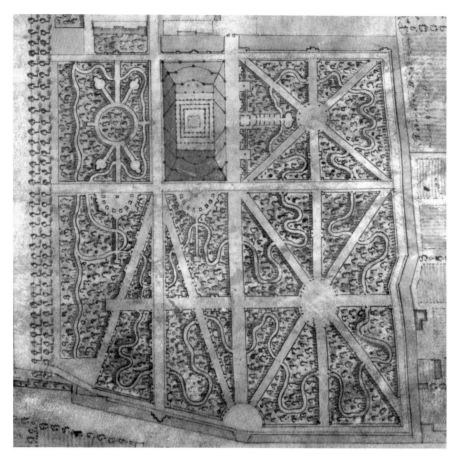

58.
Charles Bridgeman, plan of Kensington Palace, c.1733, pen
and ink and watercolour wash, detail showing the mount
at top left of image. The Huntington Library, San Marino,
California. The Stowe papers (ST Map 147)

The nurseryman and author Thomas Fairchild also promoted the idea of forming
mounts covered entirely with trees. In *The City Gardener* (1722), he supplied his
readers with detailed instructions on how to make and adorn their squares 'in the
Rural Manner' and 'how to dispose the several Plants in them'. Mounts were a 'proper
Embellishment for a Square', and they 'should be cover'd with Trees very close set
together; and upon this the Elm, the Lime, and others of the tallest Growth should
be put' (fig. 59). They were to be loftiest and among the most conspicuous features of
a square. They were not often, however, to be ascended by means of windings and

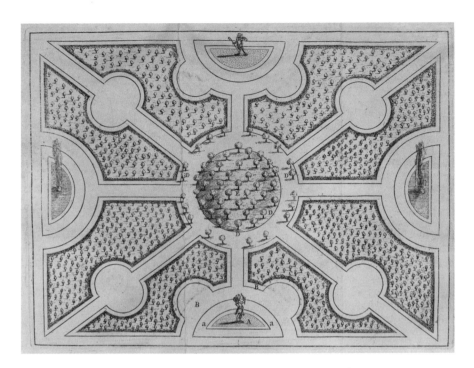

59.
Artist unknown, plan of a garden square with
a mount at its centre, engraving, from Thomas
Fairchild, *The City Gardener* (1722). Private collection

possessed no structures on their summits: they were conceived as eye-catchers for the residents who lived on the square, as no planting within it was to 'break the Prospect' across the same, since obstructing views to the mount and the interior of the square would 'rob the Gentlemen of that View which they have by their Expence endeavour'd to gain'.[34] Not everyone followed Fairchild's advice: the artificial mount proposed for middle of Portman Square in 1766 was to be laid out in the more conventional manner, where a 'spiral walk' was proposed to wind its way through shrubs and evergreens to a terrace at the top 'from whence there will be a beautiful prospect'.[35]

Although mounts had the potential to add variety to a garden: they were also seen as a potential problem, threatening to diminish the coherence of small gardens, or to appear ridiculously over-ambitious in a small space. The Revd Joseph Spence, who proposed 'little mounts' in his 'Plan for a Garden for a house in Buckingham Gate' (1747), affirmed that, although 'very small swellings will help . . . if properly placed', 'two or three sugar-loaf mounts only point out the defects of the ground'; and Lord Kames recommended that such forms of artifice be used sparingly, and the

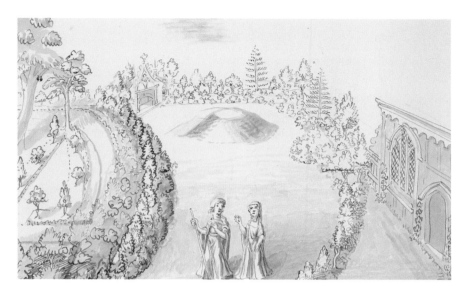

60.
William Stukeley, *The Hermitage Garden
Kentish Town*, August 1760, pen and ink with
watercolour wash. Bodleian Library, Oxford,
Gough Maps 230, fol. 350

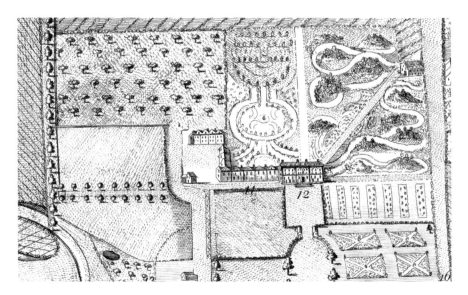

61.
Joshua Rhodes, *Topographical Survey of the Parish of
Kensington*, 1766, detail showing planted 'swellings'
in the garden of Campden House Boarding School.
Kensington Central Library, London, Kensington and
Chelsea Local Studies Collection

whole kept to a simple layout, since 'profuse ornament hath no better effect than to confound the eye, and to prevent the object from making an impression as one entire whole… superfluity of decoration hath another bad effect: it gives the object a diminutive look'.[36]

These injunctions did little to dissuade London gardeners from raising artificial 'swellings' in their gardens – whether for symbolic reasons at Aaron Hill's garden in Petty France (*c.*1730), antiquarian interest at William Stukeley's druidical garden in Kentish Town (*c.*1760) (fig. 60), or for purely decorative reasons at a small garden in Kensington, portrayed on Joshua Rhodes's *Topographical Survey* (1766), where the mounts seem 'as natural as flower beds' (fig. 61).[37] Mounts were occasionally even raised in modest town gardens: the gardens of some houses in Pall Mall had 'Mounts adjoining to the Royal Garden', and an auction prospectus of 20 March 1812 proclaimed that the leasehold premises at 13 Finsbury Square had 'a Small Garden with a raised Mount behind the House' which commanded a 'View over [the] Artillery ground' from its summit.[38]

'A "sublime sifted wonder of cockneys"'

Perhaps the most notorious artificial mount ever created in London was Smith's Dust Heap, which straddled a long, triangular ground at the top of Gray's Inn Road where it joins Euston Road, by King's Cross Railway Station. Though it was not conceived as a garden, it ranks as among the conspicuous, if unsanitary landscape features in Regency London. The 'mountain of filth and cinders', which was 'said to have been existing on the same spot since the Great Fire of London', is commemorated in a series of watercolours by E. H. Dixon painted in 1837 (fig. 62).[39] His two views illustrate it in different lighting conditions, suggesting that the artist appreciated the picturesque qualities of this public eyesore.

The giant ash heap was the inspiration for a cordillera of ash mountains that feature in Dickens's *Our Mutual Friend* (1865), where the misanthropic miser Mr Harmon 'grew rich as a Dust Contractor, and lived in a hollow in a hilly country entirely composed of Dust. On his own small estate the growling old vagabond threw up his own mountain range, like an old volcano, and its geological formation was Dust. Coal-dust, vegetable-dust, bone-dust, crockery dust, rough dust and sifted dust, – all manner of Dust.' Upon his death, this ensemble was entrusted to his faithful servant Nicodemus (Noddy) Boffin, of Harmony Jail, who renamed it 'Boffin's Bower', because he thought it 'so picturesque as contrasting with the surrounding flatness of the scene'.[40] He described it as 'a charming spot, is the Bower, but you must get to appreciate it by degrees. It's a spot to find out the merits of; little by little, and a new'un every day. There's a serpenting walk up each of the mounds, that gives

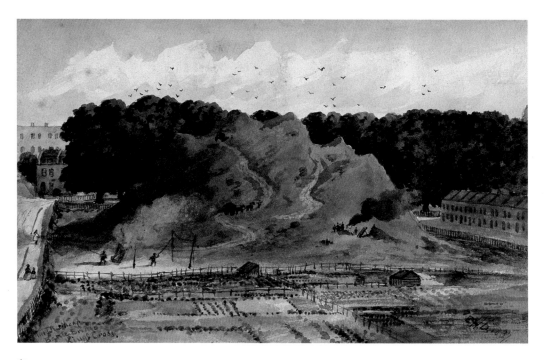

62.
E. H. Dixon, *Smith's Dust Heap*, 1837, watercolour.
Wellcome Collection, London

you the yard and neighbourhood changing every moment. When you get to the top, there's a view of the neighbouring premises, not to be surpassed. The premises of Mrs Boffin's late father (Canine Provision Trade), you look down into, as if they was your own. And the top of the High Mound is crowned with a lattice-work Arbour.'[41]

The great 'cinder heap', like Boffin's Bower, was, in fact, a valuable asset, and, ultimately, like all good mounts, it served a very practical purpose: it was removed in 1848, when it was 'bought in its entirety by the Russians to help make bricks to rebuild Moscow'.[42]

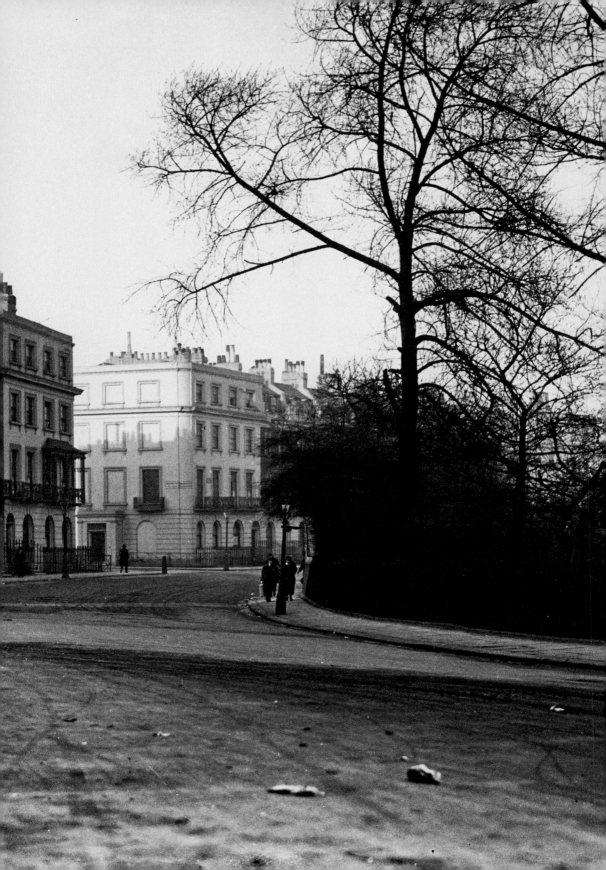

4.

Squares

Garden squares are 'the pride of London's planning'; they have been the *desiderata* of urban improvers since the reign of James I, have promoted novelty of design, elegance and spaciousness in the urban plan, and, through a combination of unique local circumstances – including land ownership, management agreements, legislation and the English love of nature – have come to represent what has described as 'the special strain of civilisation which Britain has bequeathed to the world'.[1] They have for centuries been purveyors of light and air, and their evolution has been closely tied to the provision of spacious residential development and the improvement of the city's street. They have, moreover, gone a 'good way towards ordering and "civilizing" the vernacular landscape' and have 'introduced rural values into the urban fabric in ways that continue to shape urban landscape ideals today'.[2]

Not until late in the nineteenth century did it become apparent that measures would have to be taken to safeguard London's legacy of squares. This impetus coincided with the establishment, in 1889, of the London County Council (LCC), which introduced the London Building Act (1894) to bring into public control the widening of streets, the extent of open space around developments and the heights of buildings. It also launched a crusade to develop and implement its own cultural initiatives, which included the provision and maintenance of public open spaces. The remit of the council was to take an interest in the horticulture, gardening and town planning, and to play an active role in efforts to protect open space throughout the Administrative County of London. Its approach reflected the increasing popular view that saving the squares was not a mere parochial or local matter, but one that affected

63. (facing) Detail of fig. 70

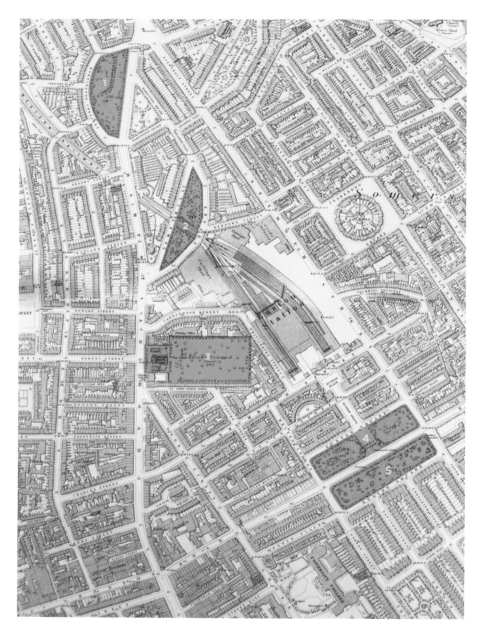

64.
Ordnance Survey map, 1876, detail showing
1. Mornington Crescent, 2. Ampthill Square,
3. St James's Gardens, 4. Euston Square and
5. Endsleigh Gardens. Private collection

A correspondent to The Times *observed on 22 February 1890 that 'the mere existence of a great railways terminus seems to be a standing menace to every open space in its neighbourhood . . . no open space near Euston [Station] is safe'. All of the above gardens were destroyed or built over between 1925 and 2018.*

the welfare of the entire metropolis, and that the best way to protect them was to enact legislation.

The loss of Mornington Crescent and Endsleigh Gardens in the early 1920s disturbed public opinion enough to cause the appointment of a Royal Commission on London Squares in 1927 to consider whether and on what terms squares and enclosures should be protected as open spaces (fig. 64). When it published its report the following year, it concluded that squares were a 'very distinctive and attractive feature of the plans and parts of London in which they are situate', and that they added greatly to the amenities, not only of their immediate surroundings, but of London as a whole, that the air spaces they afforded were of benefit to the well-being of the community and that they should be preserved.[3] This, in turn, galvanised the enactment of the London Squares Preservation Act (1931) – among the first acts of parliament to protect designed landscapes – which gave protection to 461 squares and enclosures across London and constrained the potential for development within them. This measure was desperately needed as several squares' enclosures had, since the late nineteenth century, been preyed upon by developers who were keen to build over their gardens.

Euston Square, Ampthill Square and Endsleigh Gardens were laid out on former nursery grounds in an area north of the New (Euston) Road that was described in 1813 as 'one vast brick-field'.[4] Euston Square was commenced in 1812 on the site of the Bedford Nursery, north of Tavistock Square and, like Eaton Square in Pimlico, was conceived as a large parallelogram bisected by the New Road. The road was flanked on each side by two pairs of matching oblong garden 'divisions', which were combined to give the impression of a single, long pleasure ground. The nine-acre (3.6-hectare) plot upon which the square was built was reported in 1802 as being 'laid out with superior neatness and beauty' and possessing 'a handsome little Dwelling-house, in the cottage style, besides Green-houses, a Pinery, Stove-houses, &c. &c'.[5] Writing in 1813, John Peller Malcolm hailed the 'half *completed*' square as 'magnificent'.[6]

The garden possessed some of the most distinguished, Athenian-inspired eye-catchers in London, including an imposing propylaeum, known as the Euston Arch, which supplied a striking northern entrance to the square, and William Inwood's St Pancras New Church – the body of which was modelled after the Erechtheum, and the steeple copied from the Tower of the Four Winds – which formed the eastern terminus of the garden enfilade. In spite of the presence of these grandiose monuments, the square never achieved the acclaim of its rival, Eaton Square, because, from the late 1830s, the terminus for the new railway line from London to Birmingham – now known as Euston Station – was built adjacent to the gardens. This development had an instant and lasting negative impact on the 'Southward and Northward Parts of Euston Square' and the neighbourhood of Somers Town in

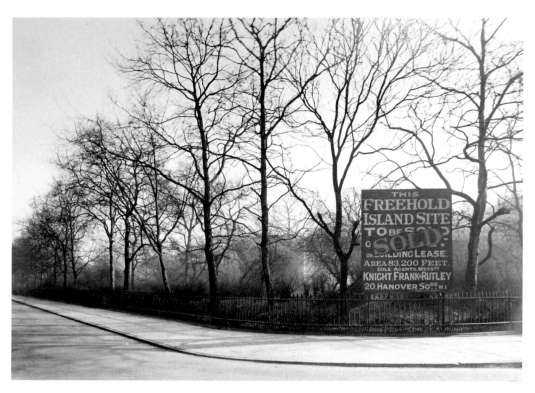

65.
Endsleigh Gardens, Euston Road up for sale,
before the construction of Friends House, 1922.
Religious Society of Friends (Quakers) in Britain,
Hubert Lidbetter Collection

general. In 1851, Charles Knight described the gardens as 'a mere bulging out of the highway which bisects them' and 'spruce and uninteresting'; and the southern half of the square – from 1879 known as Endsleigh Gardens – was criticised in 1876 as having 'long been in a disgraceful state', its custodians accused of 'aboricide' for threatening the gardens' trees with 'destruction by being choked with the earth and rubbish piled about their roots'.[7]

The square was first faced with potential extinction in 1890, when Euston Station threatened to encroach on the gardens. The 'ragged and beggarly' enclosure limped on until December 1921, when its 'island site', comprising '83,000 square feet... [of] vacant land' was put on the market for development (fig. 65).[8] In August 1923, Basil Holmes, the Secretary of the Metropolitan Gardens Association (MPGA), wrote in *The Times* that, ever since it became known that Endsleigh Gardens – 'this picturesque garden

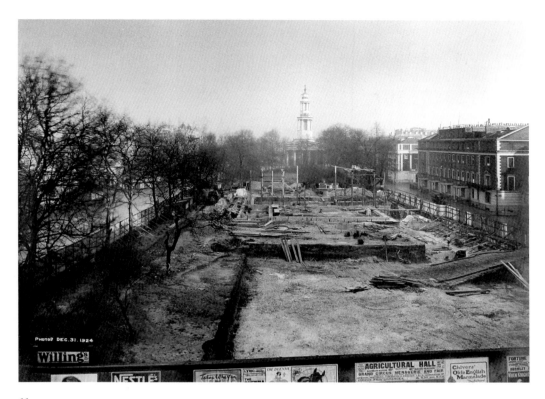

66.
Excavating the foundations of Friends House in
Endsleigh Gardens, Euston Road, 31 December
1924. Religious Society of Friends (Quakers) in
Britain, Hubert Lidbetter Collection

*The 'desecration' of the garden was condemned by a contributor
to the* Westminster Gazette *in October 1925 as 'one of the
worst acts of vandalism perpetrated in the Metropolis in recent
years' – a view shared by the* MPGA *and those keen to see the
LCC take 'prompt steps to protect permanently these vital
amenities which have done so much to make London one of the
most attractive cities in the world'.*

area – about two acres in extent' was for sale, the MPGA had endeavoured to raise
the funds for its purchase, but, owing to the fact that it had very valuable frontage on
Euston Road, they were unable to find the necessary amount. They proposed instead
that the purchaser adopt a scheme that confined any buildings to the 'central section
of the enclosure, leaving an open space at each end, which might be purchased for the
conversion into public gardens.' He remarked that, whenever it had been possible to
obtain such areas 'as gifts or on comparatively moderate terms', the association took
steps to secure them and lay them out for public use, and, in this way, had added some
thirty grounds of this character to the public open spaces of London.[9] In the event,
the Society of Friends built their new headquarters in the garden enclosure, and the

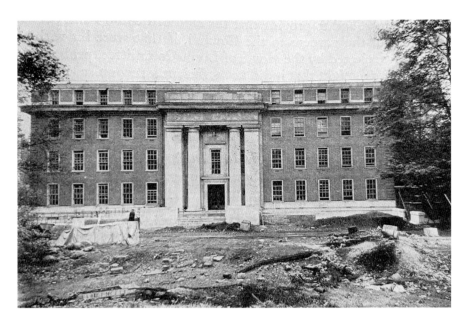

67.
'Endsleigh Gardens To-day', 1917, from *London Squares and How to Save Them*. Private collection

Quakers were thus the 'first to set the bad example of shutting out the light and air in one of the best planned areas of Central London' (figs 66 and 67).[10]

Ampthill Square – first known as Russell Crescent – was built on the site of Rhodes Farm,[11] latterly Robert Green's Nursery.[12] The nursery ceased trading in 1878, at which time Green sold up his collections of 'Palms, Yuccas, Dracaenas, Araucarias, &c'.[13] Beresford Chancellor described the square in 1907 as 'not only merely a triangle, but even this is intersected by a deep cutting of the London and North-Western Railway at its south-west corner'.[14] Though never smart, the crescent-shaped garden enclosure, which sat immediately to the north-west of Euston Station was an important amenity for the residents of the square. In 1884, the London and North Western Railway Company threatened to seize it for development. The residents – who were proud and jealous of their open space – protested, arguing that it supplied 'green to the eyes and fresh air instead of brick and mortar and smoke'.[15] Their objections were to no avail – the square was incrementally consumed by the encroaching railway track widening. Spencer Gore, who lived in the square from 1912, painted a view from his first-floor window overlooking the garden enclosure. His picture reveals nothing of the impact of the railway lines on the gardens, concentrating instead on the extravagant luxuriance of their vegetation (fig. 68). Parts of the eastern side of the

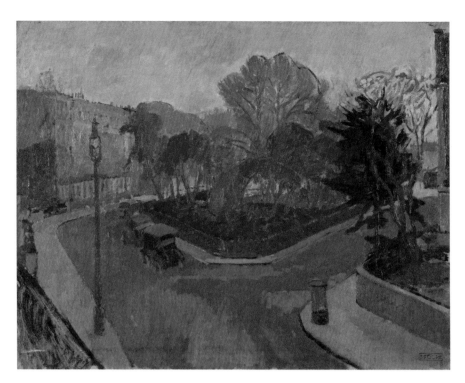

68.
Spencer Gore, *Houghton Place*, 1912, oil on canvas. Tate, London

Gore painted this view from Houghton Place to Ampthill Crescent from the balcony window of his first-floor flat at 2 Houghton Place, overlooking the square.

square were damaged during the Blitz, and, by the late 1940s, much of its housing was derelict. Although the gardens were refreshed in 1954/5, the whole of the square and its precincts were cleared and replaced in the early 1960s to make way for Camden Council's Ampthill Estate. This development has been described as 'indifferent' and its large tower blocks 'clumsy'.[16]

Mornington Crescent was laid out on the Southampton Estate in Camden in the wake of the Napoleonic wars for the prosperous middle classes; from 1821, thirty-six four-storey, stucco-fronted houses were erected in a great crescent.[17] The three-acre (1.2-hectare) garden enclosure is depicted on John Britton's *Map of the Parish of St Pancras* (1834) as encompassed by hedges, threaded with informal paths and dotted with plantations; later editions of the Ordnance Surveys suggest that the garden remained reasonably unchanged throughout the nineteenth century. Spencer Gore's view of 1911 corroborates a view expressed earlier in *The Garden* that the

69.

Spencer Gore, *Mornington Crescent*, 1911,
oil on canvas. Tate, London

Gore lived in the crescent from 1909 to 1912 and
made several paintings of its central gardens.

enclosure was a 'good illustration of what is possible even amid the fog and smoke of
the metropolis' (fig. 69).[18]

In 1919, the estate trustees decided to sell the gardens of the 'fashionable one-time
residential quarter' to a developer. Appeals were made in 1924 urging retention of the
gardens, as they 'would be of great value to the children of the neighbourhood, which
is largely working class in character'.[19] The houses did not possess any appreciable
garden space at the rear, and the communal garden square compensated for this
deficiency; the gardens, moreover, were said to add to the health of the inhabitants
of a wider area than that covered by the houses immediately overlooking them
(fig. 70). In so far as there was no mechanism in place to block such a development,
and since the Metropolitan Borough of St Pancras declined the opportunity to buy it,
the 'doomed site… once an oasis of grass and trees' was developed to become the new
Egyptian Revival style factory of the Carreras Cigarette Company (fig. 71).[20]

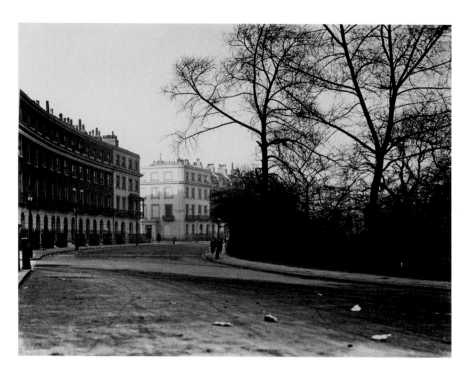

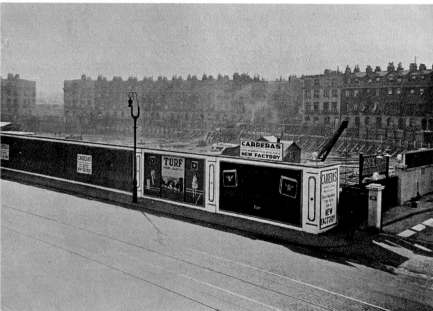

70.

Mornington Crescent, 1924. London
Metropolitan Archives

71.

The site for the Carreras Cigarette factory
in Mornington Crescent garden, 1928.
Private collection

Though few London squares have completely vanished, several have been disfigured by the process of 'extension' – one of the more popular and innovative post-war means of creating new 'units' of public space that resulted from the implementation of the London Development Plan (1951). Typically, a square extension was the creation of a new public open space through the addition of neighbouring building land to an existing square – land formerly occupied by a square's surrounding premises, or contiguous sites that became available through slum clearances or demolitions. Because the London Squares Preservation Act forbade the building of new permanent structures on protected gardens, the outlines of the original pleasure grounds frequently remained intact and were embedded within successive treatments of the space. Thus, the open spaces survived but their original architectural settings, which framed the gardens, were lost.

Such enlargements took place at Carlton and Ford squares in Stepney, Ion Square in Bethnal Green, Holford and King squares in Finsbury, Addington, Leyton and Lorrimore squares in Southwark and Melbourne Square in Lambeth. The latter was a very modest Victorian garden enclosure, which, when it was given by the Ecclesiastical Commissioners to Lambeth Borough Council in 1925, was described as 'an almost square area planted with flowering shrubs'. In 1958, it passed to the LCC; the following year, it was announced in *The Times* that the former private garden had been laid and extended to form a 'new public open space' and was to be called Melbourne Fields, 'because the shape is irregular' (fig. 72). The correspondent accused the council of robbing the square of its dignity by demoting it to mere 'Fields'.[21] This was not, however, the last time that the square suffered an identity crisis: in 1971, the garden became the responsibility of the London Borough of Lambeth and was renamed Mostyn Gardens.

Most of the aforementioned 'extended' squares were reasonably modern – or what the publisher and writer Charles Knight categorised as 'fourth division' – and had 'an intolerable sameness about them'.[22] Much greater is the loss of two East End squares of 'venerable antiquity' – Wellclose and Swedenborg – whose evocative remains were transmuted into featureless 'square-extensions' in the 1960s and 1970s (fig. 73).[23]

At the end of the seventeenth century, a small church to the design of the Danish sculptor Caius Gabriel Cibber was raised on a piece of land between Cable Street and the west end of Ratcliff Highway to accommodate a small community of Scandinavian sea captains and merchants who had settled in the East End soon after the accession of William III. The 'Templum Dana–Norvegicum' rising amidst its precinct is depicted in Kip's engraved view of 1697 (fig. 74). The so-called Danish–Norwegian Church was destined to form the centrepiece of Nicholas Barbon's new, speculative residential square that took shape in the early 1680s, the layout of which would inform his design of Red Lion Square in Holborn. Wellclose (originally Marine) Square was

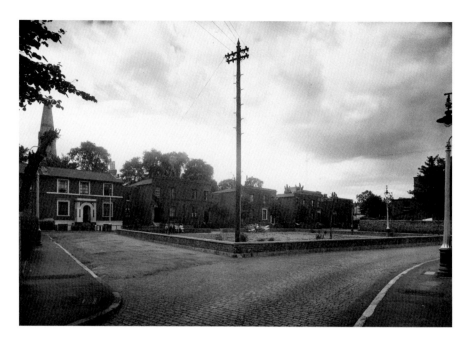

72.
Melbourne Square, Lambeth, 1949. London
Metropolitan Archives

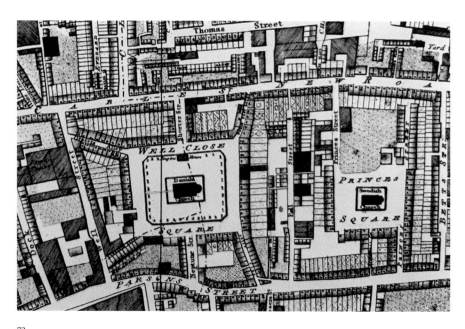

73.
Richard Horwood, *Plan of the City of London, City of Westminster
and Southwark*, 1799, detail showing Wellclose Square and
Prince's (later Swedenborg) Square, Stepney. Private collection

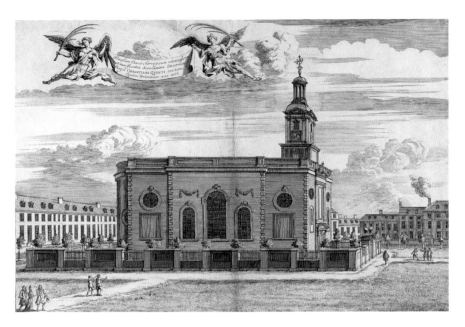

74.
Johannes Kip after C. Gabriel Cibber, the Danish–Norwegian
Church in Wellclose Square, 1697, engraving.
London Metropolitan Archives

designed to appeal to the 'well-to-do members of the East End's maritime community' and was, in the early eighteenth century, the 'only significant example of planned, residential development' in the parishes of Stepney and St Mary's Whitechapel – 'standing out from the chaotic growth of the riverside hamlets and piecemeal development creeping north and east across the fields of the old Manor [of Stepney]'.[24]

The success of the square galvanised another Scandinavian community to form a similar, but smaller development in the late 1720s: Swedenborg (originally Prince's) Square was projected by three builders and a 'London [Swedish?] merchant' and destined for a plot of ground immediately to the east of Wellclose Square: here they agreed to build a 'complete square', and to 'build a church [at its centre] for the service of the Swedish nation'.[25] As at Wellclose Square, the church sat within a railed enclosure, and we know from surviving records that, in 1746, the area within it was embellished with trees and shrubs and that the precinct was looked after by two gardeners.[26] The presence of the trees is corroborated by John Rocque's *Map of London* of 1746 which shows the central areas of both squares encompassed by rows of trees; and Benjamin Cole's engraved *Prospect of the Sweeds Church* of around 1750 reveals juvenile trees rising above the railings enclosing the central garden.

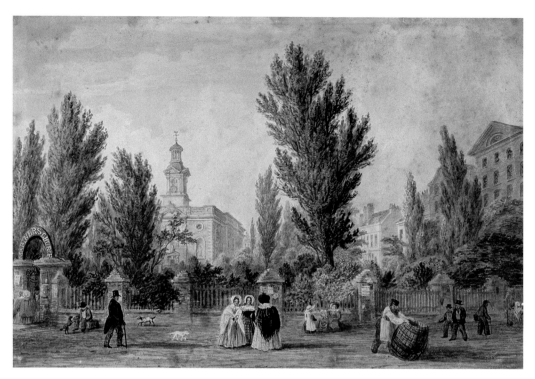

75.
Artist unknown, exterior view of the old Danish–
Norwegian Church, Wellclose Square, Stepney, which
became the British and Foreign Sailors' Church in
1845, c.1845, watercolour. Private collection

Roughly a century later, the central area of Wellclose Square was described as 'planted with trees and overrun by weeds, grass, and common yellow marigold'.[27] A contemporary watercolour of about 1845 portrays the gardens as a 'verdurous wall of Paradise up-sprung' (fig. 75);[28] and Knight described the precincts in 1851 as displaying 'more of life and humanity in their outward show [than other City Squares]: probably the elastic spirits of the gallant tars who were its earliest occupants, lent a light-heartedness to the very atmosphere that has never since deserted it'.[29] There is no comparable nineteenth-century description of Swedenborg Square, though a sketch by Frank Emanuel from 1908 shows the churchyard and its environs looking rather bleak and unkempt (fig. 76). This scene brings to mind Knight's perceptive observation that 'however dull and desolate these squares may seem to the casual visitant . . . no such fancies dim the minds of the residents: there is probably more constant sunshine of the soul there than among the more splendid regions of the metropolis'.[30]

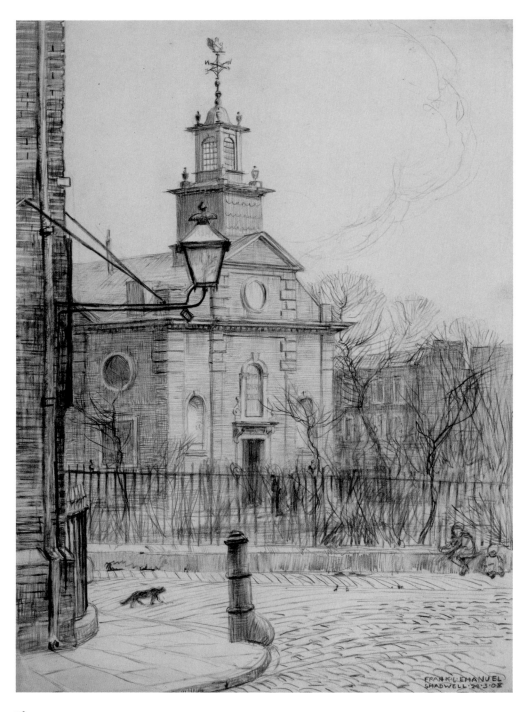

76.
Frank L. Emanuel, view of the Swedish
Church, Prince's (later Swedenborg)
Square, 1908, crayon. London
Metropolitan Archives

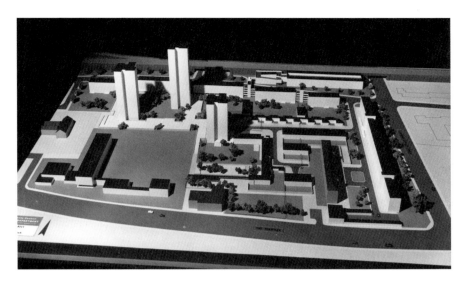

77.
Model for the proposed redevelopment of Swedenborg
Square, 1964. London Metropolitan Archives

These two squares, which both went down in the world in the nineteenth century, were dismantled in the twentieth century: the trustees of the Swedish Church having failed to sell their church and its Swedenborgian precincts in 1908, sold it in 1923 to the MPGA and Stepney Borough Council, and the site was subsequently cleared and the church pulled down to make way for a children's playground. The environs were once again remodelled shortly after 1959, when the LCC declared the surrounding houses of the square a 'slum', to form Swedenborg Gardens and St George's Housing Estate (fig. 77). Wellclose Square suffered a similar fate – 'its houses went down but the street pattern was retained, creating a strange non-place'.[31]

Ian Nairn, writing in 1966, must have the last word. Having visited the melancholy remains of Wellclose and Swedenborg squares, he summed up what the architectural historian Will Palin has described as the 'terrible plight of these two architectural gems':

Embedded in it [Cable Street] are the hopeless fragments of two once splendid squares... built for the shipmasters of Wapping when London began to move east. Those who could care about the buildings don't care about the people, those who care about the people regard the decrepit buildings rather as John Knox regarded women: unforgivable blindness. Nobody cares enough, and the whole place will soon be a memory.[32]

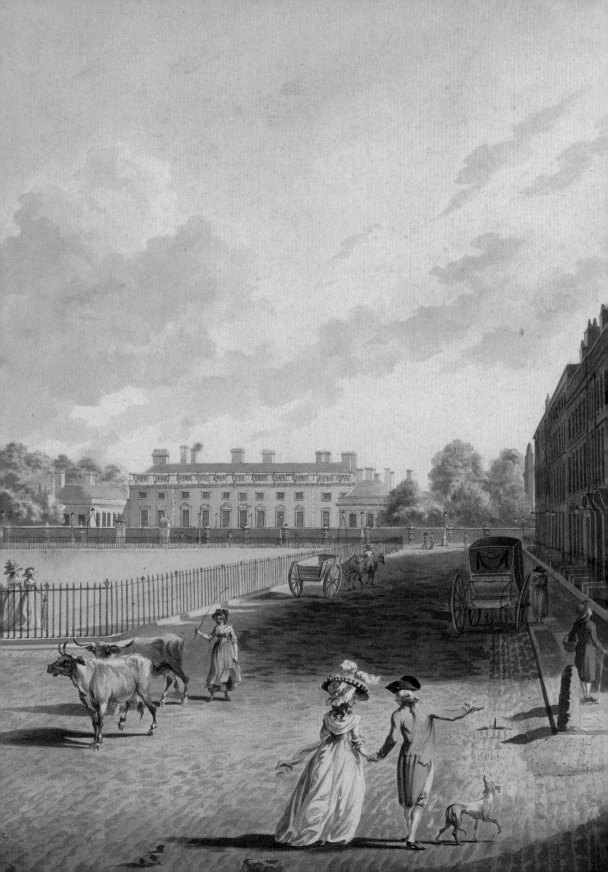

5.

Aristocratic Gardens

It is perhaps not surprising, given the extensiveness of London's great aristocratic gardens, that many have vanished: the pressure of redevelopment has meant that the city's mansions have invariably fallen victim to house-breakers, and their former grounds have been covered with buildings.

Because these gardens were often large and shut in by high 'frowning walls', they were perceived by their owners as secluded private sanctuaries and were generally regarded by the polite as contributing to the greening of the town or creating a sense of *rus in urbe*. While many of the grounds were initially conceived as highly decorative gardens, over time, they often metamorphosed into sombre, 'shady places' overshadowed by trees and leafy shrubberies. If these overgrown gardens imparted a sense of melancholy and desolation, they were not entirely devoid of life: flourishing colonies of rooks and sparrows would remind those on the other sides of the walls that gardens possessed a certain power of their own to animate the metropolis.

An extraordinarily rare plan of around 1562–7 documents the precincts of 'Cecil House' in Strand (fig. 79). The house, which was known variously as Cecil, Burghley and latterly Exeter House, was built on land acquired by 1560 by William Cecil, 1st Baron Burghley, then Secretary of State to Queen Elizabeth I and one of the most powerful people in the kingdom. The plan purports to be the 'earliest representation of any identifiable English garden' and has been attributed to Lawrence Bradshaw, Surveyor of the Royal Works.[1]

Cecil's newly built mansion house was conceived as a country house in town; it sat hard on the north side of Strand, while its north-facing garden front gave on to open

78. (facing) Detail of fig. 88

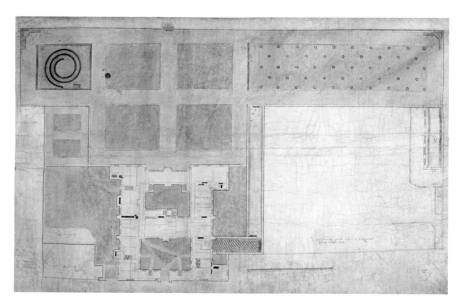

79.

Attributed to Lawrence Bradshaw, plan of Burghley
(later Exeter) House and its garden, 1562–7, pen and
ink and watercolour wash. Burghley House Collection

fields. John Norden's *Speculum Britanniae* (1593) suggests that 'Burleigh howse' was
the most prominent building on the north side of Strand, and that its walled garden
was princely in extent (fig. 80). The presence of what appears to be a central gatehouse
inserted in the garden's north wall suggests also that the principal or ceremonial
approach to the house may have been from the north, across an open 'pece of pasture
grounde beyng partt of one great pasture lately called the Covent Garden'.[2]

Bradshaw's plan shows the garden layout in considerable detail: the house
possesses two internal courts, and two inferior courts. A tennis court, bowling
green and orchard lie to the east and northeast, and a large quadripartite garden
immediately to the north of a central loggia that links the east and west wings of the
mansion. The garden's north boundary wall is shown as having a central gatehouse
and two belvederes, or elevated viewing pavilions accessed by sets of steps, at its east
and west ends. These were not the only structures contrived to take advantage of the
extensive views to the north: a mount, indicated by a bold, spiral path on the plan,
erupted from an enclosure in the northwest corner of the garden. The presence of a
staircase within this mount garden suggests that the artificial earthwork was set at a
level lower than its surroundings. The garden also boasted an antique inscription from

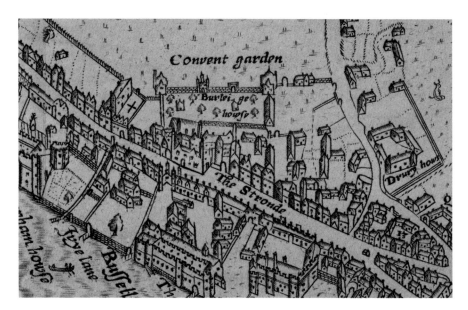

80.

John Norden, *Speculum Britanniae*, 1593,
detail showing Burghley House and garden.
Folger Shakespeare Library, Washington, D.C.

the Roman remains at Chichester which prompted the antiquary William Camden in 1577 to dub Cecil the 'Nestor, of Britain', comparing him with the legendary king of Pylos.[3]

In assessing the mansion's garden, the historians Jill Husselby and Paula Henderson observe, 'one of the many remarkable things about the ... plan is the sense that the gardens were almost as important as the house itself'; this was a 'highly organized plan, almost Plinian in the unity between architecture and nature'. Cecil 'saw his house and garden as one bold statement' – that the 'house and its surroundings were visualized *ab initio* as a single harmonious entity'.[4] Cecil's urban palace was in every regard regal – indeed, the fact that it possessed both a bowling green and a tennis court – a 'fine brick court with ... [a] splendid red and white chequerboard floor' – put it on a footing with Hampton Court.

Sadly, Cecil's palace complex was short-lived. It was demolished in 1676, shortly after Hollar depicted it on his bird's-eye view of about 1658. The plot was redeveloped, and much of its garden built over by the tide of bricks and mortar that was precipitated in the 1620s by the earls of Bedford in the redevelopment of their Covent Garden estate.

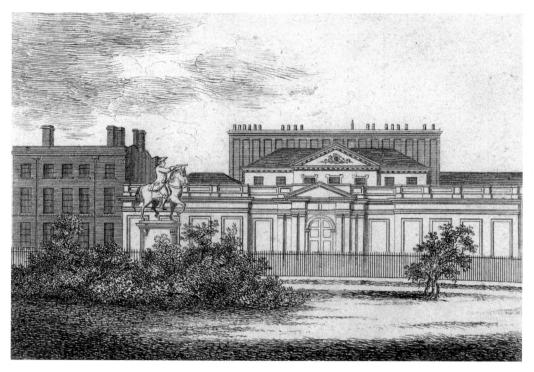

81.

James Peller Malcolm, 'The West Side of
Cavendish Square', etching, from J. P. Malcolm,
*The Anecdotes of the Manners and Customs of
London*, 1808. London Metropolitan Archives

Most high-status houses were enclosed by high walls. Several centuries later,
London was said to possess 'on the whole, a fair share of gloomy houses'. Some
of these were very large. In fact, the larger the house the gloomier very often its
appearance. None was, however, as gloomy and 'absolutely forbidding' as Harcourt
House in Cavendish Square (fig. 81).[5] Its noble incumbent, the reclusive William John
Cavendish-Bentinck-Scott, 5th Duke of Portland, surpassed all his contemporaries
in their precautions for privacy. Within a few years of occupying his West End house,
the so-called 'Mole Duke' (on account of his passion for tunnelling) transformed
the already unwelcoming pile into what the editor and writer Walter Thornbury
later described as 'a dull, heavy, drowsy-looking house', which had about it 'an air
of seclusion and privacy almost monastic'.[6] He attributed its increased seclusion to
'three high walls, which have been raised behind the house, the chief object of which
appears to be to screen the stables from the vulgar gaze'.[7]

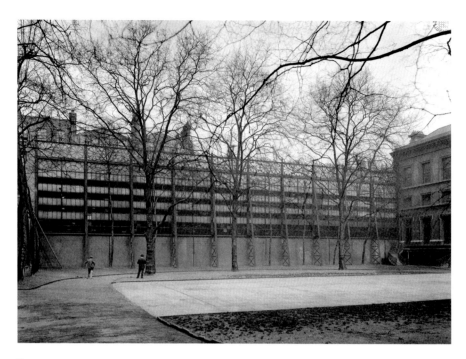

82.
Glass screen on the northern boundary of
Harcourt House, Cavendish Square, c.1906.
Westminster City Archives

For almost two centuries the palatial residence and its garden had the distinction of being among the most private and impenetrable premises in London. Known variously as Bingley, Harcourt and Portland House, it was vaunted by James Ralph in 1734 as 'one of the most singular pieces of architecture about town'. It was, however, 'rather like a convent than a residence of a man of great quality'.[8]

Although remodelled outside and in by its various early occupants, the mansion was always distinguished by what Tim Knox has described as 'a sombre superannuated stateliness'.[9] It certainly cannot be said to have embellished its situation overlooking one of the West End's oldest and grandest squares. Instead, it presented to the world 'a dreary expanse of high brick wall, pierced by a pair of stout panelled gates topped by iron spikes'.[10]

Under the 5th duke, the house's polite but conventional garden was transmuted into something otherworldly: from April 1862, he erected an immense glass screen on the north and south sides of his garden to provide privacy for a path round it for 'carriage exercise' (fig. 82).[11] This translucent barrier was 'upwards of 22 feet [6.7 metres]

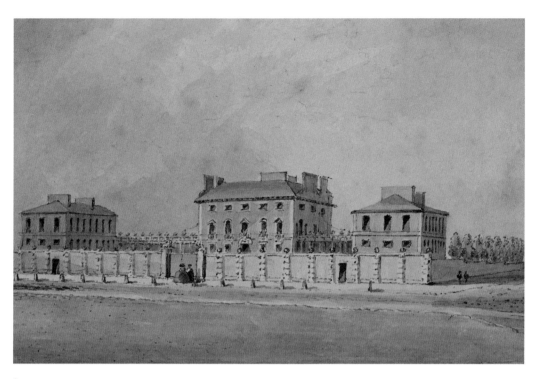

83.
J. T. Smith, *Chesterfield House, South Audley Street*, c.1750, watercolour.
London Metropolitan Archives

in height above the inclosing fence wall of the garden of Harcourt House, and about 35 feet [10.7 metres] from the ground'.[12] The screens were not the only visual barriers to be erected within the garden: the duke also commissioned the building of a colossal stable block at the western end of the garden to occlude views into Wimpole Street, and a short tunnel to link it to the house.[13]

The duke died in 1879, and his town palace remained intact until June 1906, when house-breakers armed with 'pickaxe, spade, and shovel' began to demolish it. Within no time it was little more than a mass of 'unsightly ruins'.[14]

Chesterfield House was one of the first high-status mansions to be raised in the south-west corner of Mayfair. Built between 1747 and 1752 by Isaac Ware for Philip Stanhope, 4th Earl of Chesterfield, the house enjoyed 'a fine open prospect into Hyde Park'.[15] John Rocque's map of 1746 depicts the Palladian mansion as lying at the western edge of a large, rectangular enclosure, the forecourt of which opened into South Audley Street; and J. T. Smith's watercolour view of about 1750 shows it

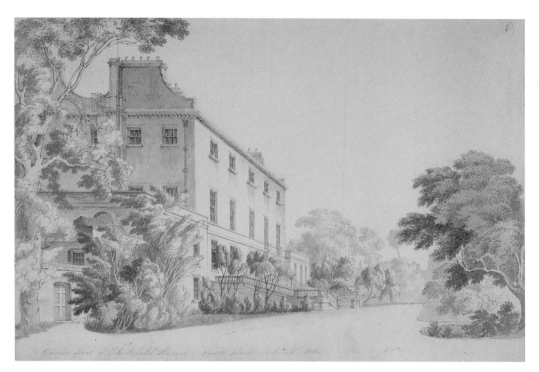

84.
Jean-Claude Nattes, *Garden Front of Chesterfield House, South Audley Street*, 1816, pencil and watercolour wash. London Metropolitan Archives

as enclosed by high brick walls with a row of trees in the back garden (fig. 83). These walls concealed the earl's capacious, east-facing garden, which he described in 1749 as 'now turfed, planted, and sown, and will, in two months more, make a scene of verdure and flowers, not common in London'.[16]

Sadly, there are no early views of what Chesterfield's neighbour William Beckford is alleged to have described as the 'finest private garden in London'.[17] Jean-Claude Nattes, however, produced seven views of the house and garden in 1816 which supply an overview of the now mature gardens and record a variety of improvements proposed by Jeffrey Wyattville and carried out between 1811 and 1813.[18] His sketches focus on the garden and the mansion's 'Garden front' and particularly its immense east-facing terrace and perron staircase leading to and overlooking the gardens, and give the impression that the house was set in a heavily embowered setting (figs 84 and 85). There are no views looking west to Hyde Park as the former panoramic view had been reduced to a keyhole vista by the building of Stanhope Street by the 1760s.

85.

Jean-Claude Nattes, view from the basement
arcade of Chesterfield House looking east into
the garden, 1816, pencil and watercolour wash.
London Metropolitan Archives

In 1870, the 6th earl sold the house and grounds to Charles Magniac, and he in turn sold much of the garden for the development of 'very large mansions'.[19] It was reported in the *Morning Post* in July 1870 that

> it is not without a pang of regret that Londoners, who jealously guard the few trees they possess, have witnessed the destruction of the fine old trees in the garden of Chesterfield House, and see the fatal boarding which denotes that the foot of the builder has in its stern march not spared the green spot which has for so many years formed a cheerful feature in the aspect of Mayfair ... in two months from the present time this same garden will become a scene of bricks and mortar not uncommon in London; but there are many who will think the loftiest palaces that can be erected but a poor exchange for their trees in which a short time ago the rooks built their nests, the music of their caws mingling with the rumble of the carriages in Curzon-street, and forming a strange melody, the last echoes of which have now died away for ever.[20]

Another correspondent, writing in the *Western Mail,* regretted that the 'clearing-axe of the builders' was sweeping down 'clusters of trees like those casting their shadows hitherto over the precincts of Chesterfield House, sacred until now to the urban rook and sparrow ... it is charming, of course, to make sunshine in a shady place, but it is almost more charming (a sentiment, this, for hot weather) to preserve shady places in the sunshine.[21] By 1878, nothing but the mansion was left, 'despoiled of all its beauty and significance!'.[22]

Ducal Demolitions

The Russell family – the earls and later dukes of Bedford – have the distinction of having willingly given up two of their extensive gardens to facilitate the march of bricks and mortar. The family's original town palace, Bedford House, was built in about 1585 for Edward Russell, 3rd Earl of Bedford, on the north side of Strand: it commanded views over the 'greate pasture' of Covent Garden, and its garden is among the most prominent features on Hollar's view of the 'West Central District' of London, made before the Great Fire in 1666 (fig. 86).[23] From 1627, the 4th and 5th earls put in place substantial improvements to Bedford House and its gardens, which included recasting the 'garden front' of the mansion, raising a long, east-west viewing terrace along the northern edge of the garden, forming a grotto, erecting a pair of domed classical banqueting houses and laying out a large *parterre de broderie* and a labyrinth (later a 'wilderness'). Dianne Duggan has recently suggested that there can be 'little doubt that the designer of this Renaissance garden was Isaac de Caus with... "[Inigo] Jones in the background"', and that the design of the garden bore a formal relationship to

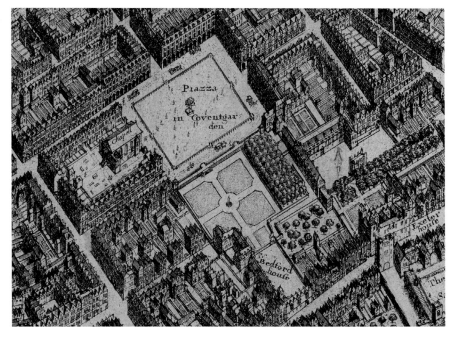

86.
Wenceslaus Hollar, bird's-eye view of the
'West Central District', before 1666, etching,
detail showing Bedford House and garden.
Folger Shakespeare Library, Washington D.C.

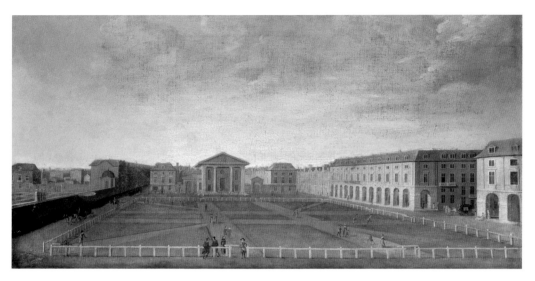

87.

Artist unknown, view of the piazza of Covent
Garden, 1649–56, oil on canvas. Private collection

*The north garden wall of Bedford House can be seen on
the far left of the painting.*

and was integrated with the layout of Covent Garden Piazza – London's first square.
The earl's garden, in effect, created a 'fourth side' of the Italianate piazza and was an
integral element of the planning of the new development.[24] An anonymous painting
of Covent Garden of around 1649–56 suggests that the garden formed a verdant buffer
and an ornament to both the piazza and Bedford House (fig. 87).

But, in 1704, all this changed, for the 2nd Duke of Bedford instructed the demolition
of Bedford House to make way for 'four very noble Streets' and went to live in his
mother's family house, Southampton House, on the north side of Southampton (later
Bloomsbury) Square (fig. 88).[25] This mansion was renamed Bedford House and its
grounds were described in 1755 as 'repaired and beautified', and the ground upon
which the house stood as 'without Dispute, one of the finest Situations in *Europe* for a
Palace'. The south side of the forecourt occupied 'one whole Side of … [Southampton]
Square for a Front, and the Square itself serves as a magnificent Area before it: Then
there is a grand Street just opposite to it, which throws the Prospect of it open to
Holborn … Then behind, it has the Advantage of most agreeable Gardens, and a View
of the Country, which would make a Retreat from the Town almost unnecessary;
besides the Opportunity of exhibiting another Prospect of the Building, which
enriches the Landscape, and challenges Approbation' (fig. 89).[26]

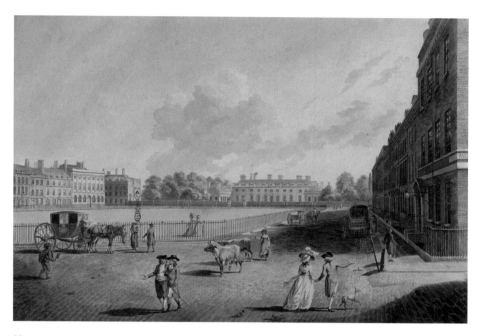

88.

After Edward Dayes, Bloomsbury (formerly Southampton) Square, 1787, pen and grey ink, with grey wash and watercolour. Private collection

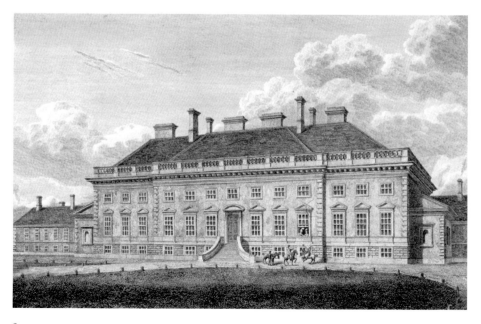

89.

Bartholomew Howlett, *North Front of Bedford House, Bloomsbury Square*, 1822, etching

When the New Road (now Pentonville Road) was projected in 1756, the 4th Duke of Bedford objected to it on the grounds that he would be 'poisoned by the dust and deafened by the noise', that it would destroy his uninterrupted prospect and it would cover his gardens with dust.[27] This, combined with the decline of the social character of the Bloomsbury estate, later precipitated the departure of the Bedfords once again for greener pastures. A plan of 1790 documents the extent of the immense tree-lined, funnel-shaped grounds that lay behind the mansion that was given up in the late eighteenth century to roll out yet more streets of houses and squares across their Bloomsbury estate (fig. 90). Thomas Malton, writing in 1792, expressed bewilderment that 'a situation so favourable for a town residence . . . [was] shortly to be sacrificed to the more profitable purpose, of letting the ground on building leases'.[28] Bedford House was pulled down in 1800 and streets and three squares – Russell, Tavistock and Woburn – were later laid out on the its extensive grounds.

Montagu House lay immediately to the west of Bedford House in Great Russell Street; the seven-and-a-half-acre (3-hectare) site was carved out of a pasture then known as Baber's Field and leased from the Southampton Estate by Ralph Montagu, 1st Earl of Montagu and later 1st Duke of Montagu (fig. 91).[29] The new house of the one-time Ambassador-Extraordinary to the Court of Louis XIV was described in 1687 as one 'that go's beyond all the rest', in 1714, as a 'most magnificent Palace . . . after the manner of the *Hostels* at Paris', and, in 1734, as 'long, but very ridiculously esteem'd one of the most beautiful buildings about town' (fig. 92).[30] A plan of the gardens is included on William Morgan's *Map of the Whole of London* of 1682, at which time they exceeded those of Bedford House in size and grandeur: they were divided into large regular compartments and terminated in the north in a great apsidal belvedere to supply panoramas over the neighbouring countryside. The historian Thomas Salmon reported in 1733 that the 'high Wall and Gates' of the house concealed the 'Beauty of the Building from Passengers', and that the 'Front towards the Gardens and Fields, is equal to that which looks towards the Town and makes a grand Figure as we approach the City from *Highgate* and *Hampstead'*.[31] A drawing from the late seventeenth century attributed to François Gasselin reveals the resplendent mansion in its park-like setting as perceived from what is now known as Tottenham Court Road, near the junction with Store Street (fig. 93).

The premises were described in 1755 as 'remarkable for several Things', including the 'spacious and grand Area before it' – sometimes referred to as a 'piazza' – and the 'beautiful Garden and Front', the 'fine Orangery, with Orange-trees of a Growth beyond what can be seen in a Northern Climate', the 'noble Prospect of the Back front . . . For the Figures of the four Cardinal Virtues in the Front . . . [and] For the Statues of a Gladiator, a *Venus*, and a Satyr in the Gardens' (fig. 94).[32] The north-facing

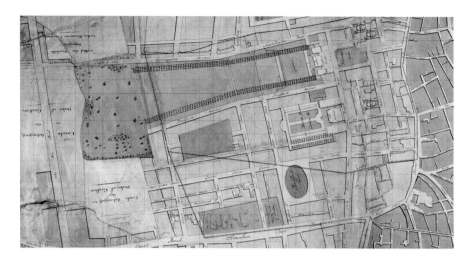

90.
Plan of the Bedford Estate, *c*.1795,
pen and ink with watercolour wash.
Woburn Abbey, Bedford Estate Archive

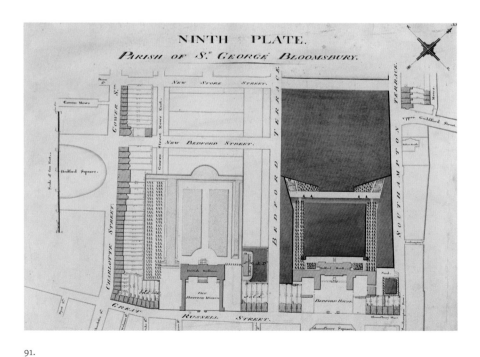

91.
Artist unknown, *Parish of St. George
Bloomsbury*, *c*.1795, pen and ink with
watercolour wash. Woburn Abbey,
Bedford Estate Archive

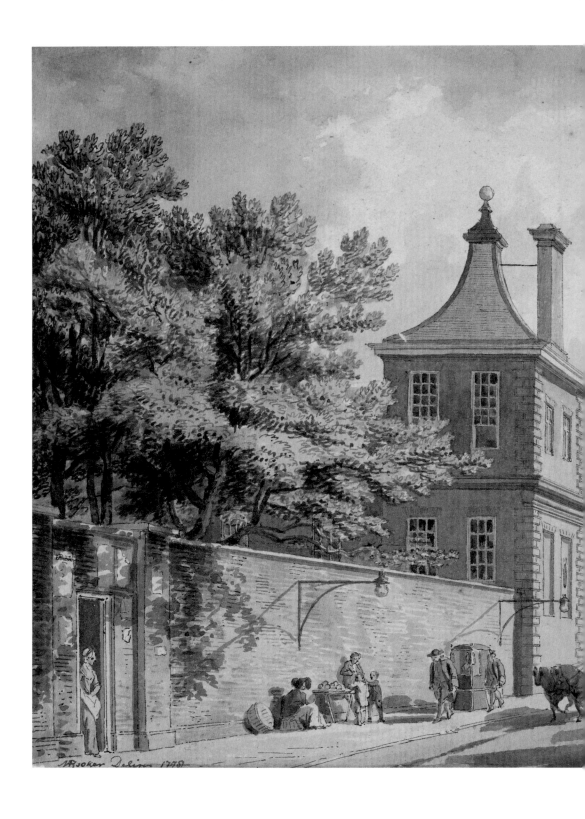

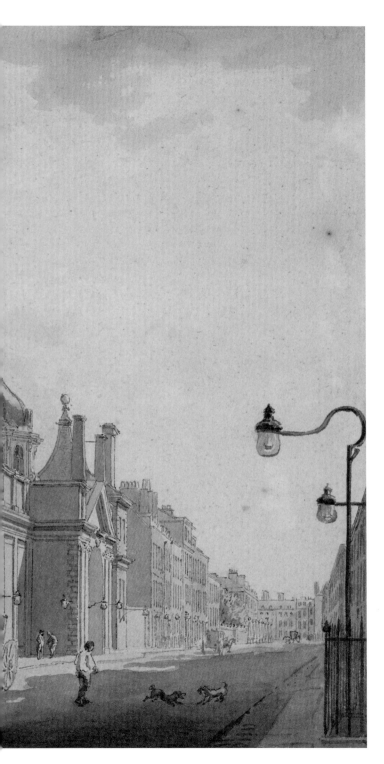

92.
Michael Angelo Rooker, south façade of Montagu House in Great Russell Street, Bloomsbury, 1778, pen and ink and watercolour wash. British Museum, London

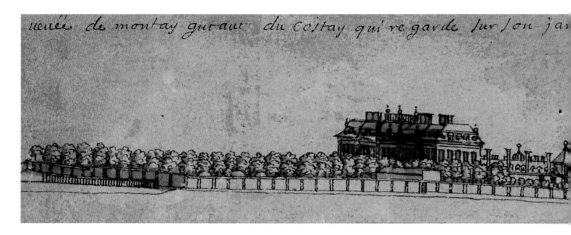

uenée de montay guiaut du Coſtay qui regarde ſur ſon jar

93.
Attributed to François Gasselin, Montagu
House from the north-west, 1686–1703,
pen and ink and watercolour wash.
British Museum, London

pleasance and its statuary are portrayed in an engraved view of around 1750: a broad central walk is intersected by an octagonal pool pierced by a *jet d'eau* and flanked on either side by large grass panels edged with alternating displays of small conical evergreens and plants (possibly citrus) grown in tubs. The garden is encompassed by a raised terrace-walk, the sloping banks, or *glacis*, which are just visible in figure 94. The wide flight of steps discernible in the foreground lead from the garden to its elevated belvedere.

The pasture that lay to the north of these gardens, known as Long-Fields, was then a celebrated 'Place of duels' and fights – and at least on one occasion a 'desperate ['pugilistic'] battle'.[33] In July 1780, the field and the house's garden were occupied by the York Regiment during the Gordon Riots; the militia's picturesque encampment is clearly shown in a contemporary watercolour by Samuel Grimm (fig. 95).

The garden layout was simplified after it was abandoned by the 2nd Duke of Montagu in 1731, and, from 1755, when the estate was acquired by the nation to house the British Museum, the grounds were 'subsequently and by degrees built over, to contain the [Museum's] numerous collections'.[34] One of the earliest encroachments is documented in an engraved vignette of 1813, which shows the 'New Building' that had recently been raised at the south-west corner of the garden, 'intended to receive the valuable and magnificent monuments from Egypt' (fig. 94). The erection of this edifice necessitated the partial destruction of what was described in the press in 1804 as an 'artificial mound', but which was, in fact, the tail end of the seventeenth-

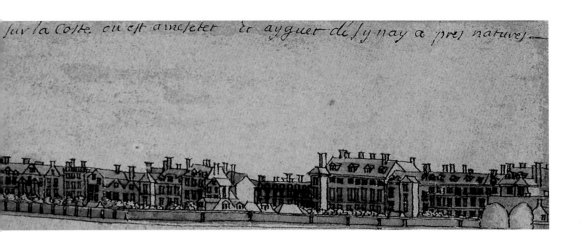

sur la Coste ou est amesleter et ayguer desynay a pres natures.

94. (below)
After James Simon, *Montague House (now the British Museum) and the New Building*, 1813, etching.
British Museum, London

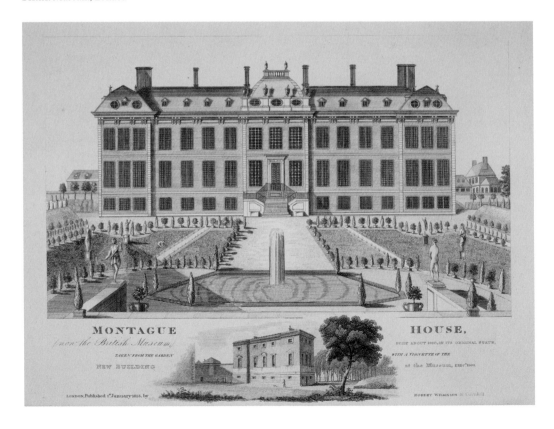

MONTAGUE HOUSE,
(now the British Museum) BUILT ABOUT 1680, IN ITS ORIGINAL STATE,
TAKEN FROM THE GARDEN WITH A VIGNETTE OF THE
NEW BUILDING of the Museum, ERECTED

LONDON, Published 1st January 1813, by ROBERT WILKINSON 58 Cornhill

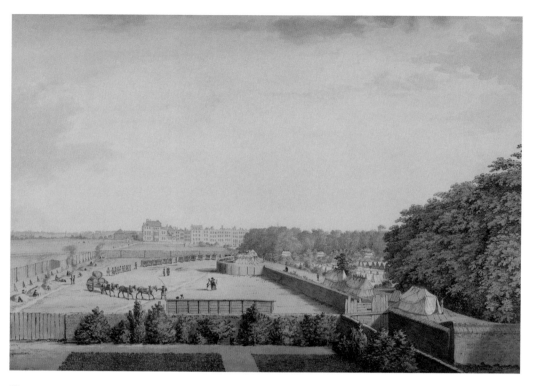

95.
Samuel Hieronymus Grimm, the encampment
outside Montagu House during the Gordon
Riots, 1780, pen and ink with watercolour
wash. British Museum, London

century, eastern terrace-walk. It was emphasised at the time that 'no portion of the beautiful little grove adjacent to it has been destroyed'.[35] The remains of the truncated earthwork are visible in the right foreground of the vignette.

Montagu House itself was not, at first, razed to the ground, but 'was enlarged and added to as the occasion required', until it was finally completely demolished between 1845 and 1849.[36] Its destruction would not have surprised Thomas Salmon, who declared in 1733 that no house in this part of town could possibly eclipse Montagu House, nor 'is [it] like to meet a Rival in this Age, unless the Duke of Bedford should pull down *Southampton-House* [Bedford House], and lay out three or fourscore thousand Pounds in rebuilding it'.[37] In a strange twist of fate, Bedford House was levelled well before the Trustees of the British Museum embarked on the systematic dismemberment of what had been one of London's grandest private demesnes.

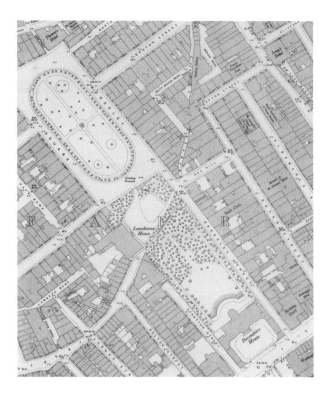

96.
Ordnance Survey, detail
showing Berkeley Square
and environs, 1869.
National Library
of Scotland, Edinburgh

Borrowing the View

The gardens of Lansdowne House and Devonshire House lay adjacent to and
contributed in large part to the beauty of Berkeley Square (fig. 96). The rear garden
of Devonshire House (formerly Berkeley House) adjoined the front garden of
Lansdowne House, separated by Lansdowne Passage – a narrow, stone-paved sunk
alley lined on both sides by forbidding brick walls. From the vantage point of the
square, the gardens appeared to be a single continuous extent of verdure. This gesture
had seventeenth-century origins: in 1672, John Evelyn described Baron Berkeley
of Stratton's House – then Berkeley House – as possessing a noble 'fore-court' and
'incomparable' gardens, 'by reason of the inequality of the ground, and a pretty
piscina [fish pond]'.[38] The extensive grounds occupied what had formerly been part
of Hay Hill farm and included all of what is now known as Berkeley Square and
its adjacent streets. Evelyn, visiting again in 1694, at the request of Lady Berkeley,
who had been galvanised by the demolition of the 'magnificent pile and gardens
contiguous to it' to contemplate the sacrifice of her own garden to make 'piazzas and

buildings', remarked, 'I could not but deplore that sweet place (by far the most noble gardens, courts, and accommodations, stately porticos, &c., any where about the town) should be so much straitened and turned into tenements'.[39] He was anguished by Lady Berkeley's resolution to let out the grounds for an excessive price; it was, he affirmed, 'to such a mad intemperance was the age coming of building about a city by far too disproportionate already to the nation'.[40] In the event, Baron Berkeley subdivided his large plot, selling strips on either side of the mansion for development, but retaining the garden that lay to the north of the house and undertaking to refrain from building upon it to preserve the vista northward to Hampstead and the adjoining countryside (fig. 97); the southern portion of the property adjoining Piccadilly was sold in 1696 to William Cavendish, 1st Duke of Devonshire, who renamed the house Devonshire House (fig. 98). Shortly before the latter was razed to the ground in 1733, the French tourist Pierre-Jacques Fougeroux observed that its garden was 'very large and quite well divided up, in the English style: that is to say, always with carpets of grass surrounded by wide walks of limes'.[41] Later observers, on the other hand, commented on the extent to which the garden layout had been naturalised: in 1861, John Timbs remarked that 'from the rear windows... is enjoyed a *rus-in-urbe*, extending to Berkeley-square, by means of a sunken passage between the grounds of Landowne and Devonshire Houses;'[42] and Augustus Hare observed that 'its large gardens with its tall trees give the house an unusual air of seclusion'.[43] Not everyone was complimentary: the house was compared in 1892 to a 'grim barrack, secluded behind one of the ugliest dead-walls in London'.[44]

When, in 1762, the Marquess of Bute acquired the 'piece of waste ground, that lay between the garden-wall of Devonshire house and the bottom of Berkeley-square' – the land that had been retained by Lord Berkeley – it was described as 'a pool of dirty water, disembogued from Curzon-street, &c.'. After 'raising the ground, and draining the water, Lord Bute resolved to build a magnificent house, but proceeded no farther. He sold the premises ... and the Marquis of Lansdowne (then the Earl of Shelburne) bought them'.[45] The gleaming white portico of this 'splendid hotel betwixt courtyards and gardens' was described in 1818 as peeping 'above rich foliage of the surrounding trees',[46] and by Samuel Lewis in 1831 as 'half enveloped in fine gardens and plantations' (fig. 99).[47] Its garden was praised for supplying the square and its 'shrubbery in the middle' with 'a more picturesque appearance than any of the other squares in London',[48] and was for many years the 'chief ornament' of Berkeley Square.[49]

Devonshire House was pulled down and its grounds redeveloped in 1924, and the garden at Lansdowne House, with its 'great velvety lawn, as fresh as if brought but yesterday from the riverside', which as late as 1927 was described as giving 'the effect of a country house in town', was covered with streets and buildings in the early 1930s.[50]

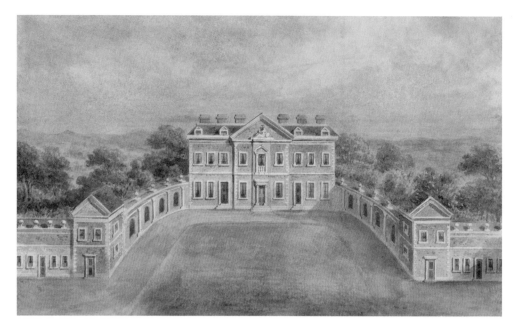

97.
Artist unknown, bird's-eye view of the
bygone Berkeley House in Piccadilly, *c.*1735,
watercolour. British Museum, London

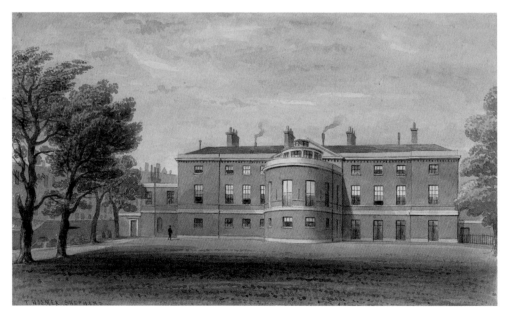

98.
Thomas Hosmer Shepherd, the garden of
Devonshire House, *c.*1830, watercolour.
London Metropolitan Archives

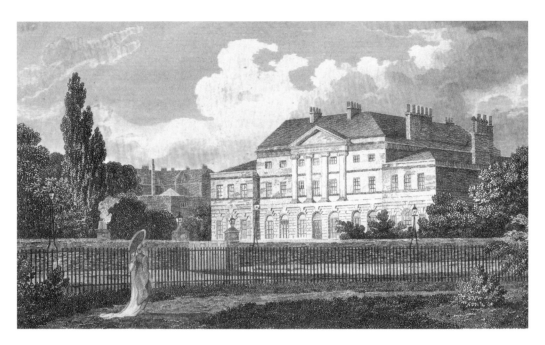

99.
Robert Blemmell Schnebbelie, *Lansdowne House, Berkeley Square*, 1808, engraving.
London Metropolitan Archives

Wimbledon Manor House, in the early seventeenth-century, was a great and 'daring structure' of almost unrivalled splendour, and its extensive gardens were said to have been brought 'by the taste of Charles I. to their highest perfection'.[51] Built on earlier foundations, the house was successively over the centuries demolished and rebuilt by a list of distinguished owners, among them Thomas Cromwell, Earl of Essex, Catherine Parr, Cardinal Pole, Sir Christopher Hatton, Thomas Cecil, 1st Earl of Exeter, and his son Edward, 1st Viscount Wimbledon, Queen Henrietta Maria, the Earl of Bristol and Sarah, Duchess of Marlborough – many of whom made their mark on the gardens. Here Charles I instructed the planting of Spanish melons days before his trial, and Henrietta Maria recast the gardens under the guiding hand of the French gardener André Mollet. Indeed, it was affirmed by John Burke in 1846 that so powerful were 'the attractions of the locality' that they 'converted the stern Republican [General John] Lambert into a florist, and during his tenure, Wimbledon became celebrated for its tulips and gilliflowers'.[52]

The manor house was situated on rising ground looking north over the present-day Wimbledon Park, and, like a giant wedding cake, it stood upon the summit of

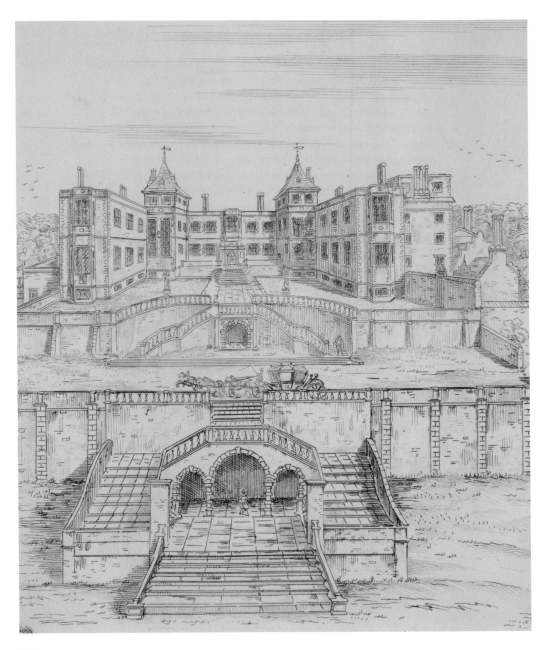

100.

Artist unknown, 'Wimbledon Manor', engraving, from Daniel
Lysons, *The Environs of London*, vol. 1: *County of Surrey* (1792)

*This view, based on an early drawing, shows the 'singular ascent to
the north front' of the house. This extravagant gesture is reminiscent
of the Villa Farnese at Caprarola.*

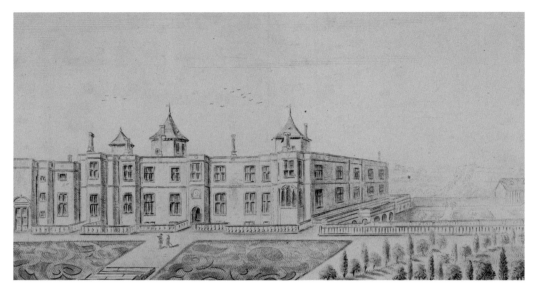

101.

Artist unknown, 'Wimbledon Manor', engraving,
from Daniel Lysons, *The Environs of London*, vol. 1:
County of Surrey (1792)
*In 1649, the house's south-facing gardens boasted
'mazes, wildernesses, knots, allies &c.'*

five immense terraces ('ascents'), which were connected by flights of steps.[53] The house
had been remodelled by Inigo Jones, and the gardens were possibly influenced by
Italian hillside villas. The topmost terrace was designated as the 'Great Garden'
(figs 100 and 101).[54]

Fortunately for posterity, 'a very accurate and minute survey of the house and
premises' was taken by order of Parliament in 1649.[55] The survey records that 'the
orangerie' – among the first to be erected in Britain – was said to have contained
forty-two orange trees in boxes, 'one lemmon tree bearing greate and very large
lemmons... one pomecitron tree... six pomegranet trees' and eighteen young orange
trees. It also mentions 'three great and fayer fig-trees', the spreading branches of which
covered a very 'greate part of the walls of the south side of the manor-house'. Several
of the gardens were described as consisting of 'mazes, wildernesses, knots, allies, &c.'
and possessing 'a great variety of fruit trees, and some shrubs; particularly a faire bay-
tree and one very fayer tree called "the Irish arbutis", very lovely to looke upon'; and
'above 1000 fruit' were enumerated, 'among which is every sort now cultivated except
the nectarine'. Mention is also made of a 'muskmilion' (muskmelon) ground, 'at the
end of the kitchen-garden, trenched, manured, and very well ordered'.[56]

Burke remarked rather presciently in 1846, 'We have a melancholy feeling in thus recording the glories of Wimbledon manor; a brief time hence this fine estate and rural district will probably become one of the most attractive suburbs of the marvellously extending metropolis; for it is proposed to convert this honoured spot into villas and private residences, and on the site, which once served for the lordly luxury of one, to provide handsome dwellings for thousands'.[57]

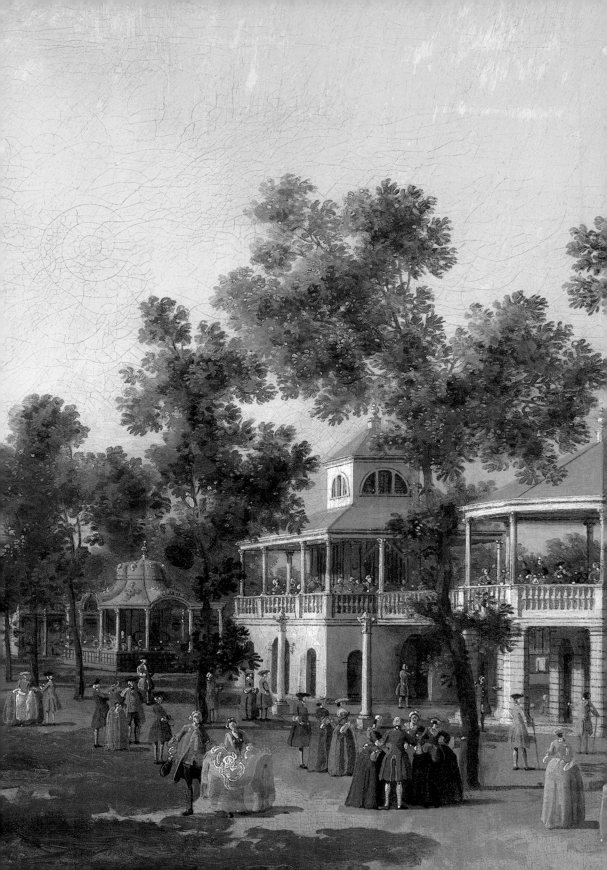

6.

Gardens for Entertainment

Vauxhall Gardens . . . is peculiarly adapted to the
taste of the English nation; there being a mixture
of curious show, – gay exhibition, musick, vocal
and instrumental, not too refined for the general
ear; – for all of which only a shilling is paid; and,
though last, not least, good eating and drinking for
those who choose to purchase that regale.[1]

Samuel Johnson, quoted by James Boswell (1778)

The public pleasure garden was among the most significant cultural innovations of
eighteenth-century London, and Vauxhall Gardens, which lay on the south side of
the River Thames near the modern-day Vauxhall Bridge, was one of the grandest
of these 'Seminaries of Luxury': 'here a 'profusion of Expence has not been spared
to invite Persons of both Sexes to meet, to assist in and promote the Propagation of
these Amusements; which under the Names of Breakfasting-Places, Concerts, Balls,
Assemblies, &c. have over run the Kingdom; and which equally threaten a general
Dissolution of Manners, and a Dissipation of Fortune'.[2]

Originally known as New Spring Gardens, the resort replaced an earlier and
notorious 'rendezvous for the ladys and gallants' near St James's Park which had been
'shut up and seized' in 1654 by Oliver Cromwell and his partisans.[3] That Vauxhall
was to become synonymous with pleasure gardens the world over is a tribute to its
proprietor, the 'Master Builder of Delight', Jonathan Tyers, who, between 1729 and
his death in 1767, transformed an old-fashioned and unwholesome tavern garden
into a dream-like Elysium that 'dazzled and confounded' its many visitors through its

102. (facing) Detail of fig. 104

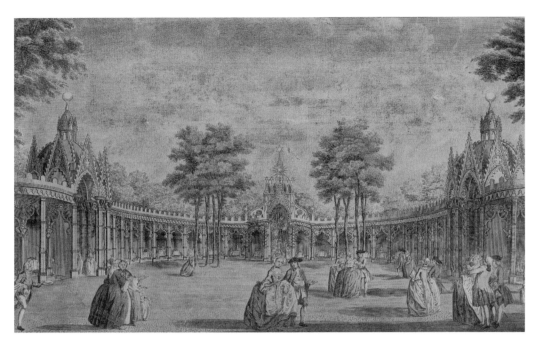

103.
Carrington Bowles after Samuel Wale, *A View of the
Chinese Pavillions and Boxes in Vaux Hall Gardens*, 1751,
hand-tinted engraving. British Museum, London

ever-changing parade of spectacle and striking assemblages and illuminations.[4] One
of Tyers's overarching aims was to provide a decorous and delectable environment in
which people of all sectors of society could assimilate and exercise an appreciation of
fine works of art and music – and to do so *al fresco* in groves, alleys, piazzas, supper-
boxes, tents and pavilions (fig. 103). The resort was seasonal and nocturnal, highly
sensitive to the vagaries of the weather, and its gardens were an 'irresistible mix of
beauty, wit and music': in its verdant glades one could admire the works of Hogarth,
Roubiliac and Hayman or listen to the music of Handel.

A combination of high brick walls and wooden palisades enclosed the densely
wooded gardens, which were designed to 'accommodate as many people as
possible without seeming overcrowded, while at the same time never appearing too
underpopulated' (figs 104 and 105).[5] Although there were ample areas for repose,
drinking and dining, the layout of broad gravel walks and alleys lined with lofty trees
encouraged movement: visitors promenaded in groups and actively participated
in the spectacle, strolling through a startling array of fanciful and exotic garden

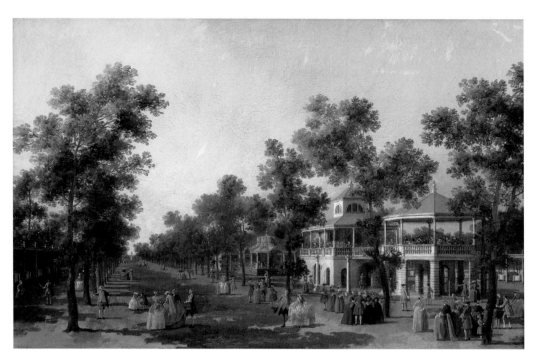

104.

Giovanni Antonio Canal, called 'Canaletto', *The Grove
and the Grand Walk, Vauxhall Gardens*, c.1751, oil on
canvas. Compton Verney, Warwickshire

architecture.[6] This scenery was also enriched by decorative paintings and *trompe
l'oeil* murals depicting scenes as diverse as the Temple of Neptune, Chinese gardens
and the ruins of Palmyra. Surviving views and accounts suggest that the gardens'
scenographic effects were regularly replaced and at considerable expense.

Visitors were charged an admission fee to discourage pickpockets, higglers,
sharpers and prostitutes, though the gardens inevitably attracted their share of the
demi-monde. It was observed in the 1780s, however, that 'the manners of the lower
order of the people have... been humanized by often mixing with their social betters,
and that national spirit of independence which is the admiration ... of Europe ...
takes birth from the equality it occasions'.[7]

Although the gardens continued sporadically to flourish after Tyers's death, the
nature of the entertainments changed to reflect a change in its audience, which
became more middle class, and to compete with rival resorts, latterly the West End
theatres. From early in the nineteenth century, the traditional formula of concerts

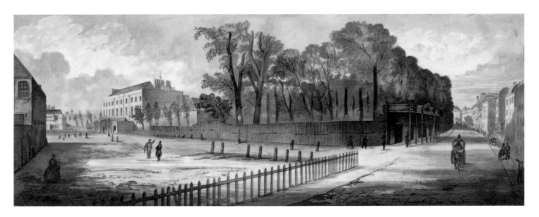

105.
George Scharf, panoramic view of the exterior of
Vauxhall Gardens, looking down Kennington Lane,
c.1859, watercolour. British Library, London

and suppers interspersed with regular galas and fêtes was expanded to include a
wider range of novelties, including balloon ascents, comic songs, rope walking, lion-
taming, dancing, equestrian displays, acrobatics and pyrotechnical displays.

After years of declining attendance, and various changes of management, the
gardens were finally closed in July 1859 – and in great style. The journalist Laman
Blanchard compared the prospect of the final farewell with the sale of the pyramids,
the 'positively last fall of the Falls of Niagara' and the 'final extinction of Mount
Etna'.[8] Fifteen thousand people attended. After 'the final galop' and the playing of
the National Anthem, 'no sooner had the band finished, than a rush was made to
one of the trees on the platform and the British public broke off twigs as souvenirs of
Vauxhall, but with the small branches lamps were also pulled down, at first by ones
and twos, and then by dozens, and oil and glass fell on the platform amidst the cheers
of the audience, until at length the police interfered.'[9] Soon afterwards the garden's
effects were sold, and the land redeveloped.

In the 1970s, the site was once again cleared and laid out as a park and is now in the
ownership of the local authority. Spring Gardens opened to the public in 1976, and
was recently renamed Vauxhall Pleasure Gardens, though it bears no resemblance
whatsoever to its eponymous forebear.

A 'Minor Vauxhall'

From late in the seventeenth century, London's northern suburbs were possessed of a broad range of establishments, including pleasure grounds, spas, inns and tea and assembly rooms, which catered to pleasure-seeking city dwellers from all sections of society.[10] Mineral spas became especially popular, as they combined health and pleasure, and in few districts were they more abundant than in Islington. The area was transformed from the 1670s with the opening of Sadler's Wells, which in turn spawned numerous rival establishments including White Conduit House, New Tunbridge Wells (or Islington Spa), Bagnigge Wells, the Royal Oak and the London Spa. Most of these possessed handsome and extensive pleasure grounds peppered with exotic buildings including kiosks, pavilions, grottos, and sometimes supper boxes.

A contributor to the *Penny Magazine* in 1837 pronounced that Vauxhall Gardens and White Conduit House were the 'most conspicuous' remaining suburban places of amusement in the metropolis. White Conduit House in Pentonville was a 'Minor' Vauxhall and 'never, like [the original] Vauxhall, a "fashionable" resort, but from a comparatively early period was a favourite with the middle and working classes'.[11] It was established around 1735 on a 'Pleasant situation on an elevated gravelly soil' about a mile north-west of Smithfield, commanding extensive prospects and a 'most agreeable view of the metropolis, and the surrounding country'.[12] It took its name from an ancient conduit that supplied water to the Charterhouse, some way to the south-east.

The establishment was advertised by its proprietor in 1754 as possessing a 'long [later, 'grand'] walk, with a handsome circular fish-pond, [and] a number of shady pleasant arbours' for the 'better accommodation of the gentlemen and ladies' and was 'inclosed with a fence seven feet high, to prevent [visitors from] being the least incommoded from people in the fields'.[13] This imposing, close-boarded fence, which appears to have been a feature of many contemporary pleasure gardens, is depicted in C. H. Matthews's drawing of 1832 (fig. 106).

White Conduit was later described as 'very elegantly laid out' with 'several walks, prettily disposed' and 'gardens laid out in a happy stile of elegant simplicity'.[14] The 'noble circular pond' was 'well stocked with carp and tench', and the 'genteel [tea]-boxes for company, curiously cut into the hedges, and adorned with a variety of Flemish and other paintings'.[15] At the north-east end of the grand walk, there was 'a painting of a garden in perspective', depicting ruins, 'which is so well executed, that many people who view it at a distance suppose it to be real'.[16] The grounds also boasted fountains, a band stand, an organ, a tea and dancing saloon, and 'a kind of shrubbery, laid out in serpentine walks', which led to 'an elegant garden, at one end of which is a little wooden building, in the form of an antique church, in which is a pretty ring

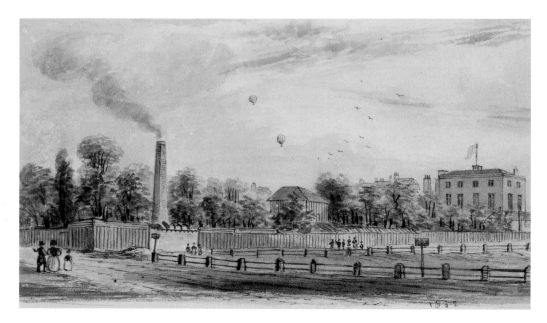

106.
C. H. Matthews, *White Conduit Gardens, North View*, 1832, watercolour. British Museum, London

of bells, which ring at stated hours, for the amusement of the company'.[17] There were Dutch-pin grounds 'for the exercise of Gentlemen', and the proprietor 'provided bats and balls for his customers to play cricket in the meadow adjoining'.[18] Attendance at the place was said to be very great, and *The London Guide* of 1782 proclaimed that the 'accommodations of all kinds are adapted to the genteelest visitors'.[19]

Over the succeeding decades, the gardens of this 'pleasant Vauxhall in miniature' were improved on a regular basis, through the introduction of new planting, 'well-executed pieces of statuary', a Chinese pagoda, a 'superb Theatre', a bandstand and a 'Grotto with Hermit in his devotions'.[20] Frederick Crace's view, 'looking from the Balcony' over the grounds, documents some of these changes and shows how the central area was dotted with exotic pavilions emveloped in informal plantations (fig. 107). Unlike Vauxhall, there was much greater emphasis placed on the extent and horticultural richness of the planting: gardens and shrubberies were 'brilliantly illuminated', and the 'foliage' was reported frequently in the press as being 'in a most luxuriant state' or in a 'high state of cultivation'.[21]

From about 1810, the entertainments became more diverse and included balloon ascents, concerts, ballet, 'juvenile fetes' and fireworks. Miss Clarke's performance on a

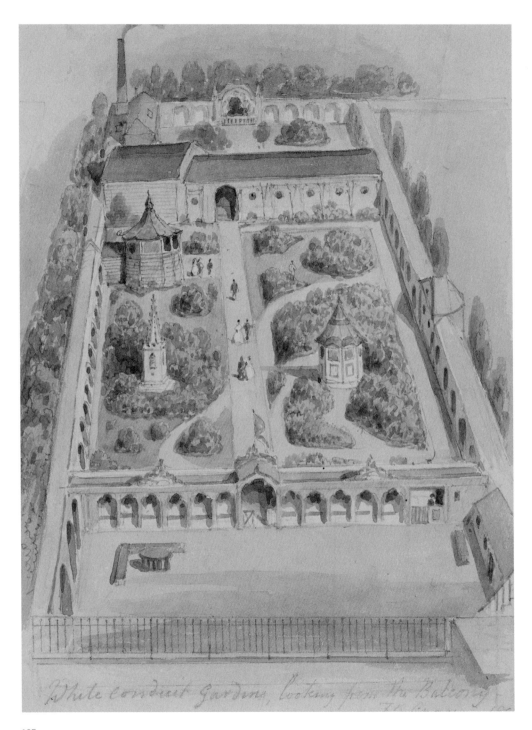

107.
Frederick Crace, *White Conduit Gardens, looking from the*
Balcony, 1848, watercolour. British Museum, London

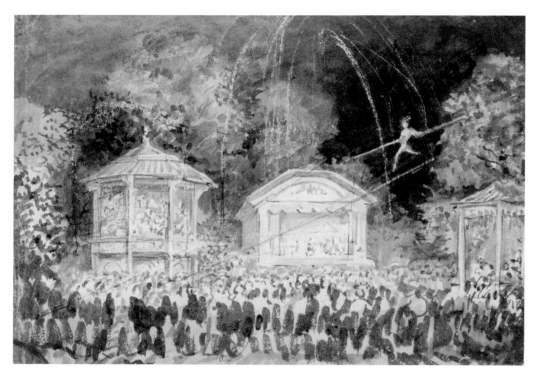

tightrope, during which she ascended 'to a stage erected above the highest trees in the
garden amidst a blaze of light', was among the most spectacular attractions (fig. 108).[22]

As at Vauxhall, the closing of the gardens was marked by a farewell ball, and, in
late January 1849, the house and gardens were swept away. White Conduit meadow,
however, continued in use as a cricket ground long after the demise of the resort.

Bagnigge House, near what is now the junction of Wharton Street and King's
Cross Road, was, like White Conduit House, anciently noted for its chalybeate water.
Although, until 1756, it was 'one of the most disagreeable swamps in the neighbourhood
of London', the following year, Mr Hughes, a 'gentleman curious in gardening', and
its then proprietor, 'changed this place from a Bog to a Paradise'.[23] Here he formed a
public spa, which soon became 'much in fashion and was resorted to by many people
in pursuit for health, the place being elegantly fitted up for their reception'.[24]

The waters were drunk at the pump-room – a 'neat dome-roofed' temple – which was the centrepiece of the gardens.[25] The author of *A Sunday Ramble* (1774) reported that the Wells were 'a place of general resort… by no means… barren of amusement'.[26] The establishment consisted of the following:

> several beautiful walks, ornamented with a great variety of curious shrubs and flowers, all in the utmost perfection. About the centre of the garden is a small round fish-pond [which contained hundreds of gold and silver fish], in the midst of which is a curious fountain, representing a cupid bestriding a swan which spouts three streams of water through it's [sic] beak to a great height. Round this place, and indeed almost over the whole garden, are genteel seats for company… At a little distance from the pond, is a small neat cottage, built in the rural stile; and not far from that, over a bridge leading across a piece of water that passes through part of the garden [the River Fleet], is a pretty piece of grotto-work, large enough to contain near twenty people. Besides which, there is a small house, and several seats by the water-side, for such of the company that chuse to smoak, or drink cyder, ale, &c., which are not permitted in other parts of the garden.[27]

A later account reports that 'throughout the gardens are walks, recesses, harbours [arbours], and all kinds of convenient accommodations. There are elegant private gardens, hot-houses, green-houses, pinery, &c. in which are a variety of exotic shrubs, trees and plants' (fig. 109). At the northern end of the principal walk there was a 'perspective painting of an avenue to a Gentleman's seat'; and in the 'grand tea-room' there was an 'excellent organ' which was 'frequently touched by very happy fingers'.[28]

The grotto was a 'small castellated building on the north-east side of the gardens' containing 'two apartments; it was constructed of various kinds of sea-shells, fossils, &c., which being intermixed with fragments of glass and broken mirrors, made the building very attractive'; the 'arbours for tea-drinking, covered with honeysuckle and sweetbriar, surrounded the gardens', and a 'bowling-green', a 'skittle-alley' and a 'bun-house', were also included among the attractions.[29]

The author of *The London Guide* affirmed that 'the company resorting to the tea-rooms and gardens are more numerous than at any other public place of the kind'.[30] Those who frequented the gardens, however – merchants, shopkeepers, journeymen, professionals and their families, as well as fashionable invalids, pleasure seekers and prostitutes – were not as genteel as at other similar resorts. 'Sportive effusions of poetry', such as the anonymous 'A Song: Bagnigge Wells' (1759) and John Bew's *The Ambulator* (1820), suggest that the gardens quickly gained a reputation for licentiousness, and that they became a resort for 'Vot'ries of Venus and Bacchus… Who drink, and who rake, and who whore without end'.[31] The author of *The Curiosities, Natural and Artificial, of the Island of Great Britain* [1775], shared

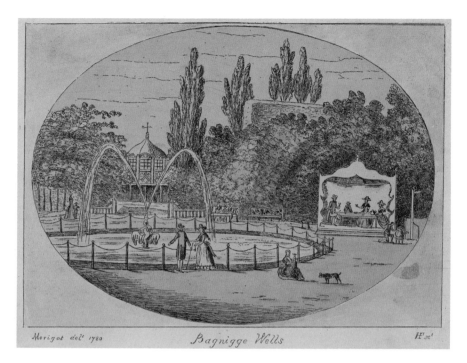

Morigot del.t 1780 *Bagnigge Wells* H.sc.t

109.
James Merigot, *Bagnigge Wells*, hand-tinted
etching, 1780. London Metropolitan Archives

*Bagnigge Wells, like other popular resorts, had its
share of disturbances that 'destroyed' its conviviality.
In December 1780, 'a young officer, ... offering some
reprehensible freedoms to a young lady of rather an
Amazonian disposition, a short scuffle ensued, which
was concluded by the heroine's fairly shoving the
follower of Mars among the ducks in the delectable
canal which runs by the side of the gardens'.*

this sentiment, observing that, although Bagnigge Wells, like White Conduit House
and Dobney's Bowling Green, were 'designed for recreation, it is to be lamented, that
many of them have been greatly instrumental in corrupting our city youth, who meet
together at night in these places of dissipation'.[32]

From about 1810, the Wells became 'almost exclusively the resort of the lower
classes, though the situation was still somewhat picturesque'.[33] The fact that the Fleet
was by this time a 'ditch-like, and, on warm evenings, malodorous stream',[34] was among
the factors that made the gardens a less appealing 'place of plebeian entertainment';
in response to these developments, in 1814, the grounds were 'reduced in extent' and
'newly fitted up and beautified in a manner most tasty, and elegant' (fig. 110).[35]

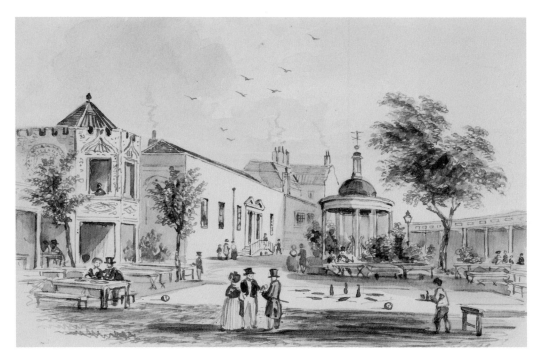

110.
C. H. Matthews, *Old Bagnigge Wells Tea Gardens*,
c.1835–40, watercolour. British Museum, London

Over the next decades, the premises frequently changed hands, and the entertainments continued – glees, farces, concerts, dances, comic songs and balloon ascents – but, in 1841, the Wells, once 'the wery pictur of countryfiedness and hinnocence',[36] were shut down, and the place dismantled.

A Tea-Garden of Lilliputian Dimensions

Gazing south from the summit of the so-called 'Art Mound' in Mile End Park, opened to the public in 1999, one gets a good view of the East End and the distant City. The fifteen-metre-high earthwork, bristling with a tangle of lavender, long grasses and weeds, is one of a multitude of idiosyncratic features sprinkled along the length of the largest urban park to be created in central London since the nineteenth century. It is not, however, the first public garden to adorn the Mile End Road. Indeed, the Art Mound erupts from the site of the former pleasure gardens of the New Globe Tavern – the 'Vauxhall Gardens of East End'.[37]

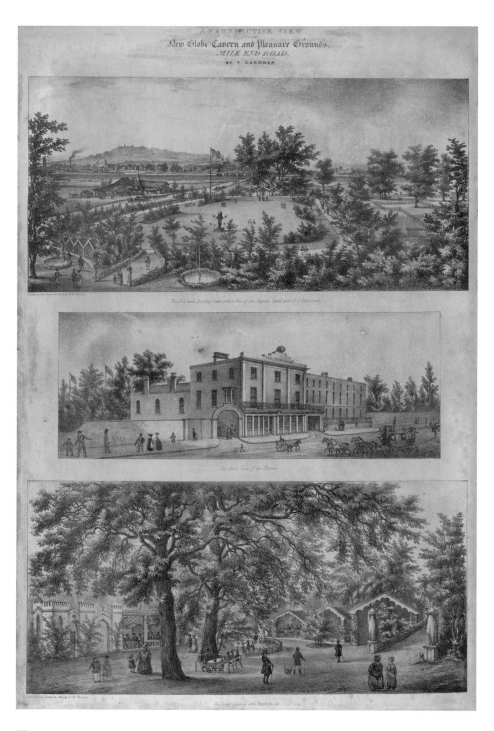

111.

Thomas Gardner, *A Perspective View: New Globe Tavern and Pleasure Grounds, Mile End Road*, lithograph. Private collection

The New Globe Tavern and its pleasure ground are recorded in a lithograph of about 1842 showing three perspectival views of the establishment, drawn by its owner, Thomas Gardner, and 'Sketched and Drawn on Stone by E. M. Wichelo' (fig. 111). The gardens are embellished with flowerbeds, rockworks, shrubberies, fountains, statues, kiosks and clusters of rustic supper boxes; an imposing lantern in the form of a statue of Atlas balancing three globes illuminates the bowling green at the centre of the pleasure ground. Although established by 1781, the tavern reached its heyday in the late 1840s with the staging of ballets, concerts, and regular and lavish illuminations of over ten thousand lights throughout the gardens. The self-styled 'aeronaut' Henry Coxwell also made various ascents in a balloon, sometimes amidst firework displays choreographed by William and John Brock, Britain's leading pyrotechnists.

The tavern's gardens were typical of what later became known as district tea-gardens: these '*rus-in-urbe* retreats', which were then an agreeable feature of suburban life, were the English answer to the Bavarian beer-gardens – 'though with inferior music'. The gardens on the Mile End Road, however, were, as I have written elsewhere, the first to show 'dramatic ambition, and to erect in some portion of its limited but leafy grounds a lath-a-plaster stage large enough for eight people to move upon without incurring the danger of falling off into the adjoining fish pond or fountain. A few classical statues in plaster, always slightly mutilated, gave an educational tone to the place, and with a few coloured oil-lamps hung amongst the bushes the proprietor felt he had gone as near the Royal Vauxhall Gardens as possible for the small charge of a sixpenny refreshment ticket.'[38]

By the middle of the nineteenth century, the popularity of the gardens began to wane, and, by 1860s, the gardens were redeveloped and laid out as streets of houses. The fate of the New Globe Pleasure Grounds was not unique: as Warwick Wroth remarks in *Cremorne and the Later London Gardens* (1907), in the 1850s, 'many of these garden spaces – often, it is true, of Lilliputian dimensions – were marked out as building-ground, which was either sold to alien contractors or utilized by the proprietor of the tavern when he thought fit to erect thereon a roomier and more imposing edifice. At the same period, or some years later, the increase of music-halls, or local theatres, and palaces of entertainment, rendered the tavern concert, with its unambitious glee-parties and comic singing, a superfluity.'[39]

Wroth, who lamented the demise of London's tea- and tavern gardens, also declared that 'the disappearance of the tavern concert may not be a matter of keen regret, but the abolition of the garden has altered – and for the worse – the whole character of the public-house'.[40]

Matchless Bathing

London has had its share of natural and artificial waterworks, many of which have vanished over the centuries: rivulets that once 'murmured pleasantly near the abodes of Londoners have long since been degraded into sewers';[41] and many a well, pool, fountain and mineral spring has suffered similar indignities. The memory of these lost features is, however, very often preserved in street names – including Fleet, Walbrook, Clerkenwell, Holywell, Bridewell, Monkwell and Spa-fields.

Among the more evocative watery street names are Bath and Peerless streets off the City Road, near Old Street roundabout. They commemorate London's most famous outdoor 'spacious bath for use and pleasure' – the 'compleatest of a public nature of any in the kingdom'.[42]

The Peerless Pool was, William Hone observed in 1825, 'distinguished for having been one of the ancient springs that supplied the metropolis with water, when our ancestors drew that essential element from public conduits; that is to say, before the "old" water-works at London-bridge "commenced to be," or the "New River" had been brought to London by sir Hugh Myddelton'.[43] Known variously as the Perillous or the Parlous Pond, the topographer John Stow described it in 1603 as a 'cleare water called *Perillous* pond, because diuerse youthes swimming therein haue beene drowned'.[44]

Hone reported that,

> in consequence of such accidents, and the worthy inhabitants of Lothbury having obtained their water from other sources, Perilous Pond was entirely filled up, and rendered useless, till Mr. William Kemp ... took possession of the place sometime in the 1730s ... After spending a decade restoring the 'ruins' of the former Perilous Pool ... Kemp, we are informed, magnanimously opened the pool and its spring – which he renamed 'to the more agreeable name of *Peerless Pool*, that is, *Matchless Bath*' – for 'public benefit', to form "the completest swimming-bath in the whole world."[45]

Kemp 'spared no expense nor contrivance to render it quite private and retired from public inspection, decent in its regulation, and as genteel in its furniture as such a place could be made'.[46] The early layout of the pool and its surroundings are clearly delineated on John Rocque's *Map of London, Westminster and Southwark* (1746) (fig. 112).

Peerless Pool sat on the north side of Old Street, opposite St Luke's Workhouse. It comprised two basins – a 'Bathing Pond' and a larger and narrower 'Fish Pond', surrounded on three sides by rows of trees. The remainder of the ground was divided into a series of compartments, including an orchard and a bowling green. It appears to have become a great commercial success soon after it was opened to the

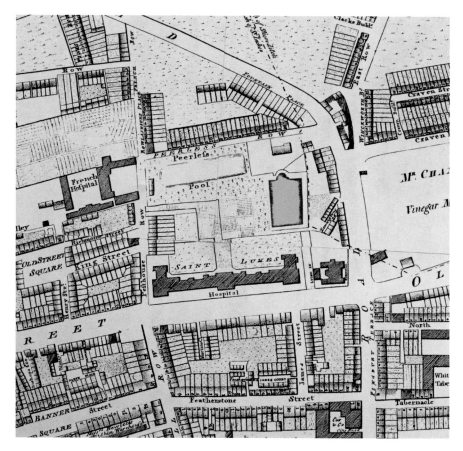

112.
Richard Horwood, *Plan of the City of London, City of
Westminster and Southwark*, 1799, detail showing
the Peerless Pool. Private collection
The bathing pool is shown in red.

public and was frequented by 'Clergymen, great numbers of Gentlemen, eminent
Merchants, and substantial Traders'.[47] Walter Harrison, writing in 1776, supplies a
detailed description:

> It being 170 feet long, and above 100 feet broad, [and] having a smooth gravel
> bottom . . . The descent to it is by several flights of steps conveniently disposed
> round it, adjoining to which are boxes and arbours for dressing and undressing,
> some of them open, and others enclosed. On the fourth side is a neat arcade,
> under which is a looking-glass over a marble slab; and a small collection of books

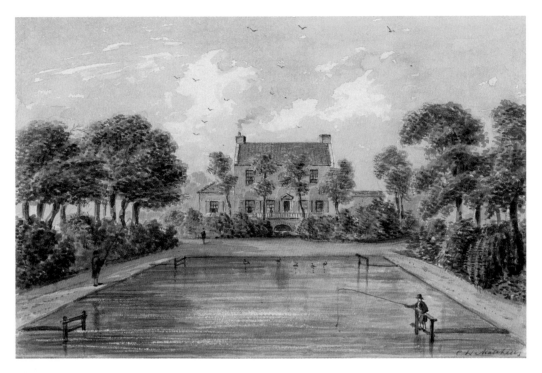

113.
C. H. Matthews, Peerless Pool, City Road,
Finsbury, c.1800, watercolour. London
Metropolitan Archives

for the entertainment of the subscribers. The ground about the pleasure bath is
agreeably laid out and well planted with trees.[48]

He also praised the 'very large fish-pond' – the largest and most impressive of the
establishment's several basins – which was 'well stocked with fish, for the use of the
subscribers who admire the amusement of angling. On each side of this pond is
a very handsome terrace walk, well planted with lime trees, and the slopes are
very agreeably covered with shrubs' (fig. 113). The gardens' various baths were 'well
attended by waiters; and the free use of the place is purchased by the easy subscrip-
tion of One Guinea per annum'.[49]

The Pool waned in popularity in the late eighteenth century but was revived
around 1805, when drastic measures were taken to improve the basins, the facilities
and its landscape setting: trees were felled, the fishpond was filled in and new
bath buildings were erected. The baths were, however, temporarily reprieved. The
refurbishment appears to have worked as it was reported in the *Morning Chronicle*

in September 1824 that there were frequently 600 to 700 bathers in a day.[50] These patrons of the establishment enjoyed the warm sea-water baths, 'medicated, vapour, gaseous [baths]', fresh water warm baths, private cold sea water baths, 'plunging cold sea-water baths' and the 'grand swimming bath of sea-water'.[51]

The 'pleasure bath in the open air' was particularly popular with school children: columns of boys from the Blue Coat School, Christ's Hospital and Charterhouse made regular visits, 'headed by their respective beadles', to make 'rapid plunges' into the pool.[52]

From the middle of the nineteenth century, the popularity of the attraction began to decline. In December 1868, it was advertised for sale as a 'site for building', and, by 1876, it had vanished.[53] Londoners had been deprived of one of its oldest, publicly accessible, open-air bathing places, and 'little or no provision' had been made to supply a similar amenity in its place.[54]

Vauxhall Redivivus

There was a mixed public reaction to an announcement made on 30 June 1949 by G. R. Barry, Director-General of the Festival of Britain of 1951, that about a quarter of Battersea Park was to be enclosed to create a pleasure garden for the festival. Barry pronounced that the new resort should be a place where 'people could have fun – elegant fun'; that it should be 'something new for London – or, perhaps... something old, something going back to the spirit of Vauxhall Gardens'.[55] The gardens would, therefore, provide 'something for all tastes and all pockets'.[56] There would be an area devoted to the 'traditional and conventional activities associated with the fairground or amusement park', but there would also be 'cafés, restaurants, entertainments of all kinds such as music-hall, concerts and spectacles', and the 'layout of the whole area, it was hoped, would be in itself an outstanding example of landscape gardening and decoration. The use of illumination and water would be predominant. The gardens would be open seven days a week for six months from the beginning of May, 1951, onwards.'[57]

Although the Festival had originally been conceived as an international exhibition to celebrate the centenary of the Great Exhibition of 1851, its remit was redefined under the direction of the Labour cabinet minister Herbert Morrison to provide a national festival that would serve as a 'tonic to the nation' – to lift the morale of the war-weary nation and to 'tell the story of British contributions to world civilization in the arts of peace'.[58]

Defenders of the 'proposed invasion' of Battersea Park argued that Chelsea and Bankside were traditional centres of amusement and that a hope of reviving the 'fetes, frolics, fireworks and fashionable frivolity' and the 'ancient gaieties' of

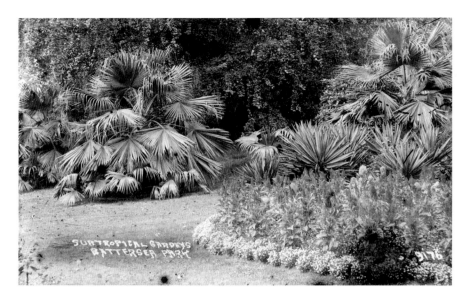

114.
'Subtropical Gardens, Battersea Park', c.1925.
Wandsworth Libraries and Heritage Service, London

Ranelagh, Cremorne or Vauxhall gardens would be a great boon to the area. Local residents, on the other hand, were concerned that they would be denied normal access to convenient public open space and that such an encroachment and 'such drastic changes' might have a lasting and adverse impact on the park.[59] Naysayers were reassured that the gardens were temporary and that the park would be returned to its 'permanent status'.[60]

Although, after the war, Battersea Park was, like so many metropolitan open spaces, a forlorn place, its soil 'usurped by the cabbage of the allotment', in the second half of the nineteenth century, it had been 'one of the wonders of London'.[61] Under the direction of the 'public gardener' John Gibson, the garden defied the 'London smoke and soot', and its luxuriant and then unusual subtropical planting 'gave an immense impetus to artistic gardening throughout the country, and enhanced, greatly enhanced, the charm and beauty of the parks and pleasure-grounds in London' (fig. 114).[62] Given this distinguished legacy, it is curious, but perhaps understandable on account of the severe financial constraints of the period, that the pleasure gardens of 1951 did not, in the end, possess great horticultural richness. Visitors were, in fact, forewarned that, if they expected to see 'vast gardens filled with rare plants', 'this was not the intention'. Since the pleasure gardens' designer, James Gardner, had to seek sponsorship to pay for many of Battersea's features and entertainments, there had

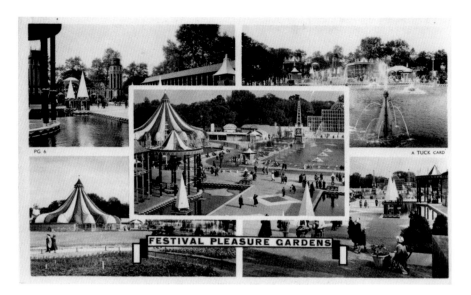

115.
Festival Pleasure Gardens, Battersea Park, 1951.
Wandsworth Libraries and Heritage Service, London

been a hope that the horticultural trade would take on certain areas to display their specialities, 'but this hope was not realised'.[63]

The organisers of the festival, nevertheless, fulfilled their promise that the gardens should supply 'gaiety and beauty in abundance'. Russell Page designed the landscape and the planting in collaboration with a team of artists and designers, including Osbert Lancaster, John Piper, Hugh Casson and Rowland Emett. The main garden comprised a landscape park in miniature and a flower garden bedded with white tulips and annuals.

It was reported in the *Manchester Guardian* in May 1951 that 'London has long been in need of such a pleasure ground as stretches now, dome and pillar and striped pavilion, fantasy upon fantasy, red and gold and blue and green, a labyrinth of light-hearted absurdity, all dedicated without ado to carefree enjoyment along the riverside acres of Battersea Park' (fig. 115).[64] The gardens boasted a 'Grand Vista', a fun-house, a roller-coaster railway, beer gardens, a boating pool, a dance pavilion, restaurants, cafés, tea houses, theatres, lakes, a miniature Crystal Palace fern house, a flower garden, a children's zoo and aviary, and even a grotto – a 'sepulchral labyrinth … that would have filled Pope or Beckford, Goldney or "Grotto Shaftesbury" with envious wonder'.[65] The tree-walk was no less captivating, featuring 'whole villages among the branches, a fiery dragon, pterodactyls, owls, bats and caterpillars';[66] and

116.
E. W. Fenton, *The exit from the Grotto – 18th century landscaping in 20th century London*, engraving, from the guide to the Festival of Britain Pleasure Gardens, 1951. Private collection

The exit from the Grotto – 18th century landscaping in 20th century London

the gardens' 'night aspect' was reported to be 'perhaps the greatest success of the Festival' (figs 116 and 117).[67]

The architect Clough Williams-Ellis rejoiced in the 'blithe beauty and glittering transformation' of the 'thirty-seven acres of Thames-side metropolitan public park'; there was in the gardens 'an exuberant laughing fancy, a bubbling prodigality of the rococo'.[68] As for the funfair section, this was 'a nice noisy, glittering mix-up, Blackpool with polished knobs on it, Butlins writ-large in more elegant Italian script'.[69]

Though not officially part of the festival, the 'Sculpture in the Open Air' exhibitions that took place in Battersea Park between 1948 and 1966 were closely tied to its cultural ambitions. The aim of this series of triennial exhibitions – the 'first municipally-funded and government-backed set of temporary displays to present sculpture in public parks in Britain' – was to democratise the appreciation of modern sculpture.[70]

The Festival Pleasure Gardens were immensely popular and were open for three consecutive seasons. They were, however, running at a loss, and, although the Labour Leader of the London County Council 'valiantly declared' in 1953 that 'London should not lose its hard-won pleasure-park', there was a growing consensus, especially among members of the Conservative party (which had won a general election in October 1951, under the leadership of Sir Winston Churchill, who regarded the festival as a sinister Socialist exercise), that no more rate-payers' money should be spent on the gardens, that they should be 'handed back to the public' and that much of the original layout should be reinstated.[71]

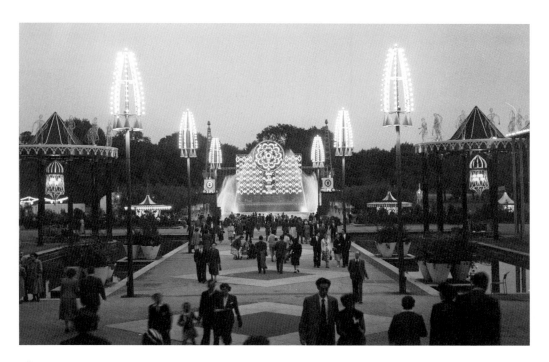

117.
Festival Pleasure Gardens by night, 1951.
London Metropolitan Archives

On 11 October 1953, fifty-three thousand people took their leave of the pleasure gardens. So ended what a member of the House of Commons proclaimed to be 'the biggest success in the history of public entertainment' and what detractors condemned as a waste of rate-payers' money and the 'intolerable encroachment' on a formerly delectable retreat that 'fulfilled the proper functions of a park'.[72]

The gardens' temporary features fell under the auctioneer's gavel in November. Soon afterwards, the riverside reverted to a grassy strip, the pier was dismantled, the funfair was reduced in size (closing in 1974). The 'most attractive shrubberies', the zoo, the tree-walk, the ornamental water in the Grand Vista and a few other features were spared.[73]

> Alas! poor Battersea... Good-bye, Grand Piazza. Farewell, Flying Cars. No more giggling in the aromatic chambers of the Grotto; no more spreadeagled sport on the whirling wall of the Rotor; no more mild roystering under a golden rain of rockets. Octopus, Gargantua, Playland, Oyster Creek – farewell. Colonnade, Pagoda, Kiosk, Fertility Symbol, and Beer Garden – good-bye.[74]

7.

Gardens of Artists, Literary Figures and Scholars

A Phoenician Fantasy

According to one of his obituaries, Dr John Samuel Phené (d.1912) had a 'peculiar type of mind that takes pleasure in the study of serpent worship and such by-ways of religious belief', and 'his views and practice on the subjects of art and architecture were equally remote from the normal'.[1] He also had a unconventional taste in garden design, which he used to great effect to express his ardent interest in his family's 'ancient descent', of which he was ferociously proud; he traced his ancestry back from the Phoenicians through India, Persia, Troy and Italy.[2]

Phené was a wealthy eccentric who inhabited a great gaunt pile in Oakley Street in Chelsea, known in his day as the 'mystery house'. Chelsea was then a fairly unfashionable and slightly shabby western suburb. The doctor's neighbours referred to his house as the 'freak' mansion, the 'quaint mystery house' and the 'Gingerbread Castle' on account of the curious encrustations which, between 1901 and 1912, accrued sporadically and unceasingly on its hitherto unornamented south-facing façade (fig. 119).[3] A correspondent to the *Pall Mall Gazette* described it in March 1912 as 'decorated in the most bizarre fashion':

> From pavement level to sloping roof it is a jumble of twisting columns and quaint symbolic figures. There are cupids, ancient goddesses, mermaids, imps, and the rest without end. Surmounting them all are two rampant dragons. Over the pillared doorway are set the words "Renaissance du Château de Savenay". The front door is covered with dirt of so many years, the windows are shuttered, the doors boarded up.[4]

118. (facing) Detail of fig. 129

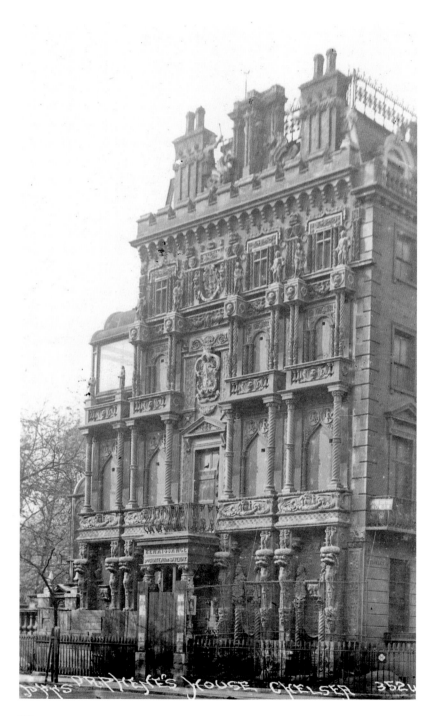

119.
Dr Phené's House, Chelsea, 1910. Royal Borough
of Kensington and Chelsea Archive, London

Phené described the house as 'the dream of my life'.[5] Its freakish façade, which represented 'the struggle between the Greeks and Trojans before Troy', did not, however, bear close scrutiny; it was a piecemeal assemblage of cheap, curious and tatty ornament. Contemporary photographs of the property lend support to this view: the house gives the impression of a spirited but clumsy pastiche – or even, as it was so often rather uncharitably described, a 'nightmare medley in gilt and plaster and terra-cotta'.[6]

The garden was equally idiosyncratic, and a very personal and private oasis – a dank jungle sprinkled with a reckless profusion of 'meaningless iron and marble, ecclesiastical symbols, baths, allegorical nymphs and cupids, and church furniture, which Dr Phené made it his absorbing mission in life to collect'.[7] The four-acre (1.6-hectare) plot was 'decorated with scores of statues and figures, many now broken and weather-worn, which the doctor collected during journeyings on the Continent or from curiosity dealers'.[8] It possessed a 'central Terrace running North and South', a 'Mound', a 'covered way', a blacksmith's forge, several fountains and a 'Greek temple with small stone cairn adjoining' that marked the burial spot of 'a thirty-seven years' old, long blind pony which he brought from Iceland forty years ago'.[9] Although the garden was purported to be rather lifeless and a 'receptacle for dead cats', it possessed a 'fowl-run with particularly lively hens'.[10] A correspondent for the *Daily Mail* suggested that, for his garden, Dr Phené 'seems to have had the terrace gardens of the Isola Bella (Lake Maggiore) in mind. But whereas on the Isola Bella, whatever one may think of the taste of this sculpture garden, everything is order and harmony, the garden in Oakley-street is an indescribable confusion and disorder'. It was, he concluded, 'a senseless and bewildering accumulation of incongruous things' (fig. 119).[11]

As few were admitted to the doctor's garden sanctuary before his death, people thronged to gaze upon the 'mysterious nightmare mansion', its 'mournful garden' and its curious collection on the occasion of his house-breaking sale. It was described in November 1912 as a 'Jumble Sale of Many Lands', and it attracted great numbers of 'furniture dealers and curio connoisseurs, ladies of title and elderly clubmen with a taste for bric-à-brac, stonemasons, builders and architects, collectors of old prints, artists and sculptors from the neighbouring colony of studios'.[12] All were 'a little awed' crossing the threshold: it was 'a nightmare of incongruities in marble and stone and terra-cotta – Gustave Doré at his wildest pitch – Madame Tussaud gone raving mad! There was just room to squeeze through the crowded avenues of dingy statuary'.[13] A correspondent to the *Daily News & Leader* put it best: the garden was 'a Classical Rubbish Heap' and the sale of its 'mildewed wonders' at auction was a 'Prosaic End to a Doctor's Splendid Dream'.[14]

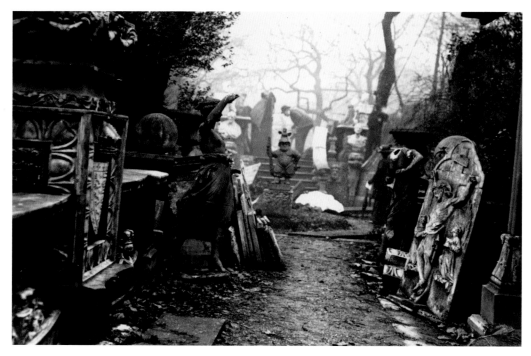

120.
Statues in Dr Phené's garden, *Daily Mirror*, 19 November 1912.
Royal Borough of Kensington and Chelsea Archive, London
The garden was described in 1912 as a reckless profusion of 'meaningless iron and marble, ecclesiastical symbols, baths, allegorical nymphs and cupids, and church furniture'.

Not long after the 'old Phoenician's' death, his house was demolished, and the garden was built over. This longstanding and bewildering Chelsea landmark had, however, long ceased to bewitch the curious. As a correspondent proclaimed in the *Evening News* in November 1912: the place was 'only a mad lumber-room after all … The mystery flew out of this rubbish heap as soon as the auctioneer turned the key in the front door'.[15]

Late Georgian Roman '*cortile*' Gardens

Images of modest eighteenth-century London town gardens are at best scarce, so it is fortunate that a handful survives – and, in a few cases, more than one image still exists – to supply detailed insights into their original character as well as evidence of how they were used.

Two gardens are particularly well evoked by their owners, both of whom were artists and happen to have been founder members of the Royal Academy: Paul Sandby's at no. 4 St George's Row, Bayswater, and Benjamin West's in Newman Street, Marylebone.

Thomas Girtin portrayed the street front of Sandby's house as seen from Hyde Park in about 1777 (fig. 121). The house is set behind a wooden paling and is perched on a small, elevated terrace above the road. Sandby's own views of his back garden are more revealing: one from around 1773 shows it from the vantage point of the first floor (fig. 122). The court is paved and enclosed on the east side by a brick wall, surmounted by a high parapet bearing a relief sculpture and an urn, and on the west side by a steeply sloping bank crowned by a railing. Steps lead up to a balcony that is attached to the artist's studio, the elegant two-storey neoclassical façade of which forms an imposing eye-catcher from the house. The glazed door and fanlight of the studio supply views to the neighbouring fields beyond. The artist depicts his garden as displaying much greater sophistication than his neighbours' to the west, pointedly emphasising the contrast between the aloof classicism of his own plot and their frenetic horticultural activity. This superior refinement is established by attempting to recreate a Roman *cortile* (courtyard) through the introduction of balustrades,

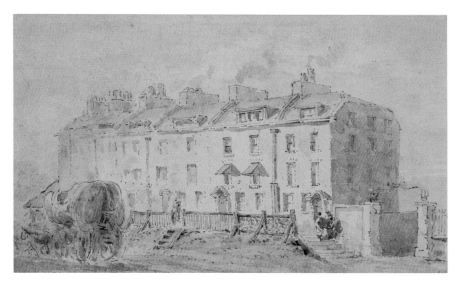

121.
Thomas Girtin, *St George's Row, Tyburn, c.1777*, pen and watercolour wash. British Museum, London
Girtin has drawn a view from Hyde Park of Paul Sandby's house, 4 St George's Row in Bayswater.

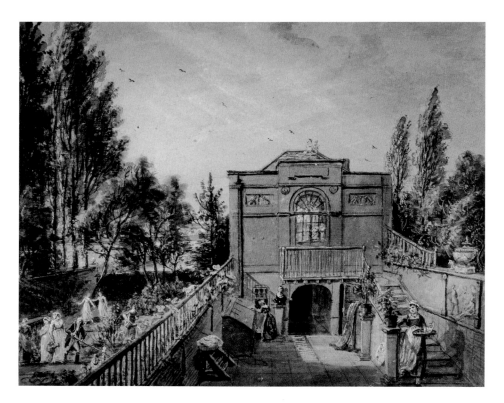

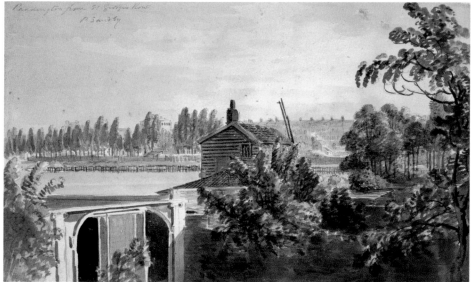

122.
Paul Sandby, view of the back garden of the
artist's house at 4 St George's Row, Tyburn,
*c.*1773, watercolour. British Museum, London

123.
Paul Sandby, *Paddington from St George's Row*,
*c.*1800–2, watercolour. British Museum, London
This view is from the back of 4 St George's Row.

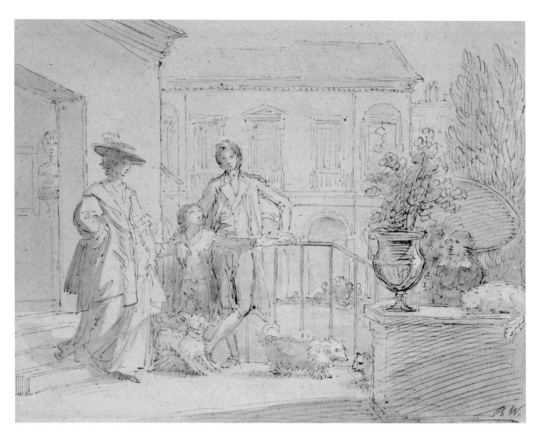

124.
Benjamin West, the artist's family in the garden of their
residence in Newman Street, London, c.1785–8, pen and
watercolour wash. Toledo Museum of Art, Ohio

statuary and urns. Sandby's second view, from around 1800, is from the north-facing window of his studio over St George's Burial Ground (now Paddington Street Gardens) (fig. 123).

Benjamin West's garden near Oxford Street was no less polished. He used his 'Italian garden' as a backdrop for two family portraits. A drawing from the 1780s shows the artist, his family and pets in elegant repose on an elevated terrace overlooking his house and garden (fig. 124). A later painting from about 1808 supplies a more expansive view of the same: here, however, the family is now seated with its pets in front of the arcaded 'house-passage' that joined the back of the house to the artist's studio and gallery (fig. 125).[16] The garden entrance to the passage is flanked by herms

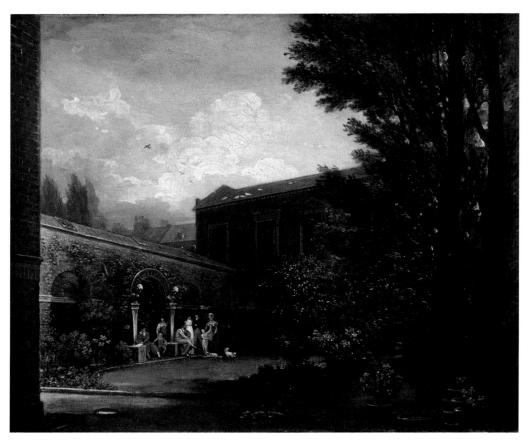

125.
Benjamin West, *The Artist's Garden in Newman
Street, Marylebone*, c.1808–9, oil on canvas.
National Portrait Gallery, Smithsonian
Institution, Washington, D.C.

surmounted by busts. Leigh Hunt later described the garden as 'very small and elegant with a grass plot in the middle, and busts upon stands under an arcade'.[17]

Both Sandby's and West's gardens share an underlying design principle that was common to many smarter Georgian town gardens: the most elaborate architectural features were assigned to the garden side of the house, rather than the public front of the house; and the garden was clearly a domain in which architectural aspiration and invention could be freely indulged, in an attempt to evade the usual constraints of the town garden.[18]

A Hesperian Haven

On 12 October 1790, Hester Lynch Thrale recollected her introduction to Streatham Park almost three decades earlier: 'On the morning of this Day twenty seven Years ago I first opened my Eyes in the House, to w[hi]ch my Mother, myself, my Uncle & distant Relation the Rev: Thelwall Salusbury who married us – were brought by Mr Thrale to reside. And what a House it was then! a little squeezed miserable Place with a wretched Court before it, & all those noble Elm trees out upon the Common… I can but laugh when it crosses my Recollection'.[19]

Hester Lynch Salusbury married Henry Thrale at St Anne's Chapel, Soho, in September 1763. He was a wealthy Southwark brewer, and she was a vivacious intellectual from a grand but impoverished family from North Wales. It was a 'loveless match which deeply embittered Hester'.[20] In her eagerness to avoid intellectual and emotional stagnation, she began to cultivate the acquaintance of literary characters, and Streatham Park's salon became 'a sort of Receptacle for Wits & Writers'. Dr Samuel Johnson was among the most distinguished figures at her 'dining table and tea-urn' and later became an exhausting and demanding, long-term house guest.[21]

Hester at first appears to have had little say in matters pertaining to the house and garden. In February 1779, for instance, she registers her vexation that her husband's 'Spirit of Alteration' caused various changes to be made to the gardens, including 'the old Seats my Mother used to sit in taken away, & the Mount poor Harry used to crawl up levelled with the Ground; the place may look finer for ought I know, but I can associate no Ideas to it in its present State'. ('Poor Harry' was Hester's son Henry Salusbury Thrale, born in 1767, who died in 1776.) She did not, she remarked, 'oppose the Alterations I complain of – nor any Alterations he can afford to make, tho' I certainly do hate 'em heartily'.[22]

Streatham Park in the Manor of Tooting Bec had been acquired in about 1735 by Thrale's father from the Bedford Estate. A map of 1729 suggests that there were already buildings on the site, including Streatham House, as well as outhouses and gardens, fields, meadows, plantations and clay pits.[23] The house lay to the south of Streatham Common and a grand double avenue of trees said to have been planted to mark a visit by Elizabeth I in 1600.[24]

Thrale's estate is recorded in greater detail on a survey of about 1770.[25] The house is encompassed by gardens, the largest of which lie east and west of the mansion. The west garden is presumably the 'Fruit Garden and Kitchen Garden' that the Bluestocking Elizabeth Montagu declared in 1777 'may vye with the Hesperians gardens for fruit and flowers'.[26] The east garden – laid out in the former 'Park Field' – is divided into eight equal compartments with a basin at its centre. Three small structures terminate the garden's north–south paths, and what appears to be a mount

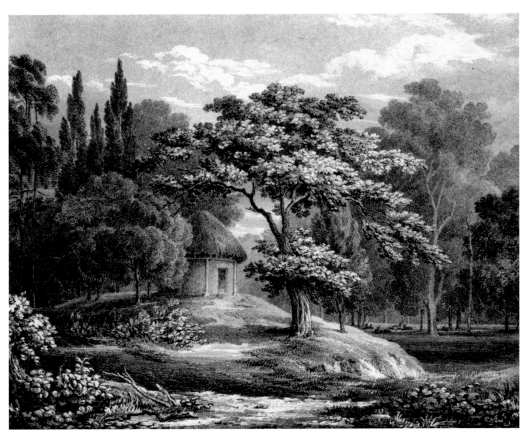

126.
G. F. Prosser, *A Summer House in the late Mr Thrale's Park Streatham The Favo[u]rite Retreat of Dr Johnson*, c.1775, lithograph. Lambeth Archives, London

lies at its north-west corner. A large, round pool dominates a paddock to the west of the house and, by 1822 (the year after Mrs Thrale's death), had been expanded to form a pond known as the 'Moat'. Dr Johnson's thatched summer house had probably not yet been erected (fig. 126), so it does not feature on this map, which documents the 'pleasure grounds' before they were reordered according to a more natural taste on the advice of Sir Philip Clerke – an improver whom Hester Thrale considered an ignorant septuagenarian.[27]

Upon the decease of Henry Thrale in 1781, Hester removed to Bath and, in 1784, married Gabriel Mario Piozzi. After a three-year excursion through France, Italy and Germany, the couple 'retired to the Groves of Streatham', where she immersed herself

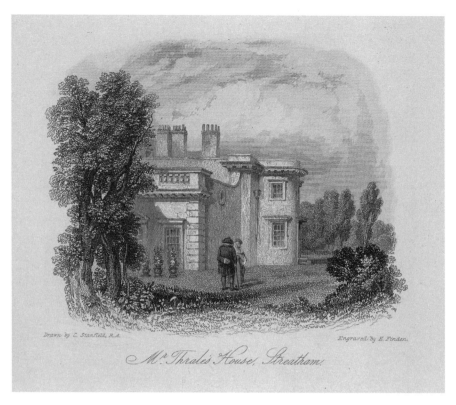

127.
C. Stanfield, *Mr. Thrale's House, Streatham,*
c.1775, engraving. Yale Center for British Art;
Gift of Herman W. Liebert, B1995.9.50

in 'Love and Literature'.[28] She had her house redecorated in 'Italianate splendour' to accommodate a 'renovated coterie' of friends and also began to channel some of her energies into gardening (fig. 127).[29]

Hester records in January 1791 that 'Streatham looks divinely itself; my present Master [Mr Piozzi] has been an admirable Steward for my past Mistresses . . . Our Nursery Garden, Shrubbery, &c. is in the finest Order I ever yet saw them; & the House has an Appearance of Gayety never attempted in Mr Thrale's Time. Constant Company, elegant, expensive and tasteful Furniture; splendid Dinners and fine Plantations'.[30] The topographer Daniel Lysons corroborates this assessment, describing the villa and its estate in 1792 as 'much improved by Mr. Piozzi: The kitchen-gardens . . . are remarkably spacious, and surrounded by brick-walls fourteen feet in height, built for the reception of forcing-frames, and producing a great abundance of fine

fruit. Adjoining the house is an inclosure of about one hundred acres, surrounded with a shrubbery and gravel walk of nearly two miles in circumference.'[31]

Hester's *Thraliana* – her 'repository' of 'anecdotes… improvised verse, quotations reflections and transcriptions of conversations and bon mots' – is, likewise from 1790 onwards, littered with gardening observations: she notes how 'My poor dear Mother's Trees, that *She said* would one Day be the ornaments of this Place, now turn out truly so'; how 'Peaches Nectarines & Grapes set firmly in the hothouse'; how the desolation caused by 'a most rigorous Winter' was the source of great grief; and how their 'vast Kitchen Garden eats one's income quite up'.[32]

In 1795, the Piozzis removed to Brynbella in Wales, leasing Streatham Park to Mr Peter Giles, a wealthy London corn factor. Although they returned frequently as visitors, they never resettled in London. The estate was sold after Hester's death in 1821, and, in 1863, the 'ancient mansion, for many years identified with the history of Surrey' was 'razed to the ground' to make 'suitable plots for building villas upon'.[33]

Dr Johnson's summer house survived the garden: Piozzi's daughter Susannah took it to her own garden at Ashgrove, in Knockholt, Kent. In 1962, a Mr Wells, who lived locally, bought it, by now in a dilapidated state, and presented it to the London County Council for exhibition to the public. It was restored by the Greater London Council (the successor to the LCC) and re-erected at Kenwood House, on the borders of Hampstead Heath. It was burnt down by vandals in 1991.

An 'impenetrable thicket'

Whereas we know little about the motivations that inspired the painters Sandby or West in the designs of their respective gardens, we are fortunate to have a more informed appreciation of the artist Lucian Freud's approach to gardening.

David Dawson has commented that Freud, for whom he worked as a studio assistant for many years, 'painted plants when life tended to become tumultuous and his relationships with other people were strained, or when he simply couldn't find a model to paint'.[34] Those who are familiar with his work will know that cast-iron plants (*Aspidistra elatior*), Zimmerlinde (*Sparmania africana*), geraniums (*Pelargonium*) and cyclamen occasionally feature in some of the interiors depicted in his paintings. These plants were to the artist mere 'studio plants', or props, which 'were allowed to grow as they pleased, sometimes into a mess'. The plants in Freud's town garden at the top of Kensington Church Street in Notting Hill were treated in a similar manner: they, too, were allowed to 'grow wild'. The artist never took care of his garden in the conventional sense of 'proper gardening', because he wanted nature to 'take its own course, and that's how he wanted to paint it'. For instance, the buddleia that became central to his late garden paintings, like so many buddleias in London gardens, was

128.
David Dawson, *Lucian's Buddleia*, 2007
(printed 2018), giclée print.
Courtesy Ordovas, London

129.
Lucian Freud, *Garden*, *Notting Hill Gate*, 1997,
oil on canvas. Private collection

self-sown: it 'just grew in the middle of the garden on its own – it was a weed' (figs 128 and 129). It developed into an 'amazing flowering bush that he enjoyed painting'. He painted it as he knew it.

Freud 'never thought of himself as a gardener', and he 'certainly wasn't a horticulturist', according to Dawson. His town garden, as we know it through his paintings, was a scruffy tangle. The ground was small, east-facing and rectangular in layout; it was also elevated well above its neighbours. The artist had a clear idea what form his garden should take, though he took little interest in the physical exertion of gardening. He chose the plants – bay and bamboo – and he or Dawson ordered them from Clifton Nurseries in Maida Vale, then owned by Freud's friend Lord Rothschild. They collected them together and returned to Kensington Church Street, where Freud told Dawson what should be placed where. Dawson prepared the ground and planted their charges. Freud 'wanted the bay trees set along the sides of the garden and the bamboo placed between them. Once planted, he let them grow – unimpeded ... he never wanted to cut them back, to prune them or to change their shape.' A large fig clambered up the garden's south-facing wall, and potted plants were occasionally consigned to its shady depths. Perhaps not surprisingly, the garden eventually meta-

morphosed into an 'impenetrable thicket'.[35] As Dawson has observed, 'the view from the kitchen doors on the ground floor was like looking into a cave; and peering out of the first-floor studio window gave the impression of being immersed in a woodland canopy'. Although Freud's 'afternoon studio' overlooked his back garden, he neither minded that the view from its window was occluded, nor that little natural daylight penetrated through its evergreen canopy.

The garden was never intended to be 'pretty'. Freud 'hated the idea of prettiness in the sense of abundant blooms and romantic roses. In the garden he was more interested in the architecture of plants, like his bamboo and bay trees. He was also fond of oak leaf hydrangeas … He loved greens and earthy colours, like the ones he often used in his paintings.'

Freud's garden was ultimately less of a composition than an assemblage of plants: he was determined that every individual plant should have its own identity, regardless of its position within the garden. Every plant was, in his eyes, equal: none was more important than its neighbour.

When Freud died in 2011, he left his house and garden to Dawson, who is himself an artist and regularly paints in his old friend's studio. As he is an ardent gardener, he has recast his little pleasance to reflect his own interests and identity. What has been lost is the haphazard, riotously disorganised character that Freud impressed on the plot of land. The garden that has disappeared supplies an example of idiosyncrasy so marked that it was almost bound to vanish with the garden-maker; it is difficult to see how any successor could have identified wholeheartedly with such an unusual conception of how a garden should be conceived of and put to use.

Jekyll at Caesar's Camp

In the summer of 1872, the Dorset MP John Erle-Drax, realising that part of his farm in south-west London would form 'excellent sites for building', leased half of what is now known as Caesar's Camp to a builder for a 'long term at a low rent'.[36] The oval-shaped, ancient earthwork, bounded by a double rampart and a broad fosse, lay on high ground on Wimbledon Common and commanded extensive views to the south and west (fig. 130). It was, at the time, 'in a state of nature, covered with grass and furze, and but for the fences would have passed for part of the adjoining Common'.[37] Erle-Drax's actions caused great surprise and consternation, and his efforts to efface this picturesque 'relic of antiquity' were eventually thwarted, but not before a 'band of labourers' had levelled part of the ramparts and the fosse.[38]

Although the Iron Age fort was saved, and later incorporated into Wimbledon Common, there continued to be an interest in building dwellings 'close to Caesar's Camp' – described as a 'noble gem' and 'altogether one of the most beautiful resorts

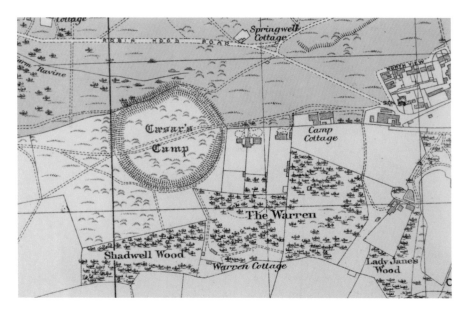

130.
London County Council Municipal map, 1930, detail
showing Caesar's Camp, Wimbledon. Private collection

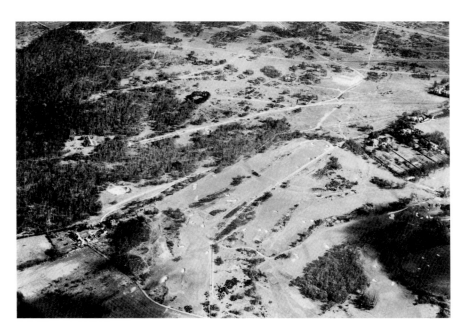

131.
Aerial view of Caesar's Camp and No. 1 Caesar's
Camp, 1948. Britain from Above/Historic England

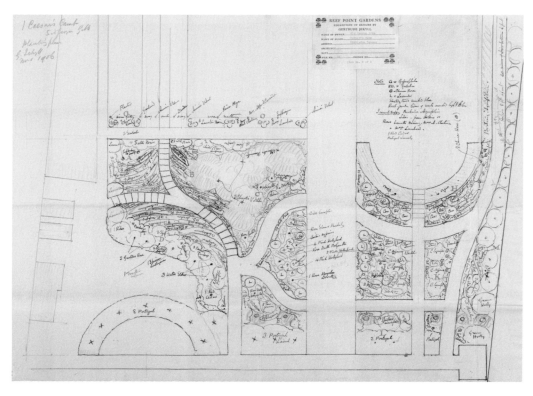

132.
Gertrude Jekyll, plan of Sir George Gibb's garden,
Caesar's Camp, Wimbledon, 1906. University of
California, Berkeley, Environmental Design Archives

of the inhabitants of the metropolis, both for health and for recreation'.[39] No one
built closer to the earthwork than Sir George Stegman Gibb, the managing director
of the Underground Electric Railways Company of London. Gibb also commissioned
Gertrude Jekyll in 1906 to design his garden at The Round, later renamed, rather
augustly, No. 1 Caesar's Camp.[40]

An oblique aerial photograph from 1923 and a mosaic of vertical aerial photo-
graphs from the late 1940s suggest that the garden was built more or less to Jekyll's
plans (fig. 131). The surviving design drawings supply us with a detailed picture of the
layout and the planting: the garden was formed on a south-facing slope, separated
from the house by a capacious lawn, and was bisected by a broad, north–south path,
flanked on the east by a 'Rockery', sweeping, stepped paths and a kitchen garden,
and to the west by flower and shrub beds and a large, formal lawn. The whole was

encircled by a perimeter path, and the garden's beds and paths were, in places, defined or enveloped by yew, Portugal laurel, holly and berberis hedges (fig. 132). A broad transverse path at the north end of the garden, terminating in the west by a summerhouse, was lined with posts linked by 'swags' draped in rambling and climbing roses under which was strung 'wire mesh' fronted by paeonies and China and Hybrid Tea roses. The landscape architect proposed that a large triangular-shaped area to the south side of this path should be laid out as a 'Rock Garden'. Although it is tempting to see this rocky outcrop as forging a link with the 'precious relic of antiquity' abutting the garden, Jekyll did, in general, like to create rockeries in full sun on sloping sites and recommended these features as a means of making the most of the gardens of 'small villas in the suburbs of London'.[41]

A large kitchen garden lay in the south-east corner of the garden; it was bisected by a broad herbaceous border with lavender hedges, long drifts of senechio, delphiniums, coreopsis, anthemis, rudbeckia, dicentra, monarda, eryngium and lupins and dotted with small clusters of hollyhock, verbascum and dahlia. Jekyll recommended that the garden should possess walks lined with 'Larch poles & wire netting with rambling Roses' and clematis.

We know little more about the garden, except that, when it was advertised to be let for the summer season in 1911, it was described as 'quiet, no motor traffic near, 3 golf courses [in the vicinity], 3 acres gardens'.[42]

Gibb's Caesar's Camp house was pulled down in about 1959, long after he and his family had departed, and was replaced first by offices and subsequently by dwellings. The gardens have largely been built over, and Caesar's Camp itself has been defiled by an unfortunate invasion of golf greens and bunkers.

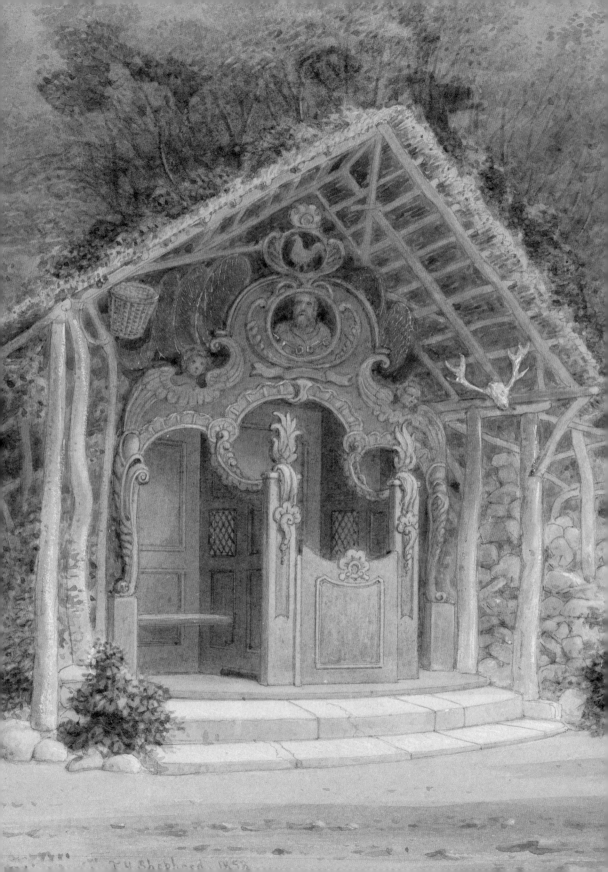

T H Shepherd 1852

8.

Gardens on the Margins

A number of lost gardens were constructed in places that would have looked like countryside at the time but, nevertheless, formed part of the life and culture of London: city-dwellers have for centuries divided their existence between the metropolis as a place of work, pleasure or partial (sometimes seasonal) residence, on the one hand, and places on the margins, to which they could retreat when, for example, in need of rest, peace or escape from urban epidemics. Some of these are considered here; they are presented as a list of disconnected items, not a sequential analysis, since the thematic links between them, for the most part, do not go far beyond those determined by their topographical location on the perimeters of London.

A Brentford Villa

In about 1705, James Brydges, later 1st Duke of Chandos, embarked upon building a 'country palace' in Isleworth on land leased from the 6th Duke of Somerset – the initiative corresponded with his lucrative promotion to the office of Paymaster General of the Forces Abroad. Thistleworth lay in a little park on the opposite side of the Brentford Road from Syon House, atop a little eminence commanding views of the neighbouring countryside. Here Brydges planted his 'barren ground' with 'peach and orange trees, gooseberry and currant bushes, flower and lettuce seed... got from Antwerp and Holland. From Portugal came Barbary hens, and from here and there unusual or rare animals.'[1] The garden also had a 'Banquetting-House' and a fountain that played in a 'very delightful Manner', the engine of which was designed by the celebrated hydraulic engineer Thomas Savary.[2]

133. (facing) Detail of fig. 140

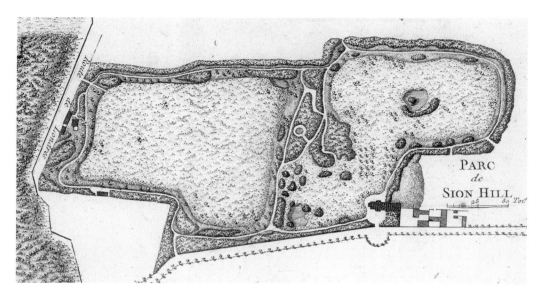

134.
Georges-Louis Le Rouge, 'Parc de Sion Hill'
(Middlesex), detail from an engraved plan published
in Le Rouge's *Détail des nouveaux jardins à la mode*,
cahier 2: *De Jardins anglo-chinois à la mode* (c.1775).
Bibliothèque Nationale de France, Paris

Brydges remarked in 1710, 'the garden I have made at Sion Hill hath made retirement so pleasing to me that I should gladly withdraw from business when I cease being paymaster of ye forces'.[3] His 'improvements' were evidently significant enough to perturb his landlord, the Duke of Somerset, who had cause to complain that Brydges was enclosing part of his 'waste', and it was later said that the duke 'did not choose that a palace should be erected in his manor of Sion, that might eclipse Sion-house itself'.[4] When Brydges eventually removed from Thistleworth in 1714, he took with him the garden's iron gates and rails, as well as some of more 'extraordinary' fruit trees.[5] This action prompted the duke's agent to pursue Brydges for 'damages and spoliations inflicted on the property', to which the accused replied, 'I could plough up the garden & turn it to what I found it, but scorn such action.'[6]

In the mid-1750s, the property was acquired by Robert Darcy, 4th Earl of Holdernesse, who, as had his predecessors, made major changes to the garden.[7] It is alleged that the 'grounds were disposed by the celebrated Brown'.[8] The earl was certainly a great supporter of the landscape improver Capability Brown, and the latter was working on the pleasure ground at Syon House at the time.[9] In a plan published in Georges-Louis Le Rouge's second cahier of *Détail des nouveaux jardins*

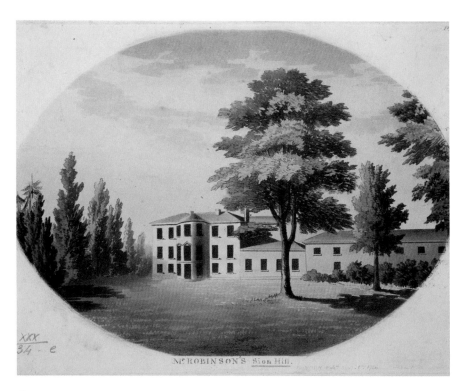

135.
Artist unknown, *Mr Robinson's Sion Hill*, 1786,
watercolour. British Library, London

à la mode, entitled *De Jardins anglo-chinois à la mode* (*c.*1775), the garden of 'Chateau
de Milord Holderness à Sion Hill' appears to be formed of two paddocks divided
by a central plantation, and the whole encircled by a perimeter walk similar to one
Brown devised for the earl's neighbour at Syon House (fig. 134). A watercolour view
of 1786 shows the mansion house, then occupied by Mr John Robinson, which was
described in 1792 as 'built at great expense, though without any magnificence of
show' (fig. 135).[10]

Arthur Young remarked in his *Farmer's Tour through the East of England* (1771) that
the earl, 'at his elegant villa . . . has laid down much arable land to grass, and with
great success. His farm was all wet arable land and unprofitable; this determined him
to throw the whole to grass . . . the fields are all well-turfed, and of good herbage.'[11]
Lady Holdernesse also took an interest in embellishing the estate, employing a Dutch
gardener who 'kept a prodigious amount of kitchen gardening [in the] Dutch style'.
Lady Northumberland, who was a frequent visitor, approved of Sion Hill's 'Hay field',

the view of which was 'entirely rural & pleasing', and noted a 'walk round a field taken off with a rope & a border of flowers on ye contrary side'.[12]

In the 1790s, the Duke of Marlborough acquired the Sion Hill estate. By June 1829, the house was in ruins, and, by 1974, the estate had 'long since been swallowed up by suburbia.'[13]

Belsize Birds-eye

Bird's-eye views were introduced from the Netherlands into England in the late seventeenth century and very rapidly became the preferred manner of representing the country's landed estates. Ellis Waterhouse dubbed the Flemish painter Jan Siberechts (1627–1703) 'the father of British Landscape'. He had been 'encouraged to come to England initially by aristocratic personal patronage and by the prospect of rich commercial opportunities'[14] and was among the most talented topographical artists to provide the nobility and the gentry with portraits of the houses and gardens. His great skill was his ability to capture the vitality and individuality of the places he depicted and to display often disjointed and idiosyncratic landscapes as coherent entities.

Sometime in 1696, Siberechts captured a likeness of the newly built house in Belsize, in the Manor of Hampstead, belonging to the goldsmith John Coggs (fig. 136). The mansion is believed to have occupied the site of an earlier 'fine seate' that had been pulled down in 1686. The former house had commanded views over London and Surrey, and its garden was embellished with 'delicate walkes of pines and firres, also corme trees'.[15]

Coggs was banker to Queen Anne, and later Prime Warden of the Company of Goldsmiths, and his 'House &c at Hampstead' (as Belsize was then known) befitted a man of his wealth and social standing.[16] Siberechts's high-angled prospect was doubtless intended to be a record of the new house and its extensive domain, and to record its relative position in regards to the metropolis and particularly to Westminster Abbey, which is faintly visible in the left background and to whose Dean and Chapter this area of Belsize then belonged. The careful depiction of the house and its setting, Laura Wortley suggests, contains 'elements of both land-surveying and book-keeping and may be read as the equivalent to a visual balance sheet', proclaiming Coggs's financial power.[17]

The painting supplies us, above all, with a reasonably comprehensive survey of the most important garden elements – the tree-lined approach road, walls, fences, gates, outbuildings and paths.[18] The largest enclosure contains an orchard that boasts an east-facing, two-storey belvedere. The house itself sits at the centre of the composition, surrounded by austere garden compartments. The patron's wife appears to be

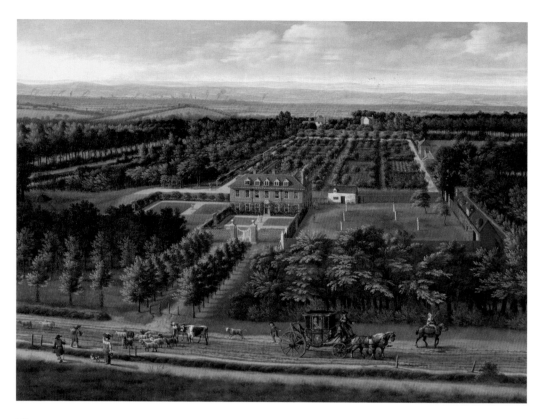

136.
Jan Siberechts, *View of a House and its Estate, Belsize, Middlesex*, 1696, oil on canvas. Tate, London

portrayed within the coach in the foreground. The house was presumably occupied primarily in the summer and as a 'withdrawing place' when there were epidemics in the capital.

An Antiquarian's Assemblage

Another property on the margins, in this case a suburban villa, is known only through images of it: its identity is a mystery. While topographers agree that it probably lies within the purlieus of London, none can say with any certainty where it once stood. The villa's grounds are documented in six large watercolour views prepared in 1858 by the celebrated topographical watercolour artist Thomas Hosmer Shepherd, who is best known for his views of Regency London, many of which were published in James Elmes's *Metropolitan Improvements; or London, in the Nineteenth Century* (1827).

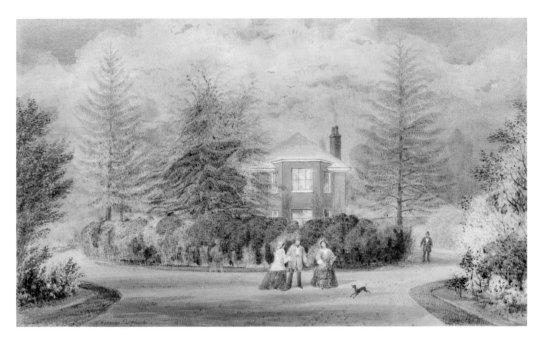

137.
Thomas Hosmer Shepherd, unidentified
house and its garden, 1858, watercolour.
Private collection

It was unusual for Shepherd to produce a rich and comprehensive illustrated survey of such modest premises; the fact that he did so in this instance suggests that the owner was either a friend or possibly a favoured patron (figs 137–9). What is clear is that this is no ordinary villa – although the house is undistinguished, the gardens are exceptionally curious: tubs of agave and other exotic-looking shrubs abound, as do colourful island flower beds. More unusual is a pair of stone pedestals supporting decorative vases, the large heap of stones (not a rock garden) by the front entrance to the house, and the garden folly (fig. 140). The latter is a bizarre confection of rustic joinery harbouring an enormous Flemish Baroque confessional. This piece of antiquarian woodwork incorporates several allusions to St Peter, including his relief portrait in the central roundel and attributes such as a cockerel and fishing nets – the cockerel (the Christian symbol of watchfulness) refers to the apostle's denial of Christ, and the nets evoke the miraculous draught of fishes. The basket hanging from the rafters may be an osier fish basket, and the rack of antlers may also have a symbolic meaning. The most striking intimation to the prophetical figure *Petrus* is, however, the large pile of stones beside the temple.

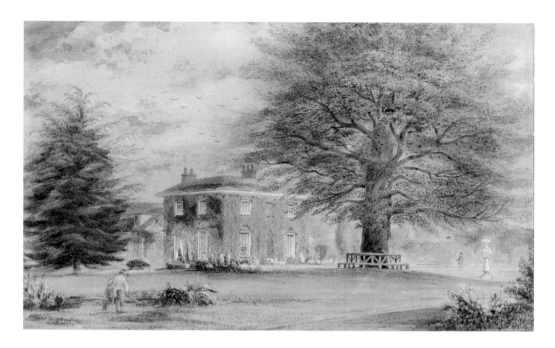

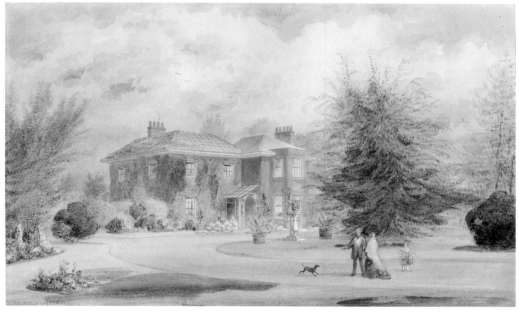

138.
Thomas Hosmer Shepherd, unidentified house and
its garden, 1858, watercolour. Private collection

139.
Thomas Hosmer Shepherd, unidentified house and
its garden, 1858, watercolour. Private collection

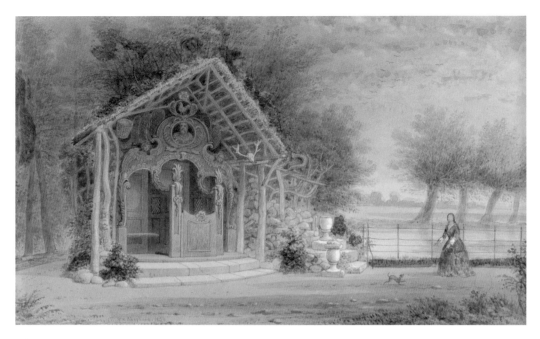

140.
Thomas Hosmer Shepherd, the garden folly of an unidentified
house, 1858, watercolour. Private collection

One doesn't know the fate of this garden, but it is highly unlikely that such a
whimsical ensemble has come down to us from the middle of the nineteenth century.

A Manor of 'especial favour'

It was announced in the *South London Press* in September 1875 that 'another relic of
old London is fast disappearing'. The paper was alluding to the Old Manor house
in Kennington Lane, which was 'being pulled down, and whose site ere long will be
covered with houses'.[19] It was said at the time that, from one of the house's grandest
saloons, 'lighted by three windows' whose fittings had been removed, one looked
'now, alas! Not on a well-kept lawn, but down a brick brand-new street of the true
Cockney suburban class'.[20]

The crenellated Jacobean house, which replaced an ancient royal residence, was
'associated with not a little that is historical'. The first properly authenticated fact
connected with the manor dates from 1189, the first year of the reign of King Richard I,
who granted the manor to Sir Robert Percy. Edward III appears to have regarded the
manor with 'especial favour', and it was the favourite residence of his son, the Black

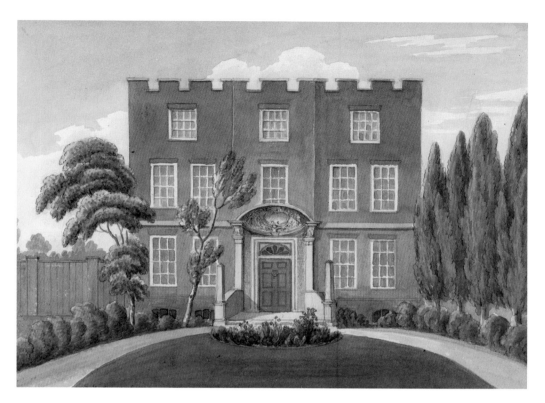

141.
G. Yates, *Manor House, Lambeth*, 1826,
watercolour. Lambeth Archives, London

Prince. In a survey of 1615, the manor was 'found to consist of 122 acres, eight of which comprised a rabbit warren'.[21]

Our view of the forecourt of Kennington Manor House (1826) shows it when it still had 'about an acre of ground behind' (fig. 141).[22] Gazing upon this simple and elegant suburban garden, it seems inconceivable that it was once the residence of the Congregational minister and psalmist Dr Isaac Watts (1674–1748) – that this pretty suburban ensemble belonged to the author of 'Vanity inscribed on all things', in which he enjoined his readers,

> Let us not doat upon any thing here below, for Heaven hath inscribed vanity upon it … What are those fine and elegant gardens, those delightful walks, those gentle ascents, and soft declining slopes, which raise and sink the eye by turns to a thousand vegetable pleasures? How lovely are those sweet borders, and those growing varieties of bloom and fruit which recall lost Paradise to mind! … Unhappy man!

who possesses this agreeable spot of ground, if he has no other Paradise in view, more durable than this, beyond the dreary mansions of the grave.[23]

This imperfect South London paradise 'fell prey to that vampire, the speculative builder' in 1875.[24]

A 'Tusculum Villa' Garden

Many antiquaries have had an interest in garden design, but few have been as experimental and energetic as the Reverend William Stukeley. Having spent much of his adult life creating gardens in Lincolnshire, he removed to London, and latterly, in 1759, he acquired a small, suburban estate in Kentish Town which was 'absolutely and clearly out of the London smoak, [on] a dry gravelly soil, and remarkably wholsom'.[25] Stukeley was then seventy-two and widowed, and he hoped to pass his days gardening at 'a calm retreat', 'far from the low, mean follys of the Great / free from the Vulgars envious hate / & careless of their praise./ blessd with a faithful female friend'.[26]

We have a pretty good idea of what Stukeley's house and gardens looked like as he was in the habit of recording them. His earliest drawings date from April 1759 and record the estate when he bought it: the house is, as he described it, 'new built for the most part; pretty, little, and elegant'. The large forecourt is plain and unornamented, and the back garden is enclosed by walls and laid out with a broad, circular path edged on both sides with small trees (fig. 142). Invoking Cicero, Stukeley referred to his new house as 'my Tusculum villa'. His garden, however, bore little resemblance to the Roman orator's: his inspiration was unabashedly druidical. He assumed the name of 'Chyndonax Druid' and set out to embellish his gardens in a druidical fashion.

142.
William Stukeley, *The garden view of my house at Kentishtown. 28 apr.[il] 1759*, ink and watercolour wash. Bodleian Library, Oxford, Gough Maps 230, fol. 352

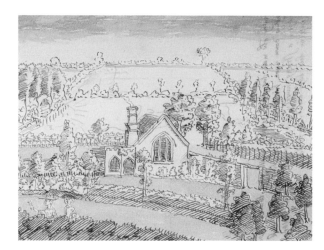

143.
William Stukeley,
Chyndonactis Mausoleum
(Kentish Town), 1764,
ink and watercolour
wash. Courtesy Spalding
Gentlemen's Society,
SPAG.2015.01, fol. 37

By October 1759, he had laid out his Druid Walk, concentric druidical circles and a tumulus – the latter was an echo of an earlier earthwork he had created in Grantham in Lincolnshire by his Temple of the Druids. He later erected a 'Mausoleum' in the gothic taste – which he described as a place 'to make a retrospect into ones life; and make some provision for one affairs; after we quit this present stage of being . . . it was erected as wel for the pleasure of retirem[en]t. & contemplation, as to keep my pictures in' (fig. 143).[27]

Elsewhere in the garden he created 'Eve's Bower' – doubtless inspired by Milton's description of Eve's prelapsarian nuptial bed in *Paradise Lost*. The bower appears from Stukeley's drawing of August 1762 to have been a verdant alcove – 'sacred and sequester'd' – enclosing a bench.[28]

The antiquary kept his rural retreat, as he so ardently wished, until 'my evening sun shal downward tend, / I'le quietly be gone'.[29] No trace remains of Stukeley's druidical wonderland.

Highbury's 'second Eden'

John Charles Brooke, writing to his friend and fellow antiquary Richard Gough in January 1778, reported that, 'according to my promise, I send you an account of the result of Mr. Topham's expedition with me to Jack Straw's Castle [later known variously as Highbury Farm and/or Highbury Castle, and not, as will become evident, the former pub on Hampstead Heath known as Jack Straw's Castle]':

> We set out on a Saturday, being a fine frosty morning, and was but in time to see the remains of the Mount, which is now nearly levelled by order of the owner

Dawes, formerly a stock-broker... who purchased the Manor of Highbury a few years since... The said Mr Dawes is about to build himself a house on the site of Jack Straw's Castle; and has paled round a considerable space of ground for a park, which will have a delightful view of the Essex hills, the vale below Hornsey, Highgate and Hampstead, and Islington.[30]

John Dawes, we are told, had also built near the edge of his estate a 'large pile of buildings... called Highbury Row' upon an 'artificial' hill composed of the shattered remains of Jack Straw's Castle and 'probably the house of the Knights Templars, who then owned the manor of Highbury'.[31] The two antiquaries also found ancient copper and silver coins, mortar, bricks, stone and glazed tiles buried in the 'large layers of rubbish about a yard from the surface'.[32]

The destruction of the early building and the remodelling of the landscape were not unusual occurrences at this time: in many of the metropolitan suburbs, similar vandalism was taking place in the name of garden-making. Although antiquarians were dismayed by these actions, others, such as the engraver William Ellis, who supported the redistribution of land, affirmed in his *Campagna of London, or, Views in the Different Parishes* (1791) that the redevelopment of the manor of Highbury afforded a 'remarkable instance of the advantages derived by the nation from the distribution of church lands':[33]

> At a distance of little more than two centuries, a gloomy castle surrounded by a moat, with a humbler dwelling at a small distance from the former, and guarded in the same jealous manner, were all the habitations that Highbury could boast; these were the residences of a few imperious men, who revelled in the spoil which they procured by credulity, and maintained by oppression. The land is now the property of various individuals, who have erected commodious houses in different parts of it, and who improve their own happiness, and that of others, by a cheerful and social intercourse.[34]

Roughly thirty-three years after the ruins of Highbury Castle had been 'erased to the ground', Highbury House, the modern mansion that replaced them, was described by the topographer John Nelson in glowing terms, and Dawes was praised for having raised an 'elegant' villa, and 'laid out grounds in a handsome manner, with shrubberies, paddocks, hot-houses, green-house, &c'.[35]

Dawes was not the last owner to embellish the spot. After his death, the astronomer Alexander Aubert made improvements

> of the first magnitude: gardens, lawns, shrubberies, and plantations, of every description, were soon brought to environ the dwelling-house; and the old moat, which had in the gloomy ages of superstition, been only passable by means

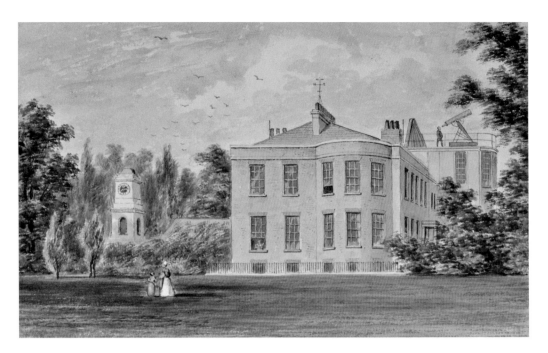

144.
C. H. Matthews, Highbury House, c.1845,
watercolour. London Metropolitan Archives

of a drawbridge, was partially filled up to form a carriage way to the house; it now assumes the appearance of a canal in front of the mansion, over which the weeping willow 'bends to the stream,' and gives the landscape a very pleasing and picturesque appearance [fig. 144].[36]

This so-called 'second Eden' also possessed 'a lofty and spacious observatory', a large reflecting telescope, and a hermitage vaunted by the bard 'Simple Susan' as a 'moss-grown cell'.[37]

Aubert was succeeded in 1805 by John Bentley, who enclosed a 'considerable part' of the grounds by erecting a substantial brick wall. This new kitchen garden was 'abundantly stored with choice vegetables of every kind; the pinery and grapery are in the finest order, and extremely productive; there is also a small orangery, and a plantation of tobacco, which in October 1809, was standing seven feet high'.[38]

The estate had a succession of owners throughout the nineteenth century, and, each time it changed hands, its acreage diminished in extent. By 1894, the house had become a school; in 1939, it was flattened, like the ancient ruins before it, and its grounds built over to make way for Eton House flats.

Capability at Cat Hill

We know little about the early 'Gardens, Walkes, Orchards, groves and yards' of Little Grove, which lay upon the summit of Cat Hill in East Barnet when it was owned and occupied in the 1670s by Lady Fanshawe, the widow of the diplomatist, keen gardener and experimental horticulturist Sir Richard Fanshawe.[39] Our first impression of the place dates from 1719, after it had been acquired by John Cotton of Ashill and the Middle Temple, who erected a new house in the modern taste around a large, west-facing forecourt. The estate was renamed New-Place and is commemorated in an engraved view (fig. 145).

The next significant round of improvements took place under the stewardship of Mr Justice Willes, Solicitor General, who employed Capability Brown between 1760 and 1770 to lay out the grounds and parkland. Earlier, Brown had his 'skill disply'd' at Astrop in Northamptonshire, where he had worked for Willes's father, Sir John.[40] Elements of Brown's scheme, can be discerned on the first edition of the six-inch Ordnance Survey map of England and Wales, including the new and informal approach road from the east and the remains of the park's perimeter plantations.

The estate was advertised for sale in September 1817, at which time the mansion possessed 'extensive views in all directions', 'an excellent kitchen garden, walled

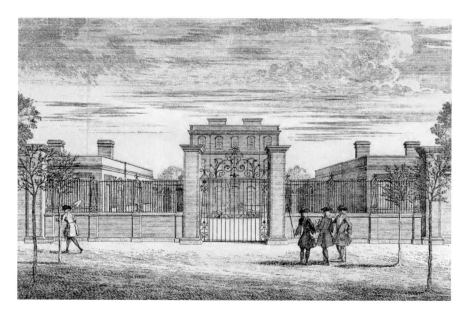

145.
The West Prospect of New-Place in East Barnet in
the County of Hertford, 1719, engraving.

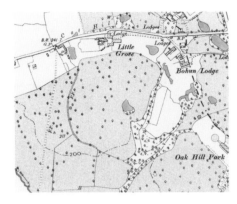

146. (left)
Little Grove, detail from the second edition of the six-inch Ordnance Survey map of England and Wales, 1897. National Library of Scotland, Edinburgh

147. (below)
South front of Little Grove, East Barnet, c.1860, engraving

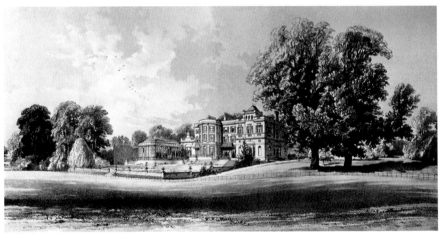

round, hot house, grapery, green house, and orchards, poultry gardens . . . and meadow land'. The whole estate encompassed fifty-five acres (22 hectares) and was 'surrounded by dry gravel walks and thriving plantations, and with full grown timber trees, the whole enclosed by park paling (fig. 146).[41] What is not included in this informal inventory are the estate's many fishponds, which were scattered across the gardens and park. The 'moderate-sized mansion, in the Italian style' and its 'charming terraces and gardens are depicted in a lithograph of the 1860s (fig. 147).[42]

The last owner of the estate was the American actress and singer Shirley Kellogg, who spent lavishly on the redecoration and repair of the house but expended little on the gardens. The estate was sold in 1931 and demolished the following year to make way for a housing estate. What was left of the pleasure grounds was divided into 'three exceptionally fine building sites'. Two and a half sides of the eighteenth-century walled garden survive.

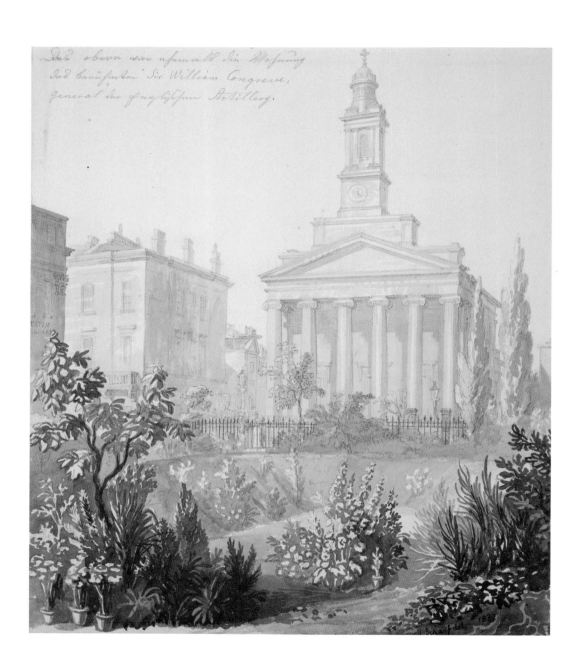

9.

Gardens of Display

An anonymous contributor styled J.R.S.C. remarked in 'London's Lesser Open Spaces – Their Trees and Plants', published in the *Journal of Horticulture and Cottage Gardener* in October 1885,

> Eaton Square... may claim, I believe, to be one of the largest of the metropolitan squares, and its open ground is divided into six parts, the two central gardens being the larger, and through it runs the King's Road, extending on to Fulham, and along which in former times were the many nurseries of Chelsea, all of which have succumbed to the builder save Little's Nursery: this, though closed, is not yet turned into a row of houses.[1]

J.R.S.C. was not the first to lament the disappearance of London's nurseries: another anonymous correspondent to the *Journal of Horticulture* wrote in 'The Old Market Gardens and Nurseries of London', in August 1876,

> Rapid have been the changes that have passed over London nursery gardens during the last fifty years ... only here and there does a nursery survive which approximates to the busy parts of London, and the owner of which has refused to listen to 'the voice of the charmer,' preferring to go on in the old style that his father, or perhaps his grandfather, did before him, though the smoke of the metropolis is sadly opposed to his successful cultivation of any plants that require a pure atmosphere.[2]

148.
George Scharf, view of the north-west garden division of Eaton Square with the façade of St Peter's, Pimlico, in the background, 1832, pencil with watercolour. British Museum, London

The writer expressed regret that these nurseries had 'vanished and fled with all their greenery to make place for long lines of doors and windows and the bustle of London streets'. But what he found 'even more disagreeable' was the 'aspect of a neglected nursery garden, where the paths are overgrown with grass or trampled out of outline; the buildings are in a miserable state of dilapidation and besprinkled about with smashed glass, while on the beds innumerable weeds disport themselves'.[3]

Although the account above describes the once celebrated Sloane Street Nursery on the eve of its metamorphosis from a 'wilderness state' into a well-appointed communal garden to 'serve as a resort for the well-to-do residents of the streets overlooking it', it could as well have described the mournful state of Eaton Square in the early 1840s, when its tenant, 'Tuck the florist' (who was also the tenant of the Sloane Street Nursery in 1876), was forced to surrender the lease of his productive gardens to make way for croquet lawns, flower-beds and shrubberies.[4]

The nurseryman and florist James Tuck figures large in the early history of Eaton Square.[5] The cause of his notoriety was that he happened to have a long lease on a plot of land that for many years thwarted the ambitions of the Grosvenor Estate in their efforts to complete the development of the garden centrepiece of their 'new and elegant' Belgravian estate.

Eaton Square (originally Eaton Place) was one of two spacious squares that were conceived and laid out for Robert Grosvenor, then 2nd Earl Grosvenor, in the early nineteenth century in a bid to transform a district of about a hundred acres in extent, known as the Five Fields, into what was described in 1827 as 'the future residence of the fashionable world'.[6]

The bones of the 'new and elegant town' were established around 1813, and the aim of the so-called 'driveway' of Eaton Square was to replace a long stretch of the King's Road, from Sloane Square to what is now Grosvenor Place. The square was conceived as a large 'parallelogram . . . 600 yards long by 120 yards wide', bisected by the realigned King's Road and flanked on both sides by three pairs of matching oblong garden 'divisions', which were combined to give the impression of a fourteen-acre pleasure ground with a church at its eastern extremity.[7]

Grosvenor's new district was begun under a special Act of Parliament passed in 1826, empowering the estate to drain the site and raise the level of the swampy ground to create a new residential district, the 'leading feature' of which was to be Eaton Square.[8] When the master builder Thomas Cubitt leased his land on the north side of the square in the early 1820s, the future gardens had, however, already been let by the Grosvenor Office to nurserymen and market gardeners on leases that expired in 1842.[9] The north-east division – which interests us here – had been granted to the nurseryman Duncan Mackenzie, and this plot became known as the Cape Nursery.[10]

Mackenzie entered an agreement with Earl Grosvenor in 1821 to lease the land at the north-east corner of what was to become part of the garden of the intended square.[11] It stipulated that he should lay out the ground in 'ornamental plantations of Trees and Shrubs' and 'to form the Walks and keep them in proper clean and neat order'. He was permitted to erect a shop within his plot.

Mackenzie did not, however, honour this agreement. By the autumn of 1826, he had run into financial difficulties: the contents of his nursery were advertised to be sold and his 'Valuable Nursery Ground' was put on the market the following July and was taken over by Tuck the florist.[12]

George Scharf's drawing of 1832 shows that the bulk of Tuck's nursery lay roughly two metres below the level of the surrounding streets (fig. 148). The plot's iron railings soar above the sunken garden, crowning its steep embankments. The planting is, moreover, scattered willy-nilly across the whole – several plants in the foreground are potted, and the boundary shrubbery is wildly picturesque. Scharf's view, which was presumably taken from Tuck's bothy in the square, depicts the Cape Nursery unadorned in the midst of a 'new city of most magnificent mansions . . . now in the course of building'.[13] It illustrates, furthermore, how the nursery was set at the original ground level before the land around it was raised to conceal the district's new sewers and other services, and that neither Mackenzie nor Tuck had implemented the ornamental garden layout agreed with their landlord.

Contemporary accounts of Tuck's garden vary – while some praised the fact that the houses in the square commanded 'a full view of the Nursery Grounds' and that the inhabitants of the 'noble mansions' were 'able to enjoy, gratuitously, the odour of his floral productions',[14] others questioned why a 'Cauli-florist' was 'permitted somehow to continue the nuisance of his ill-smelling cabbage garden under the noses of the high-rent paying inhabitants of Eaton-square' (fig. 149).[15]

Tuck's lease of the grounds in Eaton Square expired in 1842, and he moved his premises to Sloane Street Nursery, off Lower Sloane Street. It is likely that the sunken garden of Eaton Square was hastily transformed after his withdrawal – the surviving vegetation was extirpated, the buildings demolished, the ground raised and the enclosure planted afresh.[16]

City Gardening

Thomas Fairchild was one of a handful of gardeners of his time 'who united a love of science and the practice of his art'.[17] He was the first learned and influential proponent of *improved* town gardening, and his book *The City Gardener* (1722) was the earliest publication by a celebrated London florist, nurseryman and botanist to supply 'the most Experienced Method of Cultivating and Ordering such Ever-greens, Fruit-Trees,

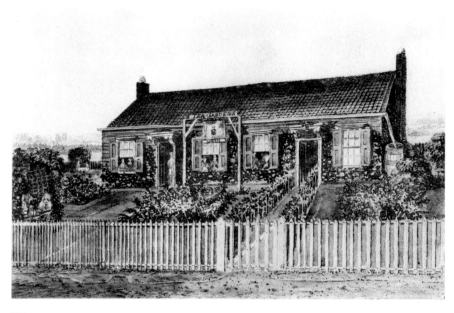

149.
Artist unknown, 'Tea Gardens', Eaton Square, engraving, from E. Beresford Chancellor, *The History of the Squares of London Topographical and Historical* (1907). Private collection

This rustic tea house is purported to have stood in one of the gardens divisions of Eaton Square. Tuck's bothy was presumably equally picturesque. The profile of the western façade of Westminster Abbey is discernible on the horizon (to the left of the tea house).

Flowering-Shrubs, Flowers, Exotick Plants, &c. as will be Ornamental, and thrive best in *London Gardens*'.

Fairchild resided at Hoxton, where his nursery, known as the City Gardens, was the 'most extensive and best near London' and was 'greatly frequented, not only for [its] agreeable situation, but for the variety, rarity, and excellence of [its] productions'.[18] An engraved plate included in his *City Gardener* depicts the nursery (fig. 150). Two gentlemen are shown in conversation by a clutch of tubs, each bearing an 'Exotick Plant'; on either side of the path are 'plates-bandes' studded with small ornamental shrubs. Gardeners toil away in the beds, and 'Stoves', or hothouses, sit hard against the garden wall. The image is an encapsulation of the achievements of a nurseryman and botanist who had been 'almost Forty Years in the Business of Gardening'.[19]

Fairchild's establishment had further distinctions: it possessed a 'Stove or Conservatory' contrived to 'bring the Ananas or Pine-Apple to bear Fruit' and to house 'the most tender plants'; here he grew on from seed a number of American plants sent from Virginia by Mark Catesby. His vineyard was among the last to be

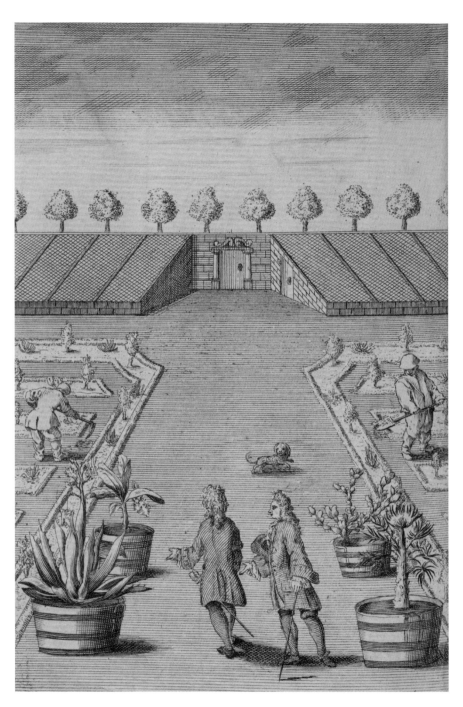

150.
Thomas Fairchild's nursery, known as the City Gardens,
Hoxton, engraving, frontispiece to Thomas Fairchild,
The City Gardener (1722). Royal Horticultural Society,
Lindley Collections

cultivated within close proximity of the metropolis and possessed more than fifty varieties for '*both for Eating and the Vineyard*'.[20] Fairchild is also credited as one of the first to grow bananas in England and for having introduced catalpa, red buckeye (*Aesculus pavia*) and American dogwood (*Cornus florida*). Most importantly, he was a pioneer in the cultivation of plants that would 'bear the *London* Smoke, and will grow even in the closest Places; as in little Courts and Yards . . . in the Heart of the City'.[21] The nurseryman was better qualified than most of his contemporaries to know which plants would tolerate the city's polluted air, since he had for 'upwards of thirty Years been placed near *London*, on a Spot of Ground, where I have raised several thousand Plants, both from Foreign Countries, and of the *English* Growth'.[22]

Upon his death in 1729, Fairchild bequeathed £25 for the endowment of an annual Whitsun sermon on either the wonderful works of God or the certainty of the creation. Although the sermon was still going strong late in the nineteenth century, his nursery ground had been let 'to build upon' more than a century earlier.[23]

Independent Botanic Gardens

R. J. Thornton remarked of the botanist and entomologist William Curtis, 'no one ever shewed . . . a greater love for botany, or ardour in its pursuit'.[24] Fundamental to Curtis's work was 'the desire to expand botanical knowledge and to record the wealth of native flora, especially in London, before the spread of industrialism and building destroyed his favourite plant hunting grounds'.[25]

Curtis established a small botanic garden in about 1770, near Grange Road at the bottom of Bermondsey Street. Here he laid out his garden 'only to cultivate without arrangement' and 'first conceived the design of publishing his great work, the *Flora Londinensis*' – the first publication to be dedicated to the metropolitan flora.[26] He very soon, however, found the garden 'too small for . . . his extensive ideas'.[27] Therefore, in 1771, he took a larger piece of ground in Lambeth Marsh, where he soon gathered 'the largest collection of British plants ever brought together into one place'.[28] It was, according to Thornton in 1805, 'the only public thing of the sort in England'[29] – 'the first independent botanic garden with the emphasis on British native flora collected and displayed using the new Linnaean system, and open by subscription to a wide range of people, both professional and amateur'.[30] James Sowerby portrayed the orderly and extensive garden in 1787 (fig. 151). Although the site was 'unpropitious' for many plants that could not bear the London smoke, still Curtis was 'unwilling to quit a spot on which he had bestowed so much time and labour, until the lease expiring, his landlord exacted terms for a renewal, too extravagant to be complied with'.[31] In his own words, he was 'disappointed, but not disheartened . . . [and resolved] to attempt its re-establishment elsewhere'. Finding that most of his subscribers 'resided in the

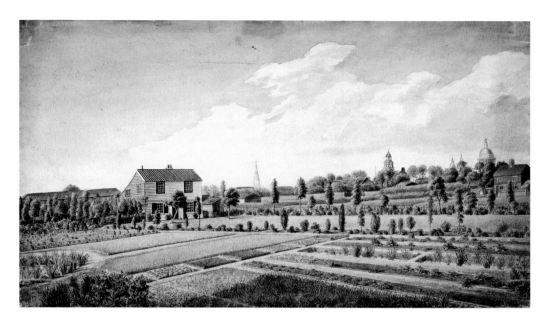

151.
James Sowerby, *William Curtis's Botanic Gardens,
Lambeth Marsh*, 1787, watercolour. Private collection

westward of the city', in 1789, he fixed on 'a spot in Brompton'.[32] Here, at Queen's
Elm, his new Botanic Garden and its appendages occupied about three and a half
acres, and an additional seven acres were set aside as an experimental garden for
agricultural crops; and here, in his 'teaching garden', his plants grew 'in perfect health
and vigour' and his labours were 'crowned with success' (fig. 152).[33]

At the door to 'this English Eden, neat and ornamental', was a 'stately door' on
which was inscribed, 'Botanic Garden, open to subscribers'.[34] A porter admitted all
visitors into the garden, which unfolded along a broad, gravel path, on each side a
'parterre, in which all the different varieties and beautiful hues of Flora'. The ground
was encompassed by a 'shady walk of poplars, which inarch, so as to form a complete
bower', and 'foreign trees and shrubs'. It was divided into various divisions, including
medicinal, agricultural, foreign grasses and British grasses, British 'plants of moderate
growth', British trees and shrubs, British plants of 'small growth and aquatic plants',
bulbs, foreign annuals, foreign 'alpine, or rock plants' and culinary plants.[35] There was
also a library, a greenhouse, a stove and an aviary.

The enterprise thrived until 1799, when, eager to secure his garden 'to the British
nation as far as was possible', Curtis entrusted it upon his demise to his friend the
gardener William Salisbury, who kept it going until 1829, when he removed his

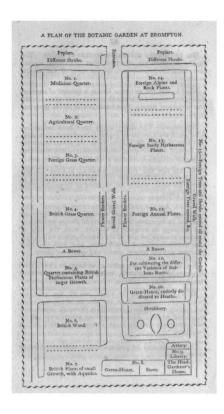

152.

'Plan of the Botanic Garden
at Brompton', published in
*Lectures on Various Subjects . . .
by the Late William Curtis* (1805)

*William Curtis's subscription
'Botanic Garden' at Queen's Elm,
Brompton, occupied about four
hectares, a large portion of which
was 'appropriated for experiments
in agriculture'.*

garden to Sloane Street.[36] The Botanic Garden at Queen's Elm was thus 'neglected'
and converted into a nursery ground 'with few vestiges of its former state'.[37]

Whereas William Curtis made his reputation through the cultivation and
promotion of native British flora, German-born Johan Busch and Joachim Conrad
Loddiges and the latter's English-born son, George, made theirs by dealing in rare
exotics.[38] Busch set up his nursery in Mare Street in the then suburban village of
Hackney sometime before 1756 and appears quickly to have established himself as a
purveyor of unusual plants. It was his links with the botanist Peter Collinson that set
him apart from his competitors: Collinson supplied Busch with seeds from all over
the world which he grew on and sold to the rich and the powerful. The establishment
later became one of the world's first commercial nurseries after it was purchased
by Conrad Loddiges, who, in 1777, began publishing trilingual nursery catalogues
to appeal to an international audience. The nursery also became 'celebrated for the
introduction and propagation of American trees and shrubs, particularly magnolias,
rhododendrons, and azaleas'.[39] It reached its apogee during the first half of the
nineteenth century under the able stewardship of George Loddiges, who, by diffusing

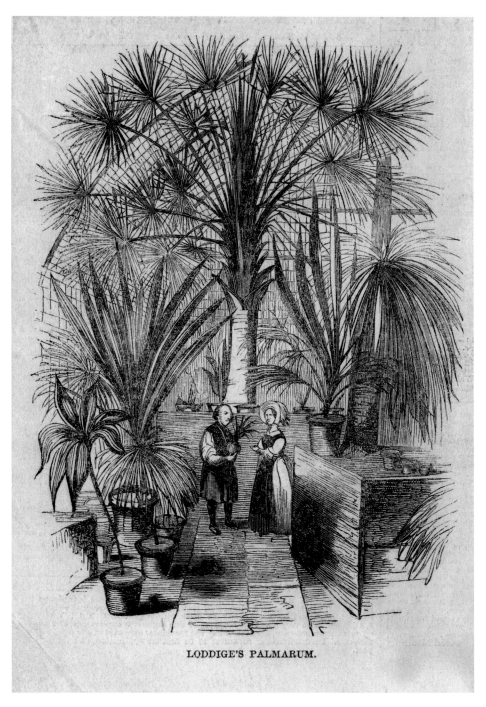

LODDIGE'S PALMARUM.

153.
'Loddige's [sic] Palmarum', showing a plantsman and
female customer, lithograph, from the *Pictorial Times*,
10 October 1846. Hackney Archives, London

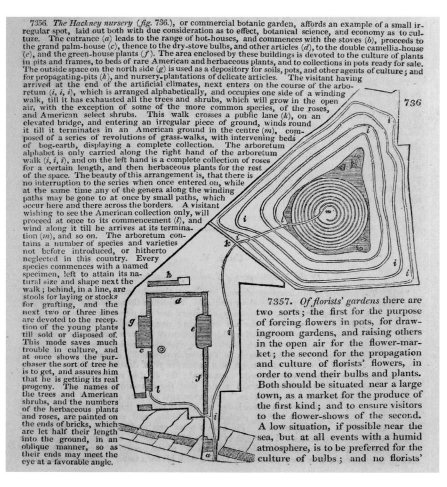

154.
Plan of Loddiges' nursery, from John Loudon,
Encyclopaedia of Gardening (1835 edn).
Library of Congress, Washington, D.C.

a taste for rare plants through the publication of a magazine, *The Botanical Cabinet*, and assembling an unrivalled collection of tender exotics, hardy trees and shrubs that made their way to some of the most distinguished gardens across Britain and Europe, made Messrs Loddiges 'one of the "lions"' of Hackney, and 'without equal anywhere in the world'.[40]

Originally known as Loddiges' Paradise Field Nursery, from 1814 it was dubbed by J. C. Loudon the 'Hackney Botanic Nursery Garden', to reflect the fact that it was a 'commercial botanic garden ... laid out both with due consideration as to effect,

botanical science and economy as to culture'.[41] It was, moreover, 'particularly devoted to the propagation of rare plants' and contained the 'best general collection of green-house and hot-house exotics of any commercial garden'. It also boasted 'the largest hot-house in the world' (fig. 153).[42] Loudon supplied a plan of the nursery ground in 1835, accompanied by a recommended itinerary (fig. 154). He informs his readers that, while several of the capital's principal nurseries, 'which have risen to their present eminence by degrees ... without having a general plan in view, [giving] the greatest confusion in appearance', the arrangement of Messrs Loddiges' 'small irregular spot' was exemplary, and the 'mode of displaying the whole to strangers, is of the most perfect description'.[43] The Botanic Nursery was also evidently an attractive place that contributed to the desirability of a 'prime part of Hackney', as premises for let or sale overlooking the nursery were often described in the press as 'pleasantly situate, with a view over Mr. Loddige's [sic] nursery and the adjacent fields'.[44]

Loddiges' emporium closed in stages between 1852 and 1854, when its long lease on the nursery ground from St Thomas's Hospital expired. Its 'valuable building materials and fittings-up of the celebrated palm house, extensive ranges of hot-houses and conservatories, pits and frames, seed-room, and various buildings' were sold at auction;[45] and its 'celebrated collection of plants' – including the fabled 'gigantic *Latania Borbonica*, or Fan Palm of the Mauritius', once in the collection of Empress Josephine at Fontainebleau – was acquired by Sir Joseph Paxton for the Crystal Palace Company (at Sydenham).

Hackney's loss was South London's gain, as, in 1853, the entire collection of the world's greatest plant emporium was deployed to adorn the 'entire slope of a lofty hill, comprehending great varieties of surface ... formed and fashioned, excavated, embanked, terraced, walled, stepped, and balustraded, into a paradise of gardening, far surpassing the architectural grandeurs of Versailles, and combining with them the peculiar features of English landscape gardening'.[46]

Bullish Optimism

It was Manor Gardens' great 'misfortune to sit slap bang in the middle of the proposed main Olympic site'.[47]

These productive gardens, known variously as the Manor Garden Allotments or Eastway Allotments, or locally as Abbott's Shoot or Bully Fen, were the brainchild of the old Etonian and philanthropist Major Arthur Villiers, a director of Barings Bank. They were established in 1924 on a four-and-a-half-acre (1.8-hectare) site on a promontory nestled between the River Lea and the Channelsea River in Hackney Wick. The area had been a Victorian rubbish tip and had been capped with a bed of clay and topsoil to form eighty-three individual allotments. Villiers's aim was to

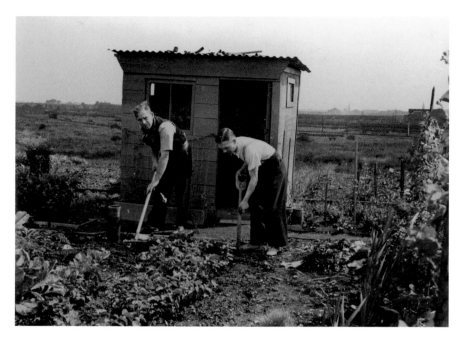

155.
Bully Fen, Stratford, c.1935.
Private collection

provide local people from this materially deprived neighbourhood of the capital with land to grow their own vegetables.[48] The site was managed by the Manor Gardening Society.

Allotment gardening was nothing new in London: instances can be traced back to the sixteenth century, when 'sundry citizens', and primarily tailors, 'who found the smoke of the metropolis unfavourable to plant-culture' took plots upon an estate in Hoxton.[49] Bully Fen was laid out after this system of tenure was formalised with the passing of the Small Holdings and Allotments Act (1908), which provided a legal mechanism for the establishment of allotments.[50]

The plot-holders who tended Bully Fen were for many decades a tight-knit community – mainly longstanding East End families, though in more recent times, and 'in keeping with the area's increasing diversity, numerous more recent joiners represented a wide variety of ethnic backgrounds'.[51] The garden flourished, and indeed became an 'extraordinary place' as the site became increasingly engulfed by new development (fig. 155): once you entered the gates 'there was a sense of stepping out of one place and entering another. The riverbanks were lined with Plum trees, planted by Villiers, and the site contained a range of indigenous flora that had

self-seeded, as well as exotic imports'.[52] The site also bore relics of the past, including bomb shelters, concrete mountings for anti-aircraft ordnance and a vast array of improvised sheds. At the heart of the gardens lay a community hut known as the Tavern on the Green.

This idyll came to an end in 2005 when the plot-holders were advised that they were to be evicted to make way for the park being built for the 2012 Olympic and Paralympic Games. They disputed the eviction, presenting an electronic petition to the prime minister, Tony Blair, but to no avail: they were turned out in 2007, and the area was flattened for redevelopment shortly thereafter.

Jane Owen, writing in *The Times* in 2008, condemned the expulsion as 'cultural vandalism', and the artist and broadcaster Grayson Perry objected not only to the banishment of the allotments but to the obliteration of the area's roads and waterways, comparing the future Olympic site to a 'Breughelian landscape in rapid mutation'.[53] The eviction also generated artistic responses, including Julian Perry's *A Common Treasury* alluding to the 1649 manifesto of the Diggers and the Levellers, who believed that the earth should be made 'a common treasury … that all men may enjoy the benefit of their Creation';[54] Jan Stradtman documented the plot-holders' sheds in a series of evocative photographs; and Thomas Pausz erected a replica of an allotment hut next to the Royal Albert Hall.

Bully Fen was more than a mere cluster of allotments – it was a community. Recent research suggests that allotments 'offer both tangible and intangible benefits. They provide a space for exercise or rest, companionship or solitude, contemplation or work. Not least of all, they supply healthy food and, accordingly, many plot holders regard allotments as a *hobby with benefits*.' Few modern plot-holders in fact profess to be motivated by economic necessity;[55] and evidence from interviews conducted with the former tenants of Bully Fen suggests that 'allotmenteering' is a lifestyle choice, and that people who garden in these community assets do not make a distinction between their recreational and functional use.

Arcadian Aspirations

In the late 1850s, the Horticultural Society of London, later the Royal Horticultural Society, was on its uppers. However, 'at its utmost hour of need, when nought but speedy extinction looked it in the face, the Prince Consort took it by the hand, and, as it were with a word, raised it to its feet and restored it to vigour, giving it strength and resources beyond any it had previously possessed'; he furthermore 'raised, as if by enchantment, the Arcadian Garden at South Kensington; organised the International Exhibition of 1862, and pointed the way for the Society participating in its advantages'.[56]

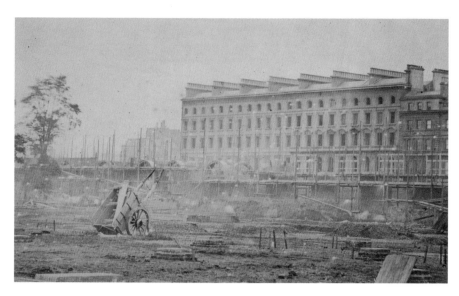

156.
The reconstruction of the Royal Horticultural
Society's Kensington Gardens, from Andrew
Murray, *The Book of the Royal Horticultural Society,
1862–1863* (1863). Royal Horticultural Society,
Lindley Collections

When the Society was formed in 1804, it was resolved that its objects should be to 'collect every information respecting the culture and treatment of all plants and trees, as well culinary and ornamental' and 'to foster and encourage every branch of Horticulture, and all the arts connected with it'.[57] For several decades they tried unsuccessfully to cultivate experimental and exhibition gardens, first at Kensington and latterly in Chiswick (figs 156 and 157). These, and other initiatives, proved such a great drain on its resources that by the 1850s the society was faced with financial ruin.

In 1858, the Prince Consort – who was then resident of both the society and the Royal Commission for the Exhibition of 1851 – recommended that the RHS lease a twenty-two acre (9-hectare), rectangular plot at the heart of the commissioners' South Kensington estate – part of which included the site of George London and Henry Wise's celebrated Brompton Park Nursery – with a view to developing it into an extraordinary show garden. This they did, and at great expense.

The prince, who took an inordinate interest in the project, determined that its layout should be Italianate and geometrical and that the landscape gardener William Nesfield should be entrusted with its design and execution. Work began in 1859 and was completed the following summer. The garden, which *Punch* christened 'Arcadia',

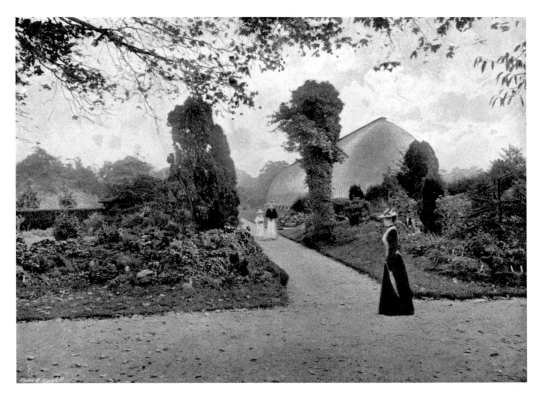

157.
'The Royal Horticultural Gardens
Chiswick', from *The Queen's London*
(1896)

was formally inaugurated on 5 June 1861. It was laid out in a series of terraces on
a gentle, south-facing slope and was enclosed entirely by arcades based on those
at the Villa Albani and at the Lateran outside Rome.[58] An immense glass-and-iron
conservatory was erected at the upper end of the garden that contained 'all that is
most rare or most beautiful in the vegetation of temperate climates'; this surveyed
extensive 'geometric' gardens enlivened by vases, statuary, basins, fountains, canals,
a cascade, 'band houses', a maze, and highly decorated compartments of flowers
(figs 158 and 159).[59] The garden was praised in the *Athenaeum*: 'in these magnificent
arcades we have something new to our country and our century – something
exquisitely Italian, and shady and cool; that in these succession of terraces, in these
artificial canals, in these highly-ornamental flower-walks, we have something of the
taste and splendour of Louis Quatorze. It was of such a garden as this that [Francis]
Bacon must have dreamt.'[60]

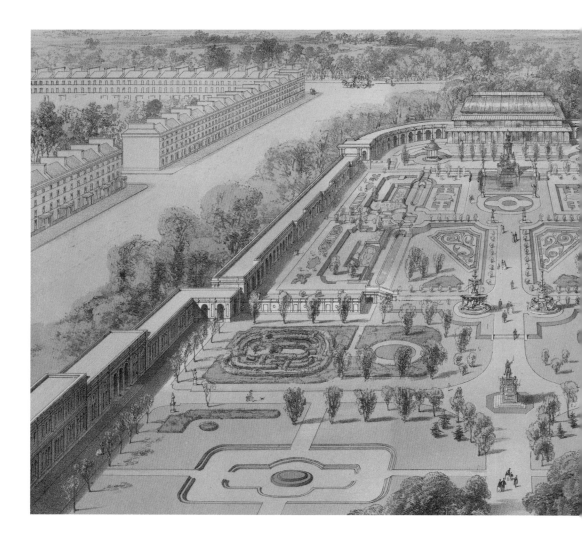

The 'Royal Founder', who had a grand vision for the development of the precinct into what later became known as 'Albertopolis', declared that the garden was to form 'the inner court of a vast quadrangle of public buildings . . . where science and art may find space for development, with the air and light which are elsewhere nigh banished from this overgrown metropolis'.[61] It was "'the attempt at least," as he humbly expressed it, "to reunite the science and art of gardening to the sister arts of architecture, sculpture, and painting"'. [62]

While the society shared some of these princely ambitions, they were determined that the gardens should promote 'Scientific Horticulture' and should remain exclusive

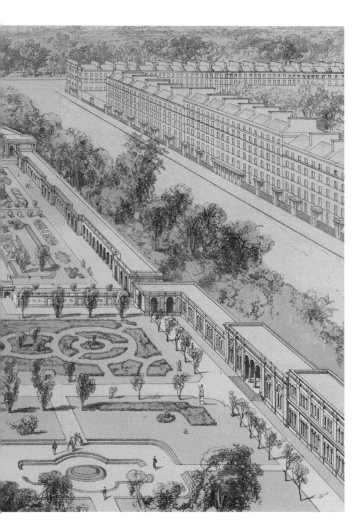

158.
Artist unknown, 'View of the
Gardens from the International
Exhibition', engraving, from
Andrew Murray, *The Book of the
Royal Horticultural Society, 1862–
1863* (1863). Royal Horticultural
Society, Lindley Collections

to the use of their membership. The Consort, on the other hand, favoured throwing
them open to the public. The society was not, however, in a position to dictate
the terms of the future use and development of the gardens, as it was constantly
short of money. It was, nonetheless, disquieted by accusations in the press that
its lavish gardens were likened to 'a very charming addition ... to the fashionable
lounges of the West-end' and a 'fine art' establishment, and acknowledged that the
smoke of Victorian London was becoming a menace to their cultivation.[63] Matters
were also made more difficult by the death of the Prince Consort in December
1861 which 'deprived the Society of strong guidance and no doubt contributed to

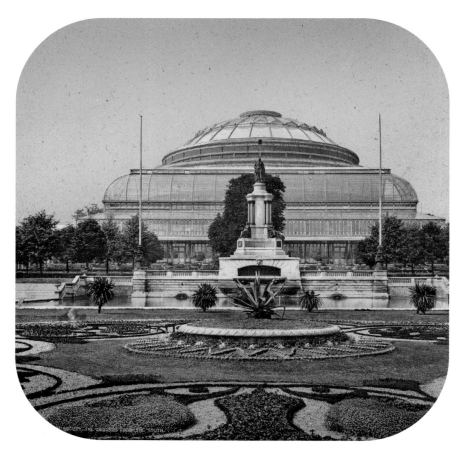

159.
Royal Horticultural Society's Kensington
Gardens, 1875–80, glass lantern slide. Royal
Horticultural Society, Lindley Collections

the subsequent decline of its fortunes and to its ultimate inauspicious departure from South Kensington'.[64] After many years of a deteriorating and often awkward relationship with the commissioners, the society finally forfeited the gardens in 1888. Within four years, Imperial Institute Road and Prince Consort Road were thrust across the former gardens, and the remainder of the site was soon obliterated by new development.

Flying the Flags of Modernism

Jonathan Glancey remarked in 2017 that Sylvia Crowe's 'balletically poised Modern garden' in the front of what was formerly the Commonwealth Institute in Kensington was the 'rarest of things' – 'an English Modern Movement urban public landscape'.[65]

The Commonwealth Institute had been founded in 1887 as the Imperial Institute and was housed in South Kensington until 1960, when changes in imperial circumstances led the government to reconsider its name and role, and the expansion of the institute's neighbour, Imperial College, precipitated its relocation to what had been '3¼ acres of rough woodland, lying between Holland Park and Kensington High Street'. It was declared at the time that the advantages of the site were that it was spacious and sufficiently isolated from other buildings to permit the architects 'to have complete freedom in their designing, uninhibited by the need to conform to neighbouring houses, offices and shops'.[66]

The replacement building was conceived by the architects Robert Matthew and Stirrat Johnson-Marshall as a 'tent in a park', or a 'park-like building'. As they were anxious to preserve the site's parkland character and to develop the street frontage 'to add a real amenity to Kensington', they proposed an extensive, open forecourt, with a 'cluster of Commonwealth flags', backed by a lower pool and lawns as a 'pleasantly peaceful break in the busy environment of the High Street' (fig. 160).[67] The input of the landscape architect Sylvia Crowe was, in her own words, 'the shaping of the lawns, the management of the water used as barriers instead of railings, the design of the paving and the arrangement of the walling and planting'. She also 'saved every tree we could possibly save, and planted a lot more'.[68]

Immediately it was opened to the public, the 'Exhibition forecourt' was hailed in the press as a 'New Square' for Kensington.[69] London's then 'newest, largest and most modernistic and imaginative building' was encompassed on three sides by water, which was compared with both a lake and a moat, and was set back behind a large lawn, so it would 'bring the park right down to the street'.[70]

If aspects of the building's experimental, hyperbolic paraboloid design were controversial, its landscaped forecourt was considered among the 'chief' of the 'many bonuses' of the new building, and its entrance approach, 'under a low canopy, through lawns and across a pool' was 'impressive' (fig. 161).[71] The route from the street was 'the great wonder' of the composition: 'the expectant wait at the end of the promenade … the joyous flags of friendly nations; the patterned paving; the open walkway; the change of angle as one crossed the bridge; the moat; the dark foyer with stained glass; [and] the explosion of space inside as the exhibition opened out in all directions under a tented roof from that magical elevated circular podium'.[72]

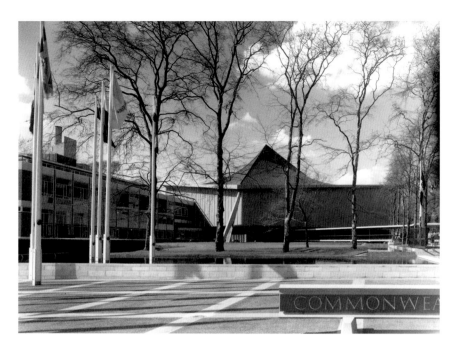

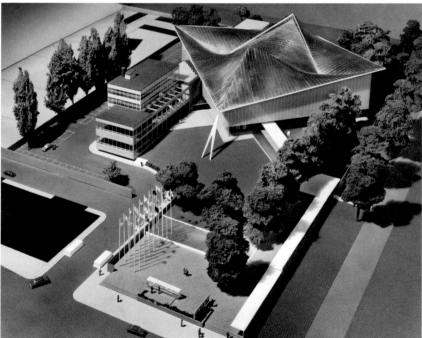

160.
Henk Snoek, the Commonwealth Institute,
Kensington, London, 1963. Architectural Press
Archive / RIBA Collections

161.
Alfred Cracknell, model of the Commonwealth
Institute, 1959. Architectural Press Archive /
RIBA Collections

The slick modernity of the gardens contrasted with 'temperate, tropical and desert' planting within the institute. This was a playful reprise to the colourful flags in the forecourt and was representative of the different flora found in the Commonwealth countries – ranging from candelabra cactus and yellow-flowering hibiscus to yellow wattle, tree ferns and palms.[73]

The institute's gardens fared well until the 1980s, after which time they began to decline through a lack of maintenance. In 2002, they were closed to the public, and, four years later, they were described as 'shamefully neglected'.[74] The site was redeveloped from 2012, and Crowe's 'magical landscaping' was superseded by a scheme that has been described in the architectural press as revealing a 'twisted perception of public benefit'.[75]

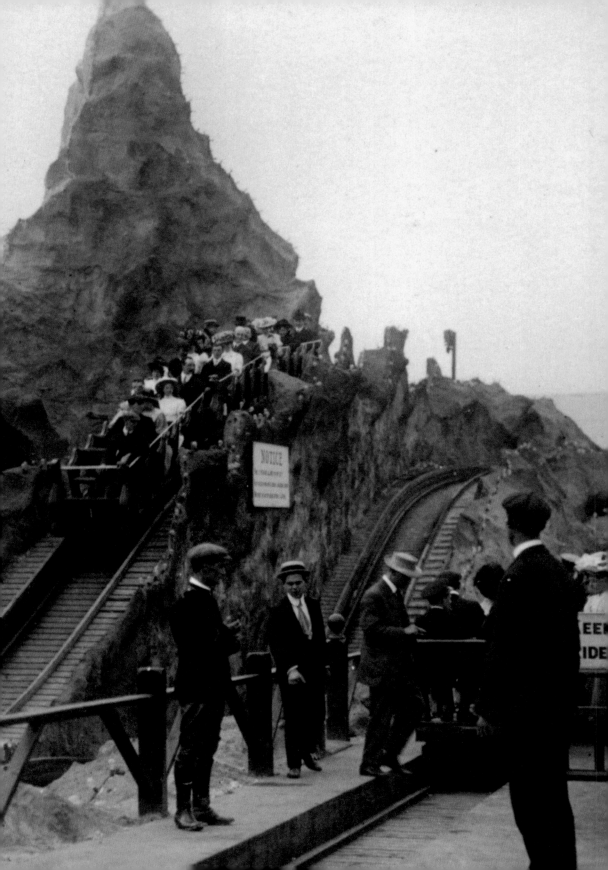

10.

Ephemeral Gardens

In Saki's short story 'The Occasional Garden' (1919), Elinor Rapsley bemoans the fact that her new town garden is a naked waste: 'too large to be ignored . . . too small to keep giraffes in', and her bedraggled and flowerless borders are ravaged by 'a congress of vegetarian cats'.[1] Enraged by the taunts of her disapproving neighbour, Gwenda Pottingdon, who possesses a 'detestably over-cultivated garden', she is encouraged by her friend the Baroness to approach O.O.S.A (the Occasional-Oasis Supply Association) to provide her with their 'emergency E.O.N' (Envy of the Neighbourhood) service in time for a lunch party she has planned for the following week. Within hours, her lugubrious patch is transformed into a dazzling and bewildering fairyland, carpeted with velvety turf, brimming with banked masses of exotic blooms and fruit trees, enclosed by luxuriant hedges, and voluptuous with a terraced fountain that abounds with slithering golden carp and a 'pagoda-like enclosure', where Japanese sand-badgers disport themselves.[2] Gwenda, who attends the lunch party, is astonished and quietly outraged by Elinor's 'miracle out of the Arabian Nights'.[3] After the lunch is over and Gwenda has departed, the temporary paradise is hastily dismantled, and the plot reverts to its former desolate state.

Some London gardens, like Elinor's, were never made to last – they were designed to be transient, to serve a particular function for a prescribed period of time, then vanish; and some, despite their fleeting lives, have greater and more enduring allure than places that have lingered for centuries.

162. (facing) Detail of fig. 175

Squares in Wartime

Many London squares have suffered indignities over the course of their long lives: some have been lost, dug up for temporary Victory Gardens or undermined by subterraneous air-raid shelters and car parks. None, however, save St James's Square, has been invaded and colonised by American soldiers.[4]

The *New York Times* announced triumphantly on 16 June 1918:

> Another cherished English tradition has been smashed by the advent of America into the war. For 200 years St James square has been regarded as sacred from all invasion. It lay green and pleasant amid some of the most stately mansions of London, but . . . today the American Y.M.C.A. has commandeered it and turned it into a first-class country club for American officers, but has done it with gentle hands. The fine equestrian statue of William III is indeed surrounded by the buildings of the Washington Inn, but not one of the century-old planer [plane] trees has been disturbed, and the wings of the structure have been so disposed as to avoid their trunks. The result is that American officers, in the very heart of London, within five minutes' walk of Trafalgar Square, have a place of their own which might be miles in the country.[5]

The Washington Inn was raised by the American YMCA in the two-acre (0.8-hectare) central garden of the metropolis's premier square at a time when efforts were being made in London to give hospitality to American soldiers, both officers and men, who were in this country on their way to or returning from the trenches during the war of 1914–18, or to provide treatment in hospitals for those who were wounded. The trustees of St James's Square agreed to hand over the garden to the YMCA on 9 October 1917 – presumably as their contribution to 'the War Effort'.

The inn was 'without question the most luxurious hostel of its kind' and must have offered a welcome respite from the devastation at the front. While it could not compare with the aristocratic splendour of the square's surrounding houses, it was 'substantially built in brick, ironwork, tiles, and wood' and boasted 110 bedrooms, hot and cold showers, a writing room and a well-appointed library and dining room, which were comfortably furnished with a grand piano, good furniture and 'engravings of famous pictures' and which, 'with their lofty beamed roofs and French windows, opening to the green turf and stately trees', were praised for giving 'the impression of being far away from the city and its dust and noise'.[6] The garden, however, was neither very capacious nor particularly attractive: a correspondent to *The Times* described 'the St. James's-square of 1913' as a 'thicket of grimy shrubs. You could not see across it. You could get no idea of its spacious dignity.' Given the size of the inn, its French windows were calculated less to enjoy the verdure of the scene than to 'look out upon the town

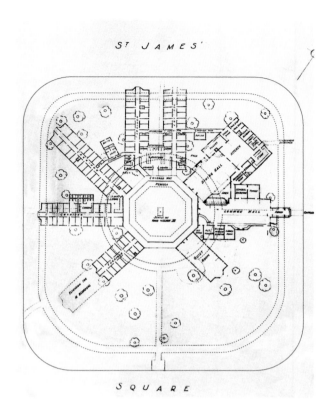

163.
S. Philip Dale, *Proposed American Y.M.C.A. Hotel for Officers St James'[s] Square*, [1917], drawing. Reproduced by kind permission of Robert Byng

residences of Lords Derby, St Albans, Strafford, Kinnaird, and Falmouth; the Hon. Waldorf Astor and the Bishop of London'.[7]

The YMCA officials compared their establishment to a monastic community: 'in the centre is a green stretch of grass with William III on his pedestal in the middle, and all around is... their cloister, only no cloister ever designed by monk made so clever a use of vines to cover its inward face. From this cloister radiate, like spokes of a wheel, the wings, which are devoted to hotel purposes' (fig. 163).[8]

The scheme was devised with careful sensitivity to the layout of the square and its garden. *The Times* reported in August 1918 that 'the trees in the centre of the square were far too precious to be cut down. The architect, being unable to dodge them, ingeniously included them in his plans, concealing the trunks with plaster but leaving a loophole for watering. It was not a new idea: the house of Ulysses in Ithaca formed a precedent' (fig. 164).[9] (The reference here, rather poignantly evoking the domestic delights of a happy marriage amid the realities of exile, however comfortable, is to Odysseus's bed in his palace. The bed was made of olive trees, which had grown into

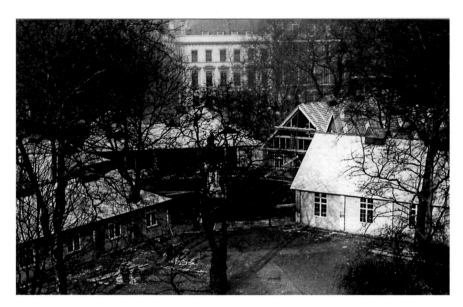

164.
Washington Inn under construction in St James's Square, *c.*1917.
Kautz Family, YMCA Archives, University of Minnesota, Minneapolis
The inn was described in the Observer *in June 1918 as 'the most picturesque example of hut-building in London'.*

the ground, so that the bed could not be moved. When Odysseus mentions this to Penelope, she sees that he must be her husband, since no one else would know this.[10])

In the event, the sprawling officers' complex in the square had a brief life: it was closed on 1 January 1921 and demolished shortly thereafter. Later that summer, the garden, which was described during its American occupation as 'all huts and typewriters and mess', was tidied up. A report in *The Times* in May 1923 noted with pleasure that 'ancient openness' had been restored by the 'spring-cleaning after the war': there was now 'space, light, grateful shadow, gentle grandeur' after many large trees had been felled, the shrubberies had been uprooted, wide lawns laid out, and magnolias and other flowering shrubs were planted around the circuit.[11]

Although the garden had been spruced up, the social character of the square had changed forever. After the war, residential occupation declined, clubs and offices moved in and, from 1933, the garden, which was once the private Elysium of the residents of the square, was thrown open to the public.

Only a stone's throw away, Trafalgar Square had also undergone an imaginative make-over at the close of the war: in October 1918, the piazza, usually awash with hurrying throngs, was metamorphosed into a desolate, ruined landscape.[12]

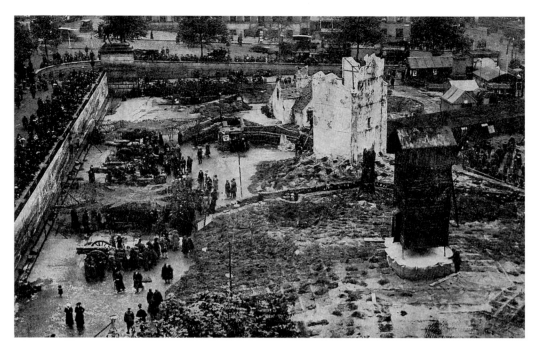

165.
Camouflage Fair, Trafalgar Square, 1918.
Private collection

The fair was described at the time as being a triumphant illustration of 'scenic display'.

This remarkable *mise-en-scène* was the backdrop to no less than two large public appeals – the Feed the Guns Campaign (7–15 October) and the Camouflage Fair (24–26 October) (fig. 165).

The Times announced on 7 October 1918 that

> Trafalgar-square has been transformed into a shell-shattered French village. For more than a week workmen have been busily engaged in reproducing a section of the Western battle front, and yesterday as the finishing touches were being given to the ruined village, their efforts were being watched with intense interest by large crowds of spectators. The battle scene which has been reproduced represents what meets the eye in every direction at the front. It depicts a ruined farmhouse, riddled with shot and shell holes, and the garden torn up and irretrievably damaged. The building stands where the ornamental fountain used to play, and is surrounded by sandbagged trenches. The Gordon statue is entirely hidden in a ruined church tower. Close by are the trunks of old trees, hollowed by nature,

which are being used for observation purposes, and standing on the basin of the west fountain is a windmill, without sails. About 20,000 sandbags have been used to make the gun emplacements and trenches, along which the visitors will walk to feed the guns with Bonds and Certificates. The breechloaders and howitzers are ranged along the north side of the square, facing the National Gallery, and each War Bond purchased will be specially stamped by a device fitted within the guns for this purpose. On the face of this wall is a huge painting representing 'the land which has been completely devastated and desolated,' ruined houses, and burning buildings.[13]

A wireless station was also erected in the square, where news from the front was issued immediately upon its arrival. A variety of fund-raising activities took place during the week-long event, from choral recitals to religious service, which helped draw in £29 million from Londoners.

Less well known, but equally compelling, was the Red Cross's Camouflage Fair, which took place nine days later in the same war-torn landscape in the square. The event was the last great 'flag day' held before the signing of the armistice on 11 November 1918, which marked the end of hostilities on the Western Front. Our Day, as it was also known, was the annual flag day of the Red Cross. Flag days, or flower days, as they were sometimes known, originated in 1912 and entailed organising respectable young women to sell representations of flowers on the streets in aid of various charities. The Red Cross was a major beneficiary of this then new form of appeal, raising almost £22 million during the period 1914–18, one third of which was raised during the annual Our Day celebrations, and half of which was raised in 1918 alone.

The Times reported on 25 September 1918 that 'a novel feature of the celebration of "Our Day" will be the Camouflage Fair, which is to be held in Trafalgar-square on October 24, 25 and 26th'. The announcement was made on the eve of the Fifth Battle of Ypres. There was to be a 'hut' at the 'Sign of the Airship', concerts and entertainments and a 'continuous cinema' to show 'interesting films, including . . . "From No Man's Land to Blighty"'.[14]

The mastermind behind the event was Lady Sybil Primrose, the eldest child of the former prime minister Archibald Primrose, 5th Earl of Rosebery. It is not known who designed the ruined landscape, which evoked the bleak and melancholy 'Old British Front' at Ypres in Flanders. Ypres had, on account of its strategic location, been the centre of intense and sustained battles between the German and Allied forces during the Great War, and, after the First Battle in 1914, when the Germans were expelled from the town, it became a symbol of Allied defiance. A clue to the identity of the square's imaginary landscape is the windmill: the ramshackle wooden structure

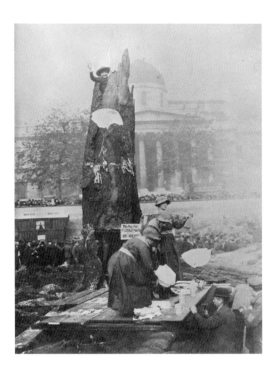

166.
Camouflage Fair, Trafalgar
Square, 1918. Library of Congress,
Washington, D.C.

resembles a traditional Flanders archetype and was probably intended to represent the mill atop Mount Scherpenberg – one of three strategic hills from which one gained a 'panorama of the Ypres battlefield which lay outspread before it, with the City of Ypres itself, white and woeful, in the distance, and the tall spire of Poperinghe as a landmark'.[15]

What are we to make of the ruined landscape created for these fund-raising campaigns of October 1918 (fig. 166)? It was not, in fact, unusual for official and semi-official events during the war to have had a scenographic quality about them. Paul Fussell remarks in *The Great War and Modern Memory* (1975) that 'the devices of the theatre were frequently invoked at home to stimulate civilian morale and to publicise the War Loan'.[16] Trudi Tate concurs, suggesting in *Modernism, History and the First World War* (1998) that these elaborately staged events encouraged civilians to enact a 'fantasy of the war as circus, or fairground, replicated in bizarre simulacra in Trafalgar Square'. Whilst some people objected to what they called "the circus business' in connection with national finance', implying that the state's money should be treated with greater dignity, they were, nonetheless, of the opinion that 'the end has justified the means', and these events served to make the British recognise their 'individual responsibility' to pay for the war.[17]

Regardless of their aims, there can be no doubt that both Feed the Guns and the Camouflage Fair were remarkable and costly productions, and their importance in the war effort to raise much-needed money and boost public morale is underscored by the fact that they took place within Trafalgar Square – the rallying point of the nation and the symbolic crossroads of the British Empire.

A Notting Hill Nuisance

The Hippodrome Racecourse in Notting Hill was among the largest ephemeral landscape initiatives undertaken in Victorian London. Formed during a pause in the building of the Ladbroke estate, and with a view to rivalling the courses at Epsom and Ascot, the Hippodrome occupied the slopes of Notting Hill and the Portobello Meadows west of Westbourne Grove. In the late summer of 1836, John Whyte took a twenty-one-year lease of 140 acres (56.7 hectares) of ground from the Ladbroke estate, and, during the following winter, he laid out a 'rather confined but good course for "flat" racing, and a steeple-chase course of over two miles'.[18] The summit of Notting Hill was designated for 'pedestrians' to watch the races, and other areas in the skirts of the hill were set aside for training grounds, the stewards' and judges' stands, paddocks and enclosures. The natural topography of the hill was in many ways suited to such a course, although the 'ground was moist, and, [so] except in the very dry seasons, unfitted for training horses'.[19] The course was opened on 3 June 1837 under the 'favouring auspices' of the Count D'Orsay and the Earl of Chesterfield.[20] A plan from 1841 shows the layout of the racecourse, and a view taken 'on the spot' by William

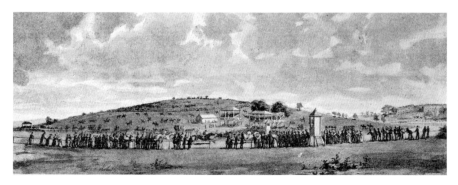

167.
William Luker, 'The Hippodrome, Notting Hill', from W. J. Loftie, *Kensington: Picturesque and Historical* (1888). Private collection

It was remarked in The Times *in March 1838 that the course was 'a nuisance to Notting-hill and the metropolis' because it was a 'serious injury to the peace and safety of the surrounding inhabitants, by corrupting their children and servants, and by rendering their workmen dissolute and idle'.*

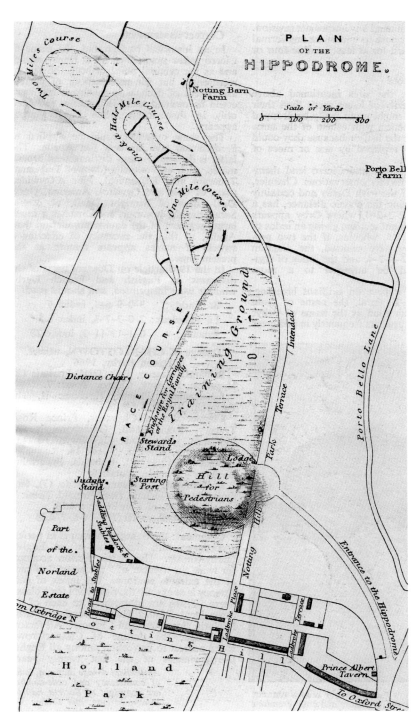

168.
'A Plan of the Hippodrome', 1841, engraving. Royal
Borough of Kensington and Chelsea Archive, London

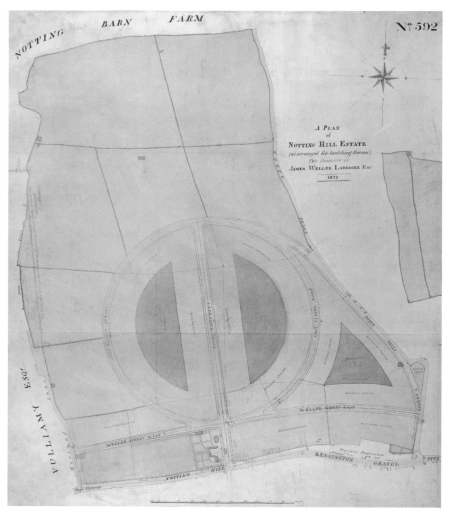

169.
Thomas Allason, *A Plan of Notting Hill Estate,*
1823, pen and pencil with watercolour wash.
London Metropolitan Archives

Luker depicts the west-facing side of the Notting Hill sprinkled with grazing horses and stands, and dozens of spectators in the middle-ground watching a race take place (figs 167 and 168).

Whyte erected a high wooden paling around the racecourse 'to exclude the rude and licentious populace of the neighbouring Potteries and elsewhere'; in so doing he also suppressed an ancient public footpath. Both actions caused considerable public

opposition, which led to litigation and to direct action on the part of some of the local inhabitants, who, armed with 'shovels, picks, saws, &c.', cut openings in the boundary fences and removed and levelled 'whatever was considered an obstruction on the path' that crossed the hill.[21]

On 29 March 1838, *The Times* published an article supplying a list of reasons why the Hippodrome was 'a nuisance to Notting-hill and the metropolis'. It gave eleven reasons for its removal, including the attraction to the neighbourhood of 'immense crowds of the idle and dissolute', the 'serious interruption to walking and travelling on the Uxbridge-road, the lines of communication with Southall, Portman, and Smithfield markets'; the 'serious injury to the numerous and respectable establishments for young ladies in this neighbourhood, who are prevented from taking their accustomed walks in the fields and Kensington-gardens; and because it is totally contrary, in its influence and effects, to the public walks in the parks, &c., for the innocent recreation of people by tempting them to sports destructive to industry and virtue, and by deluding them into scenes of gaming and debauchery'.[22] An attempt was made to salvage the reputation of the racecourse by changing its name to 'Victoria Park, Bayswater', but it closed in 1841, and the land was subsequently developed.[23]

Although the course itself has gone, a fragment of its layout is commemorated in the great arcs of Stanley and Lansdowne crescents, which crown the summit of Notting Hill and trace the rough outline of the former 'pedestrian' enclosure. The circular layout of this large area preceded the building of the racecourse and owes its origin to the surveyor and landscape gardener Thomas Allason, who, in 1823, had proposed an ingenious and inventive plan of concentric crescents and oblong 'paddocks' radiating from a central 'circus' for this 'entirely new neighbourhood' on the Ladbroke estate (fig. 169).[24]

Ecological Refuges

The prospect of creating an ecological park in central London was first mooted in 1974.[25] The pioneering environmentalist Max Nicholson persuaded his fellow members of the Environmental Committee of the London Celebrations Committee for the Queen's Silver Jubilee to create a park on an 'unsightly patch of derelict land' on the south bank of the Thames adjacent to Tower Bridge. The initiative would later become known as the William Curtis Ecological Park, named in honour of the Bermondsey-based botanist, who, in the eighteenth century, devoted himself to the study of the flora of the metropolis. The project had two overarching aims: to convert a former lorry park into a 'new Ecological Park' that was to form a link in a 'chain of environmental improvements' along the length of the Silver Jubilee Walkway; and

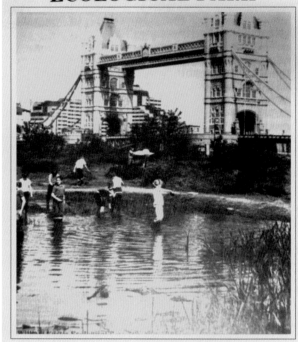

WILLIAM CURTIS ECOLOGICAL PARK

to encourage Londoners to 'look at their river and enjoy it'.[26] The Walkway was a pedestrian path that snaked its way from Leicester Square, over Lambeth Bridge and along the South Bank to Tower Bridge, ending at Tower Hill. It was intended to be a 'comprehensive, stimulating, and economical means of leaving some mark from the jubilee, not only on the face of London, but on the attitude of Londoners, and of visitors... to the London heritage in its many forms'.[27]

The concept of the park appealed to all involved on the grounds that it could be created reasonably quickly, and at little cost, and that would form a handsome setting for Tower Bridge and its environs. Two acres (0.8 hectare) of ground were therefore made available to the Trust for Urban Ecology (TRUE) by Hays Wharf and the London Borough of Southwark on a short-term lease, on the condition that the park would be temporary and that the land upon which it was to be built would be surrendered when the planned development went ahead.

The park was developed within a five-week period under the supervision of the warden-naturalist Jeremy Cotton, with generous amounts of volunteer labour, at a

cost of £2,000 (fig. 170). A large pond was excavated, into which toad and frog tadpoles and sticklebacks were introduced; innumerable shrubs and nine hundred native trees were planted around it, including alder, willow, birch and pine.[28] Nicholson is said to have been inspired by the work of Lyndis Cole, the Ecological Adviser to the Ecological Parks Trust, who had in turn been encouraged by Dutch techniques for the establishment of natural plant communities in urban areas, as seen in the *heemparken,* or native-plant gardens, across the Netherlands.[29] Cole's plan proposed the creation of a small pond and areas of mixed woodland and willow carr.

The garden opened in May 1977 to mixed reviews: some were astonished by the transformation of the former hard standing into a species-rich oasis, while others were 'depressed' by its 'unimaginative, barren urban ugliness'.[30] It was, nevertheless, an ecological triumph: within a year no less than two hundred species were alleged to be thriving within the park, and the diversity of birds had also increased. It also became a very popular attraction for local school children, over 100,000 of whom visited the park during its short lifespan (fig. 171). It is a measure of the park's success that, in anticipation of its imminent destruction in the late summer of 1985, hundreds of school children joined the 'great frog rescue', carrying '5,000 frogs to safety' before the bulldozers moved in.

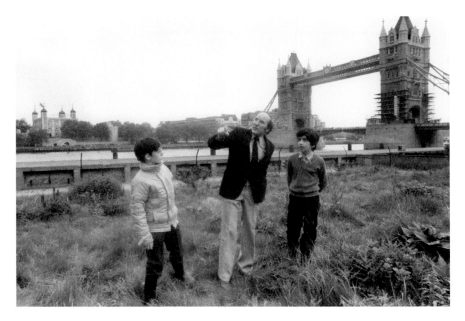

171.
David Goode, the William Curtis Ecological
Park, 21 May 1982. Private collection

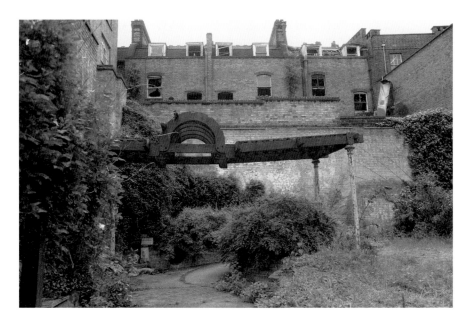

172.
Cathy Lomax, *Hackney Grove Gardens*,
1996. Collection of the artist

The park was levelled as planned, and the site is now occupied by London City Hall and Potter's Fields Park. Its demolition coincided with the *Daily Mirror*'s Living Britain Campaign, which asked the question: 'Do you care about the environment?'[31]

The Royal Town Planning Institute was also, in the early 1980s, advocating the transformation of derelict sites into urban, semi-natural parks as a means of improving inner urban areas.[32] Like TRUE, the institute acknowledged their potential to provide visual amenity and valuable education resources for local schools.[33] Among the projects it was involved with was an ecological survey of some vacant or 'wilderness sites' in Hackney, many of which had 'complex and interesting plant communities' and were 'valuable refuges for a wide range of wildlife'.

Hackney Grove Gardens was created in 1982, on the site of a burnt-out toy factory adjacent to Hackney Town Hall, by a community arts organisation in collaboration with Free Form Arts, a community arts trust. Whereas the local council was keen to develop the derelict, half-acre (0.2-hectare) sunken site into a car park, local residents petitioned the council for the provision of a 'landscaped garden'.[34] In the event, the council agreed to a short-term lease of the site while they considered options for its future development. The resultant community garden was designed and built by Free Form's 'artists-activists' in association with residents and funded by the Hackney

Planning Department. The plan was simple: steps and a gently sloping path led down from the street to a rockery and a performance space, and a serpentine path threaded through the site to form a circuit (fig. 172). The scheme was singled out for praise in the Department of the Environment's publication *Greening City Sites: Good Practice in Urban Regeneration* (1987) because of the high intensity of use it received. Despite this endorsement, the site was destroyed in 1996 to make way for Hackney Central Library and Museum.[35]

A Miniature Paradise

Of the many gardens that have played a part in temporary exhibitions and flower shows in London, one in particular made a striking contribution to the culture of the metropolis and continued for some time to occupy a place in cultural memory. The Imperial Japanese Government Commissioner, Count Hirokichi Mutsu, informed English visitors to the Japan–British Exhibition in 1910 that gardens and landscapes were so integral to Japanese daily life and daily ritual that 'Japan without gardens . . . would not be Japan at all'; the garden, he affirmed, was 'a *sine qua non* of every Japanese home. So the miniature Japan at Shepherd's Bush possesses her own gardens'.[36]

The gardens were situated in the exhibition ground at White City, Shepherd's Bush. The exhibition took place from 14 May to 29 October 1910. It made use of existing and very grandiose facilities, which had been pressed into service by the Franco–British Exhibition (1908) and the Imperial International Exhibition (1909).[37] The spectacle had been three years in the making and was the 'first great exhibition of Japanese products ever held outside the limits of the Japanese Empire'.[38] It attracted over eight million visitors and presented the British public with an up-to-date view of a country that was to many mysterious and remote.

It was observed at the time that 'perhaps nothing played so important a part in converting White City into a miniature Japan as the two admirably constructed Japanese gardens', the Garden of Peace and the Garden of the Floating Isle (figs 173 and 174).[39] Advertisements for the extravaganza suggest as much, promising visitors the prospect of exploring '150 acres of beautiful palaces, gardens and fairy scenes', of which forty acres (16 hectares) were 'under cover' and could accommodate 'over 100,000 people in rainy weather'. The Japanese and British gardens included five acres (2 hectares) of 'the enchanting gardens of Japan, with temples, bridges, and ornamental waters . . . by Nippon's greatest artists', and the 'Greatest Horticultural Display of Modern Times by leading British firms and Artist Gardeners' (fig. 175).[40]

The Japanese gardens were reviewed very favourably in the press: *le tout ensemble* was compared to 'a veritable poem and picture combined' and much was made of the

173.
'Garden of Peace, in the Japanese Gardens,
Japan–British Exhibition, [White City,]
London, 1910', postcard. Look and Learn
History Picture Archive

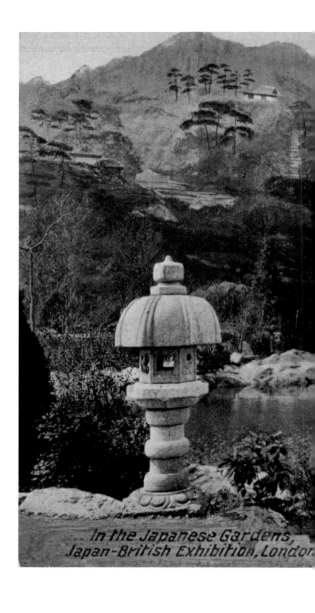

'special symbolism' of the geological specimens and the perfection of the foliage.[41]
While it was said at the time that 'some of the art features [in the general exhibition]
will only appeal to those of artistic interests', the 'marvels in horticulture' would
appeal to the 'public generally', including the 'fine collections of dwarf trees – some of
them hundreds of years old – the quaint plants and flowers trained to represent birds
and beasts and men and women'.[42] The 'model gardens and parks' were also much
admired – 'each would go on a dining-room table – with trees, lakes, brooks, bridges,

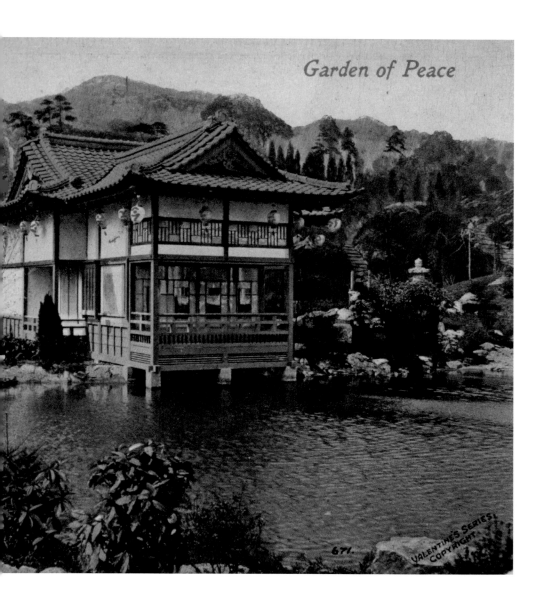

Garden of Peace

etc.'[43] – as were the 'ranges of cunningly-devised scenery representing far Japan in winter, in spring, in summer, and autumn, the illusion being as near complete as proximity will permit'.[44]

At the close of the exhibition, the Japanese gardens were presented to the British people as mementoes of Japan's participation in the event, and the Kyoto Exhibitors' Association presented a reduced replica of the Nishi-Honganji gateway to the Royal Botanic Gardens, Kew, where it remains.[45] The gardens were damaged when they

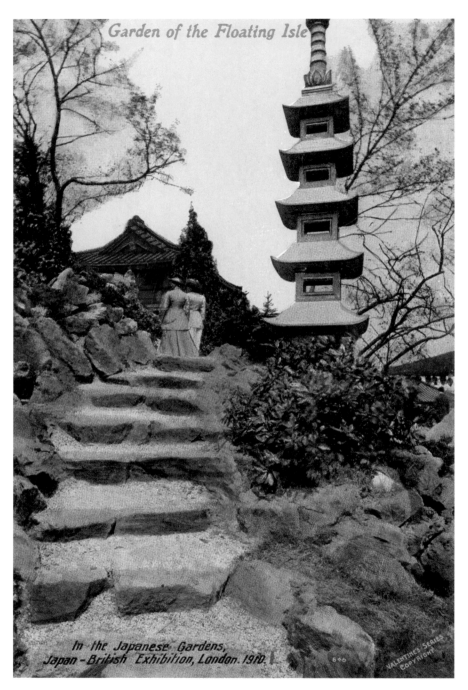

Garden of the Floating Isle

In the Japanese Gardens,
Japan–British Exhibition, London. 1910.

174.
'Garden of the Floating Isle, in the Japanese
Gardens, Japan–British Exhibition,
[White City,] London, 1910', postcard

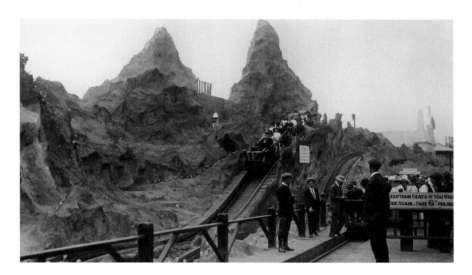

175.
'Japan–British Exhibition, 1910. Scenic Railway',
postcard. Look and Learn History Picture Archive

were occupied by the military during the First World War, and, in 1926, they were compared to a 'buried city': 'wild, and full of bird' song; while carrion crows brood maliciously over the recumbent limbs of the Flip-Flap'.[46] Although roughly one third of the site was redeveloped in the 1930s to form a housing estate (and in the 1960s to create the BBC's television studios), the Garden of Peace survived until the 1950s, when it was remodelled. What remains of the gardens was restored in 2009–10.

Although the Japanese show gardens were temporary, they had an immediate influence on contemporary English garden design: a craze for Japanese gardens developed up and down the country.[47] Many of the gardens created in this taste, however, were at best spirited yet haphazard imitations of those they sought to imitate, as an anecdote published in the *Pall Mall Gazette* in July 1913 suggests:

A wealthy landowner in [London] . . . affected with the craze for Japanese gardening, invited the Japanese Ambassador to luncheon, and afterwards showed him round the gardens and greenhouses, keeping the Japanese garden till the last as a delightful surprise. When, after admiring the beauty of all the other gardens, the Ambassador was at last taken to the imitation of the gardens of his own flowery land, he held up his hands in enthusiastic delight. 'Ah,' he exclaimed, 'this is wonderful! We have nothing like this in Japan!'[48]

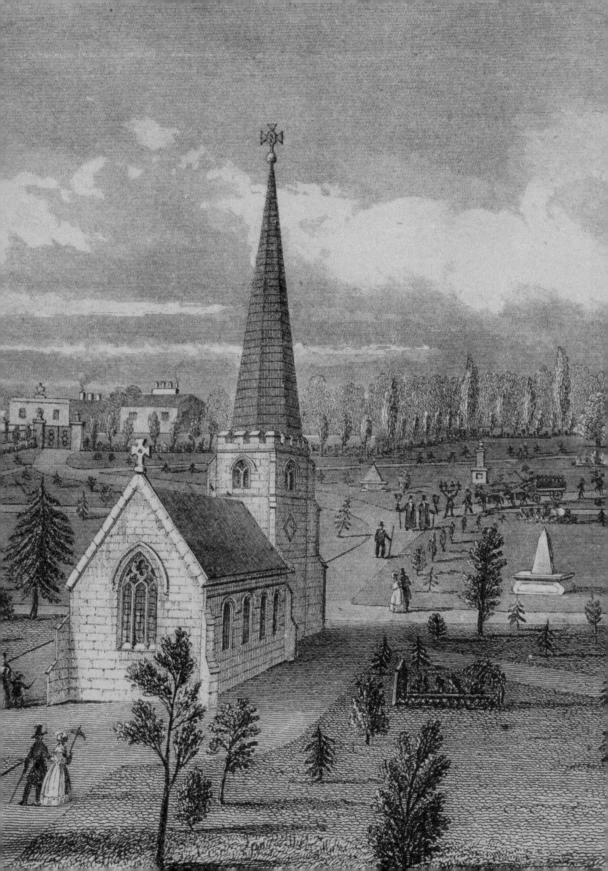

11.

Reflection and Recreation

'Yawning chasms'

Very occasionally a London garden has vanished for good reasons. This is certainly the case at Victoria Park Cemetery in Bethnal Green, which, at two and a half acres (4.6 hectares), was 'by far the largest of the private venture burial-grounds'.[1] The cemetery was 'tastefully laid out and planted' in 1845 with a view to creating a space of reflection.[2] Although purported to be the final resting place of roughly 300,000 Londoners, it was never consecrated. An advertisement from about 1850 portrays the ground dressed in what was referred to at the time as the 'cemetery style', in imitation of John Loudon's designs for Norwood Cemetery in South London and as advocated in his *On the Laying Out, Planting, and Managing of Cemeteries* (1843) (fig. 177). In Loudon's estimation, such a layout rendered a burial ground an 'attractive' source of 'amelioration or instruction' and made it a desirable place for meditation.[3] A 'garden cemetery' was not only 'beneficial to public morals, [and] to the *improvement of manners*', but was likewise 'calculated to *extend virtuous and generous feelings*'.[4]

This adoption of Loudon's approach to cemetery design suggests an attempt to create an aesthetically attractive space, and such an attempt may originally have succeeded to some degree. By 1856, however, any such attempt must have been considered a grotesque failure: the burial ground was condemned as a 'loathsome place', 'managed with disregard to health and decency', and the practices of the cemetery's director were denounced as 'really revolting'.[5] The cemetery was extremely overcrowded, and one quarter of it appeared to be 'a mass of putrefying corruption, consisting of several thousand carcases'.[6] The ground was, moreover, a resort of

176. (facing) Detail of fig. 177

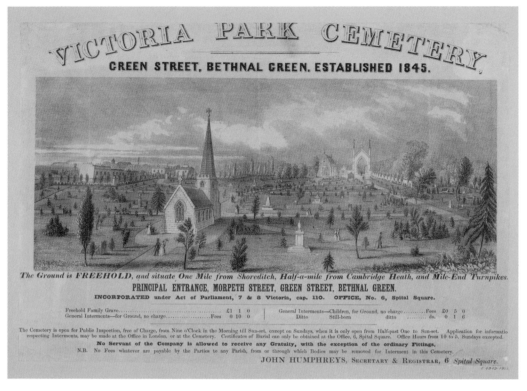

177.
'Victoria Park Cemetery, Green Street, Bethnal Green',
c.1850, wood-engraved advertisement. Victoria and Albert
Museum, London

Although the cemetery was initially 'maintained in fair order',
it was 'soon given up to the mercies of the roughs of the East End'.

'loafers and roughs of the East End, who came here to gamble and amuse themselves by the wanton destruction of the decaying property'.[7]

Before the ground was improved, it was described as 'a most dreary, neglected-looking place; the soil is heavy clay, and there used to be large wet lumps lying about all over the ground' (figs 178 and 179).[8] 'After years of negotiation and much difficulty', the Metropolitan Public Gardens Association (MPGA) secured the ground and converted the 'dreary waste of crumbling tombstones and sinking graves into a most charming little park for the people of Bethnal Green'.[9] The landscape gardener Fanny Wilkinson laid out the new public garden, which was opened in July 1894 and renamed Meath Gardens in honour of Lord Brabazon, the chairman of the MPGA, who had inherited the Earldom of Meath. J. J. Sexby, the first Chief Officer

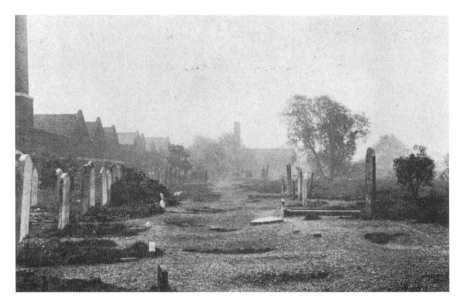

178.
Victoria Park Cemetery, from Isabella Holmes, *The London Burial Grounds* (1896). Private collection

The cemetery was in a 'neglected and deplorable condition' from about 1876 until 1893, when it was tidied up by the Metropolitan Gardens Association.

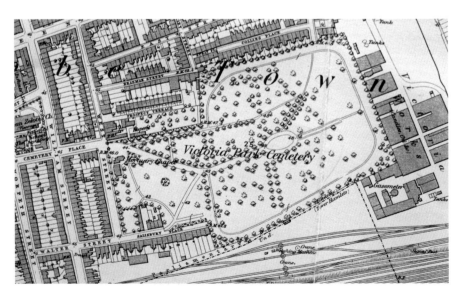

179.
Ordnance Survey, detail showing Victoria Park Cemetery, surveyed in 1870 and published in 1876. Private collection

for Parks for the London County Council, formed in 1889, reflected in 1898 that 'all who remember the gruesome state of this disused burial-ground in years past, with its yawning chasms, rank grass, and mutilated tomb-stones, will recognise what a thorough transformation has taken place'.[10]

Although parts of the park were lost to development from the 1950s to the 1990s, it still functions as a public recreation ground.

'Eden . . . in the heart of Whitechapel'

An article in the *London Hospital Gazette* in June 1899, allegedly written by a small boy, declared, 'Eden, as we know it, is a fertile and happy region situated in the heart of Whitechapel', 'before you stretches a beautiful country scene, with trees and flowers, birds and song; here and there a grassy mound, on which sweet maidens lie in various attitudes of repose, some sleeping, some thinking, some reading – all resting . . . in your mind you are in the gardens of the Pera Palace at Constantinople . . . '.[11]

He was describing the 'Nurses' Garden', or the so-called 'Garden of Eden' that had been established in 1898 within the grounds of what is now known as the Royal London Hospital in Whitechapel – then the largest voluntary hospital in the kingdom, in one of the poorest parts of the metropolis (figs 180 and 181). This was not the first time that an area within the hospital precincts had been set aside for reflection and recuperation and dubbed a terrestrial paradise: in September 1898, an 'irreverent youth' had invoked the same metaphor when describing, 'in days gone by', a verdant retreat behind St Philip's, the church situated next to the original hospital building.[12]

The Garden of Eden was the third garden to take shape on its diminutive plot: it had been preceded by a modest almshouse garden and latterly by a public garden. The first garden had been established in 1822, when the Brewers' Company erected and endowed a row of six almshouses, forming a 'picturesque structure, in a neat and effective style of domestic architecture'.[13] The inmates of John Baker junior's Almshouses, also known as the Brewers' Almshouses, were dictated by terms of the benefaction to be 'six poor female parishioners of Christchurch, either widows or unmarried, fifty years of age or upwards, "of good life and conversation"'.[14] From the early 1880s, the gardens had become 'much too large' for the inmates to cultivate, so they were 'taken in hand' by the Revd Sidney Vacher, director of the Chaplaincy Department of the London Hospital, who, in 1882, threw them open to the public.[15] The newly formed 'People's Garden' and children's playground were described in 1885 as 'a green quiet spot where you may fancy yourself "Far from the busy haunts of men." It is truly *multum in parvo*, for so much has been made of 2,500 square yards that you are, with a little stretch of the imagination, in a miniature Jardin des Plantes'.[16] It was a medley of 'mounds, walks, slopes, and excavations', had a brook

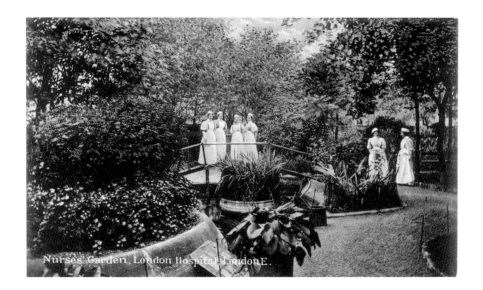

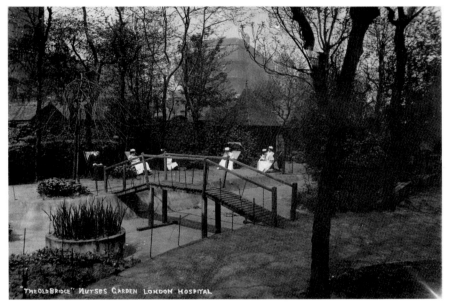

180.
'Nurses' Garden, London Hospital, London E.',
c.1905, postcard. London Borough of Tower
Hamlets, Local History Library and Archives

*The site of such a garden in the 'heart of
Whitechapel' was described in 1917 as 'fantastic
and unreal'.*

181.
'"The Old Bridge", Nurses' Garden, London
Hospital', before 1914, postcard. Barts Health
NHS Trust Archives and Museums, London

*A French visitor to the gardens in about 1907, who
was charmed by their peace and repose, compared
them with an 'Ile inconnue' (undiscovered country).*

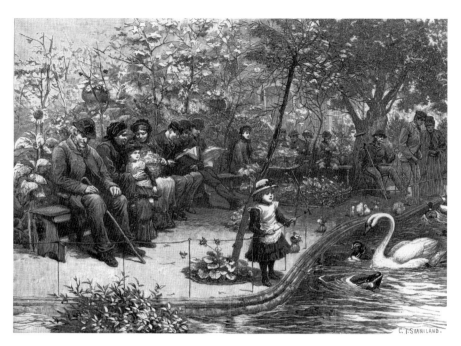

182.
C. J. Staniland, 'The Public Garden of the Brewery
Company at Stepney', steel engraving, from
The Graphic, 19 July 1884. London Borough of Tower
Hamlets, Local History Library and Archives

and a pond containing 'gold fish, dace, carp, and roach', as well as a fountain, an aviary with parrots, and a fernery. The little oasis 'proved a great boon to the neighbourhood, affording… to hundreds of men and women a means of escape from the coarseness, the dirt, and the disorder which seem to be inseparable from the lot of the poor' (fig. 182).[17]

In the late 1890s, the garden became a casualty of the hospital's expansion: the land was purchased from the Brewers' Company, the almshouses pulled down and a new 'nurses' home' was built to the east of the gardens to accommodate one hundred nurses.[18] When the former public garden re-opened in 1898, it was renamed the Sisters' or Nurses' Garden and became the exclusive resort of the hospital's nursing staff. It was praised in the *London Hospital Gazette* as 'cleverly laid out and as retired as existed anywhere': 'The Water, with its rustic bridge, the fernery, aviary etc., are … picturesque. There are hammock-chairs, and more sheltered seats, and, lastly, a "penny-in-the-slot" machine furnishes boiling water for the tea-parties which are of frequent occurrence'.[19] The sisters and nurses spent 'many restful hours' in this

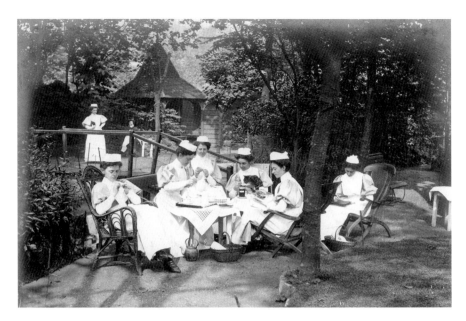

183.
The Nurses' Garden at the London Hospital,
Whitechapel, c.1905, postcard. Barts Health
NHS Trust Archives and Museums, London

'favoured spot', and its strict exclusivity, like the locked gardens of the neighbouring garden squares, was a closely guarded privilege, as it was said at the time that the 'majority [of the hospital staff] realise that the chief claim of the place would disappear if "everybody could take in anybody"' (fig. 183).[20]

From 1914, this 'peaceful, picturesque garden' for 'worn-out nurses', the layout of which had been inspired by 'a willow-pattern plate', began to suffer from a series of encroachments, first by the 'absolutely necessary enlargement of the Laundry'[21] and then by the nurses' swimming baths – hailed in 1937 as 'the most up-to-date and luxurious swimming bath in the Metropolis'.[22] It staggered on, in spite of bomb damage inflicted during the Second World War, until 1961, when it was sacrificed to make way for the new Institute of Pathology.[23]

Agitated Repose

Just down the road from the London Hospital, and overshadowed by tall buildings, lies what remains of the Novo or Neuvo Beth Chaim Cemetery – one of only two exclusively Sephardi cemeteries remaining in England, and one of five pre-1830

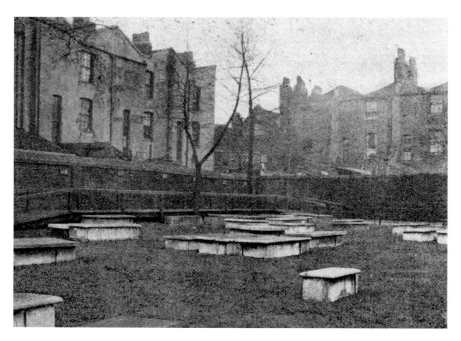

184.
The Nuevo Cemetery, Mile End Road, Stepney, from Isabella Holmes, *The London Burial Grounds* (1896). Private collection

The cemetery's distinctive flat gravestones represent the equality of all people in death.

extant Jewish cemeteries in the East End (fig. 184). Its presence supplies a 'visible link to one of the oldest immigrant communities to settle in the Mile End area of east London'.[24] The ground for this Spanish and Portuguese cemetery was acquired by the merchants Gabriel Lopes and Joseph da Costa in 1724. It was then known as Cherry Tree or Hardy's garden, and it remained an orchard until it was enclosed by walls in 1733 (fig. 185). The cemetery was expanded in 1849 and remained in use until the end of the nineteenth century. During the Second World War, it sustained bomb damage, which destroyed eight graves and left large craters.

With the exception of what remains of its brick perimeter walls and its characteristic flat ledger stones, typical of Sephardi cemeteries (though rare in England),[25] the landscaping of the cemetery has always been unremarkable – indeed, Isabella Holmes observed in *The London Burial Grounds* (1896) that, though it was 'neatly kept' it was 'bare of trees or shrubs, but is divided into plots, with paths between'.[26] The MPGA, which was, at the time, keen to see all little churchyards and burial grounds 'provided with seats' and was 'always ready to put them in order', appears to have contemplated securing the Nuevo and other Jewish burial grounds in London with

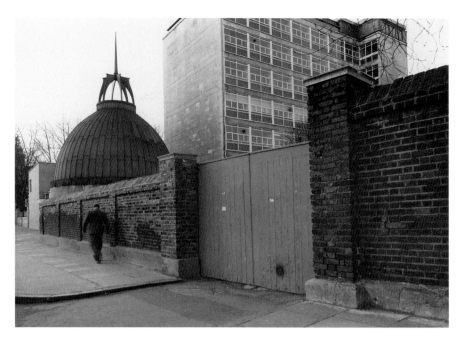

185.
Eighteenth-century south boundary wall of
the Nuevo Cemetery, Mile End Road, 1976.
London Metropolitan Archives

a view to converting them into 'public gardens'. They were, however, rebuffed, as the 'feeling of the community is against it'. [27]

Although Jewish cemeteries are founded as sacred places in perpetuity, which ought not to be disturbed,[28] this did not prevent the partial destruction of the Nuevo burial ground. Queen Mary College purchased the site in 1972 for the purpose of extending the college premises and was granted permission to do so under the 1973 Queen Mary College Act. The following year, the remains of around nine thousand bodies from the ground's oldest section, dating from 1733 to 1876, were removed and were reinterred in mass graves in the Sephardi Cemetery in Brentwood, Essex. In 2012, the Nuevo burial ground was renovated, and, in 2014, it was placed on the *Register of Parks and Gardens of Special Historic Interest* by English Heritage as a site of important historic interest (fig. 186).

It seems inconceivable that such an act of vandalism could take place today; and yet, only recently, another historic London burial ground has bitten the dust, and once again within a stone's throw of Euston Station – that veritable Bermuda Triangle of historic gardens.

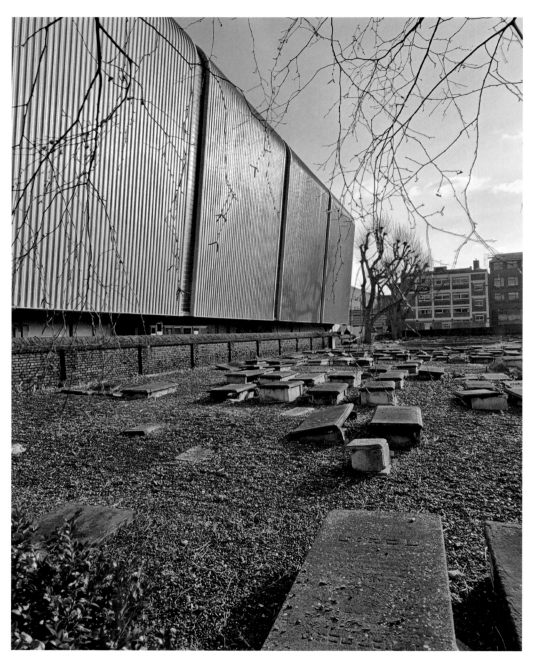

186.
Charles Saumarez Smith, the Nuevo Cemetery,
Stepney, 2024. Private collection

*In 1972/3 a Private Members Bill gave statutory
authorisation for the removal of an estimated 9,000
bodies from this burial ground. They were re-interred in
Brentwood Cemetery.*

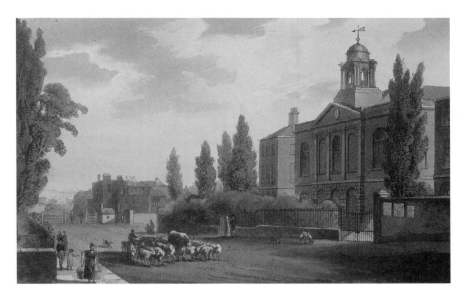

187.
Artist unknown, *Tottenham-Court Road Turnpike & St. James's Chapel*, 1812, aquatint. London Metropolitan Archives
This extramural chapel and burial ground were first threatened by the expansion of Euston Station in the late 1860s.

St James's Gardens were a casualty of the redevelopment of the station for the proposed – and now semi-aborted – high-speed railway (HS2) link between London and the West Midlands (previously projected to continue to the North). The former gardens were established in about 1788 as an overflow 'burying ground' for the Church of St James's, Piccadilly. The then large, rectangular ground was laid out amidst open fields, on the east side of the Tottenham Court Road Turnpike, now Hampstead Road.

Like so many burial grounds, it is better known for the people buried within its precincts than for the grounds themselves: here are the remains of the painters George Morland and John Hoppner, the religious agitator Lord George Gordon, the auctioneer James Christie, the explorer Captain Matthew Flinders and the pugilist Bill Richmond.

The chapel of ease, which was erected to the designs of James Wyatt, was the subject of several topographical views in the nineteenth century, none of which documents the burial ground. The chapel's forecourt is, however, depicted in 1812 as enclosed by a brick wall surmounted by railings, framed by towering fastigiate trees and screened by a luxuriant plantation (fig. 187) and was described as giving 'great

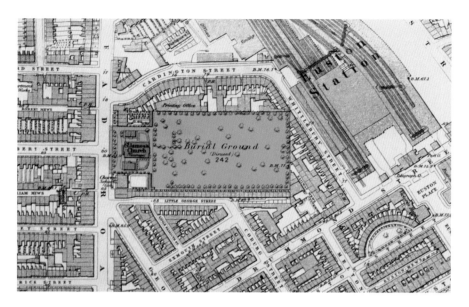

188.
Ordnance Survey, detail showing St James's Gardens
(marked in red), surveyed in 1870 and published in 1876.
Private collection

additional consequence to the appearance of the whole'.[29] This garden was a rare oasis
on what was now a 'prodigious street', since the chapel had 'recently witnessed one
of those transformations of fields into houses, produced in every direction around
the metropolis'.[30]

Later, in 1869, the ground, which had been closed for burials since 1853, was
reported to be in 'a most deplorable state, and ... resorted to by all kinds of bad
characters'.[31] It had suffered its first encroachment with the erection of the London
Temperance Hospital in 1873, and, a decade later, the North-Western Railway
proposed to appropriate 'two out of three acres' of the ground to create a new street
and to enlarge their station accommodation at Euston (fig. 188).[32] Lord Brabazon
protested on behalf of the MPGA that this would be a great loss to the city's 'breathing
spaces', and that the precedent would encourage covetous speculative builders to
prey on other vulnerable open spaces, which were urgently needed as 'places of rest
or recreation' for the 'stifled city population'.[33] In the event, the railway company was
allowed to encroach upon one third of the ground on the condition that they lay out
the 'remainder at their expense as a garden for the enjoyment of the public' – a decision
that was described by a correspondent to the *Pall Mall Gazette* in May 1883 as 'at once
so mischievous and so absurd'.[34] The chapel was demolished in 1965, and the gardens

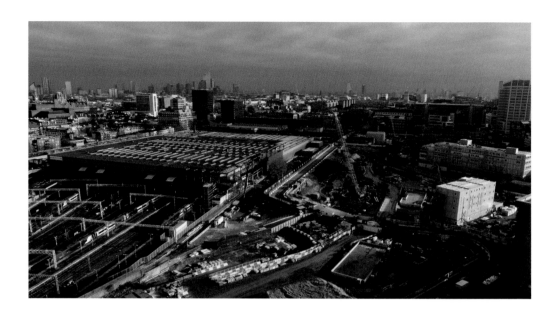

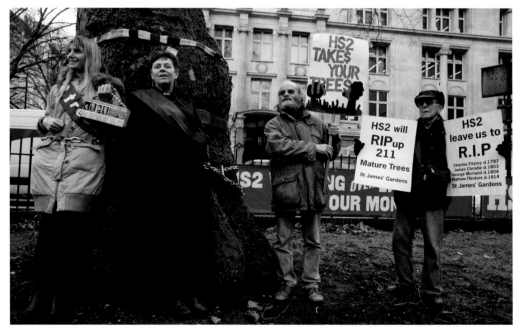

189.
Aerial view of St James's Gardens, 2023

190.
The vicar of St Pancras, Anne Stevens (second from left), chained to a large plane tree in Euston Square Gardens, 12 January 2018

Stevens was one of many that took part in protests against the clearing of trees to make way for building works on the HS2 rail network.

continued to be a popular place of public resort until they were closed in 2017, amid impassioned protests, which included a strategy of 'yarn-bombing', in which local campaigners knitted sashes to tie around threatened trees (fig. 189).[35] Roughly one hundred trees were felled and the remains of 60,000 bodies were excavated to enable building works for the proposed railway link. A large portion of neighbouring Euston Square Gardens was also destroyed, and over a dozen of its mature plane trees were felled to make way for a temporary taxi rank and cycle stands (fig. 190).

The recent sacrifice of the last remaining vestiges of the late eighteenth-century 'burying place' *cum* Victorian 'public garden' is a tragic loss, not only to St Pancras but to the whole of London. As a correspondent to *The Times* declared on the eve of the railway's assault on the same burial ground in May 1883, 'every little space where the wind can freely circulate, and air charged with human breath and all the vapours emanating from human habitations can, in however small a degree, be purified by contact with leaves and grass, is of vital importance to the health of London'.[36]

Notes

Preface

1 Accompanied by an exhibition catalogue: *London's Pride*, ed. Mireille Galinou (1990), with essays by Sir Roy Strong, Vanessa Harding, John Harris, Tessa Murdoch, Peter Stott, Hazel Forsyth, Brent Elliot, Celina Fox, Todd Longstaffe-Gowan, et al.

2 Sally Williams is Deputy Editor. The London Gardens Trust was launched as an independent charitable trust at the Chelsea Flower Show in May 1994. It is the county gardens trust for Greater London.

3 David Lambert, private communication to Todd Longstaffe-Gowan, December 2022.

Introduction

1 'Great Expectations', *All the Year Round*, vol. 4, 9 March 1861, p. 510.

2 'Great Expectations', *All the Year Round*, vol. 4, 16 March 1861, p. 530.

3 'Great Expectations', *All the Year Round*, vol. 4, 16 March 1861, p. 530; Mr Wemmick's gothick fortress is thought by some to have been inspired by the re-creation of the fortifications of Sebastopol at the Surrey Zoological Gardens.

4 'Great Expectations', *All the Year Round*, vol. 4, 16 March 1861, pp. 530–31.

5 'Great Expectations', *All the Year Round*, vol. 4, 16 March 1861, p. 531.

6 J. C. Loudon, *The Landscape Gardening and Landscape Architecture of the Late Humphry Repton, Esq.* (1840), p. 536.

7 'Mr. Steadman on Poetry', *The Critic*, 4 April 1891, p. 183.

8 Beate Fricke and Aden Kumler, ed., *Destroyed – Disappeared – Lost – Never Were* (2022), p. 5.

9 Fricke and Kumler, *Destroyed*, p. 5.

10 Fricke and Kumler, *Destroyed*, pp. 4, 5.

11 *Thraliana: The Diary of Mrs. Hester Lynch Thrale (later Mrs. Piozzi), 1776–1809*, ed. Katherine C. Balderston, 2 vols (1942), vol. 1, p. 369.

1 Riverside Gardens

1 'The Last Days at Northumberland House', *Shields Daily Gazette*, 18 July 1874, p. 3. The house and garden, which were not generally accessible, were 'shown to the public' prior to the demolition.

2 'Demolition of Northumberland House', *North Devon Advertiser*, 24 July 1874, p. 2.

3 *Central Somerset Gazette*, 31 July 1875, p. 6.

4 See Anthony Emery, *Greater Mediaeval Houses of England and Wales 1300–1500*, 30 vols (1996–2006), vol. 3, p. 217. I am grateful to Paula Henderson for this reference.

5 Thomas Fairchild, *The City Gardener* (1722), p. 44.

6 Fairchild, *City Gardener*, p. 44.

7 Fairchild, *City Gardener*, p. 45.

8 'Prothalamion', *The Yale Edition of the Shorter Poems of Edmund Spencer*, ed. W. A. Oram et al. (1989), p. 768.

9 C. L. Kingsford, 'Essex House, formerly Leicester House and Exeter Inn', *Archaeologia*, vol. 73 (1923), p. 23; Frederic Madden et al., eds, *Collectanea Topographica et Genealogica*, vol. 8 (1843), pp. 309–12.

10 Sally Jeffery, 'The Career of John Rose, Gardener (1619–77)', *Garden History*, vol. 48, no. 2, winter 2020, pp. 187, 194.

11 Kingsford, 'Essex House', pp. 16–17.

12 Only Somerset House, Burghley House, Salisbury House and Northampton House had a presence on Strand.

13 Manolo Guerci, *London's 'Golden Mile': The Great Houses of the Strand 1550–1650* (2021), p. 38.

14 Anastassia Novikova, 'Virtuosity and Declensions of Virtue: Thomas Arundel and Aletheia Talbot seen by Virtue of a Portrait Pair by Daniel Mytens and a Treatise by Franciscus Junius', *Nederlands Kunsthistorisch Jaarboek*, vol. 54, 2003, p. 325.

15 Guerci, *London's 'Golden Mile'*, p. 46.

16 See Heather Warne, ed., *The Duke of Norfolk's Deeds at Arundel Castle: Properties in London and Middlesex, 1154–1917* (2010), pp. 38, 43.

17 Guerci, *London's 'Golden Mile'*, p. 53.

18 John Bold, *John Webb: Architectural Theory and Practice in the Seventeenth Century* (1989), p. 74. Guerci affirms that Somerset House 'set the pace chronologically, stylistically and typographically for a number of other mansions, from the near-contemporary Burghley House to the early seventeenth-century Northampton (Northumberland) House (Guerci, *London's 'Golden Mile'*, p. 55).

19 Simon Thurley, *Somerset House: The History* (2009), p. 31.

20 Johann Wilhelm Neumayr, quoted in Luke Morgan, *Nature as Model: Salomon de Caus and Early Seventeenth-Century Landscape Design* (2007), pp. 112–13.

21 The statuary from this fountain now adorns the Diana Fountain in Bushy Park.

22 John Houghton, *Husbandry and Trade Improv'd* (1727), p. 223.

23 *London and its Environs Described*, 6 vols (1761), vol. 6, p. 42.

24 George Reeves, *A New History of London* (1764), p. 119; *Letters from a Moor at London to His Friend at Tunis* (1736), p. 104.

25 Robert Seymour, *A Survey of the Cities of London and Westminster, Borough of Southwark and Parts Adjacent*, 2 vols (1735), vol. 2, p. 683.

26 Thomas Salmon, *Modern History: or, The Present State of All Nations* (1733), p. 56.

27 *London and its Environs Described*, p. 42.

28 *Leigh's New Picture of London* (1822), p. 250.

29 Guerci, *London's 'Golden Mile'*, p. 2.

30 See C. Paul Christianson, *The Riverside Gardens of Thomas More's London* (2005), pp. 50–62.

31 Christy Anderson, 'The Lost Palace of Whitehall, Heinz Gallery, Royal Institute of British Architects, London', exhibition review, *Journal of the Society of Architectural Historians*, vol. 58, no. 2, June 1999, p. 201.

32 Samuel de Sorbière, *A Voyage to England* (1708), p. 16. The first French edition of this work was published in 1664.

33 Francis Line, *An explication of the diall sett up in the Kings garden at London, an. 1669 in which very many sorts of dyalls are conteined …* (1673), preface.

34 Edward Chamberlayne, *Angliae Notitia; or, The Present State of England* (1700), p. 363.

35 *Daily Courant*, 1 February 1707, p. 2; *Daily Courant*, 8 February 1707, p. 2.

36 The pub burnt down in 1756.

37 Richard Bradley, *New Improvements on Planting and Gardening* (1718), pp. 260–61. Virginian locust is known as *Robinia pseudoacacia*.

38 Fairchild, *City Gardener*, p. 17.

39 T. Luckman, *The Book of Martyrs: or The History of Paganism and Popery* (1764), p. 410; William Oldys, *The Life of Sir Walter Ralegh from his Birth to his Death on the Scaffold* (1740), p. 516.

40 *Evening Post*, 16 July 1724, p. 2.

41 The presence of Repton's garden was discovered by Stephen Daniels in 2018. See Stephen Daniels, 'From the Speaker's Garden: Repton's Designs on Westminster', *London Gardener*, vol. 23, 2019, pp. 74–85.

42 J. M. Crook, *The History of the King's Works: 1782–1851*, vol. 6 (1973), p. 518.

43 Daniels, 'From the Speaker's Garden', p. 78; Crook, *History of the King's Works*, p. 517.

44 'Improvements in Westminster', *Saint James's Chronicle*, 20 September 1808, p. 3; *Morning Advertiser*, 13 June 1808, p. 2; *Bell's Weekly Messenger*, 10 July 1808, p. 7.

45 'Including designs for the grounds of Carlton House with a vista of Westminster Abbey, for Cadogan, Russell and Bloomsbury Squares and one to convert Burlington House in Piccadilly … into a residential square with shops'. Daniels, 'From the Speaker's Garden', p. 77.

46 *Morning Herald*, 14 April 1810, p. 3. The River Fencibles were regiments made up of sailors on the River Thames and other southern English towns and cities.

47 Roy Strong, *The Renaissance Garden in England* (1979), p. 23.

48 Strong, *Renaissance Garden in England*, p. 23; John Harvey, *Mediaeval Gardens* (1981), p. 135.

49 Alexander Marr, '"A Duche graver sent for": Cornelis Boel, Salomon de Caus, and the

production of *La perspective avec la raison des ombres et mirors*, in *Prince Henry Revived: Image and Exemplarity in Early Modern England*, ed. Timothy Wilks (2007), p. 231.

50 J. M[axwell], *The Laudable Life, and Deplorable Death, of our Late Peerlesse Prince Henry* (1612), 22.

51 Paula Henderson, *The Tudor House and Garden: Architecture and Landscape in the Sixteenth and Early Seventeenth Centuries* (2005), p. 103; Roy Strong, *The Renaissance Garden in England* (1979), pp. 97–103. Mountain Jennings was Robert Cecil's gardener.

52 Luke Morgan, '"Delight unto Al Sencez (if Al Can Take)": Tudor and Stuart Garden Design', in *The Oxford Handbook of the Age of Shakespeare*, ed. Robert Malcolm Smuts (2016), p. 692. The plan was rediscovered in 1998 by Sabine Eiche in the Archivio di Stato in Florence (Miscellanea Medicea 93, ins. 3, no. 106). Robert Cowie and John Cloake, 'An Archaeological Survey of Richmond Palace, Surrey', *Post-Mediaeval Archaeology*, vol. 35, 2001, p. 4.

53 Henderson, *The Tudor House and Garden*, pp. 107.

54 Strong, *Renaissance Garden*, p. 98.

55 Strong, *Renaissance Garden*, pp. 100–1.

56 *The Diary of John Evelyn*, ed. E. S. de Beer, 6 vols (1955), vol. 3, pp. 58–9 (10 February 1652). The 'Usurpers' are, of course, Oliver Cromwell and his government.

57 John Evelyn, *Sylva, or A discourse of Forest-Trees and the Propagation of Timber* (2nd edn, 1670), p. 128; Prudence Leith-Ross. 'The Garden of John Evelyn at Deptford', *Garden History*, vol. 25, no. 2, winter 1997, p. 138.

58 Evelyn visited Morin in 1644 and again in 1651.

59 Quoted from Prudence Leith-Ross, 'A Seventeenth-century Garden in Paris', *Garden History*, vol. 21, no. 2 (1993), p. 153.

60 Quoted in P. Leith-Ross, 'The Garden of John Evelyn at Deptford', *Garden History*, vol. 25, no. 2, 1997, p. 138.

61 *Diary of John Evelyn*, ed. John Bray, 4 vols (1879), vol. 1, p. lxxii.

62 'John Evelyn', *The Gardeners' Chronicle*, 16 November 1895, p. 576.

63 John Dixon Hunt and Peter Willis, eds, *The Genius of the Place: The English Landscape Garden 1620–1820* (1975), p. 57.

64 Thomas Nash, *Christs Teares over Jerusalem* (1613; first published 1593), pp. 157–8.

65 Thomas Fuller, *The Holy State, book V* (1642), p. 360.

66 Paula Henderson, 'Public Pleasure Gardens in Elizabethan England: Spring Gardens in Westminster and Paris Gardens in Southwark', *London Gardener*, vol. 17, 2012–13, p. 22.

67 Henderson, 'Public Pleasure Gardens in Elizabethan England', p. 22.

68 A 'leaguer' is a military camp, and especially one engaged in a siege.

69 *Victoria County History of Surrey*, vol. 4, p. 150.

2 The Animated Garden

1 See Christopher Plumb, *The Georgian Menagerie: Exotic Animals in Eighteenth-Century London* (2015), Caroline Grigson, *Menagerie: The History of Exotic Animals in England* (2016), and Hannah Velten, *Beastly London: A History of Animals in the City* (2013).

2 James Rennie, *The Menageries: Quadrupeds, described and drawn from Living Subjects* (1829), pp. 28, 25.

3 Rennie, *Menageries*, p. 26.

4 Rennie, *Menageries*, pp. 26, 33.

5 Rennie, *Menageries*, p. 26.

6 Grigson, *Menagerie*, p. 340

7 George Edwards, *Gleanings of Natural History*, pt 2 (1760), p. 123

8 *Public Advertiser*, 23 January 1766, p.3; *Public Advertiser*, 19 February 1767, p. 3.

9 *Lloyd's Evening Post*, 2–4 January 1775, p. 8.

10 British Museum, Prints and Drawings, Draft Trade Card, Heal,14.2.

11 *Morning Post*, 29 June 1807, p. 3.

12 *British Press*, 7 March 1808, p. 1.

13 Quoted in Samuel Palmer, *St Pancras: Being Antiquarian, Topographical, and*

Biographical Memoranda, relating to the Extensive Metropolitan Parish of St. Pancras, Middlesex (1870), p. 206.

14 J. C. Loudon, *The Landscape Gardening and Landscape Architecture of the Late Humphry Repton Esq.* (1840), pp. 329–30.

15 Loudon, *Landscape Gardening*, p. 329.

16 Stephen Paget, *John Hunter: Man of Science and Surgeon 1723–93* (1897), p. 86.

17 Daniel Lysons, *The Environs of London*, 5 vols (1792), vol. 3, p. 181.

18 Paget, *John Hunter*, p. 86.

19 *St James's Chronicle, or the British Evening Post*, 27–29 August 1793, p. 4.

20 Paget, *John Hunter*, p. 86.

21 Rennie, *Menageries*, p. 26.

22 Paget, *John Hunter*, p. 239.

23 William Jerdan, *National Portrait Gallery of Illustrious and Eminent Personages of the Nineteenth Century*, 5 vols (1830–34), vol. 5, p. 9.

24 John Flint South, *Memorials of John Flint South: Twice President of the Royal College of Surgeons, and Surgeon to St. Thomas's Hospital… collected by Rev. Charles Lett Feltoe, M.A.* (1884), p. 106.

25 Soane Museum Archive, Private correspondence, ref. 1.B.18.1.

26 Translated and quoted in Roy Strong, *The Renaissance Garden in England* (1979), p. 96, n.10.

27 John O'Keeffe, *Recollections of the Life of John O'Keeffe*, 2 vols (1827), vol. 1, p. 6.

28 Soane Museum Archive, Private correspondence, ref. 1.B.18.1.

29 *A Companion to the Royal Surrey Zoological Gardens* (2nd edn, *c.*1834). I am grateful to Chris Stork for this reference. It is tempting to surmise that the name 'Eagle Rock' derives from the eponymous 'intimidating series of jutting crags' which looms above the River Dart in Devon. This, like Brookes's original confection, possesses an overhanging ledge that spurts water 'not far short of a waterfall' (Guy Shrubsole, *The Lost Rainforests of Britain* (2022), p. 47).

30 *Sun*, 22 July 1844, p. 6; *Morning Advertiser*, 12 May 1846, p. 3. The Zoological Gardens became known as 'Royal' in 1834.

31 *Morning Post*, 18 May 1833, p. 3; *Weekly Times*, 4 September 1831, p. 3.

32 'Miscellaneous Intelligence', *Gardener's Magazine*, vol. 8, no. 40 (1832), p. 594; Charles Frederick Partington, *National History and Views of London and its Environs* (1834), p. 213.

33 'Plan of a Flower Garden', *Paxton's Magazine of Botany, and Register of Flowering Plants*, vol. 1 (1834), p. 186.

34 'Surrey Zoological-Gardens, *The Times*, 14 June 1837, p. 6; *Sun*, 22 June 1843, p. 6.

35 *Railway Bell and London Advertiser*, 18 July 1846, p. 8.

36 'Royal Surrey Zoological Gardens', *Sun*, 21 June 1843, p. 6.

37 'Miscellanea', *Atlas*, 10 June 1843, p. 6.

38 *Morning Herald*, 17 May 1849, p. 5; 'New Picture-Model at the Surrey Zoological Gardens', *Illustrated London News*, 10 June 1843, p. 396.

39 'Lines composed after visiting Purland's Monastic Village Aviary, in Wilson Street, Finsbury', *Morning Advertiser*, 27 April 1832, p. 1.

40 *Morning Post*, 18 May 1827, p. 3

41 'Antiquarian Village Aviary', *The Mirror of Literature, Amusement and Instruction*, 30 May 1840, p. 362; A. R. Wallace, *My Life. A Record of Events and Opinions* (1905), p. 75.

42 'Antiquarian Village Aviary', p. 362.

43 John Timbs, *Curiosities of London* (1855), p. 22; 'Antiquarian Village Aviary', pp. 362–3.

44 'Mr. Purland's Aviary', *Chambers's Art Journal* (1841), p. 85.

45 'Antiquarian Village Aviary', p. 363.

46 'Aviary for Sale', *Morning Post*, 8 June 1842, p. 1.

47 Timbs, *Curiosities of London*, p. 22.

3 Artificial Mounts and other Swellings

1 Lucy Vickers, 'Spectator Competition Winners: Odes on the Marble Arch Mound', *Spectator*, 23 October 2021.

2 Tom Ravenscroft, 'Marble Arch Mound has a "serious message" says MVRDV in defence of attraction', *Dezeen*, 30 July 2021.

3 The *Spectator* invited its readers in October 2021 to submit an ode on the 'Marble Arch Mound' (Competition No. 3221).

4 William Lawson remarked in *A New Orchard and Garden* (2nd edn, 1631) that if a 'riven run by your doore, & under your mount, it will be pleasant' (p. 43).

5 Stephen Switzer, *Ichnographia Rustica: or The Nobleman, Gentleman, and Gardener's Recreation*, 3 vols (1718), vol. 2, p. 151.

6 William Mudford, *Nubilia in Search of a Husband* (1809), pp. 23, 163.

7 Mudford, *Nubilia*, p. 163.

8 Mudford, *Nubilia*, p. 170.

9 Mudford, *Nubilia*, pp. 170–71.

10 Mudford, *Nubilia*, p. 171.

11 Mudford, *Nubilia*, p. 171.

12 Mudford, *Nubilia*, p. 171.

13 Mudford, *Nubilia*, pp. 171–2.

14 *Il Moro: Ellis Heywood's Dialogue in Memory of Thomas More*, trans. Roger Lee Deakin (1972), pp. 3–5.

15 *Sir Thomas Browne's Works including his Life and Correspondence*, ed. Simon Wilkin, 4 vols (1836), vol. 1, pp. 375–6: John Evelyn, letter to Dr Browne, 28 January 1657/8.

16 *Thomas Platter's Travel in England, 1599*, trans. and introduced by Clare Williams (1937), p. 199.

17 'Baums, the Late Residence of Sir George Whitmore, in Hoxton', *European Magazine*, vol. 58, December 1810, p. 449.

18 *The Prompter*, no. 88, 12 September 1735, p. 1.

19 John Milton, *Paradise Lost: A Poem, in Twelve Books* (1751 edn), book 4, ll. 132–53.

20 John Milton, *Paradise Lost: A Poem, in Twelve Books, with notes of various authors by John Rice* (1766), p. 132.

21 *Letters of Mr. Alexander Pope, and Several of his Friends* (1737), p. 223: Alexander Pope, letter 136, to Dr Atterbury, Bishop of Rochester, 19 March 1721/2.

22 Switzer, *Ichnographia Rustica*, vol. 3, p. 125.

23 'On the Queen's Mount at Kensington', *Gentleman's Magazine*, no. 28, April 1733, p. 206.

24 'On the Queen's Mount at Kensington', p. 206.

25 Lord Beauchamp, 'Of the Fire-ball seen in the Air, and of the Explosion heard, on Dec. 11, 1741', *The Philosophical Transactions (from the Year 1732, to the Year 1744), Abridged*, vol. 8: *From 1735 to 1743* (1809), p. 541.

26 Madame [Anne-Marie] du Bocage, *Letters concerning England, Holland and Italy*, 2 vols (1770), vol. 1, p. 49.

27 *Gentleman's Magazine*, August 1733, p. 436.

28 Ray Desmond, *Kew: The History of the Royal Botanic Gardens* (1998), p. 11; TNA (Kew), 4/6, 24 September 1734. See also David Jacques, *Gardens of Court and Country: English Design, 1630–1730* (2017), pp. 302–3.

29 'The King's Palace in St James's Park', *Baldwin's London Weekly Journal*, 9 September 1826, p. 1.

30 Lord Kames, *Elements of Criticism*, 3 vols (2nd edn, 1763), vol. 3, p. 353; Kames, *Elements*, 2 vols (4th edn, 1769), vol. 1, p. 299.

31 John Dalrymple, *An Essay on Different Situations in Gardens* (1772), p. 24.

32 Switzer, *Ichnographia Rustica*, vol. 3, p. xi.

33 Joseph Addison, *The Spectator*, no. 477, 6 September 1712.

34 Thomas Fairchild, *The City Gardener* (1722), pp. 38, 41–2.

35 *Gazetteer and New Daily Advertiser*, 25 February 1766, p. 2.

36 James Marshall Osborn, *Joseph Spence: Observations, Anecdotes, and Characters of Books and Men*, 2 vols (1966), vol. 2, p. 648, and vol. 1, p. 411; Kames, *Elements*, 2 vols (5th edn, 1774), vol. 2, pp. 434–5.

37 Conversation with Chloe Chard, 11 December 2023.

38 Bodleian Library, University of Oxford, John Johnson Collection of Printed Ephemera, BOD, b.59 (28).

39 John Timbs, *English Eccentrics and Eccentricities*, 2 vols (1866), vol. 1, p. 101.

40 P. L. Simmonds, *Waste Products and Undeveloped Substances: A Synopsis of Progress Made in their Economic Utilisation during the Last Quarter of a Century at Home and Abroad* (1873), p. 441.

41 Charles Dickens, *Our Mutual Friend*, 2 vols (1865), vol. 1, p. 43.

42 *Notes and Queries*, series 12, vol. 6, 22 May, p. 237.

4 Squares

1 See Todd Longstaffe-Gowan, *The London Square: Gardens in the Midst of Town* (2012). Quotation from Elain Harwood and Andrew Saint, *London* (1991), p. 95.

2 Peter Borsay, *The English Urban Renaissance: Culture and Society in the Provincial Town, 1660–1770* (1989), p. 74; Henry W. Lawrence, 'The Greening of the Squares of London: Transformations of Urban Landscapes and Ideals', *Annals of the American Association of Geographers*, vol. 83, no. 1, 1993, pp. 90–118.

3 *The Royal Commission on London Squares: Report and Appendices* (1927), p. 27.

4 J. P. Malcolm, 'Original and Gradual Increase in Somers Town', *Gentleman's Magazine*, vol. 83, pt. 2, November 1813, p. 428.

5 'Bedford Nursery', in *Rural Recreations; or The Gardener's Instructor* (1802), p. 184.

6 Malcolm, 'Original and Gradual Increase in Somers Town', p. 428.

7 Charles Knight, *Cyclopaedia of London*, 6 vols (1851), vol. 1, p. 752; Silvanus, 'Arboricide in Euston Square', *Echo*, 29 June 1876, p. 4.

8 'Spring in London', *Glasgow Herald*, 6 May 1893, p. 4; *The Times*, 21 December 1921, p. 6; 'Central Sites', *The Times*, 23 February 1922, p. 22.

9 Basil Holmes, 'Euston-Square', *The Times*, 2 August 1923, p. 8.

10 Royal Commission on London Squares, Parliamentary Archives, FCP/1/46: E. Bonham Carter, letter to L. W. Chubb, 3 July 1923.

11 'The Old Market Gardens and Nurseries of London – No. 28', *Journal of Horticulture, Cottage Gardener, and Home Farmer*, 11 December 1879, p. 468.

12 'The Old Market Gardens and Nurseries of London – No. 28', p. 468.

13 'The Old Market Gardens and Nurseries of London – No. 28', p. 468.

14 Beresford Chancellor, *The History of the Squares of London: Topographical & Historical* (1907), p. 250.

15 C. E. Maurice, 'The Railway Vandal in London', *Pall Mall Budget*, 14 March 1884, p. 26.

16 Bridget Cherry and Nikolaus Pevsner, *Buildings of England. London 4: North* (1998), p. 388.

17 *Survey of London*, vol. 24: *The Parish of St Pancras, part 4: King's Cross Neighbourhood* (1952), p. 132.

18 F. W. B., 'Town Gardens', *The Garden*, 14 March 1891, p. 235.

19 'Open Spaces in London. Need of Preservation Policy', *The Times*, 8 March 1924, p. 7.

20 'Disappearing Squares of London: The Threat to Bloomsbury', *The Times*, 8 December 1926, p. 20.

21 'On the Square', *The Times*, 21 May 1959, p. 11.

22 Knight, *Cyclopaedia of London*, p. 749.

23 Knight, *Cyclopaedia of London*, p. 748. Knight categorises the contemporary late seventeenth-century and early eighteenth-century squares of Hoxton and Kensington as examples of enclosures of 'venerable antiquity'.

24 Will Palin, '"This unfortunate and Ignored Locality": The Lost Squares of Stepney', *London Gardener*, vol. 12, 2006–7, p. 98.

25 Palin, '"This unfortunate and Ignored Locality"', p. 101. The square was renamed in 1936 in honour of the Swedish philosopher and theologian Emanuel Swedenborg, who had been buried in the vaults of the church in 1777.

26 Swedish Church, Harcourt Street, London W1, Swedish Church Records Box 0II/I Vol. court Copies deeds, 10 June 1764.

27 Annie Mount, "Wellclose-Square – Fifty Years Ago', *East End News and London Shipping Chronicle*, 25 July 1894, p. 1.

28 John Milton, *Paradise Lost: A Poem, in Twelve Books* (1667), book 4, l. 143.

29 Knight, *Cyclopaedia of London*, p. 749.

30 Knight, *Cyclopaedia of London*, p. 749.

31 Palin, '"This unfortunate and Ignored Locality"', p. 108.

32 Palin, '"This unfortunate and Ignored Locality"', p. 112; Ian Nairn, *Nairn's London* (1966), p. 161.

5 Aristocratic Gardens

1 Jill Husselby and Paula Henderson, 'Location, Location, Location! Cecil House in the Strand', *Architectural History*, vol. 45, 2002, p. 164. This article supplies a detailed account of the house and its early gardens.

2 Burghley House, Exeter MSS 5/21: Francis, 2nd Earl of Bedford, grant to Cecil, 24 January 1561.

3 Manolo Guerci, *London's 'Golden Mile': The Great Houses of the Strand 1550–1650* (2021), p. 99.

4 Husselby and Henderson, 'Location, Location, Location!', pp. 173, 164.

5 'Harcourt House: A Strange Discovery', *Daily Telegraph and Courier*, 19 June 1906, p. 9.

6 Walter Thornbury, *Old and New London: A Narrative of its History, its People, and its Places*, vol. 4: *Westminster and the Western Suburbs*, 6 vols (1891), vol. 4, p. 446

7 Walter Thornbury, *Old and New London*, p. 446.

8 [James Ralph], *A Critical Review of the Publick Buildings, Statues and Ornaments in, and about London and Westminster* (1734), p. 107.

9 Tim Knox, 'Precautions for Privacy', *London Gardener*, vol. 2, 1996–7, p. 27.

10 Knox, 'Precautions for Privacy', p. 27.

11 Nottinghamshire Archives, Portland Papers, ref. DD 4P 70/32/4, 5 July 1862.

12 'Radcliffe v. The Duke of Portland – Injunction – Alleged obstruction of light and air – Glass Screen', *Law Times Reports, containing All the Cases Argued and Determined*, vol. 7, Law Times Office, September 1862 to March 1863, p. 126.

13 The new stables were roughly 13 metres (42 feet) high, replacing an earlier 5.5 metre- (18-foot-) high 'fence wall'; Giffard J. W. de Longueville, *Reports of Cases Adjudged in the High Court of Chancery* 5 vols (1862), vol. 3, p. 703.

14 'Harcourt House: A Strange Discovery', p. 9.

15 Author unknown, *A New Display of the Beauties of England* (1787), p. 32.

16 M. Maty, *Miscellaneous Works of the Late Philp Dorner Stanhope, Earl of Chesterfield*, 3 vols (1777), vol.3, p. 208.

17 Edward Hamilton, 'The Rooks and Rookeries of London, Past and Present', *The Zoologist*, vol. 2, no. 18, 1878, p. 195.

18 See Verena McCaig, 'Chesterfield House, Mayfair: "A scene of verdure and flowers not common in London"', *London Gardener*, vol. 13, 2007–8, pp. 11–33.

19 'Chesterfield Mansions, Curzon Street, Mayfair', *Building News*, 29 December 1876, p. 17.

20 'Chesterfield House', *Morning Post*, 4 July 1870, p. 4.

21 'London', *Western Mail*, 23 July 1870, p. 2.

22 Hamilton, 'The Rooks and Rookeries of London', p. 195.

23 Dianne Duggan, 'The Fourth side of Covent Garden Piazza: New Light on the History and Significance of Bedford House', *British Art Journal*, vol. 3, no. 3, pp. 53–65.

24 Duggan, 'The Fourth side of Covent Garden Piazza', pp. 60, 53.

25 John Macky, *A Journey through England. In Familiar Letters from a Gentleman Here, to his Friend Abroad* (1722), p. 181.

26 *London in Miniature: Being a Cncise and Comprehensive Description of the Cities of London and Westminster, and Parts adjacent, for forty Miles round* (1755), p. 208.

27 'An Old Map of London', *The Builder*, 24 June 1871, p. 480; *Athenaeum*, no. 2445, September 1874, p. 307.

28 Thomas Malton, *A Picturesque Tour through the Cities of London and Westminster* (1792), p. 96.

29 Sometimes known as Montague House.

30 Guy Miège, *The Grounds of the French Tongue* (1687), p.135; Mackay, *Journey through England*, p. 123; [Ralph], *Critical Review of the Publick Buildings*, p. 100. The duke's first house had burnt down in 1686.

31 Thomas Salmon, *Modern History: or, The Present State of All Nations*, 3 vols.(1733), vol. 1, p. 106.

32 *London in Miniature*, pp. 207–8.

33 Catherine Talbot writing in 1756 and quoted in G. R. de Beer, 'Early Visitors to the British

Museum', *British Museum Quarterly*, vol. 18, no 2, June 1953, p. 27; *Gazetteer & Daily News*, 15 June 1772; *World*, 23 April 1788, p. 3; *Oracle* (1797), p. 4; *Connoisseur*, no. 122, 1755, p. 138.

34 'Notes on London', *Notes and Queries*, series 1, vol. 6, 11 September 1852, p. 241.

35 *Oracle and Daily Advertiser*, 28 September 1804, p. 3.

36 'Notes on London', p. 241.

37 Salmon, *Modern History*, p. 106.

38 John Evelyn, *Diary and Correspondence of John Evelyn*, 4 vols (1854), vol. 2, p. 79.

39 William Bray, *The Diary and Correspondence of John Evelyn*, 4 vols (1850), vol. 2, p. 197.

40 Bray, *Diary and Correspondence of John Evelyn*, p. 198.

41 David Jacques and Tim Rock, 'Pierre-Jacques Fougeroux: A Frenchman's Commentary on English Gardens of the 1720s', in *Experiencing the Garden in the Eighteenth Century*, ed. Martin Calder (2006), p. 233.

42 John Timbs, *Something for Everybody; and A Garland for the Year* (1861), p. 261.

43 Augustus Hare, *Walks in London*, 2 vols (1883), vol. 2, p. 92.

44 'Piccadilly', *Chamber's Journal of Popular Literature*, vol. 9, no. 444, 2 July 1892, p. 419.

45 *The Modern Plutrarch; or, Universal Biography*, 3 vols (1806), vol. 2, pp. 156–7 fn.

46 *A Visit to Uncle William in Town; or, a Description of the Most Remarkable Building and Curiosities in the British Metropolis* (1818), p. 76.

47 'The Hermit Abroad', *British Magazine*, 1823, p. 383; Samuel Lewis, *A Topographical Dictionary of England*, 4 vols (1831), vol. 3, p. 125.

48 David Brewster, *The Edinburgh Encyclopaedia*, vol. 12 (1832), p. 209.

49 Henry Benjamin Wheatley, *Round about Piccadilly and Pall Mall, or, A Ramble from the Haymarket to Hyde Park* (2011; first pub. 1870), p. 101.

50 'Lansdown House', *Globe*, 23 November 1903, p. 7; *Yorkshire Post and Leeds Intelligencer*, 28 July 1927, p. 10.

51 James Thorne, *Handbook to the Environs of London*, 2 parts (1876), pt 2, p. 701.

52 John Burke, ed., *The Patrician*, 6 vols (1846), vol. 1, p. 322.

53 Quoted in Daniel Lysons, *The Environs of London*, vol. 1: *County of Surrey* (1792), p. 25.

54 See David Jacques, *Gardens of Court and Country: English Design, 1630–1730* (2017), p. 83.

55 Lysons, *Environs of London*, p. 523.

56 Lysons, *Environs of London*, p. 523.

57 Burke, *The Patrician*, p. 323.

6 Gardens for Entertainment

1 James Boswell, *The Life of Samuel Johnson*, 4 vols (1826 edn), vol. 3, p. 274.

2 Daniel Defoe, *A Tour through the Whole Island of Great Britain* (1769), p. 172.

3 *Diary of John Evelyn*, ed. William Bray, 4 vols. (1879), vol. 2, p. 51, entry for 10 May 1654; Charles Knight, ed., *London*, 6 vols (1841), vol. 1, p. 192.

4 Tobias Smollett, *The Expedition of Humphry Clinker*, 3 vols (1771), vol. 1, p. 135.

5 David Coke and Alan Borg, *Vauxhall Gardens: A History* (2011), p. 51.

6 *A Companion to Every Place of Curiosity and Entertainment in and about London and Westminster* (1772), p. 177.

7 'Vauxhall', undated and uncited clipping from Vauxhall Scrapbook, Wroth Collection, Museum of London.

8 *George Cruikshank's Omnibus*, ed. Laman Blanchard (1869), p. 172.

9 H. H. Montgomery, *The History of Kennington and its Neighbourhood* (1889), p. 113.

10 Elizabeth McKellar, *Landscapes of London: The City, the Country and the Suburbs, 1660–1840* (2013), pp. 111–43.

11 'A Looking-Glass for London', *Penny Magazine*, no. 28, 16 December 1837, p. 484.

12 *The London Guide, describing the Public and Private Buildings of London, Westminster, & Southwark*, 1782, pp. 31–2; *A Sunday Ramble; or, Modern Sabbath-day Journey; in and about the Cities of London and Westminster* [1775], p. 52.

13 William John Pinks, *The History of Clerkenwell*, ed. Edward J. Wood (1881), p. 533.

14 Walter Harrison, *A New and Universal History, Description and Survey of the Cities of London and Westminster, the Borough of Southwark, etc.* (1776), p. 567; *Sunday Ramble*, p. 52; *London Guide*, pp. 31–2, 9.

15 *London Guide*, p. 9; *Sunday Ramble*, p. 52.

16 Walter Harrison, *A New and Universal History, Description and Survey* (1776), p. 567; *London Guide*, pp. 31–2.

17 *London Guide*, pp. 9–10.

18 *London Guide*, p. 10; *Journal of the Royal Anthropological Institute of Great Britain*, vol. 30 (1900), p. 113.

19 *London Guide*, p. 10.

20 'White Conduit Gardens', *Sun*, 21 May 1839, p. 3; *Weekly Times*, 29 May 1831, p. 2; 'White Conduit Gardens', *Morning Herald*, 5 August 1837, p. 4.

21 *Morning Advertiser*, 11 July 1838, p. 3.

22 *Sun*, 19 July 1830, p. 2.

23 John Bevis, *An Experimental Enquiry concerning the Contents, Qualities, and Medicinal Virtues, of the Two Mineral Waters, lately discovered at Bagnigge Wells, near London* (1760), p. 32.

24 *London Guide*, p. 10; George Saville Carey, *The Hills of Hybla; being a Collection of Original Poems* (1767), p. 21; Pinks, *History of Clerkenwell*, p. 564. For a detailed account of Bagnigge Wells, see Alison O'Byrne, '"A Place of General Resort": Bagnigge Wells in the Eighteenth-Century', *London Gardener*, vol. 9, 2003–4, pp. 22–9.

25 Warwick Wroth, *The London Pleasure Gardens of the Eighteenth Century* (1896), pp. 61–2.

26 *Sunday Ramble*, p. 18

27 *Sunday Ramble*, pp. 22–3.

28 *London Guide*, p. 11.

29 Wroth, *London Pleasure Gardens*, pp. 61–2.

30 *London Guide*, p. 11.

31 Anon., 'A Song: Bagnigge Wells', *London Magazine*, June 1759, p. 341; John Bew, *The Ambulator* (1820), p. 15.

32 *The Curiosities, Natural and Artificial, of the Island of Great Britain*, 6 vols [1775], vol. 1, p. 151.

33 Wroth, *London Pleasure Gardens*, p. 64.

34 Wroth, *London Pleasure Gardens*, p. 64.

35 William Clarke, *Every Night Book; or, Life after Dark* (1827), p. 36; John Britton, Edward Brayley and Joseph Nightingale, *The Beauties of England and Wales*, vol. 3 (1815 edn), p. 600.

36 Charles Selby, *Maximums and Speciments of William Muggins, Natural Philosopher and Citizen of the World* (1841), p. 144.

37 See Todd Longstaffe-Gowan, 'The New Globe Tavern and its Pleasure Grounds, Mile End Road', *London Gardener*, vol. 9, 2003–4, pp. 53–60.

38 *Encyclopaedia Britannica* (1902 edn), vol. 31, p. 46.

39 Warwick Wroth, *Cremorne and the Later London Gardens* (1907), p. vi.

40 Wroth, *Cremorne*, p. iv.

41 Robert Chambers, *The Book of Days: A Miscellany of Popular Antiquities in Connection with the Calendar, including Anecdote, Biography, & History, Curiosities of Literature and Oddities of Human Life and Character*, vol. 2 (1832), p. 718.

42 Harrison, *New and Universal History*, p. 542.

43 William Hone, *The Every-day Book, or, The Guide to the Year* (1825), p. 971.

44 John Stow, *A Survey of London* (1603), preface. See www.british-history.ac.uk/report.aspx?compid=60017&strquery=Perillous.

45 Hone, *The Every-day Book*, p. 971, quoting from William Maitland, *The History and Survey of London from its Foundation to the Present Time, in two volumes* (1756).

46 Hone, *The Every-day Book*, p. 972, quoting from Maitland, *History and Survey of London*.

47 Maitland, *History and Survey of London*, vol. 1, p. 84.

48 Harrison, *New and Universal History*, p. 542.

49 Maitland, *History and Survey of London*, vol. 2, p. 1370.

50 'Metropolitan Marine Bath Company', *Morning Chronicle*, 10 September 1824.

51 'Metropolitan Marine Bath Company'.

52 Hone, *The Every-day Book*, p. 974.

53 *The Standard*, 12 December 1868; *The Standard*, 5 January 1869.

54 *Daily News*, 21 August 1876.

55 James Gardner (chief designer and co-ordinator of the Battersea Pleasure Park Gardens) quoted in Becky E. Conekin, *'The autobiography of a nation': The 1951 Festival of Britain* (2003), p. 203; Travis Elborough, *A Walk in the Park: The Life and Times of a People's Institution* (2016), p. 270.

56 'Battersea Park Fairground: Festival Gardens', *The Times*, 1 July 1949, p. 2.

57 'Battersea Park Fairground', *The Times*, 1 July 1949, p. 2.

58 See Mary Banham and Bevis Hillier, eds, *A Tonic to the Nation: The Festival of Britain 1951* (1976), pp. 74–5.

59 'Battersea Park Fairground', *The Times*, 1 July 1949, p. 5.

60 'Battersea Park Fairground', *The Times*, 1 July 1949, p. 5.

61 'John Gibson', *Gardeners' Chronicle and Agricultural Gazette*, 29 July 1872, p. 865; William Thomson, 'Garden Records. No. 1: Battersea Park, London, S.W', *The Gardener: A Magazine of Horticulture and Floriculture* (1870), p. 31; 'Battersea Park', *South London Times and Lambeth Observer*, 29 September 1864; 'The Sub-Tropical Garden', *Echo*, 16 September 1889, p. 1; *Punch*, vol. 217, 10 August 1949, p. 157.

62 'John Gibson', p. 865; Thomson, 'Garden Records. No. 1', p. 31; 'Battersea Park'; 'The Sub-Tropical Garden', p. 1.

63 'The Festival Gardens: Attractive Displays at Battersea', *The Times*, 18 May 1951, p. 4.

64 'The Lighter Side of London's Festival: Battersea a Masterpiece of Gay Absurdity', *Manchester Guardian*, 29 May 1951, p. 5.

65 Clough Williams-Ellis, 'The Battersea Wonder: "Light and Laughter and Beauty"', *Manchester Guardian*, 9 June 1951, p. 4.

66 Hazel Conway, 'Everyday Landscape: Public Parks from 1930 to 2000', *Garden History*, vol. 28, no. 1 (summer 2000), p. 125.

67 'A New London by Night: The Festival Gardens' Flood-Lit Beauties', *Illustrated London News*, vol. 219, no. 5856, 14 July 1951, p. 19.

68 Williams-Ellis, 'The Battersea Wonder', p. 4.

69 Williams-Ellis, 'The Battersea Wonder', p. 4.

70 Jennifer Powell, 'Henry Moore and 'Sculpture in the Open Air': Exhibitions in London's Parks', https://www.tate.org.uk/art/research-publications/henry-moore/jennifer-powell-henry-moore-and-sculpture-in-the-open-air-exhibitions-in-londons-parks-r1151300#f_1_8.

71 Clough Williams-Ellis, 'Battersea Pleasure Gardens', *The Times*, 10 November 1953, p. 9; 'Gardens' Future at Battersea: Prospects for Reopening', *The Times*, 13 October 1953, p. 4.

72 Eric Barton, 'Battersea Pleasure Gardens', *The Times*, 13 November 1953, p. 9; 'Alas! Poor Battersea', *Manchester Guardian*, 12 October 1953, p. 1.

73 Virginia Liberatore, 'Restoration of the Festival of Britain Pleasure Gardens, Battersea Park', *London Gardener*, vol. 7, 2001–2, p. 83.

74 'Alas! Poor Battersea: Infinite Jest that Staled', *Manchester Guardian*, 12 October 1953, p. 1.

7 Gardens of Artists, Literary Figures and Scholars

1 *Proceedings of the Society of Antiquaries of London* 24 (London: The Society, 1911). 235. One of his publications included *The Prehistoric Traditions and Customs in connection with the Sun and Serpent Worship* (1875).

2 'Death of Dr Phené. A Remarkable Chelsea Character. The Story of his Studious Life. Truth about his Ruined Château', *West London Press (Chelsea News)*, 15 March 1912.

3 *West London Press*, 6 March 1914.

4 'Death of Chelsea Hermit. Eccentric Doctor's Life Romance. Mystery Mansion. Bizarre Relics Placed in Silent Home'. *Pall Mall Gazette*, 12 March 1912, p. 7.

5 '"Mystery House" of Chelsea', *Daily News & Leader*, 19 November 1912.

6 'Chelsea's House of Mystery', *Daily Chronicle*, 20 November 1912.

7 'Chelsea's Mystery House, Sale of Dr Phené's Weird Collection, Romance and Ruin', *Daily Chronicle*, 20 November 1912.

8 'Death of Chelsea Hermit', p. 7.

9 Tyler & Co, 'Catalogue... For Sale on Tuesday and Wednesday, 19th and 20th November 1912', in *Chelsea Scraps*, (CRL/LHS), pp. 1068–70; E. Annesley Owen, 'The Late Dr Phené: Mr E Annesley Owen's Reminiscences', *West London Press*, 12 March 1912.

10 'Death of Dr Phené. A Remarkable Chelsea Character. The Story of his Studious Life. Truth about his Ruined Château'; 'Dr Phené's Collection', *West London Press*, 22 November 1912.

11 'Chelsea Mystery House: Jumble Sale of Many Lands', *Daily Mail*, 18 November 1912.

12 'Strangest Sale on Record: Chelsea Mystery House', *The Standard*, 20 November 1912.

13 'Amazing Jumble Sale, Dr Phené's Weird Collection, Artistic Nightmare at Auction', *Daily News & Leader*, 20 November 1912.

14 '"Mystery House" of Chelsea', *Daily News & Leader*, 19 November 1912.

15 The Londoner, 'To-night's Gossip', *Evening News*, 20 November 1912.

16 Leigh Hunt, 'Benjamin West', *Rural Repository, Devoted to Polite Literature*, vol. 26, 1850, p. 174.

17 Hunt, 'Benjamin West', p. 174.

18 See Todd Longstaffe-Gowan, *The London Town Garden* (2001), pp. 50–58.

19 *Thraliana: The Diary of Mrs. Hester Lynch Thrale (later Mrs Piozzi), 1776–1809*, ed. Katherine C. Balderston, 2 vols (1942), vol. 2, p. 782.

20 *Dictionary of National Biography*, entry for Hester Thrale.

21 Michael J. Franklin, '"Thrale's Entire": Hester Lynch Thrale and the Anchor Brewery', in *Bluestockings Now!: Evolution of a Social Role*, ed. Deborah Heller (2015), p. 125.

22 *Thraliana*, vol. 1, p. 369, fn. 2.

23 London Metropolitan Archives, E/BER/S/L/009 and E/BER/S/E5/3/1.

24 *Victoria County History of the County of Surrey*, ed. Henry Elliot, vol. 4 (1912), p. 103.

25 London Metropolitan Archive, Bedford Estate Collection, E/BER/S/5/3/2: 'Mr Thrale's Estate at Streatham', n.d. (*c*.1770).

26 *Mrs Montagu 'Queen of the Blues': Her Letters and Friendships from 1762 to 1800*, ed. Reginald Blunt, vol. 2: *1777–1800* (1923), p. 269.

27 *Thraliana*, vol. 1, pp. 373–4.

28 *The World*, 1 July 1790, p. 2.

29 *Thraliana*, vol. 1, p. 373.

30 *Thraliana*, vol. 2, p. 797.

31 Daniel Lysons, *The Environs of London*, vol 1: *County of Surrey* (1792), pp. 482–3.

32 *Thraliana*, vol. 2, pp. 790, 828.

33 'Demolition of Streatham House, Surrey', *Saint James's Chronicle*, 23 May 1863, p. 2.

34 Edited transcription of a conversation between David Dawson and Giovanni Aloi.

35 Email correspondence, David Dawson to Todd Longstaffe-Gowan, 28 December 2023. Further quotations in the account of Freud's garden are all taken from this email.

36 'The Ancient Monuments Bill, as Illustrated by the Case of Caesar's Camp', *Spectator*, 14 August 1874, p. 1034.

37 'The Ancient Monuments Bill', p. 1034.

38 'The Ancient Monuments Bill', p. 1034.

39 Edmund Kell, 'Caesar's Camp, Wimbledon', *The Antiquarian*, vol. 1, 1871, p. 180. See also 'One of the Finest Situations in London', *The Times*, 15 April 1905, p. 4.

40 Tony Matthews, 'Gertrude Jekyll's Lost Legacy in Wimbledon', *London Gardener*, vol. 15, 2009–10, p. 44. Jekyll's plans are not reproduced in this article.

41 Gertrude Jekyll, *Home and Garden: Notes and Thoughts, Practical and Critical, of a Worker in Both* (1900), p. 95.

42 'To be let furnished', *Common Cause*, 16 March 1911, p. 15.

8 Gardens on the Margins

1 C. H. Collins Baker, *The Life and Circumstances of James Brydges, First Duke of Chandos* (1949), pp. 64–5.

2 Stephen Switzer, *An Introduction to a General System of Hydrostaticks and Hydraulicks, Philosophical and Practical*, 2 vols (1729), vol. 2, p. 334.

3 Collins Baker, *Life and Circumstances of James Brydges*, p. 65.

4 Collins Baker, *Life and Circumstances of James Brydges*, p. 63; [?John Bew], *The Ambulator, or, The Stranger's Companion in a Tour round London, within the Circuit of Twenty-five Miles* (3rd edn, 1787), p. 73.

5 Collins Baker, *Life and Circumstances of James Brydges*, p. 63.

6 Collins Baker, *Life and Circumstances of James Brydges*, pp. 63–4.

7 John Harris, 'Le Rouge's Sion Hill: A Garden by Brown', *London Gardener*, vol. 5, 1999–2000, pp. 24–8. Various early sources confirm this attribution.

8 John Henry Brady, *A New Pocket Guide to London and its Environs* (1838), p. 514.

9 Mark Laird, *The Flowering of the English Landscape Garden: English Pleasure Grounds 1720–1800* (1999), p. 148.

10 Harris, 'Le Rouge's Sion Hill', p. 28; Archibald Robertson, *Topographical Survey of The Great Road from London to Bath and Bristol* (1792).

11 Arthur Young, *The Farmer's Tour through the East of England* (1771), pp. 85–6.

12 Victoria Percy and Gervase Jackson-Stops, 'From Parterres to Precipices: The Travel Journals of the 1st Duchess of Northumberland – III', *Country Life*, vol. 155, 1974, p. 308.

13 Harris, 'Le Rouge's Sion Hill', p. 26; Victoria Percy and Gervase Jackson-Stops, p. 308.

14 Karen Hearn, 'Merchant Clients for the Painter Jan Siberechts', in *City Merchants and the Art*, ed. Mireille Galinou (2004), p. 87.

15 John Aubrey, *Aubrey's Brief Lives*, ed. Andrew Clark (1898), pp. 272–3.

16 British Library, London, Add. MS 38464, fols 39, 65v.

17 Laura Wortley, 'Jan Siberechts in Henley-on-Thames', *Burlington Magazine*, vol. 149, no. 1248, March 2007, p. 151.

18 British Library, London, Add. MS 38464, fol. 98. It is partially described in this document of 1710. See also Karen Hearn, 'A Seventeenth Century Enigma: Jan Siberechts's View of a House and its Estate in Belsize, Middlesex', *Patrons' Papers* 3 (2000).

19 'Old Manor House Kennington', *South London Press*, 18 September 1875, pp. 10–11.

20 'Old Manor House Kennington', p. 11.

21 'Old Manor House Kennington', p. 11.

22 *Morning Herald*, 7 January 1858, p. 1.

23 [Isaac Watts], *Mental Pleasures, or, Select Essays, Characters, Anecdotes, and Poems* (1791), vol. 1, pp. 20–21.

24 'Some Old London Taverns', *Ripon Observer*, 24 December 1891, p. 6.

25 Revd William Collings Lukis, *The Family Memoirs of the Revd. Stukeley, M.D. and the Antiquarian and Other Correspondence of William Stukeley, Roger Gale and Samuel Gale, etc.*, 3 vols (1882–7), vol. 3, p.20. For a detailed account of Stukeley's garden in Kentish Town, see John F. H. Smith, 'William Stukeley in Kentish Town, 1759–65', *London Gardener*, vol. 24, 2020, pp. 11–27.

26 Bodleian Library, University of Oxford, MS Eng. Misc. e.138. fol. 48.

27 Quoted in Smith, 'William Stukeley', pp. 21–3.

28 John Milton, *Paradise Lost: A Poem, in Twelve Books*, book 4, l. 706.

29 Bodleian Library, University of Oxford, MS Eng. Misc. e.138. fol. 48.

30 'Letters of Messrs. Gough and Brooke', in John Nichols, *Illustrations of the Literary History of the Eighteenth Century*, vol. 6 (1831), p. 368: J. C. Brooke, letter to Richard Gough, 12 January 1778.

31 'Letters of Messrs. Gough and Brooke', p. 368: J. C. Brooke, letter to Richard Gough, 12 January 1778.

32 John Nichols, *Illustrations of the Literary History of the Eighteenth Century; Consisting of Authentic Memoirs and Original Letters of Eminent Persons*, 8 vols (1831), vol. 6, p. 368.

33 William Ellis, *The Campagna of London, or, Views in the Different Parishes* (1791), quoted in John Nelson, *The History, Topography, and Antiquities of the Parish of St Mary Islington* (1811), p. 140.

34 Ellis, *Campagna of London*, p. 89.

35 'Highbury-House', *European Magazine*, vol. 36, July–December 1799, p. 79.

36 John Nelson, *The History, Topography, and Antiquities of the Parish of St Mary Islington* (1811), p. 39.

37 Simple Susan, 'Highbury-House, A Poem, to Alexander Aubert, Esq.', *European Magazine*, vol. 24, July–December 1793, p. 139.

38 John Nelson reported in *The History, Topography, and Antiquities of the Parish of St Mary Islington* (1811), p. 140.

39 The *East Anglian; or, Notes and Queries on Subjects Connected with the Counties of Suffolk, Cambridge, Essex, & Norfolk*, ed. Samuel Tymms, vol. 2 (1866), p. 29.

40 Dorothy Stroud, *Capability Brown* (1950), pp. 213, 216.

41 *Morning Post*, 3 September 1817, p. 4.

42 *The Times*, 26 October 1868, p. 16.

9 Gardens of Display

1 J.R.S.C., 'London's Lesser Open Spaces – Their Trees and Plants', *Journal of Horticulture and Cottage Gardener*, 8 October 1885, p. 323.

2 'The Old Market Gardens and Nurseries of London', *Journal of Horticulture and Cottage Gardener*, 17 August 1876, pp. 144–5.

3 'The Old Market Gardens and Nurseries of London', p. 144.

4 'The Old Market Gardens and Nurseries of London', 17 August 1876, p. 144.

5 'The Old Market Gardens and Nurseries of London', 17 August 1876, p. 144.

6 Hermione Hobhouse, *Thomas Cubitt: Master Builder* (1971), p. 130.

7 A. W. N. Pugin and J. Britton, *Illustrations of the Public Buildings of London; with Historical and Descriptive Accounts of Each Edifice*, 2 vols (1828), vol. 2, p. 294.

8 Pugin and Britton, *Illustrations of the Public Buildings of London*, p. 292; Hobhouse, *Thomas Cubitt*, p. 90.

9 The speculative builder Thomas Cubitt (1788–1855) was responsible for the building of Bloomsbury, Belgravia and Pimlico.

10 Mackenzie's claim to fame was owning and growing a willow tree that was struck from 'part of a branch of one of the willows that over-hang the grave of Napoleon, at St Helena' (*Bell's Weekly Messenger*, 23 April 1826, p. 8).

11 Grosvenor Estate Papers, 'Counterpart of Lease, The Right Honorable Robert Earl Grosvenor to Mr Duncan Mackenzie: A Garden, Eaton Place [1821?]', ref. 429/73, and City of Westminster Archives Centre, 'Article of Agreement 1821 [containing a plan of the plot of ground]', ref. 1049/3/2/594.

12 *Morning Advertiser*, 9 November 1826, p. 4; *Morning Advertiser*, 14 July 1827, p. 4.

13 John Thomas Smith, *Nollekens and his Times* (1829), p. 164.

14 *Weekly Messenger*, 20 August 1837, p. 4; *Bell's New Weekly Messenger*, 20 August 1837, p. 4.

15 *Morning Herald*, 14 July 1831, p. 2; *Globe*, 30 August 1837, p. 2; 'Reverend Pluralists', *Chester Chronicle*, 1 September 1837, p. 2; *John Bull*, 21 August 1837, p. 7.

16 For a more detailed account of Tuck's nursery in Eaton Square, see Todd Longstaffe-Gowan, 'George Scharf in Eaton Square', *London Gardener*, vol. 27, 2023, pp. 48–58

17 George W. Johnson, *The Cottage Gardener*, vol. 6, 1851, p. 143.

18 Johnson, *Cottage Gardener*, p. 143.

19 Thomas Fairchild, *The City Gardener* (1722), p. 68.

20 Richard Bradley, *General Treatise of Husbandry and Gardening*, vol. 2 (1726), p. 472.

21 Fairchild, *City Gardener*, p. 18.

22 Fairchild, *City Gardener*, p. 5.

23 'To Lett in The City Gardens', *Gazetteer and New Daily Advertiser*, 22 August 1772, p. 2.

24 Robert John Thornton, *Sketch of the Life and Writings of The Late Mr. William Curtis* (1805), p. 30.

25 Kath Clark, 'William Curtis's London Botanic Gardens and *Flora Londinensis*', *London Gardener*, vol.15, 2009–10, p. 24.

26 John Walker, *Biographical Memoirs, Literary Anecdotes, and Characters* (1814), p. 276.

27 Walker, *Biographical Memoirs*, p. 276.

28 Walker, *Biographical Memoirs*, p. 276.

29 Thornton, *Sketch of the Life and Writings*, p. 32.

30 Clark, 'William Curtis's London Botanic Gardens and *Flora Londinensis*', p. 24.

31 R. J. Thornton, 'Sketch of the Life and Writings of the Late Mr. William Curtis', *The Botanical Magazine; or, Flower-Garden Displayed*, new series, vol. 1, 1805, p. 23.

32 Thornton, 'Sketch of the Life', pp. 23–4.

33 Thornton, 'Sketch of the Life', p. 24.

34 Thornton, 'Sketch of the Life', p. 23.

35 Thornton, 'Sketch of the Life', p. 26.

36 The Botanic Garden was renamed the Queen's Elm or Swan Lane Nursery.

37 John Simms, *The Botanical Magazine; or, Flower-Garden Displayed*, vol. 53, 1826, p. xxviii. The Sloane Nursery planted an arboretum, and, by 1835, they were operating as a subscription garden and as a nursery.

38 See Michael Symes, 'John Busch in London', *London Gardener*, vol. 23, 2019, pp. 22–30.

39 J. C. Loudon, *Arboretum et Fruticetum Britannicum*, vol. 1 (1838), p. 79.

40 'Removal of a Gigantic Palm-Tree', *Illustrated London News*, 5 August 1854, p. 13; *Dictionary of National Biography*, entry for George Loddiges.

41 J. C. Loudon, *An Encylopaedia* (1824 edn), p. 1063; Loudon, *Encyclopaedia* (1835 edn), p. 1217.

42 J. C. Loudon, *An Encyclopaedia of Gardening* (1822), p. 1225.

43 J. C. Loudon, *An Encyclopaedia of Gardening* (1835 edn), p. 1217.

44 'Mare Street', *The Times*, 26 April 1816, p. 4; 'Raymond's Buildings', *The Times*, 12 October 1838, p. 1; 'Hackney', *The Times*, 23 October 1849, p. 3.

45 'Hackney. – Important Sale of the Materials of Messrs. Loddige's', *Morning Herald*, 21 July 1854, p. 8.

46 'Removal of a Gigantic Palm-Tree… from Messrs. Loddiges' to the Crystal Palace', *Illustrated London News*, 5 August 1854, p. 13; 'The New Crystal Palace', *Perthshire Advertiser*, 3 November 1853, p. 4.

47 Giles Smith, 'Schmeichel still in need of a lift after Swayze's no show', *The Times*, 2 November 2006, p. 86.

48 Douglas Waterford, *21st Century Homestead: Urban Agriculture* (2015), p. 125.

49 'The Old Gardens of Islington and Hackney', *Christian Miscellany and Family Visitor*, 3rd series, vol. 5, 1881, p. 418.

50 Lesley Acton, 'Allotment Gardens: A Reflection of History, Heritage, Community and Self', *Papers from the Institute of Archaeology*. 21(0). doi: https://doi.org/10.5334/pia.379.

51 Manor Garden Allotments, p. 125.

52 Manor Gardening Society at Pudding Mill. See https://www.mgs-puddingmill.org/history.

53 Jane Owen, 'On Olympic Vandalism in Royal Greenwich Park', *The Times*, 9 June 2008, p. 24; Grayson Perry, 'These Humble Sheds are Symbols of our Fading World', *The Times*, 17 October 2007, p. 93.

54 *The True Levellers Standard Advanced* (1649), p. 21.

55 Acton, 'Allotment Gardens'.

56 Andrew Murray, *The Book of the Royal Horticultural Society, 1862–1863* (1863), p. viii. Murray was secretary of the society, and his book provides a detailed account of the gardens.

57 Murray, *Book of the Royal Horticultural Society*, p. 9.

58 'Prospects of the International Exhibition in 1862', *Cornhill Magazine*, vol. 4, 1861, p. 100.

59 'Royal Horticultural Gardens', *Athenaeum*, no. 1753, 1 June 1861, p. 727.

60 *Athenaeum*, no. 1754, 8 June 1861, p. 766.

61 'French Fountains at the Royal Horticultural Society's Kensington Garden', *Journal of Horticulture and Cottage Gardener*, 28 October 1862, p. 586.

62 'French Fountains at the Royal Horticultural Society's Kensington Garden', p. 586.

63 'Architecture and Public Improvements', in *The British Almanac of The Society for the Diffusion of Useful Knowledge* (1862), p. 250.

64 'Garden of the Royal Horticultural Society', in *The Survey of London*, vol. 38: *South*

Kensington Museums Area, ed. F. H. W. Sheppard (1975), p. 124.

65 Jonathan Glancey, 'Sylvia Crowe (1901–97)', *Architectural Review*, 23 February 2017: https://www.architectural-review.com/essays/reputations/sylvia-crowe-1901-1997.

66 Glancey, 'Sylvia Crowe'.

67 Kenneth Bradley, 'The New Commonwealth Institute', *Journal of the Royal Society of Arts*, vol. 111, no. 5081, April 1963, p. 405. Bradley was then the director of the institute.

68 'Landscape', *Scotsman*, 9 November 1962, p. 12.

69 'Commonwealth Institute', *Kensington News and West London Times*, 9 November 1962, p. 6.

70 'Commonwealth Institute', p. 1; Bradley, 'The New Commonwealth Institute', p. 405.

71 'The Commonwealth Institute', *Guardian*, 7 November 1962, p. 10; Michael Manser, 'But Why build a Tent?', *Sunday Telegraph*, 4 November 1962, p. 11.

72 Timothy Brittain-Catlin, 'Outrage: Commonwealth Institute Betrayed', *Architectural Review*, 21 September 2016: https://www.architectural-review.com/essays/outrage/outrage-commonwealth-institute-betrayed.

73 'His Job is up a Gum Tree: Tropical Plants at the Commonwealth Institute', *Kensington News and West London Times*, 23 November 1962, p. 3.

74 James Porter, 'A Barbaric Closure', *The Times*, 3 June 2006, p. 22.

75 Rob Wilson, 'For the Greater Good?: The Commonwealth Institute/Holland Green Housing by OMA with Allies and Morrison', *Architectural Review*, 9 July 2016: https://www.architectural-review.com/buildings/for-the-greater-good-the-commonwealth-institute-holland-green-housing-by-oma-with-allies-and-morrison.

10 Ephemeral Gardens

1 Saki, 'The Occasional Garden', *The Short Stories of Saki* (1930), p. 572.

2 Saki, 'The Occasional Garden', p. 575.

3 Saki, 'The Occasional Garden', p. 574.

4 See Todd Longstaffe-Gowan, 'The Washington Inn: The "house of Ulysses" in St James's Square', *London Gardener*, vol. 13, 2007–8, pp. 89–95.

5 *New York Times*, 16 June 1918.

6 *New York Times*, 14 June 1918; *New York Times*, 16 June 1918.

7 'St James's Lawns, Magnolias and Memories', *The Times*, 3 May 1923, p. 15; *New York Times*, 25 June 1918.

8 *New York Times*, 16 June 1918.

9 'U.S. Soldier Guests, Nation's Hospitality', *The Times*, 16 August 1918, p. 9.

10 Homer, *Odyssey*, trans. Anthony Verity (2016), book 23, ll. 177–210.

11 *The Times*, 3 May 1923, p. 15.

12 See Todd Longstaffe-Gowan, 'The "Shell-shattered French Village" in Trafalgar Square', *London Gardener*, vol. 14, 2008–9, pp. 47–52.

13 'Feed the Guns', *The Times*, 7 October 1918, p. 5.

14 'Plans for "Our Day." Camouflaged Fair in Trafalgar-Square', *The Times*, 25 September 1918, p. 11.

15 *New York Times*, 22 May 1918.

16 Paul Fussell, *The Great War and Modern Memory* (1975), p. 194.

17 Trudi Tate, *Modernism, History and the First World War* (1998), p. 132.

18 Henry Benjamin Wheatley, *London Past and Present* (1891), p. 216.

19 Wheatley, *London Past and Present*, p. 216.

20 Wheatley, *London Past and Present*, p. 216.

21 'The Ladbroke estate: The 1820s and 1830s', in *Survey of London*, vol. 37: *Northern Kensington*, ed. F. H. W. Sheppard (1973), pp. 199–200; 'The Hippodrome', *The Times*, 19 June 1837, p. 6.

22 'The Notting-Hill Racecourse Nuisance', *The Times*, 29 March 1838, p. 7.

23 Barbara Denny, *Notting Hill and Holland Park Past* (1993), p. 6.

24 See Todd Longstaffe-Gowan, *The London Square* (2012), pp. 128–33.

25 See David Goode, 'Celebrating the First Ecology Parks in London', 15 January 2017, https://www.thenatureofcities.com/2017/01/15/celebrating-first-ecology-parks-london/

26 E. M. Nicholson, 'New Jubilee Walkway', *The Times*, 16 June 1977, p. 17.

27 Philip Howard, 'Pedestrian Trail opens New Thameside Vistas to Jubilant Londoners', *The Times*, 9 June 1977, p. 2.

28 'Conservation Parks for Inner Cities', *Derby Daily Telegraph*, 5 May 1979, p. 21.

29 L. Cole and C. Keen, 'Dutch Techniques for the Establishment of Natural Plant Communities in Urban Areas', *Landscape Design*, no.116, 1976, pp. 31–4.

30 Barbara Denny, 'Wildlife in the City', *Marylebone Mercury*, 9 January 1981, p. 32.

31 Alastair Campbell, 'Kids Fight to save Frogs', *Daily Mirror*, 22 April 1985, p. 5.

32 Paul A. Moxley, 'Improving Inner Cities', *The Times*, 21 July 1981, p. 15.

33 Moxley, 'Improving Inner Cities', p. 15.

34 Krystallia Kamvasinou and Sarah Ann Milne, 'Surveying the Creative Use of Vacant Space in London, *c*.1945–95', in *Empty Spaces: Perspectives on Emptiness in Modern History*, ed. Courtney J. Campbell, Allegra Giovine and Jennifer Keating (2019), p. 171.

35 Kamvasinou and Milne, 'Surveying the Creative Use of Vacant Space in London', p. 171; *Greening City Sites: Good Practice in Urban Regeneration* (1987), pp. 117–20.

36 'The Japan-British Exhibition', *The Graphic*, 14 May 1910, p. 15.

37 A. Hotta-Lister, *The Japan-British Exhibition of 1910: Gateway to the Island* (2013), p. 5.

38 'The Japan-British Exhibition', *Farnworth Chronicle*, 4 June 1910, p. 2.

39 The Japan-British Exhibition: Official Report, *Evening Mail*, 1 November 1911, p. 7.

40 'The Japan-British Exhibition 1910', *Edinburgh Evening News*, 29 July 1910, p. 4; 'Japan-British Exhibition 1910', *The Times*, 24 March 1910, p. 10.

41 'The Japan-British Exhibition: Japanese Gardens', *Western Daily News*, 4 June 1910, p. 9.

42 'The Japan-British Exhibition ', *Stamford Mercury*, 24 June 1910, p. 7.

43 'The Japan-British Exhibition', *Farnworth Chronicle*, 4 June 1910, p. 2.

44 'The Japan-British Exhibition', *Farnworth Chronicle*, 4 June 1910, p. 2.

45 'The Japan-British Exhibition', *Globe*, 20 October 1910, p. 8.

46 'White City Japanese Garden £4,030 Claim for Restoration', *Pall Mall Gazette*, 18 July 1921, p. 3; Katharine Leaf, 'London's Buried Cities', *Manchester Guardian*, 18 June 1926, p. 18. The Flip-Flap was a large and very popular amusement ride.

47 'The Japanese Craze', *Birmingham Mail*, 2 September 1910, p. 7; 'Miscellaneous', *London and China Telegraph*, 30 May 1910, p. 11.

48 'Awkward Compliment', *Pall Mall Gazette*, 14 July 1913, p. 3. The wealthy landowner in question was Mr Leopold de Rothschild – an enthusiastic gardener and votary of Japanese gardening – who laid out a Japanese garden at Gunnersbury Park. See 'The Unexpected', *Tatler*, 14 August 1912, p. 30.

11 Reflection and Recreation

1 Isabella M. Holmes, *The London Burial Grounds* (1896), p. 202.

2 'Victoria Park Cemetery', *Morning Advertiser*, 24 September 1849, p. 1.

3 J. C. Loudon, *On the Laying Out, Planting, and Managing of Cemeteries; and On the Improvement of Churchyards* (1843), p. 8.

4 Loudon, *On the Laying Out, Planting, and Managing of Cemeteries*, p. 11.

5 Leone Levi, *Annals of British Legislation* (1856), p.297; 'The Metropolitan Cemeteries in the East', *The Times*, 21 April 1856, p. 7. The inspector also reported having 'witnessed scenes of a very painful nature', including '30 or 40 coffins thrust into graves, and all were left uncovered while he stayed; the graves were very near each other, and the bustle was continuous and distressing'; and many of the graves were also 'partly above the natural level of the ground, and covered only by a few feet of open gravel'.

6 'The Metropolitan Cemeteries in the East', *The Times*, 21 April 1856, p. 7.

7 J. J. Sexby, *The Municipal Parks, Gardens, and Open Spaces of London: their History and Associations* (1898), p. 571.

8 Holmes, *London Burial Grounds*, p. 295.

9 Holmes, *London Burial Grounds*, p. 202

10 Sexby, *Municipal Parks, Gardens, and Open Spaces*, p. 574.

11 'EDEN "Oh, it really was a very pretty garden" by SMALL BOY', *London Hospital Gazette*, no. 37, June 1899, pp. 23–5 (Royal London Hospital Archives & Museum, hereafter RLHAM). For a detailed account of this garden see Sally Williams, '"Eden as we know it, is a fertile and happy region situated in the heart of Whitechapel": The Nurses' 'Garden of Eden' at the London Hospital', *London Gardener*, vol. 18, 2013-14, pp. 99–118.

12 'Nursing Notes', *London Hospital Gazette*, no. 28, September 1898, p. 41.

13 'The Brewers' Almshouses, Mile-End', *The Mirror*, vol. 29, 18 February 1837, p. 120.

14 'The Brewers' Almshouses, Mile-End', p.120; *The Annual Charities Register and Digest. Being a Classified Register of Charities in … the Metropolis* (1897), p. 493.

15 The Hon. Mrs Evelyn Cecil (Alicia Amherst), *London Parks and Gardens* (1907), p. 295; Anne Beale, 'A People's Garden', *The Sunday Magazine*, 1885, pp. 701–3.

16 Beale, 'A People's Garden', p. 701.

17 'Public Garden at Stepney', *The Graphic*, 19 July 1884.

18 It was first realised that the nurses would benefit from the provision of a garden in 1875, when a nurses' training facility was established at the hospital. For several years, they were able to make use of the gardens within the precincts when they were on duty.

19 'Nursing Notes', p. 41.

20 'Nursing Notes', p. 41.

21 Cecil, *London Parks and Gardens*, p. 295; *Matron's Annual Letter*, no. 21, April 1914, p. 24.

22 'Gift to Nurses – Luxury Swimming Bath in "Garden of Eden"' in *The London Hospital Illustrated* (1936–7), p. 11.

23 See RLHAM, LH/A/24/57 re Disused Burial Ground Philpot Street/Varden Street, 1961.

24 'Jewish Cemetery at Mile End listed by English Heritage', *Queen Mary University of London* (online newsletter), 14 April 2014: https://www.qmul.ac.uk/media/news/items/jewish-cemetery-at-mile-end-listed-by-english-heritage.html.

25 Sharman Kadish, 'Jewish Funerary Architecture in Britain and Ireland since 1656', *Jewish Historical Studies*, vol. 43, 2011, p. 67.

26 Holmes, *London Burial Grounds*, pp. 159–60.

27 Holmes, *London Burial Grounds*, pp. 87, 161.

28 'Jewish Burial Ground, Chatham' (Historic England, *National Heritage List for England*): https://historicengland.org.uk/listing/the-list/list-entry/1482982?section=official-list-entry#.

29 Rudolph Ackermann, *Repository of Arts, Literature, Commerce, Manufactures, Fashions and Politics*, vol. 7, 1812, p. 168.

30 Ackermann, *Repository*, p. 169.

31 'St. James's Burial Ground, Hampstead Road', *St Pancras Gazette*, 23 January 1869, p. 2.

32 Lord Brabazon, 'Disused Metropolitan Burial Grounds', *The Times*, 23 April 1883, p. 10.

33 Brabazon, 'Disused Metropolitan Burial Grounds', p. 10.

34 'Another Chance for St. Pancras', *Pall Mall Gazette*, 8 May 1883, p. 2.

35 A London Inheritance: https://alondoninheritance.com/london-parks-and-gardens/st-james-gardens-a-casualty-of-hs2/.

36 'Within a Stone's Throw of Euston Station', *The Times*, 1 May 1883, p. 12.

Photograph Credits

Cover, 3, 4, 6, 7, 8, 43, 44, 45, 46, 47, 48, 63, 70, 72, 74, 76, 77, 81, 83, 84, 85, 98, 99, 100, 101, 109, 113, 117 (sc/phl/02/1071), 144, 169 (wcs/p/018), 185, 187 and pp. 6–7: Image © London Metropolitan Archives (City of London); frontispiece, 150, 156, 158, 159: rhs Lindley Collections; 1, 21, 151: Photo © Christie's Images / Bridgeman Images; 2: © The Ardizzone Trust; 5, 24: The Buccleuch Collections / Bridgeman Images / Reproduced with the kind permission of the Duke of Buccleuch and Queensberry, kt; 9, 12, 20, 80, 86: Folger Shakespeare Library, Washington, D.C.; 10, 18: riba Collections; 11: By permission of the Master and Fellows of Magdalene College, Cambridge; 13, 14: © National Portrait Gallery, London; 15, 23, 25, 34, 36, 37, 42, 92, 93, 94, 95, 97, 103, 106, 107, 108, 110, 121, 122, 123, 148: © The Trustees of the British Museum; 16, 22, 56: Royal Collection Trust / © His Majesty King Charles III 2024; 17: Magnus Gabriel de la Gardie Collection, National Library of Sweden, Stockholm; 19, 31: Courtesy of Linda Hall Library of Science, Engineering & Technology, Kansas City; 26: Gallery Of Art / Alamy Stock Photo; 27, 35: Topographical Collection / Alamy Stock Photo; 28, 29, 50, 51, 89: Heritage Image Partnership Ltd / Alamy Stock Photo; 30: Ministero dei Beni e delle

Attività Culturali e del Turismo; 32, 33, 135: © British Library Board. All Rights Reserved / Bridgeman Images; 38, 41, 61, 119, 120, 168 and p. 4: rbkc Local Studies and Archives; 39, 62, 178, 184: Wellcome Collection; 40: Courtesy of the Royal College of Surgeons of England; 49, 52, 55, 176, 177: © Victoria and Albert Museum; 53: Beinecke Rare Book and Manuscript Library; 54: Bodleian Library, Oxford; 57: © Sir John Soane's Museum, London; 58: The Huntington Library, San Marino, California; 60, 142: Bodleian Library, Oxford; 64, 112, 130, 179, 188: Image © Susannah Stone; 65, 66: © 2024 Britain Yearly Meeting of the Society of Friends (Quakers); 68, 69, 136: Photo: © Tate Images; 79: Burghley House Collection; 82: Westminster City Archives; 87: © Sotheby's; 90, 91: With Kind permission from His Grace, The Duke of Bedford and the Trustees of The Bedford Estates. The Woburn Abbey Collection (bl-px1 Plan c1795, and bl-p120 Estate Survey, 1795. Ninth Plate); 96, 146: National Library of Scotland; 105: British Library; 114, 115: Wandsworth Libraries & Heritage Service; 116: © E. W. Fenton; 118, 129: © Lucian Freud Archive; 124: Toledo Museum of Art, Ohio; 125: National Portrait Gallery, Smithsonian Institution, Washington, D.C.; 126, 141: Reproduced by kind permission of London Borough of Lambeth,

Archives Department; 127: Yale Center for British Art, Paul Mellon Fund; 128: Courtesy of Ordovas, London; 131: Britain from Above / © Historic England; 132: Environmental Design Archives, University of California, Berkeley; 134: Bibliothèque Nationale de France, Paris; 143: Courtesy Spalding Gentlemen's Society; 145: Wikipedia; 147: Art Collection 3 / Alamy Stock Photo; 149: The Print Collector / Alamy Stock Photo; 152: Common domain image; 153: Hackney Archives, Libraries and Heritage Services; 154: Library of Congress, usa; 157: Look and Learn; 160: Henk Snoek / riba Collections; 161: Architectural Press Archive / riba Collections; 162, 173, 175: Look and Learn / Elgar Collection / Bridgeman Images; 163: Reproduced by kind permission of Robert Byng; 164: Courtesy of the Kautz Family, y.m.c.a. Archives, University of Minnesota; 166: American National Red Cross photograph collection / Library of Congress, usa; 171: Steve Bent / Mail On Sunday / Shutterstock; 172: Courtesy of Cathy Lomax / © Cathy Lomax; 174: Chronicle / Alamy Stock Photo; 180, 182: Tower Hamlets Local History Library and Archives, London Borough of Tower Hamlets; 181, 183: Barts Health nhs Trust Archives and Museum; 189: Courtesy of hs2 Ltd; 190: Mark Kerrison / Alamy Stock Photo

Index

Page references in *italic* are
to illustrations

Abbot, Hon. Charles 38, 40
Addison, Joseph 84
Adolphus, Prince, Duke of Cambridge 54
Albemarle, William Charles Keppel,
 4th Earl of 59
Albert, Prince Consort 201, 202, 2046
Allason, Thomas, *A Plan of Notting Hill
 Estate* 220, 221
allotments 199–201
Alnwick Mercury 19
Alps 66
Amelia, Princess (daughter of
 George III) 54
animals 51–69
Anne of Denmark, Queen 28, 61
Anne, Queen 176
Antwerp 173
Ardizzone, Edward, 'Mr Wemmick's
 Castle' *12*
aristocratic gardens 107–31
Armistice Day (11 November 1918) 216
Arthur, Prince (son of Henry VIII) 41
Arundel, Alethia Talbot, Countess of
 25, 26
Arundel, Philip Howard, 13th Earl of 25
Arundel, Thomas Howard, 14th Earl of
 25, 26–7
Ascot racecourse, Berkshire 218
Ashgrove, Knockholt, Kent 166
Astor, Hon. Waldorf 213
Astrop, Northamptonshire 186
Athenaeum 203
Athens
 Erechtheum 93
 Tower of the Four Winds 93
Atlas 66
Aubert, Alexander 184–5
Augusta Sophia, Princess 54
aviaries 15, 51, 54, 68–9

Bacon, Francis 203
Baker, John, junior, Almshouses 234
Baldwin's London Weekly Journal 81–4
Balmes brothers 76, 77

Barbon, Nicholas 25, 100
Barings Bank 199
Barry, G. R. 149
Bartholomew, Jem 72
Baseley, William 47
bathing places 146–9
Bayne, 57
Bazalgette, Joseph 19
BBC 229
Beauchamp, Lord 81
Beckford, William 151
Bedford, earls and dukes of 109, 115
Bedford, Edward Russell, 3rd Earl of 115
Bedford, John Russell, 4th Duke of 118
Bedford, Wriothesley Russell,
 2nd Duke of 116
Beeverell, James, *Les Delices de la Grand
 Bretagne et de l'Irlande* 76
Benbow, John, Admiral 45
Bentley, John 185
Berkeley, Lady 125–6
Berkeley of Stratton, Baron 125–6
Bew, John, *The Ambulator* 141
bird's-eye views 176–7
Blair, Tony 201
Blanchard, Laman 136
Borghese Gladiator 37
Boswell, James 133
botanic gardens 194–9
Bowles, Carrington (after Samuel Wale),
 *A View of the Chinese Pavillions and
 Boxes in Vaux Hall Gardens 134*
Brabazon, Reginald (later 12th Earl of
 Meath) 232, 242
Bradley, Richard, *New Improvements on
 Planting and Gardening* 37–8
Bradshaw, Lawrence 107–8
 (attrib.) plan of Burghley House and
 garden *108*
Brentwood, Essex, Sephardi Cemetery
 239, 240
Brewers' Company 236
 Almshouses 234
Bridgeman, Charles 79–80
 plan of Kensington Palace *85*
 plan of the mounts and the Round
 Pond, Kensington Palace 79, 80

Bristol, Earl of 128
Britton, John, *Map of the Parish of St
 Pancras* 97
Brock, William and John 145
Brooke, John Charles 183–4
Brookes, Dr Joshua, rockwork 59–62, *61*
Brookes, Joshua, senior 52–4
 'Original Menagerie' 52, *53*
 trade card 52, 53–4
Brookes, Paul 54, 59
Brooks, [James] 52
Brown, Lancelot 'Capability' 174, 186
Brydges, James (later 1st Duke of
 Chandos) 173–4
Brynbella, Wales 166
Buckingham, George Villiers, 1st Duke
 of 27
Burghley, William Cecil, 1st Baron 107, 109
Burke, John 128, 131
Busch, Johan 196
Bute, John Stuart, 1st Marquess of 126

Camden, William 109
Canaletto, Antonio (Giovanni Antonio
 Canal)
 Old Somerset House from the River 32–3
 *The Grove and the Grand Walk,
 Vauxhall Gardens 132, 135*
 *View of Whitehall, looking North, with
 the Corner of Richmond House and
 its Stables… 16, 37*
Capell, E. J., *Tortoise's Grotto Surrey
 Zoological Gardens 66*
Caprarola, Villa Farnese 129
Caroline, Queen 73, 79, 81
Casson, Hugh 151
Castang, Philip 54
Catesby, Mark 192
Caus, Isaac de 115
Caus, Salomon de 42
 *Desseing d'une montagne au millieu
 d'un Jardin avec quelques grotes
 dedans 43, 44*
 'The Parnassus at Somerset House'
 28–9, *30*, 61
cemeteries 231–4, 237–44
 Jewish 237–9

Chamberlayne, Edward 36–7
Chambers, William 34
Chancellor, Beresford 96
Channelsea River 199
Charles I, King 29, 31, 128
Charles II, King 45
Charlotte Augusta, Princess of Wales 59
Charlotte of Mecklenburg-Strelitz,
 Queen 54
Chesterfield, George Stanhope, 6th Earl
 of 218
Chesterfield, Philip Stanhope, 4th Earl
 of 112–13
Chichester, Roman remains 109
Christie, James 241
Churchill, Sir Winston 152
Cibber, Caius Gabriel 100
Cicero 182
Cintra, Convention of 40
city gardening 191–4
Clarke, Miss (tightrope walker) 138–40
Clerke, Sir Philip 164
Clifton Nurseries, Maida Vale 167
Coggs, John 176
Cole, Benjamin, *Prospect of the Sweeds
 Church* 102
Cole, Lyndis 223
Collinson, Peter 196
Commonwealth of England 45
Company of Goldsmiths 176
Cooper, W. J, *A Sketch from The
 Embankment after the demolition of
 Northumberland House 13*
Copperplate Map 23
cortile gardens 158–62
Cotton, Jeremy 222
Cotton, John 186
Coxwell, Henry 145
Crace, Frederick, *White Conduit
 Gardens, looking from the Balcony*
 138, *139*
Cracknell, Alfred, model of the
 Commonwealth Institute *208*
Cromwell, Oliver 133, 247n.
Cromwell, Thomas, Earl of Essex 128
Cross, Edward 62, 68
Crowe, Sylvia 207, 209
Cubitt, Thomas 190
*The Curiosities, Natural and Artificial, of
 the Island of Great Britain* 141–2
Curtis, William 194–7, 221
 Flora Londinensis 194

da Costa, Joseph 238
Daily Mail 157
Daily Mirror, Living Britain Campaign
 224
Daily News & Leader 157
Dale, S. Philip, *Proposed American
 Y.M.C.A. Hotel for Officers St James'[s]
 Square* 213
Dalrymple, Sir John, *An Essay on
 Different Situations in Gardens* 84
Daniels, Stephen 40
Danson, George 68
 'Allegorical Pictorial Tableau[x]' 66
 'Colossal Pictorial Typorama' 67
 'Stupendous Panoramic Model' *63*, 66
Dawe, G., *Rockwork at the Surrey
 Zoological Gardens* 61
Dawes, John 183–4
Dawson, David 166–8
 Lucian's Buddleia 167
de' Servi, Costantino 43–4
 proposal for the gardens at
 Richmond Palace *44*
*The Dens in which John Hunter Kept his
 Wild Animals, 1783, Earl's Court
 House 58*
Derby, Lord 213
Derwentwater, Lake District 73
Devonshire, William Cavendish, 1st
 Duke of 126
Devonshire, William Cavendish, 4th
 Duke of 51
Dickens, Charles
 Great Expectations 11–12
 Our Mutual Friend 88–9
Diggers 201
display, gardens of 189–209
Dixon, E. H., *Smith's Dust Heap* 88, 89
Doré, Gustave 157
D'Orsay, Alfred d'Orsay, Count 218
Dr Hunter's House in Earl's Court 59
du Bocage, Anne-Marie 81
Duggan, Diane 115–16

Eagle Rock, Devon 248n.
Ecclesiastical Commissioners 100
ecological parks 221–9
Ecological Parks Trust 223
Edward III, King 180
Edward the Black Prince 180–81
elevated landscapes 78–84
Elizabeth I, Queen 23, 107, 163

Elizabeth, Princess (daughter of
 George III) 54
Ellis, William, *Campagna of London, or,
 Views in the Different Parishes* 184
Elmes, James, *Metropolitan
 Improvements; or London, in the
 Nineteenth Century* 177
Elora, Temple of, India 66, *67*
Emett, Rowland 151
English Heritage, *Register of Parks and
 Gardens of Special Historic Interest* 239
Environment, Department of the,
 *Greening City Sites: Good Practice in
 Urban Regeneration* 225
ephemeral gardens 210–29
Epsom racecourse, Surrey 218
Erle-Drax, John 168
Eusden, Laurence, 'A Letter to Mr
 Addison, On the King's Accession to
 the Throne' 17
Eustace of Fauconberg, Bishop of
 London 25
Evelyn, John 45–7, 75, 125–6
 Sayes Court, Deptford 45, *46*
The Evening News 158
Exeter, Thomas Cecil, 1st Earl of 128

Fairchild, Thomas 22
 The City Gardener 38, 85–6, *86*, 191–4,
 193
Falmouth, Lord 213
The Family of Henry VIII, 35, 36
Fanshawe, Sir Richard and Lady 186
Fawkes, Guy 38
Fenton, E. W., *The Exit from the Grotto
 – 18th century Landscaping in 20th
 century London* 152
Festival of Britain (1951) 149–53
First World War (Great War) 212–18, 229
Flanders 217
Fleet, River 141, 142
Flinders, Captain Matthew 241
Foot, Jesse, garden of Dr Hunter's House
 in Earl's Court *58*
Fotheringhay Castle, Northamptonshire
 69
Fougeroux, Pierre-Jacques 126
Franco–British Exhibition (1908) 225
Frederick, Prince, Duke of York 54
Free Form Arts 224
Freud, Lucian 166–8
 Garden, Notting Hill Gate 167

Fricke, Beata, and Aden Kumler, *Destroyed – Disappeared – Lost – Never Were* 12–13
Fuller, Thomas 47
Fussell, Paul, *The Great War and Modern Memory* 217

Gardner, James 150
Gardner, Thomas, *A Perspective View: New Globe Tavern and Pleasure Gardens, Mile End Road* 144, 145
Gasselin, François, *Montagu House from the north-west* 118, 122–3
George IV, King (earlier Prince of Wales) 54
Giambologna, *Colosso dell'Appenino* 44
Gibb, Sir George Stegman 170–71
Gibraltar
 Rock of 60, 62
 town and Bay of 66
Gibson, John 150
Giles, Peter 166
Girtin, Thomas, *St George's Row, Tyburn* 159, *159*
Glancey, Jonathan 207
Goldney, Thomas III 151
Gordon, General Charles George 215
Gordon, Lord George 241
Gordon Riots 122, *124*
Gore, Spencer
 Houghton Place 96, 97
 Mornington Crescent 97–8, *98*
Gough, Richard 183
Grantham, Lincolnshire, Temple of the Druids 183
Green, Robert 96
Grimm, Samuel Hieronymus, the encampment outside Montagu House during the Gordon Riots 122, *124*
Grosvenor, Robert Grosvenor, 2nd Earl 190–91
grottoes 44, 62, 66, 68, 76, 81, 115, 138, 141, 151, *152*, 153
Guardian 72
Guerci, Manolo 26, 27, 34
 London's Golden Mile: The Great Houses of the Strand 22
Gunpowder Plot (1605) 38

Hall, Francis 36
Handel, George Frideric 134

Harrison, Walter 147–8
Hatton, Sir Christopher 128
Hayman, Francis 134
Henderson, Paula 43, 47, 109
Henrietta Maria, Queen 27, 29, 128
Henry I, King 41
Henry, Prince of Wales 42, 44
Henry VII, King 41
Henry VIII, King 34, 34–6, 36, 47, 75, 79
Heywood, Ellis, *Il Moro* 74–5
Hill, Aaron 77, 88
Hogarth, William 134
Holdernesse, Countess of 175
Holdernesse, Robert Darcy, 4th Earl of 174
Holland, Elizabeth 48, 49
Holland's Leaguer: or an Historical Discourse of the Life and Actions of Dona Britanica Hollandia the Arch-Mistris of the wicked women of Eutopia … 49, *48*
Hollar, Wenceslaus
 Arundel House seen from the south side of the Thames 26, 27
 bird's-eye view of the 'West Central District' 20–21, 24, *31*, 109, 115, *115*
 Suffolke House 23, *23*
Holmes, Basil 94–5
Holmes, Mrs Basil, *The London Burial Grounds* 238
Hone, William 146
Hoppner, John 241
Horwood, Richard
 Plan of the City of London, City of Westminster and Southwark 54, *101*, 147
 Wellclose Square and Prince's (later Swedenborg) Square *101*
Howlett, Bartholomew, *North Front of Bedford House, Bloomsbury Square* 117
Hughes, Mr (spa owner) 140
Hunt, J. H. Leigh 162
Hunter, John 56–7
 'Lions' Den' 57, *58*, 59, 62
 rockwork 59, 61–2
Husselby, Jill 109
Illustrated London News 67
Imperial International Exhibition (1909) 225
International Exhibition (1862) 201
 Royal Commission for 202
Inwood, William 93

Isola Bella, Lake Maggiore, Italy 157

James I, King 28, 91
Japan, Japan–British Exhibition (1910) 225–9
Jeffrey, Sally 24–5
Jekyll, Gertrude 170–71
 plan of Sir George Gibb's garden, Caesar's Camp, Wimbledon *170*
Jennings, Mountain 42
Johnson, Samuel 133, 163, 164, 166
Johnson-Marshall, Stirrat 207
Jones, Inigo 26, 27, 29, 31, 41, 115, 130
Josephine, Empress 199
Journal of Horticulture and Cottage Gardener 189
J.R.S.C., 'London's Lesser Open Spaces – Their Trees and Plants' 189
Julius II, Pope 26

Kames, Henry Home, Lord 86
 Elements of Criticism 84
Katherine of Aragon, Queen 41
Kellogg, Shirley 187
Kemp, William 146
Kent, William 79, 81
 Tower of the Winds 80
Keyes, Robert 38
Kidbrooke Park, Sussex 40
Kinnaird, Lord 213
Kip, Johannes
 Balmes in the County of Middlesex 76, 77
 Danish–Norwegian Church, Wellclose Square (after Cibber) 100, *102*, *103*
Knight, Charles 94, 100
Knights Templars 184
Knox, John 105
Knox, Tim 111
Knyff, Leonard
 aerial view of Whitehall Palace 36, *36*
 Westminster, Old Palace Yard, looking North 38, *38*
'Kynges beestes' 36
Kyoto Exhibitors' Association 227
Kyoto, Japan, Nishi-Honganji gateway 227
Lake District 73–4
Lambert, David 10
Lambert, General John 128
Lancaster, Osbert 151
Lansdowne, Marquis of (earlier Earl of Shelburne) 126

Le Rouge, Georges-Louis, 'Parc de Sion Hill' (Middlesex) 174–5, *174*

le Sueur, Hubert 31

Lea, River 199

Leicester, Robert Dudley, 1st Earl of 23

Lens, Bernard, III

 A View of the West Prospect of the Mount in Kensington Gardens 70, 80

Levellers 201

Lewis, Samuel 126

Lincolnshire 182

Loddiges, George 196–9

Loddiges, Joachim Conrad 196–9

London

 Abington Street 38

 Adam and Eve, Tottenham Court Road 52, 54

 Addington Square, Southwark 100

 Ampthill Crescent (earlier Russell Crescent) 92, 93, 96–7, *97*

 Ampthill Estate 97

 Ampthill Square 15

 Arundel House 15, 25–8, *26*

 Baber's Field 118

 Bagnigge Wells/House 137, 140–43

 Balmes House, Hackney 15, 76, *77*

 Bankside 149

 Barkston Gardens 59

 Bath Street 146

 Battersea Park Pleasure Gardens 149–53, *150, 151, 152, 153*

 'Sculpture in the Open Air' exhibitions 152

 Battle Bridge 14

 Bedford Estate *119*

 Bedford House 15, 115–16, *115, 116*

 Bedford Nursery 93

 Bell and Bird Cage, Wood Street 52

 Bell, Haymarket 52

 Belle Sauvage Inn, Ludgate Hill 52

 Belsize, Hampstead 176–7

 Berkeley Square 125–6, *125, 128*

 Bermondsey 221

 Bermondsey Street 194

 Bird House Inn, Stamford Hill 52

 Black Bull, Tower Dock 52

 Blenheim Steps 59

 Blitz 97

 Bloomsbury estate 118

 Bloomsbury (formerly Southampton) Square (after Dayes) *106, 117*

Blue Coat School, Christ's Hospital 149

Brentford Road 173

Bridewell Palace 146

British Museum 122

Brompton Park Nursery 202

Buckingham Gate 86

Buckingham Palace (earlier King's Palace) 81–4

Bully Fen (Manor Garden Allotments, Eastway Allotments, Abbott's Shoot), Stratford 199–201, *200*

Burghley (earlier Cecil, Cecil Burghley, later Exeter) House, Strand 107–9, *108, 109*, 245n., 246n.

Bushy Park, Diana Fountain 246n.

Cable Street 100, 105

Caesar's Camp, Wimbledon Common 168–71, *169, 170*

Camden Council 97

Cape Nursery 190–91

Carlton Square, Stepney 100

Cat Hill 14

Charing Cross 22

Charterhouse School 137, 149

Chelsea 149, 189

Chesterfield House 112–14, *112, 114*

Chiswick House 51

City Gardens, Hoxton (Thomas Fairchild's nursery) *188*

City Hall 224

City Road 146

Clerkenwell 146

Commonwealth Institute, Kensington 207–9, *208*

Convoys Wharf, Deptford 47

Covent Garden 108–9, 115, *116* Piazza 116

Cremorne Gardens 150

Crystal Palace Company, Sydenham 199

Curzon Street 114, 126

Danish–Norwegian Church ('Templum Dana–Norvegicum') 100, *102, 103*

de Beauvoir Town, Hackney 76

Devonshire House (formerly Berkeley House) 15, 125–6, *127*

Dobney's Bowling Green 142

Eagle and Child, St Martins-le-Grand 52

Earl's Court House 56–9, *57, 58, 59*, 62

Earl's Court Lane 56

Earl's Court underground station 56

Eaton Square 93, 189, 190–91, *188*

Endsleigh Gardens 15, 92, 93–6, *94, 95*

Friends House *94*, 95–6, *95*

Essex House ('Paget Place') 23–5, *24*

Eton House 185

Euston Arch 93

Euston Gardens *243*

Euston (New) Road 88, 93, 95

Euston Square 15, 92, 93–6 Gardens *243, 244*

Euston Station 15, 92, 93–4, 96, 239, 242

Exeter-Change 62

Finsbury Square 88

Five Fields 190

Fleet Street 146

Ford Square, Stepney 100

Fulham 189

Garden Museum 9

George Tavern, Charing Cross 52

Grange Road 194

Great Exhibition (1851) 149

Great Fire (1666) 25, 66, 88, 115

Great Russell Street 118

Greater London Council 166

Grosvenor Estate 190

Grosvenor Place 190

Hackney Central Library and Museum 225

Hackney Grove Gardens 224–5

Hackney Planning Department 225

Hackney Town Hall 224

Hackney Wick 199

Hampstead 118, 126, 184

Hampton Court Palace 34, 109 Banqueting House and Mount 75–6, *76, 79*

Harcourt (Bingley, Portland) House, Cavendish Square 110–12, *110* glass screen 111–12, *111*

Hay Hill farm 125

Highbury House 184–5

Highbury Row 184

Highgate 118, 184

Hippodrome Racecourse, Notting Hill (later Victoria Park, Bayswater) 218–21, *218, 219, 220*

Holborn 52–3, 116

Holford Square, Finsbury 100

Holland Park 207

Holywell Street 146
Hornsey 184
Horse and Groom, Lambeth 52
Houghton Place 97
House of Commons 38, 39, 153
House of Lords 37
Hoxton 200, 249n.
 City Gardens 192–4
Hyde Park 72, 74, 80, 112, 113
Imperial College 207
Imperial Institute Road 206
Institute of Pathology 237
Islington 184
Jack Straw's Castle (Highbury Farm
 or Castle) 184–5
Jack Straw's Castle (pub), Hampstead
 Heath 183
Japan–British Exhibition (1910),
 White City, Shepherd's Bush 225–9
 Garden of the Floating Isle 225,
 228
 Garden of Peace 225, 226, 229
 Scenic Railway 210, 229
Kennington Manor House 15
Kensington 249n.
 Campden House Boarding School
 87, 88
Kensington Church Street, Notting
 Hill Gate 166–8
Kensington Gardens 220
 Mount 73, 74, 80, 84, 85
 Round Pond 79, 80
Kensington High Street 207
Kensington Palace 79–80
Kentish Town 87, 88, 182–3
Kenwood House, Hampstead Heath
 166
King Square, Finsbury 100
King's Cross Railway Station 88
King's Cross Road 140
King's Private Road, Chelsea 54
King's Road 189, 190
Kingsland Road 76
Ladbroke estate 218
Lambeth Borough Council 100
Lambeth Bridge 221
Lambeth Marsh 194
Lansdowne Crescent 221
Lansdowne House 125–6, 128
Lansdowne Passage 125
'Leaguer' 48–9
Leicester Square 221

Leopard and Tyger, Tower Dock 52
Leyton Square, Southwark 100
Limehouse 51
Little's Nursery 189
Loddiges' Nursery, Hackney 196–9
 Palm House 197, 199
 plan 198
Loddiges' Paradise Field Nursery 15
London Spa 137
London Temperance Hospital 242
Lorrimore Square, Southwark 100
Lower Sloane Street 191
Manor Gardening Society 200
Manor House, Kennington 180–82, 181
Marble Arch Mound 71–3, 72
Mare Street, Hackney 196
Mayfair 112, 114
Melbourne Square (later Melbourne
 Fields, then Mostyn Gardens),
 Lambeth 100, 101
Metropolitan Board of Works 19
Middle Temple 186
Mile End Park, 'Art Mound' 143
Mile End Road 143–5
Monkwell Square 146
Montagu House 118–24, 120–21,
 122–3, 123, 124
Mornington Crescent 15, 90, 92, 93,
 97–8, 99
 Carreras Cigarette Factory 99
Mortimer Street, Marylebone 68
National Gallery 216
New Globe Tavern 143–5, 144
New Road (later Pentonville Road)
 118
New Rover 146
New Tunbridge Wells (Islington
 Spa) 137
New-Place (earlier Cat Hill, later
 Little Grove), East Barnet 186–7,
 186, 187
 south front 187
Newman Street, Marylebone 159–62,
 161, 162
Northampton House 245n.
Northumberland House, Strand
 14–15, 17–19, 19, 23, 27, 246n.
 'Interior looking South' 18
Norwood Cemetery 231
Notting Hill 218–21
Nuevo Beth Chaim Cemetery (earlier
 Cherry Tree or Hardy's garden),

Mile End Road, Stepney 237–9,
 238, 239, 240
Nurses' Garden ('Garden of
 Eden'), Royal London Hospital,
 Whitechapel 234–7, 235, 236, 237
Oakley Street, Chelsea 155–8, 156, 158
Old Palace Yard, Westminster 15, 40
Old St Paul's 27, 27
Old Street 146
Oxford Street 59, 71–2
Pall Mall 88
Palm House, Loddiges' Nursery,
 Hackney 197, 199
Paris Garden, Southwark 47–8
Peerless (earlier Perilous) Pool 15,
 146–9, 147, 148
Peerless Street 146
Pentonville 137
Petty France 88
Piccadilly 54, 126, 127
Pimlico 93
Portman market 220
Portman Square 86
Portobello Meadows 218
Potter's Fields Park 224
Prince Consort Road 206
Queen Mary College 239
Queen's Elms, Brompton, Botanic
 Garden 195, 196
Ranelagh Gardens 150
Ratcliff Highway 100
Red Lion Square, Holborn 100
Rhodes Farm (Robert Green's
 Nursery) 96–7
Richmond Gardens, Hermitage 81,
 82, 83
Richmond Palace (formerly Sheen
 Palace) 15, 41–4, 41, 42
Rotten Row 74, 80
Royal Academy 159
Royal Albert Hall 201
Royal Botanic Gardens, Kew 229
Royal Horticultural Society (earlier
 Horticultural Society), gardens
 Chiswick 202, 203
 South Kensington 201–6, 202,
 204–5, 206
Royal Oak 137
Royal Surrey Zoological Gardens,
 Southwark 62, 63, 67, 245n.
 'Eagle Rock' 61, 62
 Tortoise's Grotto 62, 66

London (*continued*)

Russell Square 118

Sadler's Wells 137

St Anne's Chapel, Soho 163

St Clement Danes 23, 25

St George's Housing Estate 105, *105*

St George's Row, Bayswater 159–62, *159*, *160*

St James's Chapel 54

St James's Gardens 15, 239–44, *241*, *242*, *243*

 'yarn-bombing' protests *243*, 244

St James's Park 36

St James's, Piccadilly 241

St James's Square 212

 Washington Inn 212–14, *213*, *214*

St Luke's Workhouse 146

St Margaret Street 38

St Mary's, Lambeth 40

St Mary's, Whitechapel 102

St Pancras 244

St Pancras New Church 93

St Philip's, Whitechapel 234

St Stephen's Chapel 39

St Thomas's Hospital 199

Salisbury House 245n.

Sayes Court, Deptford 15, 45–7

Serpentine 80, 81

Serpentine Gallery 72

Silver Jubilee Walkway 221

Sion Hill, Isleworth 15, 173–6

Sloane Square 190

Sloane Street 196

Sloane Street Nursery 190, *191*

Smithfield 137

 market 220

Smith's Dust Heap, Gray's Inn Road 88–9

Somers Town 93

Somerset House 22, 27, 28–34, *28*, *29*, *30*, *31*, *32–3*, 245n., 246n.

 Parnassus fountain 28–9, *30*

 Privy Gallery 28, *29*

South Audley Street 112

South Bank 221

Southampton Estate, Camden 97

Southampton House (later Bedford House) 116–17, *117*, 124

Southampton (later Bloomsbury) Square 116, *117*

Southwark 27, 221

 brothels ('stews') 47–9

Spa-fields 146

Speaker's House and Garden 39–40

Spring Gardens (later Vauxhall Pleasure Gardens) 136

Stanhope Street 113

Stanley Crescent 221

Stepney 102

 Borough Council 105

Store Street 118

Strand 17–34, 41, 107–8

Streatham Common 163

Streatham House 163

Streatham Park, Tooting Bec 163–6

Swedenborg Gardens 105

Swedenborg Square (earlier Prince's Square) 100, *101*, 102–5, *105*

Syon House, Hounslow 173, *174*

Tavern on the Green 201

Tavistock Square 93, 118

Temple Bar 22

Thistleworth House, Isleworth 173–5

Tottenham Court Road 52–3, 118

Tottenham Court Road Turnpike (later Hampstead Road) 241

Tower Bridge 221

Tower Hill 221

Tower of London 51

Trafalgar Square 214–18

 Camouflage Fair 215, *215*, 216–18, *217*

 Feed the Guns Campaign 215–16, *218*

Twickenham 78–9

Tyburn Brook 81

Underground Electric Railways Company 170

Unicorn, Oxford Road 52

Uxbridge Road 220

Vauxhall Bridge 133

Vauxhall Gardens (earlier New Spring Gardens) *132*, 133–6, *134*, *135*, *136*, 140, 145, 149, *150*

Victoria Embankment 19

Victoria Park Cemetery (later Meath Gardens), Bethnal Green 15, 230, 231–4, *232*

 plan *233*

Walbrook 146

Walworth 11

Wapping 105

Wellclose Square (earlier Marine Square) 100–105, *101*

Danish–Norwegian Church (later British and Foreign Sailor Church) 100, *102*, *103*

Westbourne Grove 218

Westbourne River 81

Westminster 22, 34–40

 City Council 71

 Great Fire (1834) 38

 Palace of 37–8

Westminster Abbey 37, 176

Westminster Hall 37

Wharton Street 140

White Conduit House and Gardens 137–40, *138*, *139*, *140*, 142

Whitehall 34

 Palace of 34–7, *36*

William Curtis Ecological Park 221–4, *222*, *223*

William Stukeley's house, Kentish Town 182–3

Wilson Street, Finsbury Square 68

Wimbledon House 15

Wimbledon Manor House 128–31, *129*, *130*

Wimbledon Park 128

Wimpole Street 112

Woburn Square 118

York House 27

Zoological Society, Regent's Park 63

London, George 84, 202

London Bridge 41

London Building Act (1894) 91–3

London Celebrations Committee for the Queen's Silver Jubilee, Environmental Committee 221

London County Council (LCC) 91, 100, 152, 166, 234

London Development Plan (1951) 100

London Gardener 9–10

London Gardens Trust 9

The London Guide 138, 141

London Hospital Gazette 234, 236–7

London Hospital (later Royal London Hospital), Chaplaincy Department 234

London and its Environs Described 34

London and North Western Railway 96

London and Old St Paul's from near Arundel House 27

London Squares Preservation Act (1931) 93, 100

Lopes, Gabriel 238
Loudon, John 62, 198–9
 *On the Laying Out, Planting, and
 Managing of Cemeteries* 230, 231,
 232
Louis XIV, King 118, 203
Luker, William, 'The Hippodrome,
 Notting Hill' 218–20, *218*
Lysons, Daniel 165–6

M25 motorway 15
Mackenzie, Duncan 190–91
Mackenzie, Frederick (after), *St Pancras
 New Church 14*
Magniac, Charles 114
Malcolm, John Peller 93
 'The West Side of Cavendish Square'
 110
Malton, Thomas 118
Manchester Guardian 151
Mantua, Duke of 31
marginal gardens 173–87
Marlborough, George Spencer, 4th
 Duke of 176
Marlborough, Sarah, Duchess of 128
Matthew, Robert 207
Matthews, C. H.
 Highbury House *185*
 Old Bagnigge Wells Tea Gardens 143
 Peerless Pool, City Road, Finsbury
 148
 White Conduit Gardens, North View
 137, *138*
Maxwell, James 42
menageries 51–63
Merigot, James, *Bagnigge Wells* 141, *142*
Metropolitan Public Gardens
 Association (MPGA) 94–5, 105, 232,
 238–9, 242
Milton, John, *Paradise Lost* 77–8, 183
Mollet, André 128
Montagu, Elizabeth 163
Montagu, John Montagu, 2nd Duke
 of 122
Montagu, Ralph Montagu, 1st Earl (later
 1st Duke) of 118
'monticelli' 74–5
More, Sir Thomas 74–5, 77
Morgan, William, *Map of the Whole of
 London* 118
Morin, Pierre 45
Morland, George 241

Morning Chronicle 148–9
Morning Herald 68
Morning Post 114
Morrison, Herbert 149
Moscow 89
'Mount Vesuvius, as represented at the
 Surrey Zoological Gardens' *64–5*
mounts, artificial 71–89, *72*, 108, 143,
 183–4
 and garden design 84–8
Mr Robinson's Sion Hill 175, *175*
Mudford, William, *Nubilia in Search of a
 Husband* 73–4
Museum Brookesianum 59–61
Museum of London, *London's Pride:
 the Glorious History of the Capital's
 Gardens* (exhibition) 9
Mutsu, Count Hirokichi 225
Mytens, Daniel
 Aletheia Talbot, Countess of Arundel
 25, *26*
 Thomas Howard, 14th Earl of Arundel
 25, *26*

Nairn, Ian 105
Nájera, Duke of 75
Naples 63
Napoleon I, Emperor 66, 257n.
Napoleonic Wars 97
Nashe, Thomas, *Christs Teares over
 Jerusalem* 47
Nattes, Jean-Claude
 *Garden Front of Chesterfield House
 South Audley Street* 2–3, *113, 113*
 view from the basement arcade of
 Chesterfield House looking east
 into the garden 113, *114*
Nelson, John 184
Nesfield, William 202
Netherlands 173, 176, 223
New York Times 212
Nicholson, Max 221–2
'Night and day, the gate of gloomy Hell
 lies open' *48, 49*
Norden, John 23
 Civitas Londini 28, *28*
 Speculum Britanniae 26, 108
 detail showing Burghley House
 and garden *109*
North-Western Railway 242
Northampton, Algernon Percy, 10th
 Earl of 23

Northampton, Henry Howard, 1st Earl
 of 22, 27
Northumberland, Elizabeth Percy, 1st
 Duchess of Northumberland 175–6
Novikova, Anastassia 26
The Nuevo Cemetery, Mile End Road,
 Stepney *238*
 eighteenth-century boundary wall
 239
nurseries 189–91

O'Keeffe, John 59
'"The Old Bridge" Nurses' Garden
 London Hospital' *235*
'The Old Market Gardens and Nurseries
 of London' (Anon.) 189–90
Olympic and Paralympic Games
 (London, 2012) 201
Ordnance Survey maps 97, 186
 Berkeley Square and environs *125*
 Caesar's Camp, Wimbledon *169*
 Euston Square, Mornington Crescent,
 etc. *92*
 Little Grove *187*
 St James's Gardens *242*
*Original Menagerie, New Road, near
 Fitzroy Square, London. Revived by
 the Late Mr. Brooks's Son, Paul 53*
Owen, Jane 201

Page, Russell 151
Paget, Stephen 56
Palin, Will 105
Pall Mall Gazette 155, 229, 242
Paris 45, 118
 Fontainebleau, Palace of 199
Parish of St George Bloomsbury 119
Parnassus fountains 28–9, *30*, 44, 61
Parr, Catherine, Queen 128
Partington, C. F., *National History and
 Views of London and its Environs* 62
Pausz, Thomas 201
Paxton, Sir Joseph 199
*Paxton's Magazine of Botany, and
 Register of Flowering Plants* 62–3
*Peacock's Polite Repository, or Pocket
 Companion for the year 1808* 40
Peltro, John, 'Lambeth Palace from
 the Garden of the Rt. Hon.ble the
 Speaker of the House of Commons'
 (after Repton) 40, *40*
Penny Magazine 137

Percy, Sir Robert 180
Perry, Grayson 201
Perry, Julian, *A Common Treasury* 201
Peter the Great, Tsar 45–7
Phené, Dr John Samuel 155–8
Phillips, Henry 62
Philosophical Transactions 81
Pilton, James 54
Piozzi, Gabriel Mario 164–6
Piozzi, Susannah 166
Piper, John 151
'Plan of the Botanic Garden at
 Brompton' 196
'A Plan of the Hippodrome' 219
*A Plan of Part of the Ancient City of
 Westminster, from College Street to
 Whitehall, and from the Thames to
 St. James's Park 39*
Platter, Thomas 75
Pole, Reginald, Cardinal 128
pools and ponds 146–9
Pope, Alexander 78–9, 151
Poperinghe, Flanders 217
Portland, William John Cavendish-
 Bentinck-Scott, 5th Duke of 110–12
Portugal 173
Primrose, Lady Sybil 216
Prompter 76
Prosser, G. F., *A Summer House in the
 late Mr Thrale's Park Streatham The
 Favo[u]rite Retreat of Dr Johnson 164,
 164*
Punch 202
Purland, Mr (senior), 'Monastic Village
 Aviary' 15, 67–8, 69
Purland, Theodosius 15
 'Antiquarian Village Aviary' 68–9
 Museum of Antiquities 69

Queen Mary College Act (1973) 239

Raleigh, Sir Walter 38
Ralph, James 111
Red Cross 216
Rennie, James, *The Menageries* 51
*Report and Memorial of the
 Commissioners for making
 Improvements in Westminster, near
 Westminster-hall, and the Houses of
 Parliament 39*
Repton, Humphry 12, 38–40, 56
Restoration 45, 47

Rhodes, Joshua, *Topographical Survey of
 the Parish of Kensington 87, 88*
Richard I, King 180
Richmond, Bill 241
Richmond, Duke of 57–9
River Fencibles 40
Robinson, John 175
Rochester, Bishop of 78
rockwork 59, 61–2
Rocque, John, *Map of London,
 Westminster and Southwark 102, 112,
 146, 147*
Rome
 Lateran Palace 203
 Palazzo Farnese, Sala Grande 26
 Temple of Janus 66
 Trajan's Column 43
 Vatican, Cortile del Belvedere 26
 Villa Albani 203
Rooker, Michael Angelo, *South façade of
 Montagu House in Great Russell Street,
 Bloomsbury 120–21*
Rookwood, Ambrose 38
Rose, John 24, 47
Rosebery, Archibald Primrose,
 5th Earl of 216
Rothschild, Jacob, 4th Baron Rothschild
 167
Rothschild, Leopold de 260n.
Roubiliac, Louis-François 134
Royal Commission on London Squares 93
Royal Town Planning Institute 224
'rus-in-urbe' retreats 34, 74, 107, 126, 145
Russell family 115

St Albans, Lord 213
St James's Chronicle 56
Saki, 'The Occasional Garden' 211
Salisbury, William 195–7
Salmon, Thomas 118, 124
Sandby, Paul 159–62, 166
 *Paddington from St George's Row
 160, 161*
 view of the back garden at
 4 St George's Row, Tyburn 159, 160
Sargent, George Frederick
 *Gibraltar at the time of the Siege
 Surrey Zoological Gardens May
 6th 1847 67*
 Temple at Elora, Surr[e]y Gardens 67
Saumarez Smith, Charles, The Nuevo
 Cemetery, Stepney 240

Savary, Thomas 173
Scharf, George
 *A View of the Vivarium, Constructed
 principally with large Masses of the
 Rock of Gibraltar, in the Garden
 of Joshua Brooks Esq., Blenheim
 Street 60*
 panoramic view of the exterior of
 Vauxhall Gardens, looking down
 Kensington Lane 136
 view of the north-west garden
 division of Eaton Square with the
 façade of St Peter's, Pimlico, in the
 background 191, 188
 *A View of the Vivarium, Constructed
 principally with large Masses of the
 Rock of Gibraltar, in the Garden
 of Joshua Brooks Esq., Blenheim
 Street 50*
Scherpenberg, Mount, Flanders 217
Schnebbelie, Robert Blemmell,
 Lansdowne House, Berkeley Square 128
Sebastopol, Crimea, fortifications 245n.
Second World War 237, 238
Serle, John, *A Plan of Mr. Pope's Garden
 as it was left at his Death 79*
Serlio, Sebastiano 24
Sexby, J. J. 232–4
Seymour, Robert 31–4
Shaftesbury, Anthony Ashley-Cooper,
 1st Earl of 151
Shepherd, Frederick, *Earl's Court House
 56, 57*
Shepherd, Thomas Hosmer 177–80
 garden of Devonshire House 127
 garden folly of an unidentified house
 172, 178, 180
 unidentified house and its garden
 178, 179
Shields Daily Gazette 17
Siberechts, Jan 176–7
 *View of a House and its Estate, Belsize,
 Middlesex 176–7, 177*
Silverman, David 71
'Silvester', *A View of the Menagerie in the
 King's Private Road 54, 55*
Simon, James (after), *Montague House
 (now the British Museum) and the New
 Building 123*
'Simple Susan' 185
Small Holdings and Allotment Act
 (1908) 200

Smith, J. T., *Chesterfield House, South Audley Street* 112–13, *112*

Smuts, Robert 43

Smythson, John 23

Smythson, Robert
 plan of the house and garden of Somerset House 28
 survey of the ground floor and gardens of Northumberland House 22

Snoek, Henk, Commonwealth Institute, Kensington, London *208*

Soane, Sir John 39, 62

Society of Friends (Quakers) 95–6

Somerset, Charles Seymour, 6th Duke of 173, 174

'A Song: Bagnigge Wells' 141

Sorbière, Samuel de 36

South London Press 180

Southby, Mr 66

Sowerby, James, *William Curtis's Botanic Gardens, Lambeth Marsh* 8, 194, *195*

spas 137

Spectator 84, 249n.

Spence, Revd Joseph, 'Plan for a Garden for a house in Buckingham Gate' 86–7

Spenser, Edmund 24

squares 91–105
 with mount at centre *86*

Stanfield, C., *Mr. Thrale's House, Streatham 165*

Staniland, C. J., 'The Public Garden of the Brewery Company at Stepney' *236*

Steadman, E. C. 12

Stevens, Revd Anne 243

Stow, John 146

Stradtman, Jan 201

Strafford, Lord 213

Strong, Roy 41, 44

Stukeley, William 15, 88, 182–3
 Chyndonactis Mausoleum (Kentish Town) *183*
 The garden view of my house at Kentishtown. 28 apr.[il] 182
 The Hermitage Garden, Kentish Town 87, 88

Summer Fashions for 1844 63

Sun 66

A Sunday Ramble 141

sundials 36

Surrey Hills 75

Swedenborg, Emanuel 249n.

Switzer, Stephen 80
 Ichnographia Rustica 73

Tate, Trudi, *Modernism, History and the First World War* 217

taverns and inns 52

'Tea Gardens', Eaton Square *192*

tea-gardens 52, 145

Thames, River 19, 22, 23, 34, 36, 38, 41, 74, 75, 76, 81, 133

Thornbury, Walter 110

Thornton, R. J. 194

Thrale, Henry 163, 164, 165

Thrale, Henry Salusbury 'Harry' 163

Thrale, Hester Lynch (later Piozzi) 15, 163–6
 Thraliana 166

Timbs, John, *Curiosities of London…* 69

The Times 92, 94, 100, 201, 212, 213, 214, 215, 218, 220, 244

Topham, Mr (at Jack Straw's Castle) 183

Tottenham-Court Road Turnpike & St. James's Chapel 241

Trust for Urban Ecology (TRUE) 224

Tuck, James 190–91

Tussaud, Madame 157

Tyers, Jonathan 133–4, 135

Vacher, Revd Sidney 234

van den Wyngaerde, Anthonis
 Richemont 41, *41*
 river front of Richmond Palace *42*
 view of Hampton Court from the south 75, *76*

van Somer, Paul 26–7

Versailles, Palace of, France 199

'Victoria Park Cemetery, Green Street, Bethnal Green' 230, *232*

'View of the Gardens from the International Exhibition' *204–5*

Villa di Pratolino, Tuscany, Italy, Mount Parnassus fountain 29, 43

villa suburbana 34

Villiers, Major Arthur 199–200

vivariums 60–62

Ware, Isaac 112

Waterhouse, Ellis 176

Watts, Isaac 181–2

Wells, Mr (of Knockholt, Kent) 166

West, Benjamin 159–62, 166
 the artist's family in the garden of their residence in Newman Street, London 161, *161*
 The Artist's Garden in Newman Street, Marylebone 161–2, *162*

The West Prospect of New-Place in East Barnet in the County of Hertford 186

Western Mail 114

Westminster Gazette 95

Westmorland, Cumbria 84

Whyte, John 218–20

Wichelo, E. M. 145

Wilkinson, Fanny 232

Willes, Mr Justice Edward 186

Willes, Sir John 186

William III, King 75, 79, 100, 212, 213

Williams-Ellis, Clough 152

Wimbledon, Edward, 1st Viscount of 128

Winde, William 27

Winter, Thomas 38

Wise, Henry 84, 202

Wolsey, Thomas, Archbishop of York (later Cardinal) 34

Woodward, Christopher 9

Wortley, Laura 176

Wotton, Surrey 45

Wroth, Warwick, *Cremorne and the Later London Gardens* 145

Wyatt, James 39, 241

Wyatville, Jeffrey 113

Yates, G., *Manor House, Lambeth 181*

YMCA (US) 212–13

York Regiment 122

Young, Arthur, *Farmer's Tour through the East of England* 175

Young, William 53

Ypres, Fifth Battle of 216–17

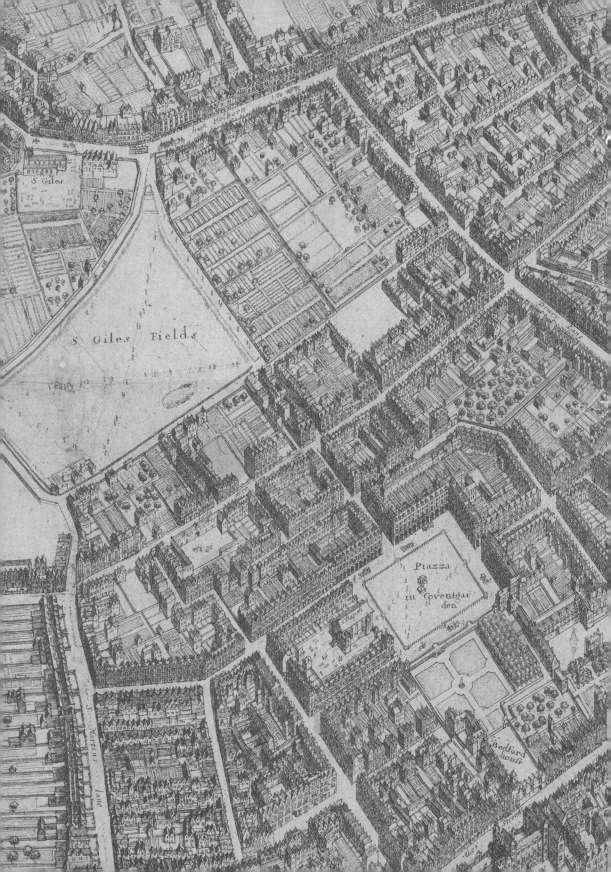